Tender Violence

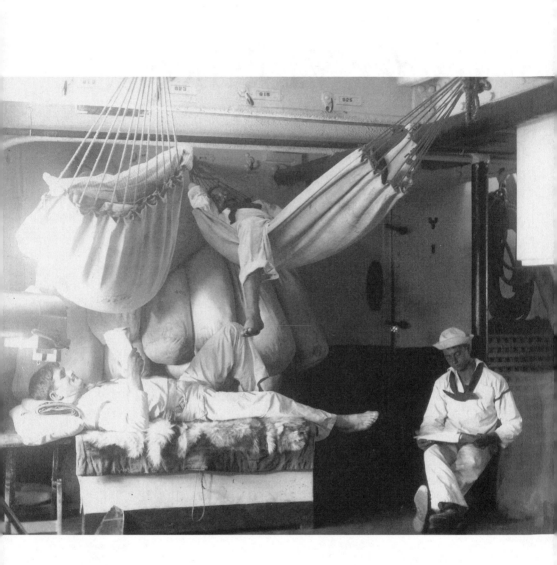

Tender
VIOLENCE
Domestic Visions in an Age of U.S. Imperialism

Laura Wexler

The University of North Carolina Press *Chapel Hill & London*

© 2000 The University of North Carolina Press
All rights reserved
Manufactured in the United States of America
This book was set in Carter Cone Galliard
by Tseng Informations Systems, Inc.
The paper in this book meets the guidelines for
permanence and durability of the Committee on
Production Guidelines for Book Longevity of the
Council on Library Resources.
Library of Congress Cataloging-in-Publication Data
Wexler, Laura.
Tender violence : domestic visions in an age of U.S. imperialism / by Laura
Wexler.
 p. cm. — (Cultural studies of the United States)
Includes bibliographical references and index.
ISBN 0-8078-2570-0 (alk. paper) — ISBN 0-8078-4883-2 (pbk. : alk. paper)
1. Women photographers—United States—History. 2. Photography—
United States—History. I. Title. II. Series.
TR139 .W39 2000
770'.9'73'09041—dc21 00-039251

Earlier versions of Chapter 2 appeared as "Seeing Sentiment: Photography,
Race and the Innocent Eye," in *Female Subjects in Black and White: Race,
Psychoanalysis, Feminism,* edited by Elizabeth Abel, Barbara Christian, and
Helene Moglen (Berkeley: University of California Press, 1997); and under
the same title in *The Familial Gaze,* edited by Marianne Hirsch (Hanover,
N.H.: University Press of New England, 1999). Chapter 3 was originally
published in substantially the same form as "Tender Violence: Literary
Eavesdropping, Domestic Fiction, and Educational Reform," *Yale Journal
of Criticism* 5, no. 1 (Fall 1991): 151–87; and as "Tender Violence: Domestic
Fiction and Educational Reform," in *The Culture of Sentiment: Race, Gender,
and Sentimentality in Nineteenth-Century America,* edited by Shirley Samuels
(New York: Oxford University Press, 1992). Chapter 4 had a previous and
somewhat different life as "Black and White and Color: American Photo-
graphs at the Turn of the Century," *Prospects* 13 (1989): 341–90.

FRONTISPIECE:
Below decks aboard Admiral Dewey's flagship, the *Olympia,* from which
he directed the U.S. assault on Manila. Frances Benjamin Johnston,
photographer

08 07 06 05 04 6 5 4 3 2

For my mother,

Helen Miller Kaplan,

and the memory of my father,

Bernard Isaac Kaplan

More than any other medium, photography is able to express the values of the dominant social class and to interpret events from that class's point of view, for photography, although strictly linked with nature, has only an illusory objectivity. The lens, the so-called impartial eye, actually permits every possible distortion of reality: the character of the image is determined by the photographer's point of view and the demands of his patrons. The importance of photography does not rest primarily in its potential as an art form, but rather in its ability to shape our ideas, to influence our behavior, and to define our society.

—Gisele Freund, *Photography and Society*

Contents

Acknowledgments

From my initial discovery almost two decades ago of Frances Benjamin Johnston's photographs of the Hampton Institute to my most recent investigations of the Ramer School shooting incident, researching *Tender Violence* has put me in touch with not only an extraordinary cohort of American women photographers from the turn of the century but a vibrant, contemporary intellectual community as well. Many people have helped bring this book to fruition, and as I relinquish the manuscript for publication, I find it is their gifts that fill the space it leaves behind.

I would like to thank Sacvan Bercovitch for my earliest sense of permission to write on American photography as cultural history and for my first copy of Beaumont Newhall's *History of Photography.* Alan Trachtenberg gave steady personal attention, probing criticism, and the brilliance of his own work in this field as a model for which to strive. I cannot imagine a better or more generous teacher. The late C. Vann Woodward offered reading, suggestions, and a neighborly sense of approbation that expanded my view of this material. Maren Stange shared her deep intelligence concerning American photography, honoring my efforts to collaborate in making visible its "ideal life." Judith Fryer Davidov's passion for women's camera work helped sustain my own. Tom Ferraro, Gabrielle Foreman, Margaretta Lovell, Franny Nudelman, Joel Pfister, and Nancy Schnog gave years of affection, conversation, and encouragement without end. June Howard was there at the presentation of every conference paper, clarifying just how the project might communicate something of broader interest and greater use. Hazel Carby, Nancy Cott, Michael Denning, Gabrielle Foreman, Margaret Homans, Amy Kaplan, Joel Pfister, Karen Sanchez-Eppler, and Alan Trachtenberg read and commented upon the entire manuscript. Their contributions to the book are a matter of great pride to me, and needless to say, if it has not managed to benefit from every one of their suggestions, the dullness is entirely mine.

From this vantage point, the five-year run of the Trinity/Wesleyan/Yale Women Writers Group seems a miracle of time and feminist commitment. Ann DuCille, Farrah Griffin, Joan Hedrick, Gertrude Hughes, Barbara Sicherman, and Indira Karemcheti were a devoted circle of critics whose respect I sought and to whose judgments I deferred. The episodic incarnations of the Southern New England Left Triangle and the What's Left group were inspiriting, and the ongoing Nineteenth-Century American Women Writers Study Group is a continuing source of supportive community. Patricia Willis of the Beinecke

Library, Carlotta deFilo of the Staten Island Historical Society, Teresa Roane and Barbara Batson of the Valentine Museum, Beverly Brannan and Jeffrey Flannery of the Library of Congress, Holly Hinman of the New York Historical Society, Pete Daniel of the Smithsonian Institution, Elizabeth Ellis of the Museum of the City of New York, Susan Kismaric of the Museum of Modern Art, and especially Linda Anderson of the Yale Women's and Gender Studies Program provided invaluable information, resources, and technical assistance of a very high order.

Thanks also, in alphabetical order, to Elizabeth Abel, Jean-Christophe Agnew, Nancy Armstrong, Martha Banta, Judith Baskin, Betsy Brett, Dick Brodhead, Harriet Chessman, Jane Cutler, Elizabeth Dillon, Wai-chee Dimock, Ann Fabian, Cheryl Finley, Moira Fradinger, Christopher Geissler, Warren Ginsberg, Susan Gilman, Glenda Gilmore, Jennifer Greeson, Sandra Gunning, Bob Gross, David Grubin, Patricia Hill, Marianne Hirsch, Matt Jacobson, Pat Johnson, Carla Kaplan, Carolyn Karcher, Joy Kasson, Patricia Klindienst, Karen Klugman, Stephen Lassonde, Paul Lauter, Jonathan Lear, R. W. B. Lewis, John Mackay, Sandra Matthews, Jim Miller, David Montgomery, Ron Moore, Charles Musser, David Phillips, Jules Prown, Lynn Reiser, Joan Rubin, Maggie Sale, Shirley Samuels, Alicia Schmidt-Camacho, Paul Schwaber, Ivy Schweitzer, Jillian Slonim, Shawn Smith, Al Solnit, Sally Stein, Robert Stepto, Andy Szegedy-Mazak, Lenny Tennenhouse, Rosemarie Garland Thompson, Priscilla Wald, David Waldstreicher, Jo-Ann Walters, Lynn Wardley, Jerry Watts, Bryan Wolf, the YJC Collective, Elizabeth Young, Elisabeth Young-Bruehl, and Sandy Zagarell for materials, comments, and moments of solidarity. They are much appreciated.

Parts of this book were presented as papers and talks to lively audiences at meetings sponsored by the American Historical Association, the American Studies Association, Cornell University, Dartmouth College, the Modern Language Association, the New Haven Creative Arts Workshop, New York University, Salem State College, the University of California at Los Angeles, the University of California at Santa Cruz, the Yale Alumni/ae Association, Yale University, and Wesleyan University. I thank the organizers of those events for the opportunity to speak.

Institutions as well as individuals contributed generously to the writing of this book. A Yale University Samuel F. B. Morse Junior Faculty Fellowship and a Senior Faculty Leave underwrote time and travel. In addition, the book was published with the assistance of the Frederick W. Hilles Publication Fund of Yale University. I am very grateful for the University's support. I am grateful also to the College of Letters at Wesleyan University for making me a Visiting Fellow in the mid-1980s, by which means Paul Schwaber and Elisabeth Young-Bruehl supported the initial stages of my research, and to the Wesleyan Center for the

Humanities under the direction of Dick Ohmann for providing the opportunity to participate in the kind of community of diverse minds that occasionally transfigures academic life.

David Perry, Ruth Homrighaus, and Kathy Malin of the University of North Carolina Press stepped up to the plate for this book with a fierce devotion to excellence that I was under the mistaken impression had departed the contemporary editorial scene. I thank them for their labor, their vision, and their steady hand, without which the final book would not be nearly so fine.

My son Thomas supplied a writer's company, and my daughter Rebecca the sound of strings. Their radiance enriched profoundly the mental and emotional space in which *Tender Violence* took form. My husband Bruce allowed his active talent for family life to become entwined with the finishing of this book in a way that has left the two inseparable and enhanced. I am looking forward to seeing his own wonderful book appear. My mother, Helen Kaplan, was a constant source of companionship and comfort, both material and spiritual. My father, Bernard Kaplan, died before I began to work on this book. But while I was growing up, his memories of his service with the Army Signal Corps in Hawaii, the Philippines, and Japan during World War II and my mother's weekly television series *Looking Ahead* were my introduction to the power of putting the world on film. *Tender Violence* is dedicated to both of them, with love.

My surpassing debt, however, is to the faculty and students of the Yale American Studies, Women's and Gender Studies, and African-American Studies programs. They have helped to teach me how to do this work. More importantly, their insights into seeing as a means to social justice have kept before my eyes the reasons why.

New Haven, Connecticut
March 2000

Tender Violence

There is an aggression implicit
in every use of the camera.
—Susan Sontag, *On Photography*

Introduction

· ·

It is commonly alleged that nineteenth-century photography was
a democratic medium, one that made family portraits available "to the millions."
Yet, as Jeanne Moutoussamy-Ashe has pointed out in *Viewfinders: Black Women
Photographers,* "if indeed photography was a 'democratic art,' then it was so only
to the extent that those who used the process were free to express themselves."[1]
In the nineteenth century this freedom of expression was limited and asym-
metrical. The majority of white families could use domestic photography for
expanded self-making, but others were comparatively less welcome to express
themselves. At first, white men and, by the end of the century, large numbers of
white women had easy access to photography. But the picture was different on
the other end of the social scale. If slaves, for instance, were allowed to be cre-
ative, notes Moutoussamy-Ashe, "they were only to be creative in their menial
labors, such as carpentry and basketry work for their owners." The ability of
slaves to express themselves through photography was severely restricted in the
most basic of ways. Although it has been ascertained that African American pho-
tographers were working in the United States from 1840 to the Civil War, most
were free men and women.[2]

Scholars also largely agree on the prices of individual studio portraits of top
quality, which would have placed them beyond the personal resources of almost
any mid-nineteenth-century Southern slave. It is thus fair to say that slaves did
not generally have studio photographs made of themselves and their families,

unless it was at the behest and with the money of their masters. Although a myriad of what James Scott calls "hidden transcripts" encrypt resistance into many such official records of compliance, this meant that virtually any slave's photograph could be used in countless ways to serve the discourse of the masters, and that the slave's self expression in domestic photography would be in the mode of subversion.[3] Probably this is one reason why both Sojourner Truth and Harriet Jacobs documented the fact of their legal freedom with photographic portraits. *Their* images, at least, could be assertive documents in evidence of self-respecting selfhood for the millions whose self-portraits could never have been made.[4]

Histories of photography have begun to appreciate the significance of the few black photographers who worked on their own during the years of slavery. For example, Angela Davis describes the vitality of the neglected history of black photographers in *Women, Culture, Politics:*

> Many will find it astonishing that black people became involved in photography shortly after the invention of the daguerreotype: Julius Lion, who became acquainted with this process in France, may well have introduced it to the city of New Orleans. But then, how many prominent scientists, scholars, and artists have been banished from historical records for no other reason than their racial heritage, only to be revealed, shamefully late, as outstanding contributors in their fields? Julius Lion, Robert Duncanson and J. P. Ball ought not now to evoke new responses of surprise. Rather, they should be celebrated as evidence of what knowledgeable persons should have strongly suspected all along. Yes, Black photographers were active during the very earliest stages of their medium's history.[5]

However, as Davis points out, we will never have as vivid and full a vision of that era as we would have had had access to photography been more open or had collectors made an earlier and more vigorous effort to recognize politically distinct photographic practices that did exist in the early to mid-nineteenth century. Instead, our very recognition of the presence of certain nineteenth-century black American photographers must be read simultaneously as a sign of absence:

> Slavery imposed a historical prohibition on virtually all forms of open aesthetic creation; only music, misunderstood as it was by the slaveocracy, was permitted to flourish. But what about the untapped artistic potential of those millions of slaves? Do we dare imagine how many pioneering Black photographers there might have been had more favorable socioeconomic circumstances prevailed?[6]

This is not democracy. A century and a half into the abundant store of photographic images of American domestic life, it is well to remember that the Ameri-

can family album was severely out of balance from the start. The paired questions of who takes the pictures and who is in the pictures are not the only issue. The evidence from slavery suggests that the formal principles of family photography can only evolve in relation to the political principles that govern the recognition of families in the first place. Who would gain control of the domestic signifier through photography has been an issue ever since the medium was invented in 1839.

Underlying that issue is the effect of nineteenth-century domestic ideology as the system of signification within which domestic photographs were produced, circulated, and consumed. It is a mistake to assume that the value of a domestic image is the same for all through whose hands it passes, but it is less obvious that one also cannot assume that value to be innocuous. Under certain conditions of political domination, ordinary-looking family photographs can be highly manipulative weapons. The "hidden transcripts" of slave owners made them into brutal reading. Slave owners even used photographs of individual members of slave families as a means through which to try to increase their own economic as well as psychological dominion. Moutoussamy-Ashe reports the following rare correspondence between Louisa Piquet, a free woman, and her slave mother, Elizabeth Ramsey. The story is told in full by Louisa Piquet herself, in a narrative she dictated to the Reverend Mr. Mattison.[7]

Elizabeth Ramsey and her daughter Louisa had been separated since Louisa was fourteen. Louisa was in the process of trying to buy her mother. In this correspondence they are sending photographic portraits to one another. They communicated with the permission of her mother's master, through letters dictated to and written by others:

> March 8, 1859
> Whorton, Texas
> My Dear Daughter,
> I want you to have your ambrotype taken also your children and send them to me I would give the world to see you and my sweet little children; my god bless you my dear child and protect you is my prayer.
> Your affectionate Mother
> Elizabeth Ramsey

Later, after Louisa had answered her mother's letter and also asked for a daguerreotype, Elizabeth Ramsey wrote to her daughter in response:

> It is not in our power to comply with your request in regard to the daguerreotypes at this time, we shall move to Matagorde shortly, there I can comply with your request.

Sometime later, the mother's owner wrote to the daughter:

I send you by this mail a daguerreotype likeness of your mother and brother, which I hope you will receive. Your mother received yours in a damaged condition.

Respec'y yours,
A. C. Horton

A few months later, Louisa, now living up North, received the daguerreotype, which Mattison described as follows: "both [were] taken on one plate, mother and son, and are set forth in their best possible gear, to impress us in the North with the superior condition of the slave over the free colored people."[8] As Gabrielle Foreman explains, the mother's owner was apparently trying to prove that the price he demanded was just, "inscribing Ramsey not as mother, not as family, but as fungible property. He asks Louisa either for money or for another female of greater 'worth' in exchange for her own mother, — literally asking the daughter to buy a slave, and trade."[9]

Evidently, even these rare photographic tokens of the domestic sentiment of slaves — precisely because they were tokens of sentiment — were made into vehicles for the master's allegations that the family life that he provided in slavery for Elizabeth Ramsey was superior to the condition of the black people who were free. Therefore, although Louisa Piquet has finally obtained photographs of her mother and brother, she cannot learn of their true condition from looking at the images. Like wartime propaganda, these images are thoroughly suspect. The pull on the heartstrings, the longing they provoke for mother and home, those sentimental staples, are being used here with the calculating malevolence of a man who wishes receipt of the photographs to destroy even the small sense of security that they dangle. Louisa's experience of domestic photography is not separable from the social system in which it was embedded. For her, the camera is no "spirit of fact that transcends mere appearance," as photographic historians Robert Sobieszek and Odette Appell write of Albert Southworth and Josiah Hawes daguerreotypes, and no "truth in the delineation and representation of beauty and expression," as Southworth himself, her contemporary, believed.[10]

The fierce critique of the photographic image that characterizes contemporary critical sensibility therefore represents not only what Martin Jay has recognized as the "denigration of vision" in the "radical dethroning of Cartesian perspectivalism" but also a turning away from the deviously subtle ways in which, historically, photography has intertwined gender, race, and class to create false images as it makes our private lives public.[11] In the words of Patricia Holland, Jo Spence, and Simon Watney, photography "generates images which are coercive to the extent that they are able to mobilize powerful models of social behaviour and appearances according to which the major divisions of age, race,

class and sex are made to appear both natural and desirable."[12] The institutions of production, circulation, and reception of photographs effectively discourage inquiry into how things got to be the way that they appear. It is necessary to learn that every photograph, as John Berger writes, "is in fact a means of testing, confirming and constructing a total view of reality," but insight into photography's "ideological effect" can become useful only if appearances are not taken as realities.[13]

This is difficult to do. In fact, as Susan Sontag proposes, the deceit that photography offers has by now become ubiquitous and necessary to our functioning as a society. In her judgment, "a capitalist society requires a culture based on images." She explains, "Cameras define reality in the two ways essential to the workings of an advanced industrial society: as a spectacle (for the masses) and as an object of surveillance (for rulers). The production of images also furnishes a ruling ideology. Social change is replaced by change in images."[14] Our very eyesight has been pressed into service as a mode of social control.

One cannot watch the news, read the magazines, or be dazzled by the advertisements and call this bleak picture incorrect. At the same time, however, the same photographic images we see there still harbor a potential for reenvisioning that prevents such closure. There still are "other uses" of even the most common photographs, like family photographs, that do not devolve into bad faith or nostalgia.[15] As Berger reminds us, "there can of course be no formulae, no prescribed practice" for such reintegration of subversive truths, yet, he argues, "in recognizing how photography has come to be used by capitalism, we can define at least some of the principles of an alternative practice."[16]

Those who would work for such alternatives can hardly afford to relinquish photography's potential for making acts of representation visible or to cease developing "ways of seeing" that expose alternative histories. If domestic images, for instance, present an apparently coherent but imaginary vision of real conditions, these same domestic images can put into question such presumed coherence by focusing counter-memories against it.[17] "Downcast eyes," as Martin Jay calls the "antiocularcentrism" of this position, "are no solution to . . . [the] dangers in visual experience."[18] The need instead is to accept the necessity of working against optical illusion to build photography's multitudes of ephemeral traces into documents as solid as any other.

What might such alternative interpretations be? How might we, as Berger asks, "incorporate photography into social and political memory, instead of using it as a substitute which encourages the atrophy of any such memory?"[19] Knowing, for instance, that family photographs falsify, how might we yet come to read in their glib affirmations what Berger calls the utopian "prophecy of a human memory yet to be socially and politically achieved?"[20]

Answers to such questions are necessarily partial, but they are not necessarily less powerful for being so. Photographic images of domestic life—which include the military propaganda, family portraits, school photographs, public relations and magazine and newspaper illustrations that are the subject matter of this book—can be read, in Alan Sekula's terms, "against the grain" so that "normally separated tasks . . . are . . . allowed to coexist . . . between the covers of a single volume."[21] Reading "within" and alongside and through those photographs projects an evidential space where the fact and fiction, exposition and poetry, publicity and privacy, memory and loss, courage and cowardice of social struggle interpenetrate. In the end, I believe, we can use such a space to expose cracks in the mirror of history. Though a democratic vision may not be what is reified in the photographs, it can be aroused in the critical eyes of their beholders.

I have hoped that this book will contribute to the formation of democratic counter-memory by historians to consider the function of gender in the birth of American photojournalism at the turn of the last century. Far from proposing, as once I might have done, that our understanding of the past will become a "more human memory" simply as it comes to value women's contributions, in writing it I have come to see a more equivocal story of the role of women in photography. I understand, like most feminist critics, that gender became a personal empowerment for formerly objectified, nineteenth-century, middle-class, white women when they moved from in front of to behind the camera. But I also see that their shift from object to operator emboldened justifications of Anglo-Saxon aggression at the start of the American century. Specifically, I now believe that the first cohort of American women photographers to achieve serious public careers as photojournalists at the turn of the century often used the "innocent eye" attributed to them by white domestic sentiment to construct images of war as peace, images that were, in turn, a constitutive element of the social relations of United States imperialism during the era's annexation and consolidation of colonies.

My term, "the innocent eye," designates a deeply problematic practice of representation that developed within the private domain of family photography at midcentury in the United States. At that time, white middle-class women, in both the North and the South, were regularly portrayed in family photographs as if looking out from within, without seeing, the race and class dynamics of the household. What I have also called the "averted gaze" of domestic sentiment functioned to normalize and inscribe raced and classed relations of dominance during slavery and to reinscribe them after its legal end. As a representational practice, this private gaze took on a new national significance when in the late 1890s and early 1900s a certain group of American "New Women" photographers—among them Frances Benjamin Johnston; Gertrude Käsebier;

Alice Austen; the Gerhard sisters, Emme and Mamie; and Jessie Tarbox Beals; the subjects of this book—learned to turn it to their professional advantage by ensuring that from the panorama of foreign wars fought by white American men, white American women would construct visions of domestic peace. That is to say, women's professional exploitation of the innocent eye at the turn of the century laid the basis for a new social division of labor in seeing.

The denials in these women's photographs of the structural consequences of slavery, colonization, industrialization, and forced assimilation developed not as a matter of conscious policy but as a matter of gender—that is, as a matter of course. Theirs was a seemingly natural way of seeing that did not imagine itself as misrepresenting. But their pictures helped to heighten regard for territorial acquisitions in the Caribbean and the Pacific by erasing the violence of colonial encounters in the very act of portraying them. It is not only what the women portrayed, therefore, but how they traded on their gender privilege *not* to portray that gave—and still gives—their photography its particular evidentiary value. In their work we can see that the constitutive sentimental functions of the innocent eye masked and distorted what otherwise must have been more apparent: hatred, fear, collusion, resistance, and mimicry on the part of the subaltern; compulsion, presumption, confusion, brutality, and soul murder on the part of the colonial agent. The particular form their gender rebellion took virtually guaranteed that their efforts would go to strengthen the hand of those whom Matthew Jacobson calls the "nation's Anglo-Saxon stewards," whether they had wished that to be so or not.[22]

Typically, historians have cast a trusting and largely vacant eye upon the pictures these women produced. But turn-of-the-century "women's camera work," in Judith Fryer Davidov's memorable phrase, naturalized the dominations that it was assigned to document.[23] The numerous gaps in domestic memory that subtend the vision of so many of these white, middle-class American women of the late nineteenth and early twentieth centuries result from their habitation of an historically specific class and racial point of view. Far from merely recording a world already made, the way these photographers saw the world helped to promulgate the violent disjunctions that supported the late-nineteenth-century, U.S. imperial construct. As Martina Attille persuasively argues in a provocative essay on Georgia Sea Island photographs taken in the early twentieth century by Doris Ullman, an upper-middle-class white woman photographer, "Identification is the issue, and finding routes to perspective systems is the work at hand."[24]

The critical practice of reading whiteness, evident in a growing body of work by feminist scholars, has inspired my search for these routes. Gail Bederman, T. J. Boisseau, Ruth Frankenberg, Marilyn Frye, Sandra Gunning, Jacquelyn

Dowd Hall, Amy Kaplan, Jane Lazarre, Toni Morrison, Louise Michele Newman, Minnie Bruce Pratt, Karen Sanchez-Eppler, Vron Ware, and Robyn Wiegman, to cite only some of those whose contributions are vital, have revealed just how complexly gender, class, and sexuality articulate with race to constitute the American visual field.[25] Additionally, recent examinations of the gender and racial politics of American photography by Elizabeth Abel, Lauren Berlant, Judith Butler, Hazel Carby, Judith Fryer Davidov, Ann DuCille, James C. Faris, James Guimond, Donna Haraway, Camara Holloway, bell hooks, Lucy Lippard, Andrea Liss, Catherine Lutz and Jane Collins, Deborah McDowell, Paula Rabinowitz, Vicente Rafael, Maren Stange, Shawn Smith, Deborah Willis, and myself—again to name a small number of those engaged in such work—have deepened both our knowledge of and our ability to ask feminist questions about photographic representations.[26] Informed by provocative historical studies of the changing character of racial formation in the United States by Etienne Balibar and Immanuel Wallerstein, Robert Blauner, Virginia Dominguez, Barbara Fields, George Fredrickson, Paul Gilroy, Reginald Horseman, Daniel Kevles, Michael Omi and Howard Winant, George Stocking, Ronald Takaki, and Priscilla Wald; and by outstanding books of the past decade by such scholars of the production and performance of ethnicities as Noel Ignatiev, Matthew Jacobson, Eric Lott, Joseph Roach, David Roediger, Michael Rogin, and Werner Sollors—once again, among many others—this effort to make whiteness visible has put the feminist goal of demonstrating the "intersectionality" of race, class, and gender literally within sight for the first time.[27] My own understanding of American visual history is not merely indebted to the splendid body and communal spirit of this historical scholarship, I would have been unable to take even a single step without it.

The route I discovered has led me through photographic archives in Massachusetts, Washington, Virginia, and New York and has fostered my appreciation of the myriad ways in which albums, portfolios, catalogues, books, and boxes of nineteenth-century domestic photographs shaped the look and power of white supremacy at the century's end. In some of the family photographs that I have studied, there are striking monuments of resistance to the blind momentum of American domestication, and in many there are indications that such photographs were sites of serious social protest as well as mechanical social reproduction. But the difficulty of parsing each discovery has also highlighted the necessity of continuing to struggle against the presumptions of gender that originally informed the idea of an "innocent eye." Working with these photographs has taught me, most fundamentally, that if we do not interfere with certain of the stories about gender, race, and nation that the repertoire of nineteenth-century family photography still evokes, their destructive aspect will continue on unchecked. Against the current atmosphere of nostalgia that descends upon almost

any nineteenth-century domestic images that are unearthed, the affirmation I am seeking is the one that will say no.

Tender Violence begins with Frances Benjamin Johnston's photographs of the sailors aboard Admiral George Dewey's flagship, the *Olympia,* taken after its triumphal return from the theater of war in the Pacific in 1899. Johnston's photographs exemplify the ways in which late-nineteenth-century, white American women photographers brought the resources of their gender to the imperial program. Johnston, a Washington, D.C., socialite artist-turned-photojournalist, was recommended to Dewey by Theodore Roosevelt as a "lady" who could accomplish what Dewey needed most at that moment: a public image of himself and his men as clean, upstanding, authentic American heroes bringing peace to foreign parts. The brilliant set of pictures Johnston made aboard the *Olympia* demonstrates that she was more than equal to the challenge of imperial propaganda and in firm command of the opportunity that existed for a woman photojournalist at the turn of the century who could turn domesticity into documentary. It also demonstrates the need for a nonessentialist theory of gender that integrates race and class with the history of photojournalism, one that goes beyond the mere counting of women.

In this spirit, Chapter 2 moves back in time from the war of 1898 to the mid-nineteenth century, seeking the origins of turn-of-the-century women photographers' new role in the private photographic practices of the model of domesticity, a model within which that first cohort of women photojournalists, born directly after the Civil War, had been raised. The post–Civil War family photograph album, like plantation fiction written during the same period, validated the maudlin memories of slaveholding that lay in the bosom of many white families by creating saccharine fictions of the "good darkey" who happily served the family's interests from his or her "place" just outside the focus or the frame. This exploitation of sentiment eased the conscience concerning the subjectivity of the human chattel who had plowed the fields, mended the tools, kept the house, and nursed the children before the war. Such representations, I argue, encouraged a selective, self-congratulatory, and monitory conception of the character and composition of the postwar middle-class domestic unit.

A set of family photographs belonging to George Cook, a photographer from Richmond, Virginia, and another set of local-color images made by his photographer son, Eustis, serve in this chapter to clarify the ideological links that drew literary sentimentalism together with widespread domestic representations at midcentury. I am suggesting that family photographs like those of the Cooks laid down future possibilities for historical distortion and violent denial that operated both forward and backward in time. That is, they piggybacked new forms of racial and class domination, such as lynching and imperialism, on

old visual conventions of the slave system. The averted gaze of countless "innocent" white mothers, conveyed by such family representations, helped to make the "home" invisible as a means of cultural imperialism when it was assumed as a specifically female viewing position by the first generation of professional white women photographers at the turn of the century.

Chapter 3 moves forward again in time to find the sentimental structures of feeling, embodied in domestic novels and family portraits of the 1850s and 1860s, transformed into material structures of brick and stone in the 1870s, 80s, and 90s. Public and charitable institutions built during the Civil War and directly thereafter, such as Negro and Indian boarding schools, sought to assimilate non-white, non-middle-class segments of the domestic population to white middle-class domestic norms. Historians have established that the curricula of these institutions functioned in large part, although not entirely, through the imposition of noncorporeal, affect-based models of discipline based on the family values that marked the emergence of white middle-class identity. I am arguing that photographs were a central resource of those means of regulation. Many institutions used "before and after" images of students and inmates to display remarkable transformations said to have been effected by sentimental reeducation. Such photographic narratives were patriarchially inflected efforts to exploit for these institutions the averted gaze of domestic sentiment that originally organized race, gender, and sexuality within the middle-class household during and directly after the slave regime.

Chapter 4 interrogates at some length Frances Benjamin Johnston's photographs of Hampton Normal and Agricultural School, searching for visible evidence of subversions of race and class as well as for the gender protest for which she has become well known. I have found few direct traces of such an intent on the part of the photographer herself, although there does exist evidence of such protest on the part of those she photographed. Many people who were subjected to this degradation resisted this kind of attention. Ironically, the presumed innocence of the contexts in which Johnston's photographs of domestication were produced and consumed could render this resistance invisible. Interestingly, where Johnston equivocates is in the visibility she gives to such potential for resistance, but finally, I believe, her intention was to support the contemporary order.

For instance, the Hampton images, exhibited in Paris at the "American Negro Life" exhibition of the International Exposition of 1900 alongside a different album of photographs, taken by Hampton's ideological opponent, W. E. B. Du Bois, can be read as an intervention in the mounting struggle over the status of race in the New South. Addressing them as such, one can see that Johnston's images sublimate and defuse the political opposition by contemporary blacks and Indians to the reactionary constriction of American citizenship. Despite the

existence of widespread, lively debate on nationalism, colonialism, trade union-ism, and the question of whether "the Negro" should serve in the Philippines, one would not suspect from the *Hampton Album* photographs that the Civil War, one generation past, or the war in the Philippines, still raging, held much of any significance for the student population of the school. At Johnston's Hampton, politics is privatized, violence is a thing of the past, and the social progress of "American Negro Life" is gentle, controlled, and inevitable. Neither racial nor class conflict has the capability to disturb even for an instant Johnston's exquisite equanimity. Only "gender trouble," as Judith Butler calls it, flares occasionally across her radar, although it is almost enough, at moments, to give her pause.[28]

Although it was most aggressive toward the histories of those it portrayed as "others," this business of materializing the innocence of whiteness in photo-graphic representations of domestic sentiment was also not an innocuous enter-prise for those engaged in producing it. Their remarkable poise notwithstand-ing, it can be seen in retrospect that the challenge of mining gender not only influenced the type of images these women made but often rebounded upon the photographers themselves. Women's photography at the turn of the century was far from a monolithic endeavor, and it would be a mistake to imagine white women's "ways of seeing" as all the same; on the contrary, as professionals or serious amateurs, these women were often in direct competition with each other for jobs, prizes, and artistic recognition, and they survived by identifying and developing individual specialties. However, one generally shared aspect of their efforts was the highly intimate side to the work of policing the boundaries of American domesticity, which many of the women seem to have experienced as internal contradiction. The final three chapters of *Tender Violence* examine some of the ways in which fault lines in the domestic unconscious can be seen to have surfaced in the differing perspectives on American domestic images developed by three white middle-class American women photographers from New York, contemporaries in photography at the turn of the century. An historically based, nonessentialist theory of gender's role at the birth of photojournalism must be ready to expose the ways in which domesticating American imperialism placed these women in conflict with themselves. These chapters consider their photo-graphs as interventions that helped to discipline not only external territories but the inner landscape as well.

Domestic sentimentalism was ascendant, for instance, in Gertrude Käsebier's immensely successful professional career, shaping the mystique of upper-class white motherhood in the late 1890s and early 1900s, and a long procession of domestic portraits, fine exhibition prints, and prestigious magazine article illus-trations issued from her Fifth Avenue studio. Chapter 5 explores Käsebier's ex-ploitation of her own and her clients' maternalism through the juxtaposition of a pair of her most famous images, "Blessed Art Thou Amongst Women" and

"The Heritage of Motherhood." Taken together, these eloquent images posit the death of a child as the worst tragedy that can befall any mother. But juxtaposing them once more with a magazine article in which Käsebier published images of a costumed troupe of Native American performers from Buffalo Bill's "Wild West" show exposes the hypocrisy and self-deception of her sentimental claim. Despite warm personal relationships that developed between Käsebier and the Sioux during a series of sittings that she held with them between 1899 and 1902 at both her portrait studio on Fifth Avenue and her home, and despite her beliefs about the sacred bond between mother and child, Käsebier's own writings reveal that she failed to register an *Indian* mother's loss as devastation. Domestic pieties notwithstanding, almost half a century after the end of slavery, with the massacre at Wounded Knee a recent memory, race was a divide across which the great white mother could not, or would not, see.

Alice Austen's photographs, which I discuss in Chapter 6, also convey nativist habits of mind. Unlike Käsebier, who became a professional photographer after marrying and raising a family, Alice Austen was a committed homebody and an amateur, though not at all a conventional figure. Many of Austen's photographs brilliantly demolished received ideas about sex and gender long before the concept of social construction became theoretically available. Nevertheless, Austen's forays into sexual rebellion did not translate into any comparable repugnance for the racial and class regimentation of her day. Instead, they exploded the realm of sentimental innocence without offering any true domestic salvation or escape from patriarchy.

Working tirelessly from her home on Staten Island, Austen made many but published few images during a long lifetime devoted to amateur photography. Occasionally, though, she did try her hand at photojournalism and illustrations for efforts of social reform. Among the images Austen designed for public consumption are *Street Types of New York,* a series of open-air vignettes depicting the working class in New York during the vogue for street photography in the 1890s. In this set of photographs, Austen isolated "types"—streetsweepers, policemen, newspaper boys, and so on—in the streets of the city as objects of fascination, vivid specimens intelligently displayed in a native habitat. Although she clearly means to be sympathetic to the laboring strangers in her land, ultimately they are also a highly abstract presence, kept carefully at arms length, contained in the middle distance of her frame. At roughly the same time, Austen also produced a "shadow archive" of the *Street Types* in another public commission she undertook, illustrating the work of the U.S. Public Health Service. Austen's pictures of Hoffman and Swinburne Island sanitation equipment concretize the abstraction of the immigrant "street type" almost entirely in terms of infection and disease that must be kept under control by good American housekeeping.

Chapter 7 examines the work of Jessie Tarbox Beals, an outright adventurer

who forsook domesticity in order to become a photojournalist in Buffalo, New York. As a newspaper photographer, Beals was much more explicitly engaged than either Käsebier or Austen in portraying daily life. She was especially ambitious to record the domestic habits of the people of the United States' newest colonies and trading partners. Beals took many photographs at the St. Louis World's Fair of 1904. Most were scenes of the "exotic" home life of women and children living at the Fair's anthropological exhibits. Beals approached her subjects with unusual warmth. Her sympathetic photographs of foreigners in exotic dress, practicing exotic customs, were considered constructive subjects for public edification, and she sold much of her work to the newspapers. But evidently, her public achievement at the St. Louis Fair also disguised less acceptable personal compulsions. After the Fair, Beals wrote poetry about the sight of native men who stirred hidden yearnings in her soul. The birth of a "eugenic child" to Beals in 1911, possibly fathered by an outspoken white supremacist—and the poetry she wrote about her outlaw love—suggests that "ogling Igorots," as Christopher Vaughan calls the activity of many visitors to the Fair, also aroused her racial ambitions.[29] The social latitude of Beals's professional work as a photographer, with its gender-bending privilege, seems to have eroded the sentimental "innocence" of her stance and allowed her to rationalize expressions of the sexual drives of white supremacy that were explicitly barred to her as a "lady" though implicitly encouraged in her as an "Anglo Saxon."

And finally, in a brief Epilogue, *Tender Violence* returns to Frances Benjamin Johnston, considering the work she did photographing black schools in the rural south after completing the Hampton commission. On one occasion in a small Alabama town in 1902, Johnston's simple presence as a "lady" photographer escorted by several black men became the pretext for the near-lynching of her companions. Outraged, Johnston went to see the governor in Montgomery, where she threatened to enlist the help of "her friend," President Theodore Roosevelt. But the incident ended without reprisals, and Johnston continued to photograph rural black schools in Alabama as if this threat had not occurred. Such an outcome suggests that even when turn-of-the-century American politics opened the "innocent eye" of the middle-class white American woman photographer, she did not then necessarily picture herself in solidarity with the victims of the domesticated violence she photographed.

In *Another Way of Looking*, writer John Berger and photographer Jean Mohr conclude that every kind of narrative situates its "reflecting subject" and her viewers differently. "The epic form," they believe, "placed it before fate, before destiny. The nineteenth century novel placed it before the individual choices to be made in the area where public and private life overlap. (The novel could not narrate the lives of those who virtually had no choice.)" Beginning in the middle of the

nineteenth century, "the photographic narrative places [the reflecting subject] before the task of memory: the task of resuming a life being lived in the world. Such a form is not concerned with events as facts—as is always claimed for photography. It is concerned with their assimilation, their gathering and their transformation into experience." [30] Photographic narrative is for Berger and for Mohr a unique kind of representation, not so much because of what it portrays as because of the moral stance it requires of its viewers.

I too wish to situate the reflecting subject differently. This is why the narrative of *Tender Violence* ends by invoking the internal contradictions that accumulated alongside the professional accolades that buoyed the success of turn-of-the-century American women photographers. It is not my idea to turn away from their very considerable achievements. They were a remarkable group of people—energetic, independent, accomplished, eager, and able to assume an active role in their world and time. Their photographic productions, like their drive, are always impressive, and often stunning. Inevitably, in carrying out their projects, they significantly challenged the patriarchal constraints of True Womanhood, making the world for women of their race and class significantly larger.

Rather, *Tender Violence* seeks to invest these women's photographs with a kind of cultural power that to the best of my knowledge has not been proposed for them before. Literally as I write, photographs of Kosovar Albanian refugees fleeing genocide are filling American visual space with tragic evidence of murderous nationalism. But most of these images are once again domestic visions, often reported by pioneering women journalists of the 1990s. They configure war and torture as a family problem rather than as the antithesis of human kinship. As such, they are oxymorons, affording greater scope to imagined empathy than to analytical inquiry or political agency. By focusing on the strengths and limitations of gender as an instrumental force in the field of vision, I hope to provide a sharper, more politically nuanced view of what it meant to the women who presided at the birth of photojournalism at the turn of the last century—and what it still might mean to us, at the turn of the next—to use domestic images as a means to "resume," in Berger and Mohr's sense of the term, "a life being lived in the world."

I

A revelation of what the women of this
country have accomplished in triumph over
the remainder of the world.
—"Progress in Photography,"
 Washington (D.C.) Evening Star,
 July 6, 1900

What a
Woman Can
Do with a
Camera

In the early morning of August 5, 1899, a "small, frail but very attractive" young American woman photographer named Frances Benjamin Johnston packed up her camera, glass plates, plate holders, tripod, and black cloth and climbed on board Admiral George Dewey's famous ship, the *Olympia,* as it sat calmly at anchor in Naples Bay. Johnston was in Italy on vacation, hoping a tour of Europe would refresh her energies for the demands of the extraordinarily successful professional career as a photojournalist that she had begun a few years earlier.[1]

Even so, this was something of a busman's holiday for Johnston. While on vacation, Johnston had accepted photographic assignments in Paris and, at the urging of George Grantham Bain, her agent in Washington, D.C., she agreed to travel to Naples to photograph Admiral George Dewey on his flagship before her rival, a male photographer named J. C. Hemment, got there first. Bain's instructions to Johnston somewhat facetiously mimicked "Our Hero," a popular poem written in Dewey's honor with a refrain that went "Dewey! Dewey! Dewey! / Is the hero of the day / And the Maine has been remembered / In the good, old-fashioned way."[2] "Get Dewey! Dewey! Dewey!" Bain told Johnston. "Get him walking, riding, eating and drinking. Then get views of the *Olympia* from every quarter." Before she left the States, Johnston had taken the trouble to track down her friend Theodore Roosevelt, then assistant secretary of the Navy, at his home at Oyster Bay for a letter of introduction to Dewey. Roosevelt's let-

ter read: "My dear Admiral Dewey, Miss Johnston is a lady, whom I personally know and can vouch for; she does good work, and any promise she makes she will keep."[3] Now was her chance to prove him right.

Dewey, too, was seeking R&R. He too had earned it. Almost a year and a half earlier, immediately prior to the commencement of open hostilities between the United States and Spain in the war that contested Spanish control of the colony of Cuba, policymakers in the United States sensed that Madrid was also vulnerable in the Philippines. A popular uprising led by Emilio Aguinaldo and a small group of Philippine nationalists called the Katipunan was challenging three centuries of Spanish rule. Dewey, then commodore of the "Asiatic squadron" of the American navy, sailed from Mirs Bay, China, about fifteen or twenty miles from Hong Kong, under orders to "use utmost force to capture or destroy" the Spanish fleet "then presumed to be in Manila Bay, under command of Admiral Montojo."[4]

Dewey's squadron left Mirs Bay for the Philippines on April 27, 1898, and sailed up the channel at Manila late at night on April 30. Finding the Spaniards there indeed, he commenced attack early in the morning of May 1. The attack was astonishingly successful. Applying "utmost force" turned out to be so easy that the U.S. Navy broke "for breakfast" and had largely finished before lunch. According to the language of a typical American report, by dinnertime it was

My dear Admiral Dewey Miss Johnston is a lady whom I personally know & can vouch for, she *Miss Frances Benjamin Johnston.* does good work, and any promise she makes she will keep. Theodore Roosevelt 1332 V. Street.

1.2. Theodore Roosevelt's note to Admiral Dewey on Johnston's behalf

clear that Dewey "sank, burned or captured all the ships of the Spanish squadron in the bay, silenced and destroyed three land batteries, obtained complete control of the bay, so that he could take the city, the chief port of the Philippine Islands, at any time, and all without losing a single man, and having only nine slightly wounded."[5]

For this brilliant strike, in which a legendarily powerful enemy was totally disabled at no cost whatsoever in American lives, Dewey immediately became a national hero. He was honored repeatedly by President McKinley, who proclaimed, "the magnitude of this victory can hardly be measured by the ordinary standards of naval warfare."[6] Congress bestowed upon him a "sword of honor" that "with the exception of the steel blade and the body metal of the scabbard" was made entirely of pure gold, 22-karat fine."[7] Handsome medals with sculpted images of Dewey on one side and an ordinary seaman on the other, designed in bas relief by Daniel Chester French, were distributed to all his officers and men. The retired rank of rear admiral of the Navy was restored to American military nomenclature simply so that Dewey could occupy it. It seemed likely that Dewey would be nominated for president. The country celebrated wildly, with speeches, parades, and flotillas, all the time ignoring the increasingly pressing fact of violent native Filipino resistance to the growing American control over their national insurrection against Spain.

Small matter that it was the "Hero of Manila Bay" himself who had met with rebel leader Aguinaldo both in China, where Aguinaldo and the rest of the Katipunan leadership were in exile at the time, and in the Philippines after Aguinaldo

1.3. *Sword and belt embellished with precious stones, made by Tiffany & Co. of New York and presented to Dewey by Congress*

followed the American fleet back to the Philippines from Hong Kong. Apparently, Dewey's responses to Aguinaldo's requests had encouraged the Filipino leader to believe what the U.S. consul to Singapore, General E. Spenser Pratt, had earlier intimated: that the United States would support the rebels' bid for the islands' total national independence if Aguinaldo would lend a hand to the Americans' effort to defeat the Spanish. Dewey doubted that the United States would actually be able to take or hold the city of Manila before a large number of American ground forces arrived if he did not get help. He quickly gave guns to Aguinaldo, and Aguinaldo subsequently did enlist thousands of Filipino resistance fighters to join with the American effort against the Spanish occupation in an active alliance with Dewey. As a result, thanks to Dewey's own maneuvering, when the revolutionaries' relationship with Dewey turned sour—as was inevitable, since the United States had no intention of turning over the Philippines to Aguinaldo—a third column of Filipino freedom fighters was already in place to commence a bloody guerrilla war against the U.S. occupation.

Small matter, too, that the Spanish navy in Manila Bay was merely a "remnant" of its once awesome might; that "some of Spain's ships were hulks, rotting at dockside, with guns that would not function"; and that it was not the Spanish sailors but the Spanish troops who were fighting on land who had the better guns, the better positions, and the better marksmanship.[8] In the heady summer of 1898, nothing else seemed to count with the American public but the impression of a painless and absolute Dewey-led American victory over a formidable European colonial power.

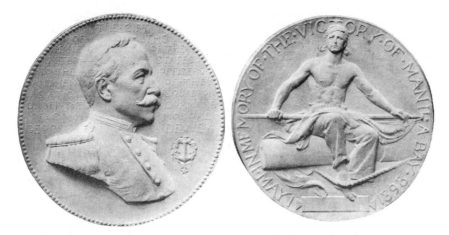

1.4. *The Dewey Medal, designed by Daniel Chester French and given to each man who fought with Admiral Dewey, was inscribed "In memory of the victory at Manila Bay, May 1, 1898"*

A year later, in the summer of 1899, Dewey's victory was still cause for popular acclaim. The United States, triumphant in the Spanish-American War, was now an acknowledged world power with ever clearer colonial ambitions in the Caribbean and the Pacific. When Johnston met up with Dewey in Naples, he and his squadron were on a tour intended to broadcast the solid fact of American naval dominance to anyone who might be contemplating a challenge. It was Dewey's task to captain this spectacle with the same élan he had shown in the South Pacific. Once again Dewey proved the man for the job. Photogenic and often photographed after his great victory had transformed him into an American icon, Dewey understood that there was strategic potential in photographic images.

For her part, Johnston entered the situation with particular credentials. Born in West Virginia in 1864 and raised in New York City, Rochester, and Washington, D.C., by a mother who had been "a former newspaper correspondent [and] who frequently acted as her daughter's secretary," Johnston had a superb sense of visual form in photography and "a talent for detail." Her eye had been developed by training at the Academie Julien in Paris and the Washington Art Students' League; an apprenticeship with Thomas Smillie, the first official photographer of the Smithsonian Institution; and ten years of experience in the field.[9] She was an excellent technician, well known for her beautiful photographs of the buildings at the World Columbian Exposition, her first government assignment. Her nuanced, expressive portraits of individuals or groups of people connected with governmental, educational, commercial, and philanthropic institutions, and her illustrated magazine articles on such topics as "The Foreign Legations of Washington," "A Day at Niagara," "Through the Coal Mine with a Camera," and

"Mammoth Cave by Flashlight" were widely distributed. And from Dewey's perspective, Johnston was well positioned socially. Johnston's close connections in Washington among the business and social elite of the city as well as members of Congress, the cabinet, and the president himself, included many Dewey admirers. Johnston's own political views were pragmatic. Although she worked for a living herself and worked tirelessly to promote careers for women in photography, she was, as her biographers Pete Daniel and Raymond Smock judiciously call her, "neither a crusader nor a reformer." [10]

Nor was George Grantham Bain, Johnston's agent, a reformer. Founder, in 1898, of what was probably the first picture news agency in the United States, Bain understood that even though the halftone printing process—invented in 1880 after many years of work on the problem of how to reproduce images on the same printing block as text—was still an expensive proposition, it was the harbinger of a new era in journalism.[11] In this regard Bain was a true social visionary. He served as agent between nearly all the major magazines and newspapers in the country and a stable of photographers whom he would regularly send out on assignment, to produce 500-word text-and-picture essays on news events, celebrities, and urban issues such as "strikes, riots, or celebrated murders." [12] Bain and his stable of photographers, including Johnston, were early pioneers of the photo-essay form.

But at the same time, there was not a politics of principle behind such innovations. Instead, as photohistorian Peter Hales concludes, Bain's "chameleon-like shifts of attitude toward rich and poor, striker and strike breaker, urban hope and urban discord" show him to be "ready in an instant to mold his treatment to fit the demand." [13] If Bain was a prophet of visual mass communications, he was nonetheless not so much a social prophet as to endanger his own profits. With business first and foremost, the fundamental principle in Bain's assignments to Johnston was to get money! money! money! Bain aimed to sell the pictures that Johnston made on board the *Olympia* to high-end mass circulation periodicals, such as *Demorest's Family Magazine,* the *Illustrated American, Cosmopolitan,* and *The Ladies' Home Journal.* They might pay as much as fifty to one hundred dollars for photographic portraits of celebrities.[14]

Strong anti-interventionist sentiments did, of course, arise in the mainstream press immediately after Dewey's mission in the Philippines was made public. These voices grew stronger after the November 19, 1898, formation of the Anti-Imperialist League, whose founding members included such well-known figures as William Dean Howells, Mark Twain, William James, John Dewey, Jane Addams, Edgar Lee Masters, Finley Peter Dunne, George Ade, and William Vaughn Moody. The ethnic press, as well, followed events with a sharp and often disapproving eye.[15] In May 1899, the Anti-Imperialist League circulated "Soldiers' Letters: Being Materials for the History of a War of Criminal Aggression,"

a leaflet that challenged the accommodating perspective on U.S. military engagement in the Philippines being given out in hundreds of stereoscopic views distributed by commercial publishers. Publishers such as Underwood & Underwood and James M. Davis sold stereopticon images that allowed Americans to view what Jim Zwick, scholar of anti-imperialism in the United States, has called "the war from the parlour."[16] But neither Johnston nor Bain chose to address such criticisms directly. Photographer to five successive presidential administrations, beginning with that of Benjamin Harrison, and a friend of McKinley and Roosevelt, Johnston was as happy to use her camera to further official interpretations as Bain was happy to sell them.

Thus, on August 5, 1899, as Dewey welcomed Johnston and her traveling party aboard his flagship *Olympia,* he and his crew stood ready to cooperate with her efforts, and she with theirs. The collaboration was a significant one. Together, the admiral and the lady turned the decks of the *Olympia* into a stage of the new kind of theater of force with which this book is centrally concerned: the production of domestic images in an age of American imperialism.

What is meant here by the term "domestic images?" Although it is common sense to think of pictures of mothers, babies, and family groupings as domestic images, this book takes the position that the presence of such figures is not necessary for the depiction of domestic space. Domestic images may be—but need not be—representations of and for a so-called separate sphere of family life. Domestic images may also be configurations of familiar and intimate arrangements intended for the eyes of outsiders, the *heimlich* (private) as a kind of propaganda; or they may be metonymical references to unfamiliar arrangements, the *unheimlich* intended for domestic consumption. What matters is the use of the image to signify the domestic realm. The domestic realm can be figured as well by a battleship as by a nursery if that battleship, as in the case of the *Olympia,* is known to be on a mission to redraw and then patrol the nation's boundaries, the sine qua non of the homeland.

In other words, the character of domestic images is not to be defined as a constant element, an essential presence, but as a set of relationships that change according to time and situation. Domestic images are complex, multivalent signs whose symbolic meanings are determined by their insertion into underlying cultural and political patterns. As such, domestic images are historical representations. They are crystallizations of forces. Their codes cannot be understood separately from the entire system of signification that encompasses them. Set by set and image by image we must discover, rather than merely assume, what is domestic about domestic images.

Domesticity, as Anne McClintock notes in *Imperial Leather,* "denotes both a space (a geographic and architectural alignment) and *a social relation to power.* The cult of domesticity—far from being a universal fact of 'nature'—has an historical

genealogy. The idea of 'the domestic' cannot be applied willy-nilly to any house or dwelling as a universal or natural fact." [17] That is, the domestic is a meaning that has to be produced; it is not simply found in nature but is selected from an array of available symbolic resources in accordance with historically specific needs.

Not everyone has equal access to the rules, or reasons, or means for its production. Production of the domestic signifier entails what McClintock calls "processes of social metamorphosis and political subjection of which gender is the abiding but not the only dimension." [18] Many vectors, including race and class, must converge for the character of domesticity to emerge. Domestic images, one might say, are ideological molds that shape such vectors to such ends. They are active, difference-producing mechanisms.

The cult of domesticity was a crucial framework for American imperialism in the late nineteenth century. In the United States, apologists for colonialism used conceptions of domestic progress as both a descriptive and a heuristic tool. Customary ways of life needed protection and advancement at home; they also, apparently, needed conquest and continuing domination of foreign lands. At home, American domesticity was a potent concatenation of ideas of scientific racism, social Darwinism, and economic pragmatism that could be used to orchestrate consent for expansionist policies. In the colonies, and in the institutions and social agencies that dealt with subjugated peoples within the (constantly expanding) borders of the continental United States, such ideals of domestic life were also disciplinary structures of the state. It was domestic photography that brought these two realms into relation.

In this book, I will be considering as domestic images several sets of late-nineteenth-century American photographs that presented views of American daily life which resonated with, at the very least, and sometimes deliberately sought to amplify the voices of American imperialism. With few exceptions, the images I examine were public images, published and viewed in public venues as an integral part of the late nineteenth century's social construction of social knowledge. I have counted them as domestic images regardless whether the literal or customary signifiers of domesticity are in place. For instance, George Cook's personal family photographs of his wife, child, and nursemaid certainly do depict the middle-class primal scene. With them, Cook marks his family life as the location of culture, class, and "civilization." But Gertrude Käsebier's published images of a group of Sioux who passed through her Fifth Avenue photography studio on their way to Europe with Buffalo Bill's Wild West show also serve to legitimate radically xenophobic ideas of American domestic virtue, even though they are missing any of the usual symbols of the American home that characterize her more transparently domestic images, such as Anglo-Saxon

mothers and children. Despite variations in their literal content, I am seeking to understand how all these images constructed the idea of the domestic in a way that differentiated hierarchically the lives of "civilized" Americans from the lives of a variety of people not considered adequately domestic.

It seems likely from the handsome set of photographs that resulted that Admiral Dewey himself saw a domestic use for Johnston's pictures. That is, he clearly understood the occasion of Johnston's visit as an opportunity to secure and strengthen the image of his own legitimacy as an American hero. Through Johnston's photographs, he could broadcast his particular interpretation of how the American conquest of the Philippines came about: how ordinary Americans (among whom he included himself) became an internationally potent force through effective leadership, rational self-discipline, and, as General Arthur MacArthur later said, "years of target practice."[19] In effect, Dewey used Johnston's visit to body forth the military prowess of the United States in such a way as to make doubting its supply of the right stuff unthinkable.

Dewey's hopes for Johnston's photographs were well in line with an existing tradition in American photography, one that sought, like an earlier model of American landscape painting in the hands of Thomas Cole and Frederick Church, to manifest American identity as if it were, as Angela Miller remarks in *The Empire of the Eye,* a "fully natural development of an emergent nationalism freed of a diversity of claims."[20] Looking at Johnston's pictures of the much-loved admiral sitting thoughtfully and modestly, if somewhat stiffly, at his desk or relaxing on deck with his dog "Bob" and those of the crew demonstrating their fencing skills, or showing off their tattoos, or sharing lunch with Miss Johnston in their living quarters below decks, one is tempted to take this claim to American nature just as it is presented. The problem at hand does not seem to be one of self-construction.

One might also fruitfully compare the portrait of Dewey at his desk to the iconic vision expressed in Mathew Brady's *Gallery of Illustrious Americans.* In Brady's gallery, as Alan Trachtenberg observes in *Reading American Photographs,* "we see male public figures in moments of abstraction from pressing affairs, perhaps deep in thought or caught in reverie—in any case, unaware of being seen . . . (an effect achieved by looking anywhere but into the lens)." In these poses, he notes, the "faces project a public space, a space for viewing men in the guise of republican virtue: *gravitas, dignitas, fides.*"[21] Or, one might compare the easy stances of the sailors to Whitman's slouched portrait of himself as a democratic American specimen in the engraving of a now lost daguerreotype by Gabriel Harrison fronting the 1855 edition of *Leaves of Grass,* again noting, as Trachtenberg does, "defiant comfort in a posture of insouciance and open sexuality."[22] In other words, the men on board Dewey's ship were assuming roles that the

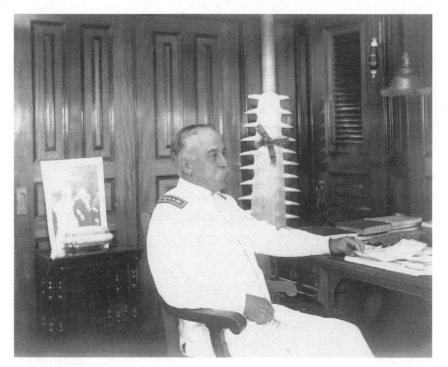

1.5. *Admiral Dewey at his desk*

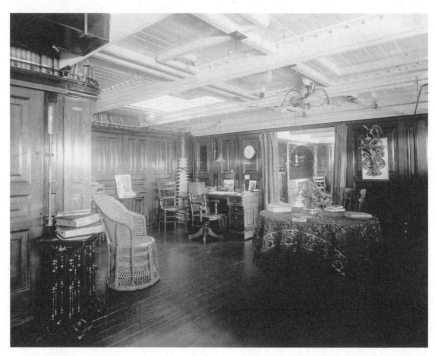

1.6. *The admiral's quarters*

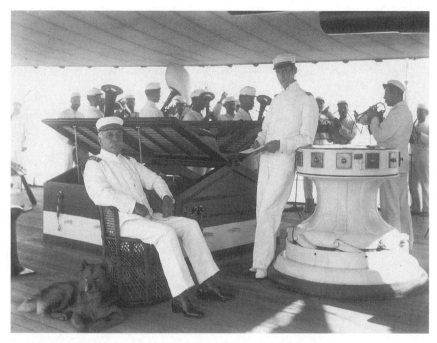

1.7. *Admiral Dewey on the deck of the* Olympia *with his dog, Bob*

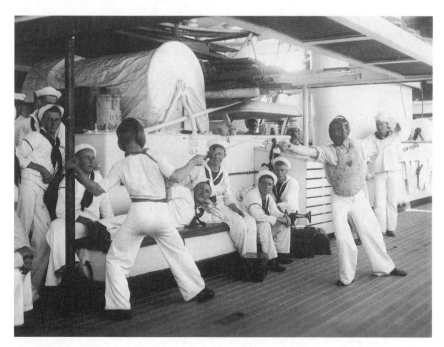

1.8. *Fencing on deck*

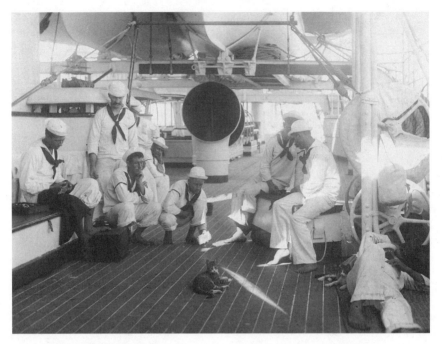

1.9. *Sailors playing with their kitten*

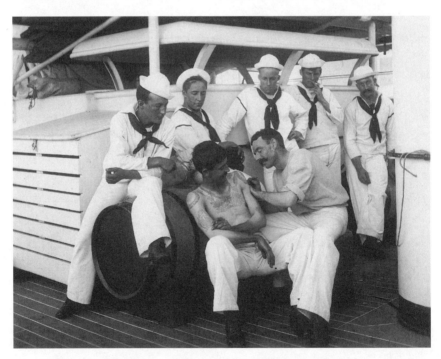

1.10. *An elaborate patriotic tattoo with "America" inscribed across the sailor's heart*

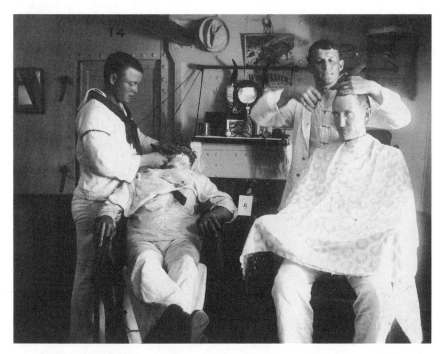

1.11. *Sailors getting haircuts*

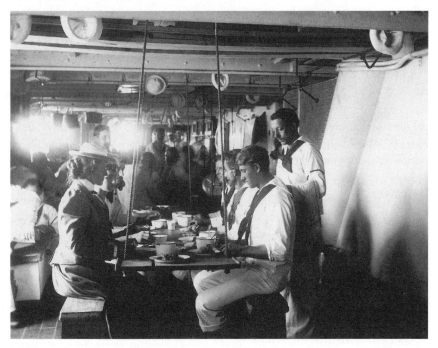

1.12. *Johnston in the crew's mess of the* Olympia

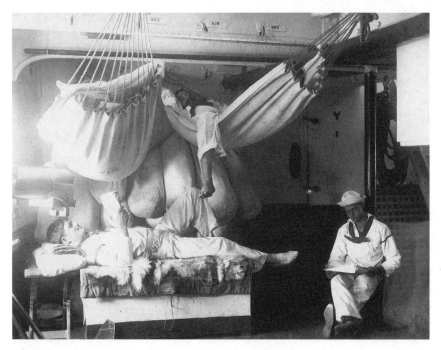

1.13. *Below decks*

American public already knew from other photographs. They did not mean to make themselves anew. They were comfortable being the heroes they already were.

However, the fait accompli that Dewey seems to have been trying to convey—that the officers and men on board the *Olympia* were national heroes, worthy of the medals granted them by Congress in May of 1898—was by no means a sure thing in August of 1899. A national outcry had been developing ever since it became clear that Dewey's miraculous accomplishment in defeating the Spanish navy was equivocal; that the war in the Philippines, in fact, was not over; and that Aguinaldo and the Katipunan had begun to wage a second war of independence, this time against the American forces themselves. Anti-imperialist protest had not yet tarnished Dewey's public reputation—nor would it ever, largely due to his protectors in Congress—but by the time Johnston visited the *Olympia,* it had already sullied that of the American enlisted man, who was being accused of wartime atrocities.

In particular, news that American troops in the Philippines were torturing native Filipinos shocked the American public. In May of 1899, from "A private in the Utah Battery," whose letter was published by the Anti-Imperialist League in *Soldiers' Letters,* the public read:

The old boys will say that no cruelty is too severe for these brainless monkeys, who can appreciate no sense of honor, kindness, or justice. . . . With an enemy like this to fight, it is not surprising that the boys should soon adopt "no quarter" as a motto, and fill the blacks full of lead before finding out whether or not they are friends or enemies.

From "A corporal in the California Regiment," they read:

We sleep all day here, as we do our duty all night, walking the streets. We make every one get into his house by 7 p.m., and we only tell a man once. If he refuses, we shoot him. We killed over three hundred men the first night. They tried to set the town on fire. If they fire a shot from a house, we burn the house down, and every house near it, and shoot the natives; so they are pretty quiet in town now.

And from "F. A. Blake of California, in charge of the Red Cross," they read:

I never saw such execution in my life, and hope never to see such sights as met me on all sides as our little corps passed over the field, dressing wounded. Legs and arms nearly demolished; total decapitation; horrible wounds in chests and abdomens, showing the determination of our soldiers to kill every native in sight.[23]

Later, rumors emanating from the Philippines about the "water cure" being practiced by American troops put at risk the McKinley administration's competing narrative of Dewey's water cure, a military liberation. As described later by Senator Thomas MacDonald Patterson at the Senate investigatory committee hearings, in the Philippines the water cure meant "the holding of a person, usually a native, the pouring of water into his mouth and stomach until he is distended, and thereby forcing him, through the pain, to give information such as you desire to secure from him, as, for illustration, the location of arms or anything of that kind."[24] Actual testimony from the Senate hearings paints an even more vivid picture:

Q: Whom do you mean by the *presidente?*
A: The head official of the town.
Q: The town of Igbaras?
A: Yes, sir.
Q: A Filipino?
A: Yes, sir.
Q: How old was he?
A: I should judge that he was a man of about forty or forty-five years.
Q: When you saw him, what was his condition?

A: He was stripped to the waist; he had nothing on but a pair of white trousers, and his hands were tied behind him.

Q: You may state whether or not there was a water tank in the upper corridor.

A: Just at the head of the stairs on the right there was a large galvanized-iron tank, holding probably one hundred gallons, about two barrels. That was on a raised platform, about ten or twelve inches, I should think; and there was a faucet on the tank. It was the tank we used for catching rainwater for drinking purposes.

Q: You first saw the *presidente* under the conditions you describe with his hands being tied behind him?

A: Yes.

Q: What else did you observe being done with him?

A: He was taken and placed under the tank, and the faucet was opened and a stream of water was forced down or allowed to run down his throat; his throat was held so he could not prevent swallowing so that he had to allow the water to run into his stomach.

Q: Was anything done besides forcing his mouth open and allowing the water to run down?

A: When he was filled with water it was forced out of him by pressing a foot on his stomach or else with their hands.

Q: How long was his mouth held open?

A: That I could not state exactly, whether it was by pressing the cheek or throat. Some say that it was the throat, but I could not state positively as to that, as to exactly how they held his mouth open.

Q: About how long was that continued?

A: I should say from five to fifteen minutes.

Q: During the process, what officers were present, if anybody?

A: Lieutenant Conger was present practically all the time. Captain Glenn walked back and forth from one room to the other, and went in there two or three times. Lieutenant Conger was in command of water detail; it was under his supervision.

Q: You may state whether or not there was any Filipino interpreter present.

A: There was a native interpreter that stood directly over this man—the *presidente*—as he lay on the floor.

Q: Did you observe whether the interpreter communicated with this *presidente*?

A: He did at different times. He practically kept talking to him all the time, kept saying one word which I should judge meant "confess" or "answer."[25]

Given the discrepancy between the wholesome image of Dewey's clean victory that the administration wished to promote and mounting evidence of the use of torture by American troops in letters and pamphlets written by the soldiers themselves, we can see that the image of American forces was a critical site of contestation. As Alan Trachtenberg writes, "The history represented in American photographs belongs to a continuing dialogue and struggle over the future of America."[26] The history represented in Johnston's photographs of Dewey is no exception.

In this underlying struggle over the meaning of Dewey's "splendid achievement and overwhelming victory," Johnston's photographs emerge as factors in dialogue with that history. There were many questions for which Johnston's images were plausible answers. Her pictures are not reflections of a reality already secured, but representations intended to inflect the significance of the *Olympia* in a certain direction.

For one thing, at the turn of the century there existed widespread middle-class anxiety that, as Gail Bederman has put it, the "manliness" of "American civilization" had been fatally compromised by immigration, miscegenation, racial strife, class struggle, and "a recurring round of severe economic depressions," and consequently "both 'manliness' and middle-class identity seemed to falter."[27] As an antidote to this anxiety, Johnston's pictures provided a general counternarrative of muscular male fellowship that was alive and well aboard the *Olympia*.

That whiteness was also an important factor is suggested by comparing the scenes Johnston recorded aboard the ship to a photograph taken by Dewey's aide in the Philippines, Joseph L. Stickney, who had taken his own camera aboard the *Olympia*. Stickney, a noncombatant, actually photographed the naval battle at Manila. Stickney's images, which he copyrighted in 1899 and published in his book *The Life of Admiral George Dewey and the Conquest of the Philippines: The Story of a Hero and How We Acquired an Empire*, make it clear that not only was race an issue in the Philippines, but the crew of Dewey's ship was not composed solely of white men. In his photograph of the men "on board the *Olympia*," who "came on deck from the turret to get a breath of fresh air while the ship was turning to make another run across the front of the Spanish line," a black or Asian sailor stands prominently in the foreground. But Johnston, unlike Stickney, did not make any images that included nonwhite fighters who were crew members aboard the *Olympia*. Instead, except for "Three Chinese Cooks," Johnston absented men of color from the visual record of shipboard life.

At the same time, these abstract signs of the wholeness, or wellness, of whiteness also held a more specific significance. Given the unresolved situation in Manila, Johnston's documents of manhood could reassure the American public that the future still belonged to "our race, trustees under God, of the civilization

1.14. *On board the* Olympia. *Joseph Stickney, photographer*

of the world . . . henceforth to lead in the regeneration of the world," as Sena-
tor Albert J. Beveridge, another of Johnston's photographic subjects, laid it out
in 1900.[28] The splendor of these particular white male bodies in their luminous
"imperial white"[29] dress uniforms or stripped to the waist to show off the supple
young musculature that Daniel Chester French also celebrated in his medal in
their honor offered evidence that colonialism was indeed regeneration or healthy
expansion, rather than poisonous distension. From this evidence, Dewey's re-
cent enterprise against the Spaniards and the Filipinos, like Roosevelt's "rescue"
of Cuba, could be proven salutary rather than scurrilous.

But what is particularly interesting is that Johnston's images perform this
primarily apotropaic function, dispelling internal fears and threatening exter-
nal enemies, not through formal martial narratives or battle reenactments—like
Theodore Roosevelt's *The Rough Riders,* or Stephen Crane's "Vivid Story of San
Juan Hill," or Richard Harding Davis's *The Cuban and Puerto Rican Campaigns*[30]
—but through visual tableaux that seek to capture American military might on
its time off, that is, in domestic time. Johnston ranges over Dewey's entire ship,
as Bain instructed her to do, not only to represent it as the seat of an unassail-
able power, but to represent that unassailable power as a home. The imagery
of conquest in Johnston's photographs does not consist in invocations of in-
cursions upon others coded as "self defense" or "protection of the weak," the
more customary inversions undergirding imperial rhetoric. Rather, it is the rou-
tine decency of daily life that has lined up these particular men with American
destiny. From Johnston's camera comes a view of entirely self-contained ritu-

1.15. *Three Chinese cooks*

als of physical culture, self control, and teamwork that ward off the threat of national dissolution almost without lifting a weapon, much the way these same sailors finished off Spain between breakfast and lunch. That which is logically the furthest thing from the ideal of domestic peace—imperial aggression—is represented in Johnston's photography as a peace that keeps the peace.

This tautology expresses beautifully the ideological thrust of sentimental fic-

tion. The country first learned from the overwhelming response to the publication of Harriet Beecher Stowe's *Uncle Tom's Cabin* in 1851 that inscriptions of the "peace that keeps the peace" were not to be derided as a political force. Stowe's portrait of Rachel Halliday's civil disobedience reverberated throughout the middle years of the nineteenth century, as radical abolitionism gathered steam. But whereas Stowe's image of Quaker domesticity was an image of radical action, one of the theses of this book is that domestic photographs, in the second half of the century, reshaped this reservoir of literary sentiment into a conservative—indeed, aggressively imperialistic—idea of war as peace.

It is obvious in Johnston's photographs that the officers and the crew of the *Olympia* were acting their part in some such fiction. They are too fresh-faced, too gallant, and quite too clean to be believed. To man the *Olympia* was surely a more strenuous enterprise than this. In several of the pictures, the sailors virtually make a game out of being on display, signifying their concession to the demand for a public image by means of a display of self-consciousness before the camera. But judging from the gravity with which they carry out this pantomime, it also seems that although strictly speaking they might be acting, Johnston's subjects register their representation of life aboard the *Olympia* as no mere pretense. No possibility of an alternative interpretation threatens their composure. Underneath the image, their manly virtue, like that of Melville's "handsome sailor," is the real thing.

This confidence was a gift of the imperial power the *Olympia* represented. The manhood of the sailors is guaranteed not because the cult of domestic sentiment in itself produces "real men," as it does "true womanhood," but because through it are inculcated virtues that have just been tested under fire and found to be authentic. Some Americans, such as Carl Schurz, had already begun to turn acid toward the government's equivocation over the drive for acquisition of the Philippines, charging, "We are engaged in a war with the Filipinos. You may quibble about it as you will, call it by whatever name you will—it is a war; and a war of conquest on our part at that—a war of bare-faced, cynical conquest."[31] But the ironic register is completely absent from Johnston's *Olympia* scenes. On August 5, 1899, Dewey's sailors were not dissimulating either their manhood or the American mission in the Philippines that proved it.

There was, however, considerable room for ambiguity in the position of the spectator. While the handsome figures we see in Johnston's photographs so cheerfully escorting their pretty visitor about the deck or showing off their sleeping quarters down below were scripting themselves as gentlemen, there is not the barest hint in Johnston's pictures that these boys next door, or others exactly like them, have just come from enforcing—and intend to continue enforcing—the Open Door policy in the Pacific through the organized military terror of a counterinsurgency campaign. If one did not already know about the continuing

bloodshed in the Philippines and the brutal actions of American troops in subduing the domestic population, one could never discover it from these images. But if one did, one knew one was seeing sentiment.

What the collaboration between Johnston and Dewey demonstrates, I would contend, is domestic sentimentalism at work as an imperial instrument. The ambiguity of the political context is the signifying space that Johnston's images enter as conclusive viewpoints. Within the sentimental construct, home boys must in some sense be mamma's boys, which prevents them from being arsonists, rapists, looters, lynchers. The historically violent side of the domestic sublime is invisible in domestic images. This, indeed, is exactly what made that mode of photography so useful for the purposes of imperial consolidation. Unlike the social documentary photography of Jacob Riis and Lewis Hine, which sought to make the invisible visible, domestic photography hoped to make the visible disappear. By definition, the imperial house of horrors was outside the frame.

Frances Benjamin Johnston was a member of a remarkable cohort of American women photographers who held a very significant place in American photography at the turn of the century and then were "lost" to history in the years just after World War I. For a generation, beginning roughly in the late 1880s, these women traveled widely throughout the United States and Europe making pictures for both public and domestic display. They photographed mill workers and miners, oyster shuckers and newsboys, county fairs and world's fairs—in fact, they created an exceptionally compelling photographic panorama of American life and America institutions. They were not reformers; if anything, they were photojournalists of a kind, working the new market in a new medium: mass-produced, printed photographic illustrations. Sometimes they also managed portrait studios, exploiting the older business end of the medium. What was new about them was that their images reached the public. Even those who remained amateurs sought opportunities for publication of their photographs.

These women may be characterized as a group by the passion they shared for a life in photography. And they proudly emphasized the fact that they were women. They were trying to see, as Johnston herself put it, "what a woman can do with a camera."[32] They meant to "startle the old world," wrote a reporter for the *Washington (D.C.) Evening Star* on the eve of Johnston's departure for Europe. Johnston had in tow an exhibition of 142 photographs by twenty-eight American women photographers, an exhibition the *Star* touted as "a revelation of what the women of this country have accomplished in triumph over the remainder of the world."[33]

Then, although their number includes figures as important as Zaida Ben-Yusuf, Amelia Van Buren, Alice Austen, Marion Clover Adams, Chansonetta Emmons, Floride Green, Mary Bartlett, Mathilde Weil, Catharine Weed Ward,

Virginia Prall, and Sarah Jane Eddy, as well as Frances Benjamin Johnston, Gertrude Käsebier, Alice Austen, the Gerhard sisters, and Jessie Tarbox Beals, whose work this book discusses, the mounting prestige of the photographic high modernism championed by Alfred Stieglitz after the Armory Show in 1913 buried their trail. Mid-twentieth-century histories of U.S. photography—from Robert Taft's *Photography and the American Scene* (1938) to successive editions of Beaumont Newhall's *The History of Photography* (1937–1982) to William Welling's *Photography in America* (1978)—virtually ignored them.

The erasure of these women from the record was anathema to feminist scholars who, encouraged by the success of feminist social history in restoring women's lives to view, began in the 1980s to reestablish the scope of their work along the lines of the earlier recovery and recuperation of "lost" American female writers of the same generation, such as Charlotte Perkins Gilman, Sarah Orne Jewett, and Kate Chopin. Monographs were written. Exhibitions were held. The historical record began to be corrected. In 1994, Naomi Rosenblum published a major compilation, titled *A History of Women in Photography,* in which she noted,

> Women have tended to be slighted and dismissed. . . . Women have consistently been scanted in the general histories of the medium. For instance, Peter Pollack's *Picture History of Photography* (1969) lists fourteen women, the same number as in Beaumont Newhall's 1982 revision of *The History of Photography from 1839 to The Present Day* (that figure is three more than Newhall's 1964 revision, which had two fewer than the original 1949 edition). In *Masterpieces of Photography,* a 1986 compendium of highlights from the George Eastman House Collection, eight of the 194 photographers are women; four women are among the ninety-six individuals included in Mike Weaver's *Art of Photography, 1839–1989* (1989); sixteen women are included among the 202 named photographers whose works are illustrated in John Szarkowski's summation, *Photography until Now* (1989).[34]

This scanting persists despite the fact that, as Toby Quitslund remarks, women have always been photographers: "among professionals, the number of women photographers reported by the United States Census was 228 in 1870, 451 in 1880, 2,201 in 1890, and 3,580 in 1900."[35]

But it is not enough to look at what turn-of-the-century American women photographers were doing in terms of their numbers or their own individual achievement. Nor is it enough to look even in terms of their collective success as a group unless at the same time the "cultural work" of this success itself is also exhumed and interrogated. Now that the lives and the photographs have begun to be available for study and now that more information about women's participation in photography at the turn of the century is constantly being discovered, we have the opportunity to examine more closely the terms of this erasure and

subsequent recovery. It is crucial to ask not simply why these highly success-ful women disappeared from history but, even more fundamentally, why these women were able to have such careers in the first place.

It is particularly important to interrogate the conceptual boundaries and in-strumental effects of American domestic sentimentalism, within which most of their careers sprouted and flourished. The story of turn-of-the-century Ameri-can women photographers' domestic visions is more equivocal than the simple morality tale of American female talent lost and found. As Jane Gover gamely admitted in her excellent pioneering study *The Positive Image: Women Photog-raphers in Turn of the Century America,* the women whose careers she studied were not exemplary social activists like Jane Addams or Emma Goldman, al-though they were these women's contemporaries. "Women photographers did not emerge as the radical people I wanted them to be. . . . With few excep-tions, women photographers kept their middle-class ties intact. . . . The cam-era provided women with the means of stepping beyond the private, domestic space. At the same time, the women's lifestyles and imagery sustained middle-class ideology as it celebrated the domestic ideal and women's place as nur-turer." [36] But nothing need hinder a radical critique of the images these women produced.

Initial reevaluation of the historical significance of these women's work took place during what Gerda Lerner has called the "compensatory" phase of women's history, much as it did with American women writers. [37] In this kind of historical analysis, the subject is plainly "women's lives." Its theoretical ground is essentialism, which defines the "female" as a biologically based social role that develops in binary opposition to equally stable notions of what is "male." This vantage point is reflected in the titles of publications from that period: *The Woman's Eye, Women See Women, Women See Men,* and so on. The interest in women's cultural production lies first and foremost in the potential "difference" or "distinction" with which women conceive of and portray their subject matter, compared to their male counterparts. Hence, the changing discourses of mascu-linity and of race that were so central to American institutions in the era during which these women worked formed little part of the initial reevaluations of their photographs; the articulation of their womanhood with their social class was also largely ignored. With the intense focus on the "femaleness" of their work, the backdrop of nation-making fell away, and the social and political salience of their whiteness went unobserved. The medium of photography itself appeared simply as an instrument. The critical variable was "womanhood," but what that entity actually represented was largely taken for granted.

An increasingly well formulated critique of biological essentialism has offered gender as the conceptual tool with which to redraw this picture. The impetus to do this stems from the recognition that, as Denise Riley puts it,

"women" is historically, discursively constructed, and always relatively [*sic*] to other categories which themselves change; "women" is a volatile collectivity in which female persons can be very differently positioned, so that the apparent continuity of the subject of "women" isn't to be relied on; "women" is both synchronically and diachronically erratic as a collectivity, while for the individual, "being a woman" is also inconstant, and can't provide an ontological foundation.[38]

While "women's lives" and "women's work" remain central as objects of investigation, their definition is no longer transparent, unchanging, and plain. Instead, all fixed binary oppositions between "female" and "male" become unseated as the move to fix them becomes itself the subject of historical analysis. We need, says Riley, to see "the alterations in what 'women' are posed against."[39] This shift in focus from the figure to the ground of "woman" presents the work of turn-of-the-century American women in photography in an entirely new light.

Gender was certainly on Frances Benjamin Johnston's mind. Throughout a very long career, Johnston insisted upon being a "lady photographer" and tried to use the fact of being female to her advantage. An early photograph shows Johnston's photographic tent set up at some kind of a fair. "Frances Benjamin Johnston TINTYPES" is proudly advertised to one side. Johnston's signage appeals directly to the male customer. "GENTS! Have your PICTURE TAKEN with your lady friend. PALACE OF PORTRAITURE." Meanwhile, she and a group of women friends and colleagues sit in front of a sign reading, "LOOK! LOOK!! LOOK!!! TINTYPES. CHEAP, FAITHFUL, LASTING," as if they themselves were the bargains on display.

Later, Johnston used family connections in Washington, D.C., to give her access to photograph the president, members of the cabinet, members of the Supreme Court, and their wives. She had a reputation as an excellent Washington portraitist even before she began to receive public commissions. However, if special ties to Washington society first earned her the sobriquet of "court photographer of the White House," it was her ability to be a lady while at the same time a businesswoman that sustained it. Johnston's career in photography made for a contradiction in terms, a shuffling of gender roles, that never ceased to delight her.

Johnston also tried to teach other women how to do the same. As early as 1897, Johnston published an article in the *Ladies' Home Journal* entitled "What a Woman Can Do With a Camera." There Johnston urged that "photography as a profession should appeal particularly to women, and in it there are great opportunities for a good-paying business—but only under very well-defined conditions." She wanted women to be well prepared because she knew they could

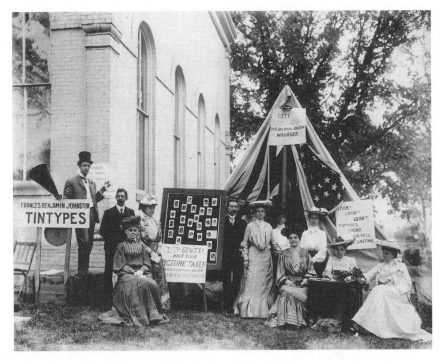

1.16. *Johnston selling tintypes at a Virginia county fair in May 1903*

be successful. Thus, although Johnston counseled that a woman photographer's personal qualities should include "good common sense, unlimited patience to carry her through endless failures, equally unlimited tact, good taste, a quick eye, a talent for detail, and a genius for hard work," she also insisted that an aspirant needed hard-headed "training, experience, some capital, and a field to exploit."[40]

As late as 1915, Johnston lectured at New York University as part of a course titled "Woman in Industry: Her Opportunities in Business Today." She told her audience,

> Photography to my mind is preeminently the vocation which calls to women who find in it a means of individual expression, who feel, in addition to making a livelihood, a distinct need of putting their personality into their work, and certainly the most successful women photographers illustrate this.[41]

However, she was also quick to caution,

> It is not a vocation to take casually as an easy means of livelihood, say, for the reason that one makes good pictures with a snapshot camera. That

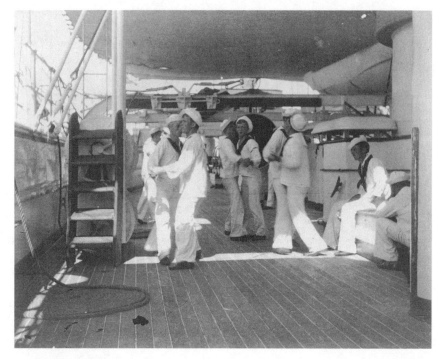

1.17. *Dancing sailors*

may show the right tendency but there is a long rocky road to travel, involving personality, mental poise, physical strength, staying qualities, technical training, unrestricted patience and endless attention to detail.[42]

Small wonder that even near the end of her life, in 1952, we find Johnston still fixed on the importance of the fact of her character to her practice of photography, and claiming that she was "the greatest woman photographer in the world."[43]

Nor is it changing the subject to remark that Johnston was quite aware that the fact of her being a woman helped her gain access to Dewey in the first place. For Johnston, womanhood meant both a social role and professional opportunity, and there were numerous occasions on which she made photographs that explicitly drew upon the former, sensing that to do so would enhance the latter. That Johnston was alive to gender while aboard the *Olympia* is suggested by her picture of "dancing sailors," which references surprisingly openly the figure of the homosexual sailor that winds through the history of American art, and by the image of "two officers relax[ing] with one of Johnston's traveling companions beneath the *Olympia*'s big guns," which invokes heterosexuality. She seems unwilling to forget that she is a woman and the sailors are men, whether they dance with one another or not. Indeed, a certain eroticism suffuses many of the

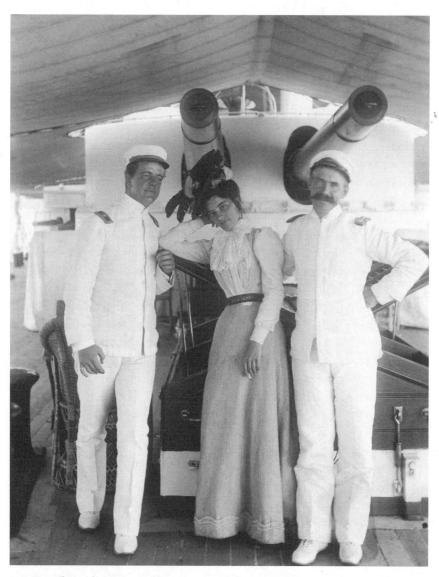

1.18. Two officers relax with one of Johnston's traveling companions beneath the Olympia's *big guns*

Olympia photographs, from the bare-chested display of "An elaborate patriotic tattoo with America inscribed across the sailor's heart" to the sailor lying prone upon his bunk with a book in his hand and a smirk on his face in "Below decks."

Yet to focus on Johnston's own particular exploration of gender roles is also a diversion from exploring the role of gender itself, in another register in which sexual politics functions in these photographs: the social. We may think of gen-

der in this register as what mediates between the experience of the individual and the class structure of society at large. It is here that we see what "womanhood" is poised against. Gender is, in effect, a delivery system for race and class distinctions, and the arousal of gender consciousness has to be taken also as a sign of other activations as well as those, or along with those, of sex. Theoretically, consciousness of gender difference implicates the entire order of difference, in which sexuality plays one part.

Contesting interpretations of manhood aboard the *Olympia* were certainly possible. By the summer of 1899, it was already beginning to occur to members of the newly formed Anti-Imperialist League that Dewey's conduct of the initial stage of the war was in need of some defense, particularly his dealings with the Philippine rebel forces who had been our American allies. Carl Schurtz laid the blame squarely at the door of President McKinley, who in his "benevolent assimilation" order of December 21, 1898, "[directed] our military commander at Manila to extend the military government of the United States over the whole archipelago." By this, Schurtz wrote, "the slaughter of our late allies began." Dewey's "splendid achievement at Manila" was being "desecrat[ed]," Schurtz declared, "by making it the starting-point of criminal aggression, and thus the opening of a most disgraceful and inevitably disastrous chapter of American history, to be remembered in sorrow."[44] On the floor of the Senate, acrimonious debate over administration policy often turned to the question of what Dewey had promised Aguinaldo, implying more policy and less innocence in Dewey's actions than fit his upright image. So by the time of Johnston's visit to the *Olympia,* both Dewey and the administration had a good deal at stake in preventing alternative viewpoints from spreading.

This incipient backlash highlights the usefulness to Dewey of a photographer who, like Johnston, would play "lady" to his "gentleman" and refuse to question the underlying narrative. In essence, Johnston agreed to be the canary in Dewey's coal mine: if it was acceptable for "lady" photographers to be on the scene, the scene itself must be acceptable.

When challenged, Dewey and his supporters rooted his defense in his own character as a representative American and a Civil War veteran. Again and again, Dewey was made out to be a common, capable fellow who rose to the occasion as any other similarly well trained American man would do when offered the opportunity to serve his country. It is even plausible that when he met Johnston, Dewey already knew that his ship should be documented in this particular way as insurance against future imputations of mismanagement of his part in the war in the Philippines. The photographs prepare a brief, as it were, that might come in handy for Dewey.

And, in fact, Dewey did eventually have to call in self-defense upon the public image of his ship as an island of order in a sea of trouble—the image that

Johnston helped him to create. In January of 1902, as the "uprising" in the Philippines was escalating toward its bitter climax and the American body count was mounting toward 4,000 dead and almost 3,000 wounded, a Senate investigating committee pressed Dewey to explain the original terms of his connection to Aguinaldo. Dewey testified that Aguinaldo was a "man of no ability at all."[45] The tenor of Dewey's opinion of the Filipino revolutionary leaders is best captured by quoting his testimony at some length.

Sen. Patterson: Was there any communication between you and Pratt in which the matter of a written pledge or agreement with Aguinaldo was discussed with reference to the Philippine Islands? . . .

Adm. Dewey: I received lots of advice, you understand, from many irresponsible people.

Sen. Patterson: But Pratt was the consul general of the government there?

Adm. Dewey: Yes; he was consul general.

Sen. Patterson: And he communicated with you, giving you such information as he thought you might be interested in, and among other information he gave you was this concerning Aguinaldo?

Adm. Dewey: I don't remember; no, I really don't remember his telling me anything about Aguinaldo more than that cablegram there, and I said he might come. And you see how much importance I attached to him; I did not wait for him.

Sen. Patterson: What you said was "Tell Aguinaldo to come as soon as possible."

Adm. Dewey: Yes, but I did not wait a moment for him.

Sen. Patterson: Yes; but there was a reason for that.

Adm. Dewey: I think more to get rid of him than anything else.

Sen. Patterson: Rid of whom?

Adm. Dewey: Of Aguinaldo and the Filipinos. They were bothering me. I was very busy getting my squadron ready for battle, and these little men were coming on board my ship at Hong Kong and taking a good deal of my time, and I did not attach the slightest importance to anything that they could do, and they did nothing; that is, none of them went with me when I went to Mirs Bay. There had been a good deal of talk, but when the time came they did not go. One of them didn't go because he didn't have a toothbrush.

Sen. Burrows: Did he give that as a reason?

Adm. Dewey: Yes; he said, "I have no toothbrush."[46]

In his testimony, Dewey represents the Katipunan leaders as worse than incompetent; in his eyes they are irresponsible children who "do nothing" while he does real work. Aguinaldo carried disorder on board the *Olympia*. He and

his friends took up Dewey's important time with idle chatter. Then, despite "a good deal of talk," they did not even arrive in time to be transported back from Hong Kong to the Philippines, as agreed upon, and Dewey left for Mirs Bay without them. Dewey's point is that any military alliance that might have been mistakenly arranged between the "irresponsible" General Pratt, and these "little men" would obviously have been of no consequence, just as one cannot make a contract with a minor. In Dewey's view, the Senate investigating committee cannot expect him to have honored the presumption of an alliance with men who would not go to war because they "did not have a toothbrush."

It would be astonishing how quickly this rhetoric of the "little brown brother" who needed American guidance and discipline was put in place were it not for the analogies offered by a reserve of racial understandings inherited from American slavery and Indian wars. It is also notable, however, that no matter what demeaning analogies he drew, the "little men" continued to be such a thorn in Dewey's side that four years after these events he was still distinguishing the morality of his forces from that of the Filipinos on the basis of domestic virtue. That toothbrush, a common enough symbol at the time of white racial fantasies of superiority over darker peoples throughout the world, was not a marginal but a key element in Dewey's portrayal of the culture of the *Olympia* as the culture of civilization. This was broadly and well understood. Cleanliness was next to Godliness was next to whiteness. Even the Pears soap company ran an ad in the wake of Dewey's victory portraying the admiral carefully washing his hands aboard his ship and bringing civilization to the Philippine natives, although not necessarily in that order.

But what if Anglo-Saxon racial superiority could not be defended after all by routine vigilance and bright, clean, condescending American smiles? What if all the Pears' soap in the world would not wash American hands clean? What if these "little men" who, in the words of former Indian fighter General Ewell S. Otis, "wanted to drive the Americans into the sea and kill every white man in Manila," proved able to do so?[47] In August of 1899, the Hero of Manila was not dwelling on such fears. But Johnston's photographs of his orderliness and the cheerful discipline aboard his ship betray the shipboard calm as both a fetish of control and a return of the repressed, which will continue to haunt him for years afterwards.

Fencing practice aboard the ship was also a potential site of ideological rupture that needed careful management. The strong diagonal lines made a visually compelling picture in Johnston's capable hands. No doubt she had learned from H. R. Poore's *Pictorial Composition,* a book closely studied by almost all the pictorial photographers of her era, that a fencing bout is "a picturesque composition of two men and two minds in which unity of the whole and of the parts is preserved by the balance of opposed measures."[48] The image she made shows

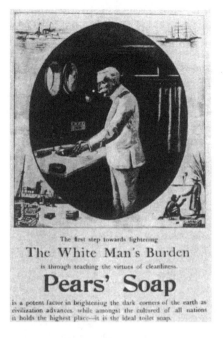

1.19. *Pears' Soap advertisement depicting Dewey in his cabin aboard the* Olympia

The first step towards lightening

The White Man's Burden

is through teaching the virtues of cleanliness.

Pears' Soap

is a potent factor in brightening the dark corners of the earth as civilization advances, while amongst the cultured of all nations it holds the highest place—it is the ideal toilet soap.

just the "feeling for oppositional line" and the "long sweeping stroke" that Poore recommends.[49] The photograph is a formal triumph.

But one must also note that this particular martial art would not be merely a formal exercise if it were true that Filipinos were incompetent men or if, as the Americans forces commonly alleged, they were fighters who did not go by the "laws" of "civilized warfare," which were codified, among other places, in fencing itself. And the Filipinos were both men and fencers. In an illuminating reading of a photograph of the young Filipino nationalist José Rizal practicing fencing with Filipino painter Juan Luna and Valentin Ventura, two of his friends in the patriot group known as Los Indios Bravos, Vicente Rafael remarks on the Filipinos' "interest in fencing, gymnastics, martial arts, and weightlifting" as a way of "marking their bodies apart from colonial categories." Rafael explains, "Posing with their swords planted firmly between their legs, the Indios Bravos display a masculine alternative to what they conceived to be the menacingly androgynous and corrupt regime of the Spanish friars."[50] If American sailors could practice fencing, so could Filipino nationalists. Once again, what Johnston encodes as an insouciant theatrical display also carries a contradictory, and quite threatening, charge. Fencing men are fighting men after all, and if they meet their match in the Filipinos, they will have to be good at swordsmanship or be killed.

And finally, the figure of Emilio Aguinaldo himself presented quite a problem of shifting signification, since Aguinaldo had originally been represented as

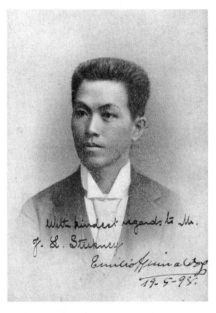

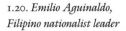

1.20. *Emilio Aguinaldo,*
Filipino nationalist leader

an American ally who proclaimed to the Filipinos on the eve of Dewey's engagement that the Americans "are our redeemers"[51] Early on, his photograph had been widely distributed, and it proved difficult to completely redraw his portrait into that of a robber who was "feathering his own nest" and formulating a "reign of terror" in the Philippines for his own personal gain.[52] In Johnston's photographs of American manhood aboard the *Olympia,* Aguinaldo is an antitype whose portrait is excluded. But Aguinaldo, too, had been aboard Dewey's ship; and had things gone differently, he too might have had his picture taken by Johnston. The memory of Aguinaldo is an uncanny presence in Johnston's images—the figure that refused American discipline, the nemesis of the white-haired admiral.

In other words, Johnston's waltzing sailors might be surprisingly androgynous and even endearing to us now in the frankness of their homosocial play, but this congenial image of "otherness" among the men should also be mapped onto another location of shifting identities—the image of the other land where "our boys" become torturers and unrecognizable to "ourselves." The peaceful display of the *Olympia*'s mess and sleeping quarters is also a mystification of these particular sailors' actual enthusiasm for the violence of the war. It was these same sailors who, before the battle of Manila, when ordered to put their mess tables "'over the side,' meaning that they should be hung outside the ship by ropes in a position where, even if they should catch on fire, they would endanger nothing else," chose instead "to interpret the order to mean that the tables should go overboard, and the result was that, after the battle, the jackies had to eat either

standing or lying down, since they had no tables."[53] That is, these men sitting with Johnston know that the domesticity is a charade; they remember when the whole thing went overboard. In fact, Johnston's sublimation of the entire background of colonial warfare into the furniture of domesticity—a feat that, as Vron Ware and Ann Laura Stoler conclusively demonstrate, was the cultural task especially appointed to white women in the age of empire—needs to be read as a transcoding of the colonial charade.[54]

What I am proposing, then, is the use of gender as an analytical category in the study of photographic narrative, as a sign of many differences, not all of which are commensurate with one another or even synchronous with the story line. This understanding of gender would suggest that the "binary machine," as David Rodowick has called it, binds men and women of the same race and class *together,* despite most current critical assessments of gender as that which differentiates *between* men and women. It was not her womanhood but her middle-class *white* womanhood that convinced Dewey that Johnston would do the "good work" Roosevelt promised in the letter of introduction. Despite what she herself believed, Johnston's success in photography was not due simply to her own enterprise or to the fact that it was interesting to see "what a woman could do with a camera." It was because Johnston was a woman who held to the imperial construction of gender that the Deweys and the Roosevelts and the McKinleys and the MacArthurs of her world erected, that she could be trusted literally to see, and therefore to show, a domestic scene where someone else might see a man-of-war.

The public did not fail to get the message. It is interesting to note that Johnston's male rival, J. C. Hemment, was also on board the *Olympia* at least part of the day that Johnston was shooting there. Despite all of George Grantham Bain's excited urging, Johnston did not manage to scoop Hemment after all, and Hemment apparently took pictures right alongside of Johnston on August 5. In fact, it seems that Johnston also took a picture of Hemment taking pictures; and when Johnston finished the *Olympia* job, she even handed her negatives over to him.[55] By August 25, Hemment was back in the United States "hawking" his own pictures "all over the country," as Bain complained, while Johnston continued her travels in Europe and her pictures were stalled in the mail.

Much to the consternation of her agent, and probably much "like a woman" in his opinion, if we can judge from the exasperated tone of other pieces of his correspondence with her over the years, Johnston was characteristically blasé about the responsibility of delivering prints in time for deadlines. A letter from Bain to Johnston of August 22, 1898, expresses his feelings fully: "Dear Miss Johnston. Your letter came this afternoon. I haven't had any doubt that you believed that you were entirely in the right in the matter, but I have an abiding faith in women's failure to comprehend business methods and perhaps that

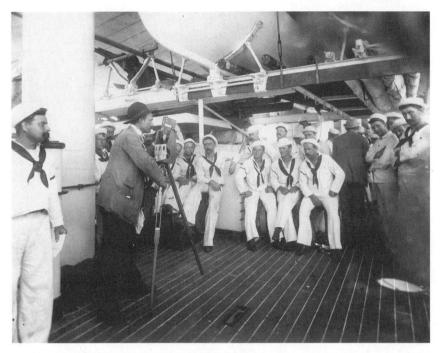

1.21. *One of Johnston's competitors, probably J. C. Hemment*

influenced my immediate judgement."[56] With the *Olympia* photos, her behavior drove Bain nearly to distraction. "And WHY did you entrust your negatives to the only person working against you?" he wrote to her, still waiting for the images, which did not arrive until September 2.[57]

Johnston's biographers, Daniel and Smock, also find her behavior opaque. They offer gender difference as an explanation of her lapse. "Evidently Hemment had charmed Francis," they surmise, "taken her negatives, and conveniently left them in London. His photographs beat hers by nine days, though both were developed in Naples at the same time."[58] Implying the existence of a romantic secret, Daniel and Smock note that Johnston "never revealed exactly what happened in Naples, why she trusted Hemment, why the negatives were so tardy," concluding, "perhaps she thought, in Victorian terms, that a gentleman could be trusted in his dealings with a lady."[59]

But the incident also suggests another reading of gender, one more in keeping with what I have been arguing was the ideological productivity of the presence of "women" in the domain of photography at the turn of the century. Despite Bain's apprehensions, public reaction to Johnston's images was excellent. Johnston's pictures sold "quite well" to American periodicals. This fact calls for some explanation.

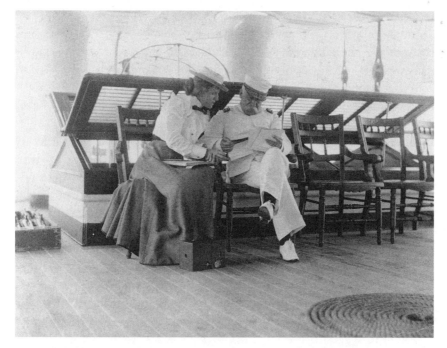

1.22. *Admiral Dewey examines Johnston's work aboard the battleship* Olympia

Both sets of photographs taken aboard the *Olympia* were voyeuristic glimpses into a normally closed off world; there was nothing to distinguish them from one another there. But Johnston's pictures also promised something extra, a titillation that Hemment could not supply. Because Johnston was a "lady," looking at her pictures aboard the battleship *Olympia* implied not only that she looked and saw what she "oughtn't" have seen; she might also have looked and *not* seen what she *ought* to have seen. Johnston alone, as a "lady photographer," could deliver the blindness with which "the innocent eye" engaged the colonial dream.

In all, Johnston made 150 pictures aboard the *Olympia*. At least one more was taken of her by someone else. In it, Dewey and Johnston draw together in a tête-à-tête to "examine Johnston's work aboard the battleship *Olympia*," as Daniel and Smock caption it. It is apparent that the admiral is interested in the results. As we have already seen, he as well as Johnston had a profound insight into "what a woman can do with a camera." She thought that photography could provide careers for women. He thought that photographs made by a woman could provide a cover for imperial aggression. She thought that gender was a resource that empowered women camera "operators," as they were called. He thought that having a woman behind the camera made photography a field of operations in what I have called the "theatre of force of domestic sentimentalism." Neither Johnston nor Dewey can have been disappointed.

Gender is "a useful category of historical analysis," writes historian Joan Scott, not only because gender is "a constitutive element of social relationships based on perceived differences between the sexes" but also because it is "a primary way of signifying relationships of power."[60] By assimilating class and racial conflict to supposedly natural hierarchies of sexual difference, gender masks the contingent, ongoing, willful violence of those divisions. On the face of it, historians have long been aware that assessments of gender differences in some way reflect the ratios of power in society, and thus open a path of historical knowledge. But to lift gender out of its concrete embodiment in male and female behavior and to relocate it in discourse—that is, to relocate it symbolically in semantic fields that seem to have little to do with the actual, lived experience of women or men, as the new gender studies seems to recommend—is a different matter. It is one thing to assert, as Scott does, that "power relations among nations and the status of colonial subjects have been made comprehensible (and thus legitimate) in terms of relations between male and female" and that "political history has, in a sense, been enacted on the field of gender."[61] It is yet another to ascertain what perspective on historical conflict the discursive turn in historiography might provide.

I want to suggest that reading women's photographs can help make more tangible the meaning of the discursive turn in gender history by reminding us what was at stake at any particular moment. The "domestic visions" of late-nineteenth-century, American, white women photographers allow us to see quite deeply into the political choices that shaped the past, choices that are preserved for the uses of the present in the stop time of the image. The first step is to identify and begin to analyze the rhetorical conditions under which their historical revelation and their intimation of surplus or endless information is staged. Contrary to popular belief, photographic meaning is a socially constructed form, rather than a naturally lucid essence captured whole from an obliging world. A photographer is limited to the record of external forms that will register through the action of light on silver crystals. These objects themselves are infinite. But for the collected shadows of these objects to be meaningful the photographer must bring them into relation to other, publicly legible, semantic structures—myth, ideology, semiotic systems. To be *seen,* photographs must be woven into other languages; otherwise, like the "unexamined life," the "unlinguistic image" will float off in an anarchy of unincorporated data. It follows that for photographs to communicate, the viewer must in turn be able to read and interpret them, like other languages and signs. How possible this will be depends upon how smoothly the image has been spliced into its constitutive semantic systems and how resourceful the reader is. If, then, the reader wishes to go further, to become a critic and to comprehend how the meaning in the photograph was produced, examination must turn to the procedures of the splicing

itself. The meaning made legible by reading must be unwoven by the critic, to see how the weaving was done.

This unweaving is a two-step process. First, one isolates and releases semantic units from the field of display and interrogates their formal relationships. In photographs, these semantic units can be elements of composition such as perspective, focus, framing, grouping, or characteristics of light. They can also be editorial procedures, such as cropping or sequencing; or narrative strategies, such as the selection of subject and setting; or a multitude of other things. But whatever is chosen for analysis, the initial question is, what rhetorical principles and, chiefly, what oppositions operate within and around these units? Second, one displaces the semantic units in question from the mythic, ideological, or semiotic webs that locate and define them. One asks, how are these units substantiated by ideological patterns, and what happens to their meaning when that particular substantiation is withdrawn? This displacement, which imagines the units strung together differently, denaturalizes the meaning of the units by uncovering surplus possibilities. It reveals that their original meaning within the web is a human construction dependent upon the position of insertion and what surrounds them.

It also reveals this meaning as a single choice among other prospects. To analyze such positionings and the pattern of such choices is to explore the social and/or unconscious forces at work in the minds of those who executed them. The pattern of coherence of these forces is in turn a reliable representation of the living past that we seek by reading the photographs, the past-as-lived that is the historian's goal.

Our white sisters
radical friends
love to own pictures of us
sitting at a factory machine
wielding a machete
in our bright bandanas
holding brown yellow black red
 children
reading books from literacy campaigns
holding machine guns bayonets bombs
 knives

Our white sisters
radical friends
should think
again.
—Jo Carrillo,
 And When You Leave, Take
 Your Pictures With You

Seeing Sentiment
Photography, Race, and the Innocent Eye

· ·

The particular convergence of conventions of seeing, showing, and knowing that made Frances Benjamin Johnston's transformations of violence into domesticity seem both intellectually credible and culturally acceptable to a large segment of the American public in 1899 had been established long before Johnston ever set foot upon the *Olympia*. Johnston's work aboard Dewey's ship draws upon a history of thought about the salutary nature of American domesticity and the benign influence of the domestic woman that was one of the nineteenth century's signal preoccupations. Her images give it a late-nineteenth-century imperial spin in which "domestication" comes to mean "pacification." However, like so many other late-nineteenth-century texts, Johnston's turn-of-the-century representations of the antithetical relation of the violent to the domestic build upon antebellum sentimental structures.

The phrase "tender violence," which I have taken as the title of this book, was coined in the 1870s by General Samuel Chapman Armstrong, founder of the famed Hampton Institute. Armstrong used the term to describe the spirit of the kind of education he believed it was necessary for the nation to undertake in order to prepare American ex-slaves and newly pacified Native Americans for citizenship.[1] With it, Armstrong also refers back to his youth in Hawaii before the Civil War, as the son of idealistic Christian educational missionaries. His parents' work overseeing the government-supported Lahaina-Luna Seminary for young men and the missionary-directed Hilo Boarding and Manual Labor

School for boys suggested to Armstrong the following conclusion: "the Negro and the Polynesian have many striking similarities. Of both it is true that not mere ignorance, but deficiency of character is the chief difficulty, and that to build up character is the objective point in education."[2]

Armstrong's comparison between what he sees as the emotional and disciplinary obligations of colonization ("the Polynesian") and those of deaccession ("the Negro") is indicative of the sentimental continuities felt by white reformers both before and after the Civil War. Sentimental power was grounded historically in the institutions of slavery and subsequently extended to colonization. What Barbara Welter identified as the "cult of true womanhood" made the notion of "tender violence" seem not to be an oxymoron even while the practice of slaveholding rendered it a domestic commonplace.

Indeed, the very idea that there could be such a thing as "tender violence" was one of the chief ideological achievements of antebellum domestic culture, in both its pro- and antislavery guises. White apologists for slavery, like George Fitzhugh, and white antagonists of the slave power, like Harriet Beecher Stowe, both relied heavily upon it. Black abolitionists such as Frederick Douglass and Harriet Jacobs found opposing it to be both tricky and central to the political problematic. Hence, we must recognize in sentimental discourse that coded American domesticity as a benign or even a benevolent force, a compromise with or even a flirtation with the mechanics of racialized terror that kept a firm hold throughout the entire course of the nineteenth century.[3] Frances Benjamin Johnston's photographs register the persistence of this notion of racially distinguishable, separate domestic spheres despite changes in the location and character of designated "homes" and designated housekeepers and in the face of the expansion of the kinds of populations rendered homeless and targeted for violence.

By "discourse," I mean historically specific, coordinated sets of meanings that are generated in a wide array of social realms; that are expressed through beliefs, habits, vocabularies, representations, and institutional practices; and that, taken together, serve to articulate what will count as knowledge and succeed as power in any given culture. Scholars have identified the ideology of separate spheres, domestic advice literature, child rearing manuals, the invention of the psychological, possessive individualism, the cult of true womanhood, pro- and antiabolitionist rhetoric, and sentimental fiction as particularly active sites for the production of antebellum domestic discourse. It was by means of these antebellum discursive devices, mostly located within or with reference to the white middle-class home, that what was "leisure" in the nineteenth century was set up against that which was said to be "labor"; what was "interior" was set up against that which was said to be "external"; what was "kindness" was set up against that which was said to be "cruelty"; what was "civilized" was set up against that

which was said to be "savage"; and what was "domestic" was established as the antithesis of the daily life of the slave.

Scholars have also shown that after the Civil War, sites for the continuing production of discourse on the domestic shifted significantly toward constitutional and juridical arenas located outside the home, such as the struggle over universal manhood suffrage, the reconstruction and reaffirmation of white male control over land and capital, the institutionalization of Jim Crow, the epidemic of lynching and vigilante terrorism, and the promulgation of eugenics as a basis of social control. However, the break at midcentury is not as sharp as it may appear. In the postbellum period many of the privatized meanings of an earlier American domesticity instituted during slavery were refitted and recycled as resources for conflicts over legal power and cultural prestige in an altered racial and economic landscape even if slavery was legally reputed. Legal scholar Reva Siegel, for instance, has traced the translation of norms of husband-to-wife domestic violence from the antebellum to the postbellum period in marriage law of the Reconstruction era. Siegel's work demonstrates "how nineteenth-century reform of the old common law coverture rules translated the status relationship of husband/wife into new juridicial forms."[4] The results of such legal debates, affirming the pertinence of past domestic precedents, weighed heavily in the continuing social construction of middle-class American private life. White women photographers were not alone in reaching backward into earlier phases of this discourse in order to shape contemporary perspectives.

But if throughout the antebellum period the sentimental characteristics of domestic discourse found their major articulation in pro- and antislavery writing, in the second half of the nineteenth century, I am arguing, the discursive task also came to rest heavily in photography, which took up the ideology of "tender violence" where sentimental fiction left off, in a relatively seamless splice. The most interesting historical question to ask of Johnston's work and that of the cohort of women photographers of which she was a part is, therefore, not simply whether or where an insensitivity to the violence of imperialism exhibited itself in their images. It is rather, or perhaps in addition, how these pictures were able to transform an earlier generation's selective vision of domesticity—the slaveholder's gambit that the violence of slavery could be quarantined in the slave quarters, the abolitionist's faith that the ideal domestic situation could cancel out the pernicious social effects of human bondage—into a gleam in the eye of a later generation that a stable new domestic order based on the old racial and economic hierarchies could be achieved through the deliberate prescription of imperial war. In many instances it was the belief that "tender violence" *was* an oxymoron, that if you had domesticity you couldn't really have brutality, that held these contradictions together. To establish the gendered construction of

the photographic gaze apotheosized aboard the *Olympia* in the Bay of Naples in 1899, one must begin a half century earlier, inquiring into the visual negotiations it became desirable for former slaveholding families to undertake in order to maintain domestic composure after the legal cessation of the American slave system.

In *Camera Lucida,* Roland Barthes distinguishes between two fields of attention to photographs. First, and always, there is a *studium:*

> Thousands of photographs consist of this field, and in these photographs I can, of course, take a kind of general interest, one that is even stirred sometimes, but in regard to them my emotion requires that rational intermediary of an ethical and political culture. What I feel about these photographs derives from an *average* affect, almost from a certain training. I did not know a French word which might account for this kind of human interest, but I believe this word exists in Latin: it is *studium,* which doesn't mean, at least not immediately, "study," but application to a thing, taste for someone, a kind of general, enthusiastic commitment, of course, but without special acuity. It is by *studium* that I am interested in so many photographs, whether I receive them as political testimony or enjoy them as good historical scenes: for it is culturally (this connotation is present in *studium*) that I participate in the figures, the faces, the gestures, the settings, the actions.[5]

Second, there may also be a *punctum.* Of the *punctum,* Barthes writes,

> The second element will break (or punctuate) the *studium.* This time it is not I who seek it out (as I invest the field of the *studium* with my sovereign consciousness), it is this element which rises from the scene, shoots out of it like an arrow, and pierces me. A Latin word exists to designate this wound, this prick, this mark made by a pointed instrument: the word suits me all the better in that it also refers to the notion of punctuation, and because the photographs I am speaking of are in effect punctuated, sometimes even speckled with these sensitive points: precisely, these marks, these wounds are so many *points.* This second element which will disturb the studium, I shall therefore call *punctum:* for *punctum* is also: sting, speck, cut, little hole—and also a cast of the dice. A photograph's *punctum* is that accident which pricks me (but also bruises me, is poignant to me).[6]

In this chapter I will read such a *punctum* in one white family's sentimental photograph of its African American "nursemaid" and their child. I have selected this one photograph from many other possible photographs of the common genre of "nursemaid" photographs somewhat randomly but not at all arbitrarily.

As an instance of the way in which the callousness of race-based domestic relations under white supremacy could be both indexed and concealed in domestic photographs it is a signal manifestation of the ideological maneuver that made Frances Benjamin Johnston's later photographs possible. As an example of the way in which the discourse of domestic sentimentalism had come to rest in domestic photographs, it illustrates the necessity to expand beyond the domain of sentimental writing to address the way it was embedded in collateral kinds of cultural production. And as a representative image produced in Richmond, Virginia, by a wealthy, white, slave-owning family sometime in the mid-1860s in a liminal period either just before or just after Emancipation, it suggests in a particularly legible form the structural components of the averted gaze adopted by white supremacists to address the crisis in white domesticity, a crisis they claimed might erupt with the end of slavery.

The authority of the innocent eye that could look at but not see the womanhood of the female slave was a standpoint created especially for white women during slavery. Domestic images helped relay it to the post–Civil War period, carrying forward a system of disregard that could look at the now former slave population but refuse to "see" their social equality. Within this discursive formation, the photograph that George Cook took of his baby son Heustis in the arms of his nursemaid is an ideal type. It clearly locates the viewing position into which later, at the turn of the century, American "lady" photographers would place themselves.

What this chapter proposes, then, is to locate the photographic genealogy of that turn-of-the-century gaze in midcentury domestic images. A genealogy, according to Michel Foucault, is

> the union of erudite knowledge and local memories which allows us to establish a historical knowledge of struggles and to make use of this knowledge tactically today.[7]

This "painstaking rediscovery of struggles, together with the rude memory of their conflicts," Foucault also says,

> allow[s] us to rediscover the ruptural effects of conflict and struggle that the order imposed by functionalist or systematizing thought is destined to mask.[8]

A genealogy, in Foucault's vocabulary, has a different purpose than merely tracing ancestry; it aims to interfere with the smug, smooth tracing of a familiar line. A Foucauldian genealogy is in fact a map of struggle. One roots out a past in order to find a "particular, local regional knowledge . . . a differential knowledge incapable of unanimity and which owes its force to only the harshness with which it is opposed by everything surrounding it."[9] That is, only by juxtaposing "meticulous, erudite, exact historical knowledge" with "local and

specific knowledges which have no common meaning" can "criticism perform its work." [10]

What genealogy seeks is disruption. In the Cook photograph of the nursemaid, the official "knowledge" of how smoothly the continuing separation of "races" could be managed within the bourgeois domestic space can be opposed to the "ruptural effects" of resistances that have left traces in the photograph. In my reading, these traces register the violence inherent both in this specific domestic arrangement and more generally. My aim in this chapter, therefore, is to take the "local knowledge"—retrievable from the Cook photograph—and examine how it belongs to a larger set of struggles that were articulated, framed, and maintained through the institutions of domestic photography. Ultimately, as Frances Benjamin Johnston's work aboard the *Olympia* indicates, such a narrative promises to allow us to resurrect connections between aggressive management of the female gaze, the work of women photographers, and the turn-of-the-century reassertion, indeed extension, of American white male hegemony in the American South and elsewhere.

First, one caveat. I have written this book in the belief that close, attentive *method* readings of historical photographs can restore a certain degree of voice and context to bearers of historical knowledge who may have been hidden or repressed. But what I offer throughout are solely my own readings. They are not meant to speak over or foreclose alternative meanings that others might be able to derive from the images. Each viewer's standpoint—and surely my own—contains ignorance and blindness that are cultural as well as personal. Perspectives on photographs, as on history, differ from individual to individual and from social location to social location. They contribute to historical consciousness only as they are made articulate and perhaps challenged or expanded.

It is also possible simply to be mistaken. For instance, an alternative reading of "Nursemaid and Her Charge" that has been suggested to me posits the nursemaid as a day laborer in the Cook family who is not at all disturbed by her situation or by the scene of photography. Since she herself has been silenced by the deracinated manner in which her image has been preserved, with virtually no supporting documentation from her life, it is theoretically possible to accept such an alternative reading. However, my research into the Cook family archives makes me skeptical. I take my cues from the general social context surrounding the photographer and his subject and from others of his photographs.

What I believe we can recover from this photograph is not some pure and transparent version of the young woman's inner life, which would be both impossible and presumptuous, but the character of the historical setting and discursive structure within which her image—stripped of her voice—was circulated and made to perform cultural work. Although this, like others of the images in this book, may be a painful picture, I hope that by drawing attention to it, in-

sisting on reading it, and naming the political functions that I see to be at work in it, I will add to the power/knowledge that such images make available, rather than objectify their subjects in ways that might invite further reification.[11]

The Greeks had a word, *ekphrasis,* that we don't have, which designated an art that we also don't have—the virtuoso skill of putting words to images. Writing a while ago in the *New York Times,* John Updike reported his joy on discovering this word, for it named what had long been an insistent but faintly embarrassing passion of his and made it seem legitimate. Similarly, Bryan Wolf recently came out in the *Yale Journal of Criticism* as a "closet ekphrastic . . . [hurling] caution and nicety of distinction to the winds . . . and [arguing] both for the rhetoricity of all art and the ideological work performed by all rhetoric."[12] But ecstatic ekphrastics hardly ever turn to photographs. Not one of the readings legitimated by Greek paternity in Updike's book of essays on art, *Just Looking,* is of a photograph, for instance, even though Updike devotes the entire lead essay to the Museum of Modern Art (MoMA) ("What MoMA Done Tole Me") and the MoMA he remembers haunting for an unforgettable twenty months between August 1955 and April 1957 housed at that time what was arguably one of the most important collections and display spaces of photographs in the country.[13]

Serge Guilbaut and Christopher Phillips have pretty well demonstrated that, through its cooperation with the government and its curatorship of the photography collection at that time, MoMA turned itself into one of the country's most productive bastions of cold war ideological politics.[14] Perhaps it is too much to have expected John Updike to have noticed any of this, even though he was there during the very months that the *Family of Man* exhibition was installed in MoMA and was drawing enormous crowds of visitors; it subsequently toured Europe, Asia, and Latin America, traveling for over two years. The *Family of Man* exhibition was an anthology of images edited to show the universality of daily human life all over the world, a universality that purportedly revolves around utterly dehistoricized, utterly naturalized experiential categories such as "birth," "death," "work," "knowledge," and "play." Supported by quotations from "primitive" proverbs or verses from the Bible, the message of this spectacle, sent by the American government all over the world, was that we are all one family.[15]

But Updike's neglect of these photographs while attending to the more prestigious realm of high art painting suggests more than a personal lapse. It represents a critical tendency that is not Updike's alone, and it suggests the need of inventing another term, *anekphrasis,* coined from its opposite. Photographic *anekphrasis* would describe an active and selective refusal to read photography— its graphic labor, its social spaces—even while, at the same time, one is busy textualizing and contextualizing all other kinds of cultural documents.[16]

Photographic anekphrasis is not innocuous. The comparative dearth of critical attention to the social productions of the photographic image is a class- and race-based form of cultural domination. It represses the antidemocratic potential of photography and distorts the history of the significance of race and gender in the construction of the visual field. The dynamic meanings of cultural forms produced and marketed since the mid-nineteenth century simply cannot be fully adduced without concurrent attention to the way in which those cultural forms have used photography to naturalize and enforce their message. One might even go so far as to say that photographic anekphrasis itself is an institutionalized form of racism and sexism, in so far as photography has always been deeply involved in constituting the discourse of the same.

Cultural theory is not guilty of photographic anekphrasis overall. Indeed, feminism has sustained a major critical engagement with the photographic image. No one has ever attributed more social power to photography than the antipornography movement. In addition, crucial questions about the commodification of representations of women's bodies in advertising; the cultural enforcement of women's positioning as representation, as image; and the reconstruction of a basis for female spectatorship that moves out from under the dominion of the "male gaze"—all have had their most serious considerations within feminist analysis of photography and film. Yet even within this significant enlargement of the critical gaze, feminist interpretation has often made it seem as if issues of gender and sexuality can be separated analytically from those of race and class.[17] While the feminist movement has been brilliantly effective in forcing discussion of the domination and objectification of women by men, it has been relatively silent about the internal dynamics of objectification within its own ranks, woman over woman, and about the ways in which women themselves have gained and lost from the race- and class-based power differentials among men. Second-wave U.S. feminism allowed the image of the middle-class white woman to circulate as the signifier of the category "woman." The third wave has made an effort to claim the gaze of "third world women." But gender distribution is not the same thing as race distinction. The notion that they are parallel inequalities and that an analysis of the sexism of photographic practice will automatically yield a model for thinking about race as a category of difference is one of feminism's anekphrases. Thus, although feminism sees photographs, it has become a question, frankly, of just what is it that feminism sees.

Antebellum sentimentality in the United States was a theory of gender. It held that differences among the domestic lives of peoples were natural, rather than historical, divisions, and that a new education in white domesticity was necessary for nondominant peoples to rise in the scale of evolution toward a greater capacity for self-government through the acquisition of greater self-control. That is in good part why twentieth-century white feminist criticism has been

able to retrieve so successfully the sentimental writings of the "Other" American Renaissance.[18] *Both* forms of cultural critique—domestic ideology in the nineteenth century and feminist theory in the twentieth—largely bracket the history of the racialized female gaze in an unarticulated insistence on the specificity of gender.

However, sentimentality left another record of these operations—in photographs. Through them it is possible to see around the edges of its masquerade as nature and into the dynamic of its production of difference. After the abolition of slavery and throughout the post–Civil War period, photography was part of the master narrative that created and cemented new cultural and political inequalities of race and class by manipulating the sign "woman" as an indicator of "civilization." Seeing sentiment in domestic photographs is one way of exposing the internal dynamics within which the subsequent imperial exchange of signs went forward.

We do not know the name of the Cooks' nursemaid or even exactly when George Cook took her photograph, which has been variously dated as circa 1865, and 1868.[19] The photograph is a paper image made from a glass negative, a technology that would support any of these dates. Joan Severa's analysis of the nursemaid's clothing, offered in *Dressed for the Photographer,* which reprinted the photograph in 1995, likewise supports either of these dates.[20] The negative is currently housed within the George Cook archive at the Valentine Museum in Richmond, Virginia, among the rest of Cook's family and business papers and memorabilia.[21]

That it was a domestic image displayed within the house, not simply any image of a domestic, is the supposition I have chosen. But it is at least within the realm of possibility, although it seems unlikely, that it was a carte de visite like the one Sojourner Truth ordered made of herself to mark (and financially support) her life in freedom.[22] Or, it could also have been a personal photograph like the one Harriet Jacobs had made of herself, as a way of "owning herself," after her escape to the North from slavery.[23]

The fact that the Cook archive contains at least two more images of women identified as "nursemaids" with family babies argues against the nursemaid's control over her own representation, however. Quite the contrary, it suggests that it was Cook who thought to make the image and wanted to keep it as a personal record of the domestic nature of his home, even if, at the same time, he gave a copy of this record to the "nursemaid" herself. The fact that this is a sentimental image of the nursemaid's labor and not of her own family also works against the idea that the young woman chose it in freedom to represent her own domestic life. Neither Sojourner Truth nor Harriet Jacobs, for instance, two black women concerned to establish the visible demeanor of emancipation, picture freedom as having anything to do with white infant "charges."

I take the "Nursemaid and Her Charge" to be a rhetorical figure in a white ambition that sought to establish the relative social weight of black and white domesticity in the immediate post-emancipation years. When we pair the nursemaid with a contemporary photograph that George Cook made of his own wife, an image that I will also analyze, we can begin to see how all three figures— "nursemaid," "baby," and "mother"—play interdigitated roles in Cook's manipulation of what Roland Barthes called the "empire of signs." They are actual people who have been photographed, but they are also symbolic constructions that produced the highly political meaning of post–Civil War white domesticity.

In "Nursemaid and Her Charge," the young woman sits for the camera in a good striped dress with a white collar. A small, simple broach is pinned exactly at the meeting place of the two starched white points of the collar, which rise up slightly from the surface of her dress. Formally, with its quiet precision, its simplification of background space, its tonal balance, its graphic playfulness, and its flat, tight framing of the figure, this image reflects the long tradition of plain-style American portraiture that unites the primitive folk art practices of the early itinerant portraitists like Ammi Phillips and Erastus Salisbury Field with the vernacular masterpiece daguerreotypes made by J. S. Plumbe and by Southworth and Hawes.

Iconographically, this image also relates to a long symbolic tradition in Western art of portraying the Madonna and Child. This tradition is a tribute to the highest achievement that womanhood can attain in Christian culture and a paean to the actual woman who occupies that mythical role. As Julia Kristeva writes in "Motherhood According to Bellini," "craftsmen of Western art have revealed better than anyone else the artist's debt to the maternal body and/or motherhood's entry into symbolic existence." Kristeva also notes the dualism inherent in this mythic tradition:

> Not only is a considerable portion of pictorial art devoted to motherhood, but within this representation itself, from Byzantine iconography to Renaissance humanism and the worship of the body that it initiates, two attitudes toward the maternal body emerge, prefiguring two destinies within the very economy of Western representation. . . . On the one hand, there is a tilting toward the body as fetish. On the other, a predominance of luminous, chromatic differences beyond and despite corporeal representation. . . . Worship of the figurable, representable man; or integration of the image accomplished in its truthlikeness within the luminous serenity of the unrepresentable.[24]

As in this photograph, the painted Madonna is often rendered in vivid detail. Also as in this photograph, the attentive "truthlikeness" to the materiality of the figure being depicted often blends into some other unidentifiable expres-

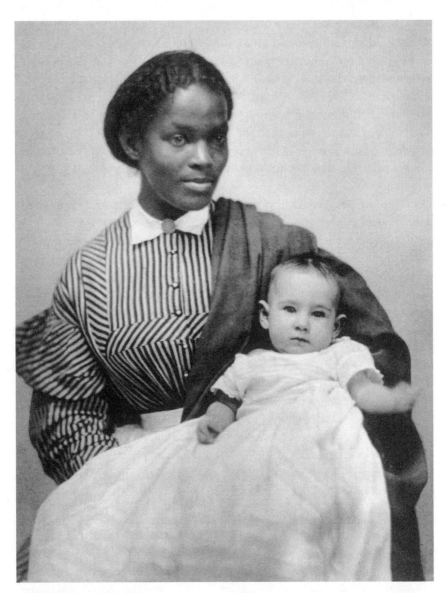

2.1. *Nursemaid and her charge*

sion, one that is "unrepresentable" or disengaged. Painted Madonnas are often holding the baby Jesus but looking away. In this averted gaze, Kristeva notes, "the maternal body slips away from the discursive hold" to become "a sacred beyond."[25]

It used to be only artists' models or wealthy, aristocratic women who could see themselves painted in this role, but the discovery of photography in the nineteenth century allowed millions of ordinary mothers to have images of them-

selves made in that virginal and compelling guise. On the strength of its formal and symbolic characteristics alone this photograph belongs in the procession of religiously influenced American art. And like the Catholic paintings of the Madonna that, as Lynn Wardley has argued, the Protestant Harriet Beecher Stowe urged her readers to hang upon the walls of their homes to signal the sisterhood of spirit and the communal reservoir of art that nurtured faith no matter of what denomination, this photograph formally considered would be an upholder of the canons of domestic sentiment.[26]

However, "a nursemaid and her charge" (as this photograph is entitled in *We Are Your Sisters,* edited by Dorothy Sterling) or "former slave with white child" (as it is captioned in *Labor of Love, Labor of Sorrow,* by Jacqueline Jones) is not an image of the vaunted female icon of Christian humanism, nor is it an example of popular folk art; merely to repeat such a formal, iconographic analysis would be deeply misleading. In fact, this image ironizes both the self-absorption that Kristeva references in western religious painting and the unexamined populism of the vernacular approach to the photographic image. For this image was made in Richmond, Virginia, circa 1865, by a skilled, white studio photographer named George Cook of his own family's "nursemaid," or "former slave" for his own family's consumption. It is a highly material picture of a maternal body whose role as "sacred beyond" has been removed.

George Cook was a northerner who settled in the South just before the Civil War. He is widely known for his pictures of military officers on both the Union and the Confederate sides. After the war he continued to photograph, maintaining a thriving studio business in Richmond. According to Norman Yetman, the one historian who has written even briefly about the political conditions under which the picture was made, the young woman depicted is almost certainly a slave or only just recently freed.[27] Since the baby on her lap appears white and she is black, most viewers would assume that it is not her baby at all, but another woman's child. And, in fact, the baby is Heustis Cook, the son of the photographer, who himself grew up to be a photographer.

"Heustis Cook," notes Yetman, "was one of the first of the 'field' photographers who packed his buggy with cameras, glass plates, plate holders, collodion, silver nitrate, plus his tent or 'darkroom' and all his developing supplies and took photography to the back roads."[28] The father and son's collection of pictures of the former slave population of Virginia, South Carolina, North Carolina, and Washington, D.C., is now in the Valentine Museum in Richmond, Virginia. A substantial portfolio of their images was reproduced in *Voices from Slavery,* edited by Norman Yetman, in 1970.

This particular Madonna is therefore a weirdly skewed rendition of the Christian story. Like Mary, she holds a baby who is virtually, perhaps even literally, her master. But this baby is not the baby that God the Father gave her to bear. That

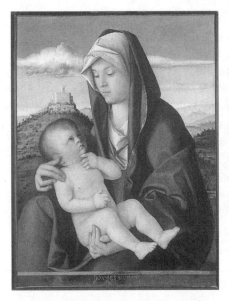

2.2. Bellini *"Madonna and Child,"* ca. 1485

2.3. *Mother and child, daguerreotype*

2.4. Bellini *"Madonna and Child,"* ca. 1480

2.5. *Frances Adams and her daughter as a small child, ca. 1852*

baby, if it exists, is elsewhere. Despite her youth and beauty, this woman cannot be simply another mother who commemorates the ecstatic moment of typological juncture, the swelling pride of womanhood fulfilled, since as a slave or former slave she has been at the same time human chattel and, to adopt Orlando Patterson's pungent figure from *Slavery and Social Death,* a social corpse.

Motherhood may be what the Madonna genre marks as woman's great accomplishment, but sitting for the white man's camera as the white woman sat, in the pose that the white woman held, holding, in fact, the white woman's baby within the iconographical space and actual society that claimed for white women an exclusive right to occupancy, the slave or domestic servant brings into existence not her own family's precious keepsake, but a monument of doubleness and double entendre. Rather than bonding figure to type, as in the painting tradition, the photograph displays instead the innumerable barriers and memories that stand in the way of that apotheosis. The "unrepresentable" that Kristeva invokes is not some abstract sacred principle, but the maternal materiality of the figure of a young black woman. Working for someone else's transcendence, she is not allowed to signify her own.

In the earliest years of its existence, photography was laminated to sentimental functions along with domestic novels, domestic advice manuals, educational reform propaganda, and abolitionist agitation. While the middle-class home became the port of entry for sentimental fictions of all sorts, the hall table and the parlor were accumulating photographs at an impressive rate. Like domestic novels, the resulting accumulation of images helped to make, not merely to mirror, the home. Photography was another mode of domestic representation. It worked by staging affect or imaging relation—literally *seeing sentiment* as a way of organizing family life. Wrote one white settler of his new home in Montana,

> Our cabin measured 16 × 20 feet in the clear. The logs were chinked and painted with clay. The roof was of poles covered with hay and sodded; we filled in the crevices with loose dirt, fondly hoping that it wouldn't leak. The floor was of earth, beaten hard and smooth. . . . A box cupboard held our stock of dishes and cooking materials. Beside it stood the churn. The flour barrel was converted into a "center-table" whereon reposed the family Bible and photograph album with their white lace covers.[29]

Or, as Nathaniel Hawthorne observed in his notebooks, when his wife Sophia rearranged the parlor and put a table with books and pictures at its center, their new house in Lenox became a home.

Valorization of the visual image of the middle-class white woman as the signifier of the category "woman," which makes other social relationships invisible, was also taking shape in the early nineteenth century. Sentimental ideologues of womanhood explicitly turned to drawn or painted images to mark the social

divisions advanced by the middle class and to make them seem to be rooted in something actual. Photography, invented in 1839, was an even better technique than drawing or painting for making images of "nature," and photography was therefore conscripted for the myth-making cause.[30] The idea was, if you could take pictures of something, it must exist. To the middle-class nineteenth-century viewer, a photograph was not only a "mirror" of nature, but, unlike other mirrors, it had a "memory" too. Photography inscribed, therefore, a very powerful image of the "Real."

But what this idea disguised is the fact that photographs have meaning only as elements of a set. Photographic meaning is a system of relations that are established not *in* but *between* images. As Patricia Holland, Jo Spence, and Simon Watney explain, photography is ideological in that it is a "set of relations established between signs, between images—a way of narrating experience in such a way that specific social interests and inequalities are thought about, discussed and perpetuated."[31] Or, in the formulation of Griselda Pollock, to interpret images of women it is necessary to develop "a notion of woman as a signifier in an ideological discourse in which one can identify the meanings that are attached to woman in different images and how the meanings are constructed in relation to other signifiers in that discourse."[32] Early-nineteenth-century, bourgeois domestic photography, then, became as productive and constitutive a force as it did because it related images of women to one another and to other cultural practices through a hierarchizing narrative of social signs. Thus, photographic sentiment helped to create the hierarchies of domesticity that, ostensibly, it only recorded.

Another significant feature of photography arose from the sheer accumulation of these photographic images, the simple weight of the fact that now there were so many of them when before 1839 there had been none. Far from exhausting demand, photography in its early years whetted a seemingly limitless appetite. If, as critics have argued, sentimental fiction fed the hunger for middle-class self-transformation through the institution of a depth psychology of self-monitoring, self-possession, and self-control, sentimental readers were also evidently famished for corresponding views of the visible surface of their lives.

Historians have also suggested that these images were personal fetishes, bulwarks against nineteenth-century anxieties of separation and early death, and no doubt that is true. But looked at in the aggregate, this cannot have been their only function. As codifications of class and identity, these ubiquitous reflections of private life in private homes must also have demarcated the edges of social visibility and invisibility for a group of people who, not yet secure, repeatedly invoked the materiality of appearances to justify their claim to dominance and their every incursion into the private space of others.[33] Anxious *for* separation, *for* a

visible difference in display and deportment that could squelch any challenge to the distinctive privileges they claimed, middle-class people must have found in the very numbers of family photographs that filled their homes an assurance that real family life was coincident with the kind of families the photographs showed.

I would like to suggest that people outside the magic circle of nineteenth-century domesticity—for instance, slaves, Native Americans, Mexicans, and later Eastern European immigrants, Cubans, Filipinos, Hawaiians, and Chinese—posed an interesting problem of exclusion in relation to such uses of photography. I also suggest that it is a problem that can be illuminated by examining the relationship of these "Others" to the regime of sentiment—taken as an aggressive, rather than merely a private, social practice. In this view, the culture of sentiment aimed not only to establish itself as the gatekeeper of social existence but at the same time to denigrate all other people whose style or conditions of domesticity did not conform to the sentimental model. Since the sentimental home was the model home, it followed that anyone else's home was in need of reform. And since the sentimental image was the model image, it also followed that any other type of photograph was an image of lack. The partitioning off of a domestic space for photographic display in the home accompanied a categorization of difference between those who did and those who did not own a "home" to decorate with their own images—a distinction for the making of which photography, even more than the written word, was a state-of-the-art technique.

It was not that the Others were actually *unseen*. Slaves, servants, the poor, the infirm, the socially dispossessed—all were in evidence in virtually every domestic landscape. In one way or another their presence and images affected virtually every middle-class household. Not only that, but, as Philip Fisher has shown, the gathering force of sentiment as a social ideal was driving home the idea that it was necessary to have a more inclusive philanthropy that included precisely these people.[34] The problem was really managerial, an orchestration of the gaze. If the function of middle-class domestic photographs was, as I have been suggesting, to precipitate a seemingly natural mirror image of the sentimental home out of the household, it would follow that the household, although it visibly and palpably sustained the home, would need to be rendered functionally invisible. The ideal of "disengagement from the body that labors," as Gillian Brown has called it, at least in this respect, extended even to the image of the domestic unit itself. Brown describes how the popular American domestic architect Andrew Jackson Downing "link[ed] the space of interiority with an ideal of leisure and privacy, an ideal of private views and protected scenes."[35] Such a domestic unit could not appear in photographs as the heterogeneous, corporate, and laborious product that it actually was.

In the aggregate, nineteenth-century American photographs indicate that families addressed this editorial problem in a variety of ways. One was obvious,

and easy. In a family portrait made in the studio of a professional photographer, the household could compose itself *as* composed only of those members whom it wished to portray. Slaves, servants, renegade sons, unsightly or unstable dependents—all were easily excised. They simply needn't be included in the trip to the studio. And, in fact, by far the greatest number of family studio portraits have this appearance. Although there were alternative practices, and there are numerous contradictory examples, the weight of the archive of mid-nineteenth-century, middle-class family portraits is not only overwhelmingly white, like the mid-nineteenth-century middle-class family, but affectively harmonious and physically eugenic. Looking at many of the images of the family in mainstream historical collections, one would hardly know that other people were around.[36]

When an itinerant photographer came to a family's residence, however, as sometimes happened in the early years, or when the photographer was a member of the family, the act of triaging the family's public image had to be more explicit. For at least some families, it appears to have been more difficult under these circumstances to manage so properly narrow an approach to its own social construction. There are numerous photographs, such as "Family Group (The 'Hidden Witness')," taken circa 1853, which show slaves or servants, for instance, on the edges of the family group, on the lawn, or under the trees. They are standing in the background, but they are clearly visible. The domestic laborers are not being depicted in these photographs as family members, but sentiment is being extended toward them as well.

In the Cook family collection, such a photograph exists. The family has arranged itself on the front porch and steps of their country house, which looks a great deal like the model house that Andrew Jackson Downing proposed as the setting for an idealized middle-class domesticity. With those seated in the front row conspicuously holding a set of croquet mallets, the family's pose expresses their sense of the pleasures of their intimacy and their leisure. At the side of the house, almost out of sight around the corner but nevertheless clearly visible as an "outsider-within," is the figure of a black man.[37] Whether the interpersonal as well as the ego boundaries were more or less permeable in such a family structure is a matter for debate, but the existence of such images seems to point to a certain level of ambiguity about where and how to draw the line.

Occasionally, a family like the Cooks might also choose to make or to purchase individual portraits of their slaves or servants, as an item to add to their own household accounts or family memorabilia. Indeed, it is difficult to imagine how an image in this genre could have signified for the nursemaid herself a moment of her own domesticity. As Deborah Willis has explained, for instance, about the 1850s image she titled "Daguerreotype Portrait of Young Black Girl Holding a White Baby," this kind of image would have given rise, instead, to a consciousness of the *absence* of that personal life. Willis writes:

2.6. *Cook family on porch of summer house*

Why was this photograph commissioned? Since it was taken during the pe-
riod of slavery, we may assume that the young black woman is human prop-
erty. Then again, what was the purpose of this photograph? Are these the
"master's" possessions? Or is the black woman the subject or object of the
photograph. . . . In asking myself these questions I began to answer them
with more conjecture. Will her family ever see this image? If so, what will they
make of her situation? Does she live with or near her biological family? The
loneliness expressed in her eyes speaks to me 150 years later." [38]

The majority of domestic images of slaves seem to come from situations like
this. Maybe having the photographs made was a kind of conspicuous consump-
tion. In any case, with slaves it was not always necessary to worry about draw-
ing the line in a group portrait, since usually the line would be drawn by color.
These so-called "nursemaid" pictures form an extensive genre in themselves. [39]
While Deborah Willis chose a single one to illustrate her realization that "this
image becomes a marker for me, for the women who wrote of their own ex-
periences in slave narratives but who were never photographed"; for Willis, the
"Daguerreotype Portrait of Young Black Girl Holding a White Baby" stands for
many more. [40] We may use another photograph, entitled "An old-time Charles-

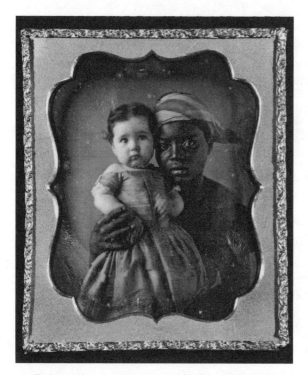

2.7. *Daguerreotype portrait of a young black girl holding a white baby, ca. 1850s*

ton 'Mommer' and her charge," to illustrate the continuity of this genre into the 1890s.[41]

It is useful to note that the nursemaid genre extended itself not only within the United States after the Civil War but also in colonial regimes around the world. Its commonness indicates, as Ann Stoler writes, not only that domestic visions were transported to the colonies from the metropole but that they were a cause of anxiety and often met considerable resistance.

> Housekeeping manuals, child rearing guides, and pedagogic and medical texts from the nineteenth century . . . focus on . . . general lack of self-control, civility, and restrained desire that children, in their "savage"-like behavior, displayed. These were, significantly, the very same characteristics attributed to those who served and administered to their needs. It was feared that servants and middle-class children would have sex but the ties might go deeper still, for it was sentiments and unseemly dispositions they were feared to share and enjoy as well. . . . European discourses on the dangers of wet nurses and nursemaids for the identity formation of noble and middle-class children have a long genealogy, suggesting that nursemaids were seen to enjoy a spe-

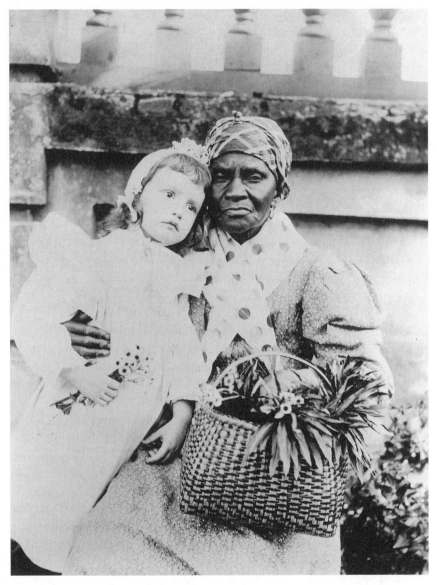

2.8. *An old-time Charleston "Mommer" and her charge*

cial power over their charges. A baby was thought to absorb the "personality traits" of his nurse when he drank her "whitened blood."[42]

The figure of the nursemaid was a material and ideological weapon that could be used against, as well as for, women of both the laboring and the governing classes. As a job category, for instance, it pressured black families to accept instruction in servitude and the "domestic arts" as progressive education for their

daughters, who were taught that the "hoeing, picking, mining, washing, and ironing that black southerners had done as slaves for centuries" were now "ideas and skills of 'self-help' and 'self-sufficiency.' "[43] As a marker of class for white families, it was a litmus test of domestic propriety whose manipulative and misogynistic value was not lost on such an educator as Booker T. Washington. In a fund raising speech in 1907, he presented a white audience with the following thought:

> In the average white family of the South, you will find that the white child spends a large proportion of his life in the arms or in the company of a negro woman or of a negro girl. During the years when that child is most impressionable, when he is at a point where impressions are perhaps most lasting, that child is in the company of the black woman or the black girl. My friends it is mighty important, in my opinion, for the civilization, for the happiness, for the health of the Southern white people that that colored nurse shall be intelligent, that she shall be clean, that she shall be morally fit to come in contact with that pure and innocent child.[44]

As Glenda Gilmore has pointed out, black women of course understood that these "images of the immoral black woman and the barbaric black home" were "grist for the white supremacy mill," and many worked to break the "direct link between the fabricated discourse on black barbarity and the industrial education movement."[45]

Seldom, however, do any of these black nursemaids have the prominent visible place within the records of a white family that is seen in the Cook collection. Cook's "Nursemaid and Her Charge" is distinctive for being, as Severa observes, exceptionally focused on the nursemaid herself:

> Baby Heustis Cook, shown here with his nurse, was the son of Richmond photographer George Cook, who took this record portrait of his baby son and his son's nurse. Heustis himself grew up to become a noted photographer of Southern life.
>
> But the attractive and neatly dressed nurse is the focus of attention in this photograph. Her bold, black-and-white-striped dress, with its directional treatment in the yoke bands, is of a most current fashion for morning dress. The small round puff at the top of the sleeve is a stylish addition that has no basis in pure function; it is cut on the bias and perfectly set in. The sleeve below it is perhaps somewhat looser than the fashion, which is generally shown as very snug below such puffs. This adaptation, however, undoubtedly made lifting and caring for a baby easier. The bodice of the dress is gathered into a waist so neat and small that it is obviously fitted over a proper corset.

Snow white linen is worn at the throat, as is a cameo brooch. Her hair is done smoothly in a net in a simple manner followed by most women for everyday.

The attire and grooming of this highly visible servant reflects the pride of the Cook family in its home and position in the community; house servants appeared as extensions of the family's means and taste. As the child's nurse, this woman would ideally stay with him, in the background, all the years of his growing up and remain with the family to care for any future children.[46]

In this particular instance, George Cook himself was a professional photographer, which made the acquisition of such a family nursemaid picture especially easy. But making the nursemaid so much the focus of attention, in her exemplary clothing and her vivid figuration, raises crucial questions about the intention of the image. It suggests that Cook might have had in mind something more specific than the usual discursive "charge" to naturalize the mammy relationship. He wished, instead, to dwell on it, as did Heustis later.

There are also other examples from the Cook collection. One, a paper print currently housed in the Valentine Museum, is not dated, but Joan Severa, who reproduced this nursemaid image in *Dressed for the Photographer,* places it in the 1860s, because of the clothing. This makes it contemporary to the "Nursemaid and Her Charge." Severa reasons that the "young nursemaid [who] appears to be not much more than thirteen in this portrait . . . wears the full bishop-sleeved housedress style of the early years of the decade, made in the spotted dark chintz thought more appropriate for servants, together with a small neat white linen collar which she has closed with a black bar pin. The skirt is held in a smooth fullness that indicates the wearing of a hoop." Severa notes that the words "Aunt Lizzie" are written by hand on the reverse side of the image but remarks that "it is not known whether this inscription refers to the nursemaid or the baby."[47] Severa's remark illustrates the utter incorporation of the nursemaid into the scene of her labor. Even her name—if it is used—has been rendered indistinguishable from that of the baby.

It is not known whether the "Aunt Lizzie" image belonged to or was made by Cook, although the solution to the photographic problem of balancing and securing the baby's head with the active left arm of the nursemaid is not a customary Cook solution. Another image from the Cook family archive—this one made by Heustis Cook—is also reproduced by Severa, who dates it between 1895 and 1897, based on the nursemaid's clothes. In it, a woman identified by Severa as "Pinkie" wears "a smart black dress with enormous . . . leg o'mutton sleeves under a puffy fichu of white lawn and (probably) Valenciennes lace. She wears a lace-trimmed white cap on her center-parted hair, and its white loops fall behind her ears at either side." Severa notes that "the fichu and cap are meant to define her position as nursemaid," indicating continuation of the signifying system that

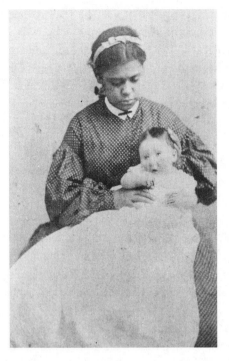

blended the nursemaid figure into the fabric of domestic life by literally cloaking her function in/as material.[48] Thus, this image is that of a second-generation archetypal nursemaid.

The Cooks—both father and son—were also very interested in making photographs of former slaves who were not nursemaids, and after the Civil War they made a great many images of black life in and around Virginia. Most of these, too, are framed as sentimental, humanistic images within the representational codes of the nineteenth-century bourgeois portrait.

By and large, the sentimentality in all the Cooks' postslavery images appears on the surface to be well intentioned toward black people. Aside from some egregious counterexamples, such as the figure of the banjo player, they are, at least apparently, nonstereotyped and generous toward the personalities and human worth of their sitters.[49] The majority of the photographs in the set clearly present the former slaves to be people of dignity, with few or no visible debilitating marks of slavery. In the Cooks' images, in fact, the former slaves appear as bona fide members of the universal "family of man." Such images could easily have had a place in Steichen's famous exhibition.

This impression of an absence of wounding mystifies the historical relation between the photographic gaze of the Cooks and the former slave population of Richmond and the surrounding area upon whom they trained it. We can sketch

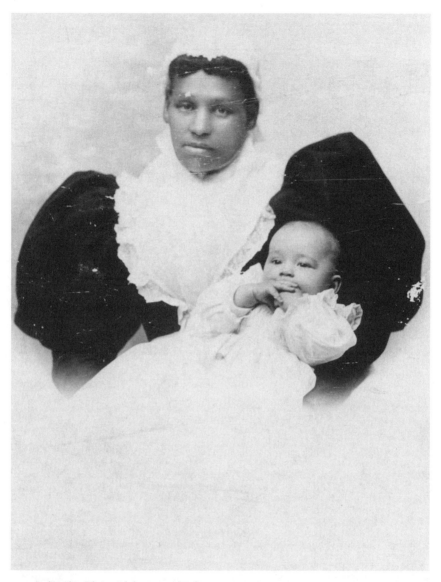

2.10. *Baby Alice Blair with her nurse, Pinkie*

at least some of its ominous associations by quoting briefly from the poetry of Benjamin Batchelder Valentine, a close family friend of the Cooks, in whose Richmond mansion, now turned into a museum, the Cook family archive is located.

In Valentine's book, *Ole Master and Other Verses,* published posthumously in 1921, Valentine makes a sustained apology for slavery and the social order it supported. In a poem entitled "The Race Question," written, as is most of his

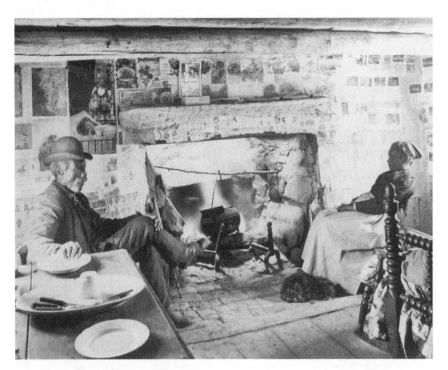

2.11. Two former slaves indoors by fire

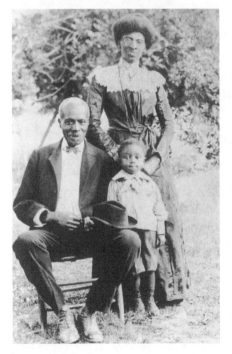

2.12. Black family

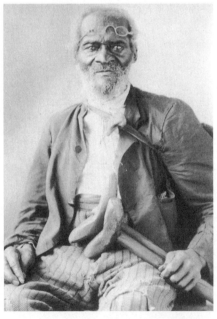

2.13. Former slave with glasses and crutches

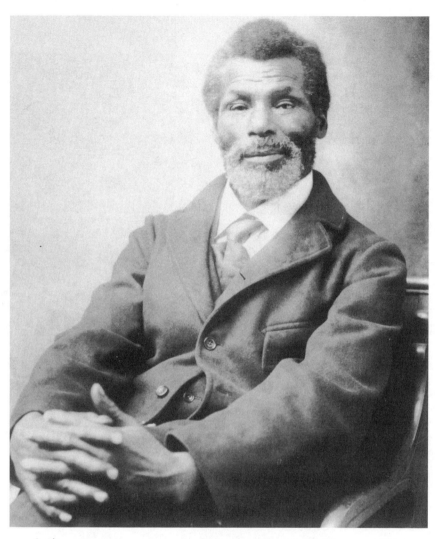

2.14. *Smiling man*

poetry, in a black dialect voice, Valentine argues, for instance, that slave labor was more beneficial to the southern black population than free labor:

> When I wuz young de color'd folks
> Wuz 'low'd ter lay de bricks;
> Dey climbed de scaffolds, toted hods,
> An' made de mortar mix.
>
> Dey'd handle hammers, saws an' planes,
> An' any tools dey'd choose

2.15. *Standing man with open book* 2.16. *A figuration of "Mammy"*

It wan' no folks 'cep' niggers den
 Whar use' ter half-sole shoes.

In dem dyar times 'twas nigger backs
 Whar gave de scythes de swing;
'Twuz big, black, shiny nigger arms
 Whar made de anvils ring.

An' settin' on de wooden horse
 Wid staves betwix' dey laigs,
Wid drawin' knives an' hic'ry poles
 De niggers hooped de kaigs.

You couldn' fin' no barber shop
 Dat we-all folks wan' dyar
De little ones er-shinin' shoes,
 The big ones cuttin' hyar.

Wid high up gem-man names print' on
 De mugs er-settin' roun';
Er heap o' niggers made dey piles
 Frum shaves an' breshin' down.

2.17. *Banjo player*

But 'tain' so now, nor dat it aint,
 De white-folks cuts us out;
Dey jumps right in an' gits de wuk
 'Fo' we knows what dey's bout.

Dey 'trac's de trade — dem out-land folks
 Dem 'Talians, Dutch, an' Greeks,
Aldo' 'tain' none whar understands
 De 'spressions whar dey speaks.

Dey shaves an' shampoos all day long,
 Dey never, stops
Dey don' pick banjers for dey fr'en's,
 An' cake-walk in de shops.

De Orishman is wuss er all
 Jes' time er nigger nod,
He step right up an' shev' him down
 An' grab er hol' his hod.

An' den de Unions layin' bricks,
 Dey hollers out ter Mike
"Ef dat dyar nigger gits dat hod,
 We-all is gwine ter strike."

Den ev'y body on de job
 Er-j'inin' in de fray,
Jes' tells de niggers, up an' down,
 Ter go 'long out de way.

De bosses don' cyar nothin' 'tall;
 Dey say we's mighty slow;
Dey kinder laugh an' los it's time
 De nigger got ter go.

An' ef we turns den ter de farms,
 Whar we had ought ter been,
We dyar gwine find some big machines
 Fer us ter buck erg'in.

Dey's took an' drove out all de scythes
 I'clar, it is er crime
Ter reap, wid one dem whirlin' things,
 De whole crop at er time.

I know we's gittin' mighty larned—
 Folks say we's making has'e;
Dyar's heap o'sass an' argyment
 'Bout "Progress er de Race."

I 'lows we' settin' up de tree—
 De nigger's on er boom—
But I wan' know whar 'bouts is I
 Gwine git some elbow room.

Er-stydy'n' bout one question, Suh,
 Nigh bu'sts my brain 'jints loose,
"Is niggers now er-cotchin' holt,
 Er is day off de roos'?"[50]

In the opinion of Mary Newton Stanard, a friend of Valentine's who wrote the introduction to *Ole Marster and Other Verses,* Valentine was entirely correct in his analysis of what African Americans had lost by gaining their freedom. She wrote,

> Southern negroes brought up by 'Ole Marster' and 'Ole Mistis,' and even descendants of these dear, dark folk who inherited their character, manners, speech and devotion to 'we all's white folks' are rapidly becoming mere tradition, and with them is passing from the American scene something vital, something precious.[51]

Valentine, in Stanard's opinion one of the "white people who were associated with them in a relation unique then and impossible now, whom they loved and served and who loved and served them," was one of the rare whites who "possessed a supreme gift for interpreting" the speech of the black population. She was relieved that "through his work they will live always." Stanard knew directly of the power of this interpretive gift, for Valentine used to give performances in which he impersonated the "faithful colored folk" in dialect verse in his "old and storied Richmond mansion, whose rooms were filled with books and treasures of artistic and sentimental value."[52] To attend a performance of these poems, remembered Stanard, was "an unforgettable experience":

> Under the quaint humor which bubbled on their surface flowed a deep current whose echo could be heard in his mellow, lilting voice, for all its contagious chuckles, and which could be glimpsed in his expressive eyes for all their merry twinkling—showing that with fine imagination, with sympathy amounting to genius, he felt at once the picturesque traits of his subjects which shallower interpreters are prone to caricature and their mental and spiritual processes. Whether or not the philosophy which was a marked characteristic of these simple souls was an original development or was imbibed from their "white folks" and passed on in intensified form to their "white folks'" children, is impossible to say, but as seen in the work of "Ben Valentine" it is as typical of the interpreter as of the interpreted. Each portrait in the gallery which his negro verse comprises is sketched with unerring touch from some point of vantage peculiar to itself, and the whole thus presents, as nearly complete as could be within the bounds so circumscribed, a visualization of a vanishing race.[53]

It seems, therefore, that the poems published in *Ole Marster and Other Verses* are the texts of the blackface performance pieces that Valentine used to present. It is likely that the Cook family also attended Benjamin Valentine's dialect performances in Richmond. Certainly they would have known of them. Part of the interest that the father and son shared in "taking photography to the back roads" was probably to present a parallel in photography to the kind of preservation of a "vanishing race" that, according to Stanard, their friend Ben Valentine was so successfully producing in dramatic verse.

In this context the "Banjo player" is not merely an egregious image but actually menacing. As Valentine's poem "The Race Question" establishes, the purpose of the effort to visualize the ex-slaves was to turn back the clock, to force Reconstruction to deconstruct, to argue that slavery was not only harmless but that it was better for the "simple souls" than the system of free labor, with its immigrant competition and labor agitation, that followed. The "Banjo player" is a figure from that supposed happy past.

Like the figure of the banjo player, the "significant figure of the Mammy," writes Catherine Clinton in *The Plantation Mistress*, "as a familiar denizen of the Big House is not merely a stereotype, but in fact a figment of the combined romantic imaginations of the contemporary Southern ideologue and the modern Southern historian."[54] Clinton found that although there were some female slaves who "served as the 'right hand' of plantation mistresses," records show that there were only very few. The Mammy is a *post*slavery invention. "Not until after Emancipation did black women run white households or occupy in any significant number the special positions accorded to them in folklore and fiction. The Mammy was created by white southerners to redeem the relationship between black women and white men within slave society in response to the antislavery attack from the North during the antebellum era, and to embellish it with nostalgia in the postbellum period."[55] In other words, the invention of the Mammy (as a sort of super nursemaid) was a political ploy of white supremacy. Her image, seen in this context, announces the reassertion of the white patriarchy.

Not only that, but it was also a clear rhetorical threat. As journalist Edward A. Pollard, another of Cook and Valentine's contemporaries in Richmond and an ardent Southern nationalist, wrote in *The Lost Cause*, the true social status of the Negro was dictated by the "fact" of "the permanent, natural inferiority of the Negro," which the white man had to control.[56] The ostensible need for white men to control the supposedly " 'savage'-like behavior" of this "inferior" population was offered as an excuse for deadly violence against that population. As Sandra Gunning has explained in *Race, Rape, and Lynching*, "the interracial male struggle over the terrain of the public would always be figured finally within the terms of the domestic—the privatized expression of the nation's political

anxieties. White Americans' conflation of the public and the private as the twin targets of black designs meant that the figure of the black as beast threatened to become a totalizing symbol of a race war many felt was already in progress."[57] Whatever their original humanistic intent toward the "hidden witness" in their midst, therefore, "permanent, natural" images made of black people framed in terms of white sentimental domesticity—such as the Cook photographs—functioned as attempts to exhibit the superior evolution of the white family and its household. When Cook photographed his private nursemaid in the early 1860s, he was demonstrating his public role as an upper-class white man in Richmond. This *included* the superlative display of the nursemaid.

I would hold, in fact, that this trajectory of white supremacy in Richmond is why the Cook photographs, including that of the nursemaid, bear no visible relation to the hardly distant violence of slavery but only allude directly to the impressive dignity possessed by their subjects. Such respectful and innocuous images would have been much more useful than deliberately damaging images to support the claim of white domestic virtue that circulated throughout the south during the Reconstruction era. The need was to establish that slavery *did* no violence.

But the photograph that George Cook made of his nursemaid also punctures this reverie.[58] It is distinct from the rest of his "portrait gallery" because of its exceptionally intimate and focused vision of its cross-racial subject. The baby, like the domesticity, is his.

The chief contradiction that the Cook photograph of "a nursemaid and her charge" poses for critical consideration of a structure of sentimentality like that of the Cooks, is that however it might function rhetorically in public, such a use of photography *within* the private zone of the family could run directly afoul of a basic sentimental principle: keeping maternity and labor separate within one's own household. The idea was clearly articulated by Stowe, Warner, Gilman, and others, that the images of women that are to be accumulated for the domestic circle—women whose physical presence, by being photographed, was in fact to be rendered permanently and intimately familiar to the family—should be images of women of sensibility in its white, middle-class incarnation. For the white, middle-class household, photographs, like paintings, are a way of instructing children. "Pictures hung against the wall, and statuary lodged safely on brackets speak constantly to childish eyes, but are out of reach of childish fingers," wrote Harriet Beecher Stowe, who also advised:

> They are not like china and crystal, liable to be used and abused by servants; they do not wear out; they are not consumed by moths. The beauty once there is always there; though the mother be ill and in her chamber, she has no fears that she shall find it wrecked and shattered. And this style of

beauty, inexpensive as it is, is a means of cultivation. No child is ever stimulated to draw or to read by an Axminster carpet or a carved center-table; but a room surrounded with photographs and pictures and fine casts suggests a thousand inquiries, stimulates the little eye and hand.[59]

The people in such photographs do not have to be kin. As the mid-nineteenth-century cult of collecting celebrity images in cabinet photographs and cartes de visite demonstrates, they could be strangers, just so long as they were an uplifting influence. Middle-class sensibility was the possession and mark of the moral being of such a person. Images like these, as Stowe put it, were all extensions of the moral function of the middle-class mother. They represented the "affective life of property" that Gillian Brown describes as "sentimental possession."[60]

A photograph such as that of the Cooks' nursemaid, one that actually focuses on a servant or a slave, could destabilize the comforting economy of this vision, just as it destabilized the relation of figure to type in the Madonna. Certainly such an image needed to be displayed very carefully when it was used for domestic consumption. Photographing the black nursemaid does not threaten the hegemony of white domestic sentiment, but it can "raise a thousand inquiries," questions that one might not want the "little eye and hand" to uncover. Therefore, unlike the white mother, the black nursemaid must not come to possess an inward sensibility by the re-creation of her image as an object of "depth" in the romantic vein. Nor can she accrue any authentic recognition of the value of her maternal labor. Instead, as Clinton writes, "[The mammy] image reduced black women to an animal-like state of exploitation. Mammies were to be milked, warm bodies to serve white needs—an image with its own sexual subtext. The Mammy does not, by any means, validate the 'closeness' of the races."[61]

I do think there is an additional layer of meaning encoded in the Cook image of the "Nursemaid and Her Charge" although I have not been able to establish it on any historical grounds. Nevertheless, it seems appropriate to say that nursemaids nurse babies, that in order to nurse a baby one must have recently borne a baby oneself, and that therefore the presence of Heustis Cook in the image may erase the presence of the nursemaid's own baby, who remains invisible. What the social relationships were that surrounded that baby, if it existed, are impossible to tell.[62] Nonetheless, the reproductive body of the nursemaid is very much part of the figure's construction.

What we do know is that in spending time and money on the nursemaid photograph, in accumulating and preserving her image in the mode of a member of the family, Cook was still not displaying her as a woman, a mother, a person. It was her job to "enhance by contrast," as Harryette Mullen has put it, the maternal power of her mistress.

In the one instance that I have located of a formal photographic portrait that Cook made of his wife, the ideological framing and mise en scène of the figure does indeed contrast with the portrait of the nursemaid. Much about the portrait of Mrs. Cook is similar to that of the nursemaid. She is dressed in a similar style to that of her slave or servant, with again a brooch pinned at the meeting place of the two halves of the white collar of her dress. The two young women even seem to be about the same age. But unlike the nursemaid, Mrs. Cook as an individual is the sole focus of the camera. She is not holding her child. She wears as if by simple right a wreath of flowers in her hair, symbols of freshness and natural innocence that have not been provided to the nursemaid. The nursemaid, by contrast, wears a uniform.

The portrait of Mrs. Cook bears the mark of patriarchal protection, in that it casts her in an ethereal light like that described by Kristeva. The photographer has lingered on the luminosity of her eyes, on the gentle smile that plays about her lips, and on the way that the braid in her hair picks up light like a halo, wanting to record them. Her figure is different from the figure of the nursemaid in that the image of the slave or servant does not offer any of these supplementary signifiers that register innocent and fragile womanhood, thus placing her within the bounds of southern patriarchal male protection.

At the same time, the photograph of the nursemaid and her charge engages in the threat by which the boundary of the white woman's innocent gaze was policed. It openly displaces the white mother by handing her baby to the black nursemaid but dissembles its threat by celebrating the sentimental framework of the white woman's motherhood. The adulatory portrait of Cook's wife reflects

the conciliatory aspect of the honorific image. The shadow archive of women who could not be included is referenced in the photograph of the nursemaid and her charge, which seeks to discipline the white woman by reminding her of the "protective barriers, ideological and institutional, around the form of the white mother, whose progeny were heirs to the economic, social, and political interests in the maintenance of the slave systems," as Hazel Carby puts it, by raising the specter of black motherhood, which lacked these protections.[63]

The figure of Mrs. Cook is also different from the other family figures who appear on the porch in the group portrait, of whom Mrs. Cook was presumably one. The scale of its close-up focus magnifies the impression of a delicate individuality and distinction. In particular, Mrs. Cook's eyes, though lively and focused, are averted slightly from the camera, in a relaxed indirection that signifies that she has no need to protect herself: the operator of the camera, who is her husband, has her best interests at heart. Whereas even if the nursemaid also looks away, there is a vigilance of self-regard in her gaze not invited but *demanded* of those in her position who cannot depend on such protection by law. Read in the context of the crisis of white supremacy in Richmond in the 1860s, the innocent averted gaze of his wife is perhaps one of the clearest signs Cook can make with his camera of the white man's ability to keep the Old South alive in his family life. The potential violence of this determination is registered in the tense, self-conscious look in the nursemaid's eye.

In another of Ben Valentine's poems, entitled "Mammy's Charge," the figure of the nursemaid is counterposed to that of the mother in such a way that every considerable virtue the nursemaid evinces is literally "outshone" by the fact that the mother has died, gone to heaven, and become a star. In this poem, a little girl's mother has died and a grieving "Mammy" has been given the assignment of keeping the child occupied during the day of the funeral. "Mammy" holds her up before the window, and eventually the child falls asleep in her arms.

> My heart is mos' broke, Judy, an' my haid is achin' bad,
> Dis is de sor'ful's evening honey, dat I is ever had.
>> Dey knowed I love dat dear sweet Chile, an' now her Mummer's daid
>> Dey could trus' her ole black mammy fer ter treat her good, dey said.
>
> So dey lef' me in de nursery fer ter keep de chile up dyar,
> But I still culd heah de service, an' de preacher read de pra'r;
>> De chile too kotch de singing an' de tears I had ter hide,
>> When, in play she kep' on 'peatin', "O Lord, wid me abide."
>
> When de fune'al it wuz over, an' de hearse wuz driv' away
> I try might'ly fer ter 'muse her, an' ter keep her dyar at play,

But she 'sist on asking questions like, "What is my Farver gone?
I wants ter see my Mummer; will she stay 'way frum me long?"

I cyar' her ter de winder, an' she look' out in de street,
'Tel she got so tired waiting dat she went right fas' asleep;
 But I set dyar in de twilight an' I hel' de little dear,
 'Tel de street wuz onty darkness, an' de stars bein ter 'pear.

Den one star come out, Judy, whar I never sees befo',
An' I look at it so studdy dat de tears wuz 'bleege ter flow;
 Den I tu'n an' see my darlin', in her sleep, begin ter smile;
 An de new star seem' a-shinin' right down upon de chile.[64]

Despite the tender warmth and sympathy extant in "Mammy's" heart, it is clear that benediction comes only from the white mother, who is, not coincidentally, "up above." If my comparisons of the photographs are apt, this sort of enhancement by contrast should also illuminate Cook's portrait of the nursemaid. It was evidently her part in the family to represent the best of earthly care, while her mistress allegorized eternal love. It is relevant that this is also not an unfamiliar role for white women, who, in sentimental structures, show their truest strength when dead.

The trouble is, photographing the nursemaid so splendidly—even if only to reflect the family's social position—also threatens to alter the balance of power between these "facts" of sentiment and hidden others. It threatens to give the nursemaid a social currency that she should not have. Therefore, it seems apparent that although the photograph imbues the figure of the nursemaid with the outward signs of feminine sensibility—the baby, the Madonna-like pose, the domestic reference, indeed almost all of the chief technologies of gender—these signs are used as a caul, to disguise rather than to convey human relation.

For the young woman portrayed within this extension of domestic representation, being rendered with visible sentiment just makes her social personhood more invisible than ever. The portrait is, in Hortense Spillers's words, a "violent jamming, two things enforced together in the same instance, a merciless, unchosen result of the coupling of one into an alien culture that yet withholds its patronym."[65] As a nursemaid, she might really teach the baby; but as an image, she must have less meaning than a piece of furniture.

This reification is also apparent in the subsequent treatment of the Cook nursemaid image. Putting her in their photograph seems to have been almost like hiding her in plain sight. The Cook family themselves could not have bothered to read the complicated body language and facial expression of the nursemaid in the photograph in their midst; or reading it, they could not have lent

it even the remotest capacity to signify. Otherwise, the photograph, coded as a sentimental family memento of her faithful devotion, must have acquired a more problematic meaning than its history as a cherished keepsake of the family would allow. Arguably, it is as much an image of the violation of her social personhood as are the more infamous Zealey daguerreotypes of Delia, Renty, and Jack; and it is as eloquent a record of the social relations that grew out of slavery.[66]

The photograph of the teenaged, bare-breasted Delia was given by a South Carolina slaveholder to Professor Louis Agassiz of Harvard University to help him to "study anatomical details of 'the African race'" in order to "prove" his theory of that blacks were a distinct species, separately created. Harryette Mullen writes of Delia,

> History preserves only the picture of her body, photographed as a 'scientific' exhibit. Prefiguring the critique of bourgeois power/knowledge monopolized by privileged white males, represented by private tutors who serve the slaveholding elite in Williams' *Dessa Rose,* Morrison's *Beloved,* and Johnson's *Oxherding Tales,* are the historical encounters of slave women with white men of science: Dr. James Norcum ("Dr Flint" in Jacobs's narrative), who instructed his slave that she had been 'made for his use'; Dr. Strain, who desired visual proof of Sojourner Truth's sex, viewing the self-empowered black woman as a freak; and Professor Louis Agassiz, who conceived a project in which the illusory immediacy of the subjugated image would provide seemingly irrefutable proof of African inferiority through a photographic display of black bodies, a project in which racial and sexual differences were to be read as perceptible evidence of inferiority.[67]

For Mullen, Agassiz's "coercive recording of her barebreasted image leaves her silent, underscoring Delia's materiality as 'property,' and 'exhibit,' as 'scientific evidence,' a unit of data within a master discourse controlled by white men, bent on denying her subjectivity. . . . [But] the lowered lids shade what is otherwise a direct outward gaze without the least suggestion of embarrassment. Stripped naked, her objectified body functions as a veil for her soul, her subjectivity retreating before the gaze of scientific objectivity materialized by the camera."[68]

Similarly, what is at stake for me, in the photograph of the "Nursemaid and Her Charge" is that there seems to be something in her body language that "escapes or at least challenges the subjugating gaze that holds her body captive." The compelling visual pattern of the striped dress is uncannily like a subliminal message to the viewer to "read between the lines." If the white cloth at the bottom of the frame, which a viewer easily could have processed at first as a single, vague entity, were earlier interpreted entirely as the infant's dress, it will now resolve itself assertively into two distinct shapes—the apron that designates a servant/slave as well as the clothing of the child. The cloth across the young

woman's left shoulder, which might have been something any mother or nanny would use in a multitude of ways to protect and shelter and swaddle the baby and herself, comes to appear as much a curtain separating the two as it does the implement of any ritual of care or bonding.

As one looks more closely, it even becomes apparent that the cloth covers unnaturally and entirely her left arm and hand; in fact, that it has been arranged or flung upon her much as if she were a chair or some other piece of upholstery, so as to set off the baby's head against a dark solid surface that corrects for the photographically busy background of the eloquent striped dress. Evidently it was very important that the baby's individuality come through sharply in this portrait; and for this purpose, the woman is merely the setting, the not quite perfect background that needs to be improved. But her body language suggests that she comprehends this expediency and that she resents it, for she makes no effort to hold or cradle the baby, but merely suffers him to be balanced upright and exhibited to the camera as he waves his arm in the crook of her exaggeratedly extended elbow.[69]

Not only the Cooks refused to read this photograph. Although the "Nurse-maid and Her Charge" has three times recently been reprinted in widely read books on African American history, including feminist books, it has never yet drawn a critical glance beyond Norman Yetman's general assessment that her image, like all the images in the Cook collection, is "sensitive . . . honest . . . [and] forthright," and that "a quality exists in each of them that marks them as an interesting composition and a work of art in their own right."[70]

Furthermore, each time it has been reprinted, the photograph has been rendered outside of the particular political context of its production in Richmond in the 1860s. What does this continuing disregard of the figure of the "Nurse-maid and Her Charge" tell us about the allegiances of our critical institutions that have, since slavery, continued to govern the interpretation of the photographic gaze? Does seeing nineteenth-century middle-class "sentiment," that critical turn that has been so vitally important for the establishment of a feminist standpoint in literary criticism, actually function as a mechanism of displacement in and by photography, ensuring that other sentiments will not be seen?

In feminist film theory the term "gaze" denotes a socially engineered avenue for looking. The gaze is a literal pathway between eye and object that reflects and intensifies the viewer's subject position and social positioning. Like other material entities, this pathway is culturally constructed. The gaze is positioned by means of the kind of subject/object dichotomies reproduced in classical Hollywood cinema by a male power of looking, which Laura Mulvey described so brilliantly in her groundbreaking essay "Visual Power and Narrative Cinema": "In a world ordered by sexual imbalance, pleasure in looking has been split between

active/male and passive/female. The determining male gaze projects its fantasy onto the female figure, which is styled accordingly."[71] The domestic images presented here reveal how much the gaze is also determined by the subject/object dichotomies produced by a white power of looking. This power, because it was so thoroughly raced and classed, set white female spectators in apposition, not opposition, to white males, even as it maintained white male supremacy. As Jane Gaines and others have argued, and as Mulvey herself has agreed, Mulvey's original, generic male/female binarism must be expanded and reconfigured to show how, in a culture that literally commodified black people, objectified racial sight lines have also long been resources for visual pleasure for both men and women. "I want to suggest," Gaines writes in "White Privilege and Looking Relationships," that "the male/female opposition, so seemingly fundamental to feminism, may actually lock us into modes of analysis which will contrive to misunderstand the position of many women. Since this theory has focused on sexual difference, class and racial differences have remained outside its problematic, divorced from textual concerns by the very split in the social totality that the incompatibility of these discourses misrepresents."[72] Mulvey has proposed that "in their traditional exhibitionist role, women are simultaneously looked at and displayed, with their appearance coded for strong visual and erotic impact so that they can be said to connote *to-be-looked-at-ness*."[73] But I would add that, in a world ordered by racial imbalance, the pleasurable fantasies of scopic advantage are split and styled in different ways, such that in other roles, certain other women are coded as *not-to-be-looked-at-ness*.

How did this come about? First, we know from slave narratives, oral testimonies of slave women, and legal records that during slavery white male pleasure in looking was seized directly, through physical sexual aggression against the female slave and ownership of her progeny. We also know from the same sources, and from the diaries and memoirs of white mistresses, that white female advantage led to a more mediated pleasure, afforded in two ways: indirectly, by symbolic refusal of the designation of "woman" to the slave her husband raped, and materially, by the prohibition of patrimony to the children resulting from those encounters.[74] Nonetheless, white men and women shared, however unevenly, the bond of race and class enacted through this differential contemplation of the body of the "other." Spectatorial privilege—that is, permission to discriminate on the basis of visible signs—was established for white women in this country during slavery, in *alliance* with the white male gaze. This privilege became the cultural resource on which white women photographers later built their careers.

Secondly, though not less crucially, during slavery the fruits of this diffidently empowered female gaze were unstable. It was in the realm of erotic pleasure that the asymmetry between the absolute domestic power of the master and the

dependent domestic power of the mistress came most fully into play. Selective vision was both her prerogative and her prison, and she learned to see and not to see at the same time.

Mary Boykin Chesnut, writing during the Civil War, expressed this contradiction quite clearly in her diary:

> Under slavery we live surrounded by prostitutes, yet an abandoned woman is sent out of any decent house. . . . Like the patriarchs of old our men live all in one house with their wives and their concubines; and the mulattoes one sees in every family partly resemble the white children. Any lady is ready to tell you who is the father of all the mulatto children in everybody's household, but her own. Those, she seems to think, drop from the sky. Good women we have, but they talk of all nastiness—tho' they never do wrong, they talk day and night of . . . my disgust sometimes is boiling over—but they are, I believe, in conduct the purest women God ever made. Thank God for my countrywomen—alas for the men! No worse than men everywhere, but the lower their mistresses, the more degraded they must be.[75]

Chesnut refers here to socially constructed limits of the female gaze, whereby what "one sees" is taken to the next step of matching "father" and "white children" with "all the mulatto children in everybody's household" whom they "resemble" but then "dropped" from consciousness. The Chesnut passage demonstrates how the master's wife could register enough discernment to see the female slave as a sexual temptation but not enough to tempt her further to identify their mutually imbricated, if differently enforced, oppressions. Instead, she took refuge in gossip, scandal, and complaint.

If ever she did allow herself to see further into the visible signs of this relation, they were likely to be a matter of pain, not "visual pleasure." The diary of Ella Gertrude Clanton Thomas contains a rare account of this kind of revelation. On June 2, 1855, Thomas wrote a confused entry in her journal stating that "[T]here are some thoughts we utter not and not even to you my journal . . . yet there are some moments when I must write—must speak or else the pent up emotions of an overcharged heart will *burst* or *break* . . . with a heart throbbing and an agitated form. How can I write?"[76] In an essay about the diary, Nell Painter proposes that what is going on here is that Thomas has begun to suspect that "her father had had children and that her husband had had a child outside their marriages," with slaves.[77] Opening her "secret eye," Painter says, Thomas here writes a kind of "conversation which in a moment, in a flash of the eye will change the gay, thoughtless girl into a woman with all a woman's feeling."[78] What she sees in this "flash" is a "chilling influence."[79] Thomas reacts, Painter notes, to the revelation of "her husband's sexual relations with a slave as people have traditionally responded to adultery—with jealousy, anger,

and humiliation, not with the cool assurance of superiority."[80] In other words, Thomas's "secret eye" recognizes that female slaves are female persons, but to keep her place in the family the white mistress must continually disavow this knowledge. She must spin the gold of insight into the straw of blindness for, as Caroline Gilman reminds herself in *Recollections of a Southern Matron*, "the three golden threads with which domestic happiness is woven . . . [are] to repress a harsh answer, to confess a fault, and to stop (right or wrong) in the midst of self-defense, in gentle submission," even though to do so "sometimes requires a struggle like life and death."[81]

And finally, after slavery, such relationships between seeing, showing, and knowing had to be reinstated. Indeed, they could never be permanently fixed, but were always responsive to context. Gender has always to be made and re-made, or it cannot be relied upon. As Hazel Carby writes, "what needs to be questioned is the necessity for the constant reiteration, in books, journals, and newspapers, that wives had to be submissive to patriarchal practices."[82] The "secret eye" deflected during slavery was both a trophy of and a potential threat to white patriarchal control. Its potential to disrupt the illusions of white domesticity did not diminish after the war. During and after Reconstruction, race-regarding "New White" males needed to count even more assiduously than before on control of "their" women as well as "their" former slave populations as signifiers of their own claim to represent "civilization," and the urgency of representations of domestic sentiment also increased. There was thus an edgy and ambivalent increase in the valuation of white women's acuity, along with increased pressure for white men to objectify and "defend" its boundaries. The female gaze invited increasing respect precisely because of the possibility for it to metamorphose into some other sort of seeing.

The photographic record suggests that during slavery few white women sought to investigate the power of the sight lines between themselves and their slaves or the power of their images of slaves. But the next generation of white women recognized in this dynamic a kind of opening. The crisis of white masculinity in the last quarter of the century was an opportunity to demonstrate a new alliance. Acting as the visual equivalent of ventriloquists, turn-of-the-century white women photographers in the United States found they could have satisfying careers if they used their photographs to mirror and enlarge the white man's image of himself as custodian of civilization, just as the white mistresses of their mothers' generation had used softened tones to amplify his voice.

Feminist scholars have long been concerned over how the objectification of women's bodies is accelerated through the circulation of photographs. But it is also a fact that many white middle-class women grasped this amplified power of the gaze in a markedly enthusiastic fashion when they took the shutter re-lease into their own hands. If anything, in moving from object to operator of

the camera, white women's looks at the turn of the century identified with the oppressor—of "others." They might have withheld the averted gaze, a threat of exposure that was uniquely photographic. But the story of these particular women is that they seldom sought the revelations of the "secret eye." Rather than initiate cross-classed, degendered, potentially radical, antiracist alliances, they preferred to remain "women photographers," as their ideological forebears on the domestic scene had preferred to remain "ladies," to the bitter end.

3

> I read a woman's book, meet such a woman
> at a party (a woman now, like me) and think
> quite deliberately as we talk: we are divided: a
> hundred years ago I'd have been cleaning your
> shoes. I know this and you don't.
> —Carolyn Kay Steedman,
> *Landscape for a Good Woman*

Tender Violence

Domestic Photographs, Domestic Fictions, & Educational Reform

· ·

The widely influential Douglas-Tompkins debate on the literary value of American domestic fiction attributes a broad range of cultural agency to nineteenth-century sentimental novels. Ann Douglas began *The Feminization of American Culture* by asserting the moral primacy of Puritan culture in the northeast United States and lamenting the tragedy—rather than merely the melodrama—of the terms under which it gave way. In her view, the Edwardsean Calvinist school of ministers was the "most persuasive example of independent yet institutionalized thought to which our society has even temporarily given credence," and its members "exhibited with some consistency the intellectual rigor and imaginative precision difficult to achieve without collective effort, and certainly rare in more recent American annals." However, she argued, the invaluable intellectual "toughness" of this theological establishment had been disastrously undermined by, among other things, the "sentimental heresy" of the cult of the victim, a cult perpetrated by "literary men of the cloth and middle-class women writers of the Victorian period." This "feminization" of American culture encouraged the idea that appropriate notice of the painful social dislocations of nineteenth-century capital and urban industrial expansion could be given symbolic expression in literary rather than theological works. The ultimate effect of this change of venue to literary representation was not, as the writers of these works often alleged, to foreground and correct social inequities but rather to provide an emergent middle-class readership with permission for a kind of

aesthetic and emotional contemplation that was underwritten precisely by its refusal to actively "interfere" in civil life. Sentimentality, said Douglas, became a way to "obfuscate the visible dynamics of development." It also functioned as an "introduction to consumerism" and as the herald of a "debased" American mass culture through which we have learned to "locate and express many personal, 'unique' feelings and responses through dime-a-dozen artifacts."

The principal literary exemplum of Douglas's thesis was the death of Little Eva in Harriet Beecher Stowe's *Uncle Tom's Cabin,* which Douglas characterized as a "beautiful death, which Stowe presents as part of a protest against slavery," but which "in no way hinders the working of that system." Adherence to nineteenth-century sentimentalism's "fake" standards, Douglas argued, had "damage[d] women like Harriet Beecher Stowe." Even Douglas herself, she admitted, "experienced a confusion" of identity just from studying the sentimentalism of the period, a confusion that separated her painfully from the "best of the men [who] had access to solutions" and associated her uncomfortably with the women writers, whose problems, she wrote, "correspond to mine with a frightening accuracy that seems to set us outside the processes of history." American Victorian sentimental fiction was, she concluded, "rancid writing"; it was her duty as a feminist to be "as clear as possible" about that fact.[1]

Jane Tompkins, in *Sensational Designs: The Cultural Work of American Fiction, 1790–1860,* vigorously attacked Douglas's thesis that the spirit of nineteenth-century domestic fiction was destructive, opening instead an expansive alternative perspective. Instead of mourning what Douglas saw as the "vitiation" of a rare, tough-minded, communal, Calvinist, "male-dominated theological tradition," Tompkins took the ideological and commercial ascendancy of nineteenth-century women's writing as a mark of "the *value* of a powerful and specifically female novelistic tradition."[2] Turning the tables on the Douglas scenario, Tompkins argued for the coming into being within this literature of a coordinated, specifically female, evangelical tradition, whose principal figures concurred and strategized with much the same serious, socially engaged intention that Douglas's Edwardsean school evinced. It followed that the most consequential difference for a critic to attend to lay not between the ministerial tradition and the women themselves but between the kinds of social knowledge and goals for reform that issued from the perspective of Victorian female engenderment and those of the contemporary intellectual establishment. As Tompkins put it,

> The very grounds on which sentimental fiction has been dismissed by its detractors, grounds which have come to seem universal standards of aesthetic judgment, were established in a struggle to supplant the tradition of evangelical piety and moral commitment these novelists represent. In reaction against

their world view, and perhaps even more against their success, twentieth-century critics have taught generations of students to equate popularity with debasement, emotionality with ineffectiveness, religiosity with fakery, domesticity with triviality, and all of these, implicitly, with womanly inferiority.

In other words, what Douglas saw as the usurpation of the chief source of serious social criticism in the northeastern United States prior to the Victorian period by a sentimentalism that was a passive and hypocritical "rationalization of the economic order," Tompkins scripted as a move toward greater scope and democratization by a sentimentalism that was profoundly "a political enterprise, halfway between sermon and social theory," an enterprise that "both codifies and attempts to mold the values of its time."[3]

For Tompkins, this "sentimental power" spoke to and of the interests of the "large masses of readers," at least some of whom were, presumably, the same persons who were suffering under the new urban industrial regime. Tompkins developed a provocative reassessment of the social function of literary stereotypes, whose "familiarity and typicality, rather than making them bankrupt or stale, are the basis of their effectiveness as integers in a social equation." The contemplation of such literary moments as Little Eva's death, she postulated, provides readers with comprehensible examples of "what kinds of behavior to emulate or shun" and thereby "provide[s] a basis for remaking the social and political order in which events take place." Sentimental fiction, in this view, offered a practical, quotidian, grassroots politics that the more abstract, theological, patriarchal Calvinist tradition tended to disdain. Nor were the authors of this literature simply apologists for the corruptions of the capitalist order. They reached down to the "impulses of the multitude which those who stood upon the Yankee Olympus wanted only to 'uplift,' and spoke words of resistance and encouragement in the mother tongue." Interestingly, as a result of her study, Tompkins, like Douglas before her, found herself surprised to be allied with "everything that criticism had taught me to despise: the stereotyped character, the sensational plot, the trite expression."[4] But Tompkins's recognition of her bond with the women novelists did not provoke the same identity crisis it produced in Douglas, whose preference for "the best of the men" made her afraid that her empathy with the women could be seen as "siding with the enemy."[5] Rather, as "[a] woman in a field dominated by male scholars," Tompkins decided strategically to discuss "works of domestic, or 'sentimental,' fiction because I wanted to demonstrate the power and ambition of novels written by women, and specifically by women whose work twentieth-century criticism has repeatedly denigrated." In *Uncle Tom's Cabin* and *The Wide, Wide World,* Tompkins found intellectual nourishment that was not "rancid," but "good."[6]

Clearly, to rule on the merits of one of these arguments over the other is

simultaneously to arrive at a position on such a large number of nineteenth- and twentieth-century social, economic, cultural, and critical perspectives that the task would be beyond the reach of a single book. Exactly this enlargement of the notion of what it would take to understand fully nineteenth-century American sentimentalism or to write its history is, however, one of the chief accomplishments of Douglas's and Tompkins's scholarship, as well as of the early supporting works by Alexander Cowie, Barbara Welter, Henry Nash Smith, Helen Papashvily, Gail Parker, Dee Garrison, Nina Baym, Mary Kelley, and Judith Fetterly, among others, which prefigure, surround, and amplify the basic insights codified by the more famous exchange. Tompkins recognized the essential contribution of this dilatation of the issue herself, when she wrote as follows of her interlocutor's work:

> Although her attitude toward the vast quantity of literature written by women between 1820 and 1870 is the one that the male-dominated tradition has always expressed—contempt—Douglas's book is nevertheless extremely important because of its powerful and sustained consideration of this long-neglected body of work. Because Douglas successfully focused critical attention on the cultural centrality of sentimental fiction, forcing the realization that it can no longer be ignored, it is now possible for other critics to put forward a new characterization of these novels and not be dismissed. For these reasons, it seems to me, her work is important.[7]

A revision of the traditional critical contempt was what Tompkins was attempting, but it was focused on writing that Douglas had put on the map.

It is evident, therefore, that in one crucial respect Douglas and Tompkins are in absolute agreement. They agree about the active and productive social function of domestic literature—the "cultural work within a specific historical situation" that Tompkins values and the "intimate connection between critical aspects of Victorian culture and modern mass culture" that Douglas castigates.[8] For both critics, sentimental fiction is a "power" and a political "force" too considerable to be neglected; it is a "protest" (Douglas) and a "means of thinking" (Tompkins).[9] Both see the task at hand as a readjustment of our notions of cultural history, a readjustment to be accomplished by reexamining this particular literary material and its effect upon its readers.

It bears recalling, however, that this shared vision of cultural history as being centered in literary history itself has roots in the Victorian era with the birth of the critical profession and that, however the critics evaluate the productions of domestic culture, their methodology inherently prioritizes a particular segment of white, middle-class, Christian, native-born readers and their texts as the chief source of information about the culture. For example, Douglas wrote of one Victorian novel, "This book, while focused on written sources, might be

described in one sense as a study of readers and of those who shared and shaped their taste."[10] Tompkins, who had earlier edited an important collection of essays on reader-response criticism, might easily have said the same. But what is meant by a reader? The readers she invokes in *Sensational Designs* are both "the widest possible audience" in the nineteenth century and "the critics of the twentieth century."[11] Douglas has in mind "American girls . . . socialized to immerse themselves in novels and letters."[12] What this emphasis on "readers" suggests is the presence of an historically determined agreement between Douglas and Tompkins that is more essential and more important even than their mutual choice of material or the joint perception of its moral urgency and social consequence: an agreement on how it is and to whom it is that reading matters; an agreement that instruction of the literate middle class is the chief object as well as the chief subject of domestic narrative; an agreement, even, on what it is that readers actually read. It seems evident that this agreement operates within the Douglas-Tompkins debate to focus, but also to circumscribe, the material that it can coordinate. The direct and indirect effect of the widespread reading of mid-nineteenth-century sentimental fiction upon those who were not either critics or white, middle-class, Christian, native-born readers is by and large left out. So is the idea that there was anything to read except words—like photographs, for instance. These omissions make for a kind of repressed margin even within a critical discourse whose impulse it always was to examine seriously the construction and function of the fringe.

Lest it seem that such an agreement bears only a general relation to the issues of domestic photography being examined in this book, I want to point out its material function in the coincidence of two anecdotes that both Tompkins and Douglas independently offer their readers, two strikingly intimate stories about reading *Uncle Tom's Cabin* that are in themselves attempts to represent—each in a fine, vivid, domestic style—the impact of this "power" and "force" on their own personal lives as readers. Without in any way softening the edge of the disagreement between the two critical positions, I would like to propose that the coincidence of these reflections on reading Stowe is important to this discussion of photography and sentimentalism beyond their decided narrative value and the generally helpful, concretizing effect they have on the clarity of the critical arguments. As specific representations of the scene of the incorporation of domestic fiction and its social effect, these anecdotes exemplify the homology of the two critics' assessments of how such fiction functions in the real world, in actual people's lives. They indicate both the range and the limitation of the debate on sentimental power as it has so far been staged. But they also imply that the debate needs to be expanded beyond writing into photography.

For her part, Ann Douglas asserted in *The Feminization of American Culture* that "today many Americans, intellectuals as well as less scholarly people, feel

a particular fondness for the artifacts, the literature, the mores of our Victorian past," adding that she wrote her book because she is "one of those people." She recalled, "As a child I read with formative intensity in a collection of Victorian sentimental fiction, a legacy from my grandmother's girlhood. Reading these stories, I first discovered the meaning of absorption: the pleasure and guilt of possessing a secret supply. I read through the 'Elsie Dinsmore' books, the 'Patty' books, and countless others; I followed the timid exploits of innumerable pale and pious heroines. But what I remember best, what was for me as for so many others, the archetypical and archetypically satisfying scene in this domestic genre, was the death of Little Eva in Harriet Beecher Stowe's novel, *Uncle Tom's Cabin*." Douglas amplified the confessional thrust of this memory:

> Little Eva is a creature not only of her author's imagination but of her reader's fantasy; her life stems from our acceptance of her and our involvement with her. But Little Eva is one of us in more special ways. Her admirers have always been able to identify with her even while they worship, or weep, at her shrine. She does not demand the respect we accord a competitor. She is not extraordinarily gifted, or at least she is young enough so that her talents have not had the chance to take on formidable proportions. If she is lovely looking and has a great deal of money, Stowe makes it amply clear that these attributes are more a sign than a cause of her success. Little Eva's death is not futile, but it is essentially decorative; and therein, perhaps, lay its charm for me and for others.

Finally, she felt forced to admit that her beloved Little Eva did not rest innocuously within the pages of an old fashioned book but reappeared as the figure "of Miss America, of 'Teen Angel,' of the ubiquitous, everyday, wonderful girl about whom thousands of popular songs and movies have been made." Thus, her "pleasure" in Little Eva was "historical and practical preparation for the equally indispensable and disquieting comforts of mass culture." Describing Little Eva's Christianity as "camp," which Douglas does one page earlier, was really a way to "socialize" her own "ongoing, unexplored embarrassment" at the strength of a persistent emotional attachment to such figures.[13]

In *Sensational Designs,* Jane Tompkins also referred to a scene from her younger days: "[O]nce, during a difficult period of my life, I lived in the basement of a house on Forest Street in Hartford, Connecticut, which had belonged to Isabella Beecher Hooker—Harriet Beecher Stowe's half-sister. This woman at one time in her life had believed that the millennium was at hand and that she was destined to be the leader of a new matriarchy." Tompkins's memory also quickly turned confessional, although for the opposite reason from that of Douglas. What Tompkins felt defensive about was not the length and durability of her connection to the writers of nineteenth-century domestic fiction, but the

overlong *absence* of that connection, prior to the entry of feminist criticism into the academy:

> When I lived in that basement, however, I knew nothing of Stowe, or of the Beechers, or of the utopian visions of nineteenth-century American women. I made a reverential visit to the Mark Twain house a few blocks away, took photographs of his study, and completely ignored Stowe's own house—also open to the public—which stood across the lawn. Why should I go? Neither I nor anyone I knew regarded Stowe as a serious writer. At the time, I was giving my first lecture course in the American Renaissance—concentrated exclusively on Hawthorne, Melville, Poe, Emerson, Thoreau, and Whitman—and although *Uncle Tom's Cabin* was written in exactly the same period, and although it is probably the most influential book ever written by an American, I would never have dreamed of including it on my reading list. To begin with, its very popularity would have militated against it; as everybody knew, the classics of American fiction were, with a few exceptions, all *succès d'estime*.[14]

Where Douglas betrayed her scholarship by responding to the women, Tompkins betrayed her womanhood by siding with the men.

Notable in both stories is the engaging particularity and lively individuality of the speakers. They respond to the literary and sociological problems raised by Harriet Beecher Stowe in the well trained, observant, mildly ironic, and self-confident voices that are characteristic of the educated American middle class. Personal anecdotes embedded within critical discourse are a form akin to gossip in the "function of intimacy" that Patricia Meyer Spacks has described.[15] This means that even the rhetorical register of the stories communicates how the social legacy of sentimentalism is something that may be explored in a private, personal space between middle-class readers and their books, which either do or do not incite them to ideas, actions, and loyalties of one sort or another. The problem of reading and responding to sentimentalism takes shape largely as an intimate matter, a question of the individual's training and sensitivity. It becomes, by extension, a question for us even of our own particular taste, rather than of our historical positioning. In these anecdotes, the theater of operations in which the act of reading is depicted as occurring and having its effect is limited to either private or professional life, as it is inflected by personal ambition. Alternative perceptions of the social action of literature—of different class orientations or other points of connection that map a differently organized social formation than the tightly knit circuit between the individual middle-class reader, the critical profession, the book, and the shifting vogue of the literary marketplace—are not illustrated or implied as examples of sentiment. In both cases it is as if the issue of the moral stimulation of sentimentalism raises questions for a literary

consciousness alone—more or less observant, more or less well educated, more or less discriminating.

But this picture neglects, and the Douglas-Tompkins debate as a whole has tended to elide, the expansive, imperial project of sentimentalism. In this aspect sentimentalization was an *externalized* aggression that was sadistic, not masochistic, in flavor. The energies it developed were intended as a tool for the control of others, not merely as an aid in the conquest of the self. This element of the enterprise was not oriented toward white middle-class readers and their fictional alter egos at all, either deluded and hypocritical or conscious and seriously committed "to an ethic of social love," as Nina Baym characterizes the theme of domestic fiction.[16] Rather, it aimed at the subjection of people of different classes and different races, who were compelled to play not the leading roles but the human scenery before which the melodrama of middle-class redemption could be enacted, for the enlightenment of an audience in which they were not even included. While sentimental pietism most certainly did "cripple" numerous ministers and lady writers, as Ann Douglas contends, and make them servants of their own oppression, it is arguable that it disabled other people far more.[17] If sentimentalism is, as Nina Baym defines it, a domestic ideal set forth "as a value scheme for ordering all of life, in competition with the ethos of money and exploitation that is perceived to prevail in American society," then those who did not have, could not get, or had been robbed of their "homes" would be, of necessity, nonparticipants in the pursuit of this ideal.[18] This fact would irredeemably dehumanize them in the eyes of those who came from "homes" and leave them open to self-hatred and pressure to alter their habits of living in order to present themselves as if they too might lay claim to a proper "domestic" lineage, in the way that the nineteenth century understood that genealogy. In *We Are Your Sisters: Black Women in the Nineteenth Century,* Dorothy Sterling writes of the insidious double bind this created:

> In the abolitionist movement, the black women who worked with whites were caught between two worlds. Only a generation or two removed from slavery themselves, hemmed in by the same discriminatory laws that poor blacks faced, they nevertheless strove to live up to the standards of their white associates. No one's curtains were as starched, gloves as white, or behavior as correct as black women's in the antislavery societies. Yet the pinch of poverty was almost always there. Light-skinned Susan Paul, an officer of the Boston Female Anti-Slavery Society and a welcome guest in white homes, did not tell her white friends of her desperate struggle to support her mother and four orphaned children until she was on the verge of eviction from her home.[19]

How can we begin to reclaim this territory? To start, it should be remarked that along with the democratization of literacy, the expanded market frame-

work, and the heightened interest in fiction that were characteristic of American mid-Victorian culture necessarily came the "unintended reader." By this term I mean readers who were *not* the ones the sentimental authors, the publishers, the critical spokesmen, or the nascent advertising industry had in mind. They were readers who read material not intended for their eyes and were affected by the print culture in ways that could not be anticipated; because of their "outsider status," such readers were ungovernable by the socioemotional codes being set forth within the community-making forces that literature set in motion.

Occasionally in the nineteenth century, although more commonly in the twentieth, unintended readers have left personal testimony about the effect that such a reading experience has had. One such unintended reader was the young Frederick Douglass, who described his chance encounter with a popular anthology called *The Columbian Orator,* in which he found "a dialogue between a master and his slave" and one of Sheridan's mighty speeches on and in behalf of Catholic emancipation"; Douglass called the encounter a piece of great good fortune, one that "gave tongue to interesting thoughts of my own soul, which had frequently flashed through my mind, and died away for want of utterance."[20] Another was Margaret Fuller, a voracious reader of masculine texts, whose classical education and intellectual appetite were carefully orchestrated by her father but contradicted the expectations or desires of her society. Adventurous readers like these, a slave and a woman, did not necessarily harbor a deluded faith in middle-class values. Literary eavesdropping could lead to stunningly vibrant political insights into the nature of class distinctions when the unintended reader compared his or her own life and even habits of reading to those of the reader who was intentionally being addressed. We can see from the syncopated experience of the unintended reader how the range of social practices surrounding the reading of sentimental fiction precipitated not merely class formation but class conflict. These experiences illustrate how any instrumental role that sentimental literature played in the formation of the new middle-class self-consciousness might have a no less forceful corollary in its disregard and disorganization of the people who were displaced by the ingathering of this new class formation, because it was against their humanity—out of the raw material of their right to information, self-esteem, and possible life choices—that this new identity was furnished and then maintained.

In addition, sentimental ideology continued to mature in power past mid-century, even while the sentimental literary mode itself—seen in the genres of poetry, short fiction, inspirational essays, journalism, and the domestic novel —was waning. The last quarter of the nineteenth century has generally been avoided in studies of literary sentimentalism, which conscientiously stop around the 1870s, when the production of such texts is perceived to have slowed. But if one excludes from the cultural work of domestic fiction the afterglow of senti-

mentalization, on the grounds that the literary genre had by then run its course, one distorts the history of its concrete social institutionalization in schools, hospitals, prisons, and the like, institutions whose building, staffing, and operation quite naturally had to lag behind the literary imagination. This foreshortened periodization is especially ironic given that increasing social and institutional productivity was the reason advanced in the first place for expending serious attention on the sentimental aesthetic. To begin to recover the submerged lineaments of the sentimental campaign, then, it seems that a more radical understanding of its extent and institutional permanence must be sought.

Thirdly, the evidence for these wider effects of sentimental fiction often lies outside of the purely literary realm, and even outside of the material world of the middle-class sentimental reader, as it has been defined and investigated by literary historians. There is a rich and largely untapped source of such evidence in visual form—in the many photographs of blacks, Indians, and immigrants enrolled in or directly affected by those institutions and in other material, collective manifestations of sentimental power that were made during this period. These photographs have come down to us sometimes with documentary testimony attached, sometimes with literary referents, sometimes without. Together with ethnic (as distinct from simply regional) writing, which began in earnest during this period, these images make it possible literally to envision the scene of the imposition of sentimental modalities on people who were in no sense the intended beneficiaries of domestic fiction but who were nonetheless as powerfully directed by its dictates as its most highly preferred audience.

What I am suggesting, then, is the usefulness of elaborating the debate on the consequence of nineteenth-century sentimental fiction even beyond the extended borders that only recently, in the aftermath of the Douglas-Tompkins exchange, have come to seem both appropriately strenuous and natural to the subject at hand. To map the power in the hands of nineteenth-century, white, middle-class domestic women and their retinue, it is helpful not only to develop new theories of language, and a fresh sense of the sociology of literature, but to leave writing itself temporarily, if strategically, behind.

It is demonstrable that the progressive educational reform movements aimed at blacks, Native Americans, and immigrants in the late nineteenth century built lavishly on the kind of social disparagement sketched out in the previous chapter, while attempting to elicit a concession of the universal superiority of the middle-class white Christian "home" that erased the history and often the recent defeat of those groups' own traditional modes of living. In "Sparing the Rod: Discipline and Fiction in Antebellum America," Richard Brodhead has traced that complicated interfiliation of sentimental values and educational policy at midcentury. What he terms "disciplinary intimacy" is a dense cross-wiring of "bodily correction . . . the history of home and school . . . and the

field of literature," which develops in the writings of Horace Bushnell, Catherine Beecher, Mary Peabody Mann, Lyman Cobb, Lydia Sigourney, Catherine Sedgwick, Lydia Maria Child, Horace Mann, and Harriet Beecher Stowe. This set of texts sets forth an argument for the replacement of corporeal discipline of children at school and at home by an internalized model of loving, middle-class parental authority, which the child would be loathe to disobey. We may think of the novel and of disciplinary intimacy together, Brodhead writes, "as being taken up inside a certain formation of family life in the early nineteenth century, [as] . . . being placed as another of those adjacent institutions (like the public school) that the middle-class family recruited in support of its home-centered functions." "Sparing the Rod" significantly enlarges the parameters of the debate on sentimentality by recognizing the ways in which the ideology of domesticity infiltrated precisely those public institutions that are gatekeepers of social existence. But Brodhead is principally interested in pointing out how this "theory of discipline through love had its force" through the medium of novels in the establishment of the middle class, rather than the disestablishment of others. In Brodhead's analysis, what this literature did was to supply "an emerging group with a plan of individual nurture and social structure that it could believe in and use to justify its ways." He adds that it "helped shape and empower the actual institutions through which that group could impress its ways on others," but this is not the history he chiefly studies. Although he recognizes its aggressive potential, Brodhead focuses on the majority: "At a time when it was in no sense socially normal the new middle-class world undertook to propagate itself as American 'normality'; and it is as a constituent in this new creation of the normative that the complex I have traced had its full historical life."[21]

We need therefore to further investigate how the fierce devaluation of the extra-domestic life, implicit within the terms of this monitory framework, was just as productive as the cult of domesticity in creating social norms, except in another way. In his elegant *Hard Facts: Setting and Form in the American Novel*, Philip Fisher has shown that "sentimentality was a crucial tactic of politically radical representation," in that it "experiments with the extension of full and complete humanity to classes of figures from whom it has been socially withheld." Pointing out that "the typical objects of sentimental compassion are the prisoner, the madman, the child, the very old, the animal, and the slave," Fisher argues that this extension of humanity is "experimental, even dangerous," writing, convincingly, from the perspective once again of the white, middle-class critic. But mustn't we ask, radical and dangerous for whom? The prisoner, the madman, the child, the very old, the animal, and the slave already have selves that are poised over the social void. Self-recognition is not dangerous for them; to themselves, they are not *novel* objects of feeling, as Fisher puts it, but *customary* objects of feeling. The extension toward them by others of newly perceived

"normal states of primary feeling" can only make for bewilderment, since this primary feeling is their normal state, though its style will not necessarily match up with the new offering.[22] The conclusion must be that the full and complete extension of "humanity," which facilitates sentimental politics, is dangerous for the sentimental reader. In addition, one must conclude that it is the sentimental reader who is dangerous for his or her "novel" object, precisely *because* he or she newly discovers in that object the possibility of a primary relation to a self that has been there all along but which must then be denied its history so that the discovery can be made. Furthermore, any meaningful enlargement by sentimentality of the percentage of the population who can come "inside" this magic circle still leaves behind the vast numbers who cannot qualify for entry under moral standards determined by arbiters who remain in power. Sentimentalism encourages a large-scale, imaginative depersonalization of those outside its complex specifications at the same time as it elaborately personalizes, magnifies, and flatters those who can accommodate to its image of an interior.

In the nineteenth century this construct did social work. It supplied the rationale for raw intolerance to be packaged as education. Without the background of the several decades of domestic "sentiment" that established the private home as the apotheosis of nurture, even within the context of slavery, the nineteenth-century interracial boarding school probably could not have existed, since it took as its mission the inculcation of domesticity in former "savages" and slaves. It is furthermore a matter of record that in at least some of these schools the Native American and black children who were the students received domestic training not as the future householders and sentimental parents they were ostensibly supposed to become but as future domestic servants (for instance, as nursemaids) in the homes of others. Such a vast institutionalized pandering to white, middle-class, domestic labor requirements obviously extends far beyond whatever hypocrisy or naïveté may have been adopted by the individual, middle-class, feminized literary imagination, working intimately on perfecting its own image. It may be useful to speak in this connection of sentimental fiction not only as a literary genre but also as a generic cultural category on its own—that is, as *the* sentimental fiction. This term would designate the alliance of the double-edged, double-jeopardy nature of sentimental perception with the social control of marginal domestic populations. The sentimental fiction, then, would be the myth that the avowed reform goals—widespread instruction in domesticity and vigorous pursuit of social reform based explicitly and insistently on affective values—were ever really intended to restore the vitality of the peoples that domestic expansion had originally appropriated.

By the turn of the century, the mutually enabling partnership sketched out in the antebellum era—between sentimental household discipline on the one hand and educational and rehabilitative theory on the other—could be taken

for granted. Moreover, this partnership was finding an unexpectedly effective adjunct in new, state-of-the-art techniques of public visual displays, techniques whose verisimilitude outstripped even the persuasive capacities of "sensational" fiction, as Jane Tompkins terms it. Especially important in terms of public instruction were the related uses of the living diorama and the documentary photographic display. Since the mid-1880s these exhibitionary practices had evolved from earlier, simpler forms into veritable mass market media. They entailed prodigious feats of technological and social engineering. Native Americans, for instance, whose subjection to genocide during the nineteenth century paved the way for the fin de siècle "revival" of their traditions, were recruited at that time to convene a spectacular simulacrum of Plains culture known as Buffalo Bill Cody's Wild West. The show toured this country and Europe, regaling millions with what was billed as an educational message about the noble defeat of the Indian way of life, a production that rivaled any sentimental fiction for either righteous passion or bad faith. Filipino peasants, whose status as objects of exchange between U.S. and Spanish imperial forces in 1898 obliterated their own recent attempt at self-determination and overrode any vision of their suffering in American eyes, were sanctimoniously imbued with an aura of domestic exoticism. This treatment climaxed when authorities set up a 47-acre reservation at the St. Louis Exposition of 1904, populated by nearly 1,200 temporarily imported tribal and urban Filipinos, in an effort "to illustrate to the American public the islands' rich natural resources and many native types, who had reached varying stages of 'civilization'" and were ripe for American supervision.[23] Images of eastern European and Asian immigrants living in the tenements of New York and other major cities, whose "crime and misery" were the subjects of "humorous or adventuresome anecdotes" presented in slide lantern shows, were exhibited to genteel native-born audiences in simulated educational "tours" of the slums led by the photographer Jacob Riis. Riis conducted such tours for the purpose of recalling the duty of domestic instruction and settlement house "reform" to the "benevolent, propertied middle class" of landlords, who needed to be reached (although Riis did not say this in so many words) before the immigrants themselves rose up and destroyed both the opportunity and the property.[24] In all these spectacles, consciousness of the social and historical reciprocity of those who see and those who are seen was effaced. It was the averted gaze of sentimentality that produced the means of deflection.

Two photographs, both made in the 1880s at the Hampton Normal and Agricultural Institute in Hampton, Virginia, by an unknown photographer, will begin to illustrate this point. The Hampton Institute, an agricultural and mechanical trade school as well as a teacher's training school, was founded in 1868 by the American Missionary Association and northern Quaker philanthropists. It was

headed throughout much of the nineteenth century by the charismatic General Samuel Chapman Armstrong, the white former commander of the Eighth and Ninth Regiments of U.S. Colored Troops during the Civil War. Armstrong had a specific vision for the education of the freedmen: the Hampton curriculum under his control was to emphasize the trade over the academic curriculum, despite the fact that spokesmen like William Roscoe Davis, a leading black citizen of the town, had called it the "height of foolishness" to teach a people who had been slaves all their lives how to work.[25]

Originally charged only to serve the former slave population, by 1878 Hampton also regularly admitted Native American students, in keeping with the rising enthusiasm throughout the country for enforced assimilation of that part of the Native population who had failed to vanish. As historian Robert Francis Engs recounts, Armstrong intended to teach blacks and Native Americans "how to educate their own race," to "provide them with Christian values, and to equip them with agricultural and mechanical skills by which they could support themselves during the months when school was not in session." Armstrong's plan included the proviso that students were to "abjure politics and concentrate on uplifting their race through hard work, thrift, and the acquisition of property."[26] The school was supported by private northern philanthropy as well as by government funding, and it enjoyed liberal Quaker support, including that of the famous abolitionist poet John Greenleaf Whittier, in whose consideration, reportedly, the Hampton militia unit was forbidden to drill with real rifles. Hampton opened its doors in 1868 with two white teachers and fifteen black male and female students, but by the end of the century it had grown to almost 1,000 students, 135 of them Native American, with about 100 faculty and administrative personnel. Despite its obvious constrictions and condescensions, Hampton benefited the black community in a number of ways and was very successful in the goal of equipping and certifying large numbers of southern blacks to educate former slaves in literacy and basic occupational skills. By 1880, over 10,000 black children in the South were being taught in schools staffed by Hampton graduates; in fact, more than 90 percent of Hampton's black graduates went on from Hampton to teach school.[27]

A much smaller number of Native Americans graduated with similarly usable credentials, since they returned home to reservations where teaching opportunities for Native Americans were scarce and brief. The Bureau of Indian Affairs' provision for schools was even more erratic than that of communities in the rural South. Native American Hampton graduates often were not employed in the field for which they had trained. Nevertheless, the Hampton administration, the trustees, and the U.S. government considered Hampton's Native American training program a success precisely because of its program of indoctrination in the white, middle-class, Christian domestic lifestyle. Apparently it was con-

sidered a patriotic service just to intervene between a Native American and the values and traditions of his or her tribe.

Armstrong's paternalistic approach to the school, his disciplinary policy, and his educational vision fit exactly the requirements of the new middle-class pedagogy described by Brodhead. In *Freedom's First Generation: Black Hampton, Virginia, 1861–1890,* Engs recounts how, according to the catalogue,

> the Hampton student's life was programmed from "rising bell" at 5:15 A.M. to "lights out" at 9:30 P.M. They attended chapel twice daily. Male students were organized into a cadet corps. Uniforms were required of all male students, which was a boon to most of them as they could not afford other decent clothing. The corps marched to classes and meals: inspection of each student and his room was performed daily. Women students were not as regimented, but were as closely supervised by their teachers and dormitory matrons. The girls were taught to cook and sew, to set a proper table, to acquire all the graces that would make a good housewife—or housekeeper. Habits of neatness and cleanliness, never required of many slaves, were insisted upon for both sexes.[28]

General Armstrong himself taught a course in moral philosophy, presented in a series of "Talks" after Sunday evening chapel, which emphasized the "practical conduct of life." He even supported coeducation because he believed the "home aspect" of the school to be its most important function, since "those on whom equally depends the future of their people must be given an equal chance," and noted that "the interest in schools like this is that the teacher has a far more decisive formative work to do than among more advanced races."[29] Engs concludes that the Hampton Institute was intended to be

> a "little world" in which all the proper attitudes of morality, diligence, thrift and responsibility were to be assiduously cultivated. . . . Among the factors which made Hampton unique was the school's intensive program to indoctrinate its students in the proper way of life. The teachers at Hampton were educated, middle-class Northerners; naturally their concept of the "proper way of life" was the way that they lived themselves. Thus, they stressed to their pupils the need to acquire middle-class styles of behavior, perhaps more intently than they emphasized middle-class goals and aspirations.[30]

Armstrong's own formulation of what was needed was a "tender, judicious and patient, yet vigorous educational system" for black men and women. "The darky," as Armstrong habitually referred to his students, needed an experience of "tender violence" to "rouse him" from the passivity of his race. The program for Native Americans seems to have been oriented no differently.[31]

Two photographs made by an anonymous photographer sometime in the

3.1. *On arrival at Hampton, Virginia*

1880s were intended to advertise that capacity to intervene, and they were no doubt used for publicity and fundraising purposes. They follow the common formula of the paired "before and after" shots, which had been a staple of Victorian charitable and educational institutions at least since Dr. Thomas John Barnardo experimented with similar sets of photographs of the street urchins taken into his Home for Destitute Lads in Stepney Causeway, England, in the 1870s. The formula itself is as old as fairy tales, if newly applied to photography, where the "happily ever after" ending serves, in Marina Warner's words, "the moral purpose of the tale, which is precisely to teach where the boundaries lie."[32] "Before and after" institutional images show very clearly the exact dimensions of the change that the students are to demonstrate. They mark the line between nothing less and nothing more.

The first photograph is entitled "On arrival at Hampton, Va.: Carrie Anderson—12 yrs., Annie Dawson 10 yrs., and Sarah Walker—13 yrs." The second is entitled "Fourteen months after." In the first image, three little girls huddle close together. They sit on a bare tile floor and lean against a wall, keeping their plaid blankets gathered closely about them. Carrie Anderson, Annie Dawson, and Sarah Walker are Native American children who had just arrived at Hampton from out West for a term of education that, given the then current thinking of the Bureau of Indian Affairs, was likely to last for several years without respite or visits home. "The policy of the Bureau of Indian Affairs [was] that Indian chil-

dren would more rapidly assimilate into American society if they were kept away from the reservation for long periods of time," writes Dexter Fisher, a Native American historian and literary critic.[33] At this point the children probably did not yet know how long they were likely to be separated from their families and the customs with which they were familiar, but they look glum and fairly suspicious, if not exactly frightened of their new environment. It is quite possible that they were not able to understand a single word of English. The smile had not yet appeared in American popular culture as a necessary facial arrangement for getting one's photograph made, but the deep, downward turn of the three small mouths is quite pronounced even in comparison to the stoic expressions commonly elicited in contemporary portraits of members of all races.

The photograph is exceptional in the individuality and distinct personality it suggests for each girl. On the left, Carrie Anderson, the smallest though not the youngest, wears her blanket like a Victorian shawl; a certain angle of the head and glimmer of the eye might portend a less defensive interest in what is happening to her than the others indicate. In the center, Annie Dawson, the youngest and tallest, has the long straight limbs of the strong, free Native American girls made famous by sentimental poets like Longfellow. Her wide eyes stare directly at the camera; her moccasined feet are held to the front, which gives her a fight/flight capability. Of the three, she seems the readiest to be openly confrontational, but she is clearly puzzled. Sarah Walker presents herself the least like a little white girl. If she retained this aspect in person, it almost certainly would have distanced her from her racialist white supervisors, guaranteeing an extra

measure both of loneliness and of privacy. All three girls have the long plaited hair that more than anything else emblematized their social condition.

In the "after" photograph much has changed and much has remained the same. The challenge is to figure out what has done which, and why. It is the same floor, for instance, and the same wall, but now the children sit, like "civilized" beings, on chairs, around a table that holds a game of checkers. Or, rather, Annie Dawson and Carrie Anderson sit. Sarah Walker is displayed standing behind the table, one hand on the back of Annie's seat and one shoulder of her white pinafore slipping down over the other arm. It is obvious that all three have been carefully posed. The spontaneous and revealing postures of the first image are long gone; they have been overridden by the imperative to dress up the Indian children in white children's outfits, place their hands upon white children's games, set their limbs at white children's customary angles. A decidedly informative balance has been achieved between the awkward symmetry of the seated figures, the rigid, standing girl, and the doll tossed into the crook of the miniature chair. The picture fairly shouts that in the most crucial respects the Native American children are just like the white doll: they are malleable to one's desires. Dressed in tightly fitting Victorian dresses with lace collars, lacking their blankets, wearing leather boots in lieu of their old soft moccasins, and, perhaps most importantly, having had their braids cut off and their hair arranged to flow freely down their backs like a Sir Arthur Tenniel illustration for *Alice in Wonderland,* Carrie Anderson and Sarah Walker replicate exactly the ideal image of Victorian girlhood. The only contradiction is the darkness of their skin, which one might easily pretend could have come from the underexposure of the photographic plate. Annie Dawson has somehow managed to retain a braid, but except for this she is similarly transformed.

Annie, Carrie, and Sarah seem to simultaneously collaborate with all of this and resist. The hands go where they are told, but the shoulders, heads, and eyes refuse the pantomime. The book lies on Carrie's lap like a stone, or like the handwork that Huck Finn didn't know what to do with when he was masquerading as a girl in Illinois. Her left hand lies across her lap, not even touching the pages that might close were she not holding the book in a valley of her skirt, a valley she makes by awkwardly opening up her legs. Absurdly, her right hand pretends all the while to be playing checkers. Only Annie Dawson looks at all like she could be considering the checkers game with comprehension and some authentic interest in its strategy. By a remarkable coincidence, some twenty-odd years after these photographs were taken, the Hampton newspaper *The Southern Workman* reported that Annie Dawson was "a leader upon the reservations and in the schools," identifying her as "Anna Dawson Wilde, an Arickaree, field matron at Fort Berthold, whose work among the Indian women has made for their progress in wholesome living."[34] The long-legged, ten-year-old girl in the

blanket, balanced on a hair trigger between resistance and restraint, turned out to be able to play the game and make the system work for herself, when many others failed.

The second photograph was taken fourteen months after the first. In fact, the school authorities were so proud of this fact that it alone was given as the title of the image—"Fourteen months after." No longer are the children named nor is any information transcribed about their lives, as it had been upon their entry into the school. The important point now is only that they have successfully completed a process: they are the picture of "after." Fourteen months is a very brief time to make a change of the magnitude of this pantomimed journey from indigenous to industrial life, and it is of this speed as well as of thoroughness that the school is boasting in the photograph and its caption. Whereas many believed that the "Red Man" was simply incapable of making the change to "civilized life," Hampton was able to raise a great deal of money on the more enlightened premise that not only did it know how to bring this change about, but it knew how to do so quickly. It is of great importance that the symbols of this change are without exception also the chief symbols of nineteenth-century, middle-class, white children's lives—hair, dress, doll, game, and book. The Indian girls are being reconstituted not just as imitation white girls but as white girls of a particular kind. They are being imprinted with the class and gender construction of the future sentimental reader. Given this, it is probably the book that is the most crucial symbol of enforced acculturation in the photograph. Ann Douglas reports that

> numerous observers remarked on the fact that countless young Victorian women spent much of their middle-class girlhoods prostrate on chaise lounges with their heads buried in "worthless" novels. Their grandmothers, the critics insinuated, had spent their time studying the Bible and performing useful household chores.
>
> "Reading" in its new form was many things, among them it was an occupation for the unemployed, narcissistic self-education for those excluded from the harsh school of practical competition. Literary men of the cloth and middle-class women writers of the Victorian period knew from firsthand evidence that literature was functioning more and more as a form of leisure, a complicated mass dream-life in the busiest, most wide-awake society in the world. They could not be altogether ignorant that literature was revealing and supporting a special class, a class defined less by what its members produced than by what they consumed.[35]

By teaching reading to Native Americans, intimates the photograph, institutions like Hampton would be able to accomplish what the entire U.S. Cavalry had tried and failed to do: to persuade the western tribes to abandon their com-

munal, nomadic way of life; adopt the prizes, mores, and values of consumer culture; and turn their little girls into desirable women on the middle-class commodity plan. Girls should read, wrote Lydia Maria Child, because a love of reading was "an unmistakable blessing for the American female." She explained ominously, if honestly: "[reading] cheers so many hours of illness and seclusion; it gives the mind something to interest itself about."[36] Now Hampton was offering Carrie Anderson, Annie Dawson, and Sarah Walker equal opportunity.

The real travesty pictured here, however, is not truly the game of dress up, no matter how intense a matter it became for the girls and the school. Nor is it even the fear and the regimentation of the body, which are so painful to behold. For Annie, Carrie, and Sarah were at Hampton in the 1880s because, for a complex set of reasons, they wanted to get a white education; they apparently wanted or needed to be able to function in the white world. The ambivalence they radiate is exactly that—ambivalence, not necessarily rejection of what Hampton had to offer. Most of all, they needed to be able to read. Reading was an absolute prerequisite both for protecting themselves and their families from the legal swindles that enmeshed the western tribes and, maybe even more urgently, for gaining entry as socially recognizable beings in the new world they now had to face. Thus, the book that is placed on Carrie's lap is not simply a public relations device depicting the job the school could do. It is not even purely a logo of the respectable veneer that the school was committed to convey. In its most important aspect, that book is a promise to the girls themselves that what they have come so far for and suffered so much to get will, with hard work, be theirs. Yet here is where the photograph lies. Fourteen months is not long enough for an illiterate, unintended reader to even begin to read such a book, much less manipulate the many cultural codes it embodies. And chances were that a lifetime of reading would not have been long enough to transform the social chances of a Native American in white society in the late nineteenth century. There is nothing casual about the fact of the book's being placed in the lap of the little girl. Neither is there anything casual in her perplexity about what to do with it. On one side the callousness, on the other side the need, is beyond measure.

Despite the fact that in 1888 it underwent, and survived, a major federal investigation on charges that its treatment of Indian students was inadequate and inhumane, the Hampton Institute was not the only nor even the most authoritarian of the nineteenth-century Indian boarding schools. Hampton was distinguished by being an interracial institution; indeed, it was one of the country's earliest large-scale experiments in interracial education. This in turn gave it a distinct atmosphere. The multiethnic composition of the student body made for the presence of a vocal, internally generated critique. In general, the black students were eager and willing to demonstrate the degree to which they could cleave to Victorian social standards and leave the imprint of their recent past

behind, while the Indian students showed a greater reluctance to forsake traditional patterns. In practice, this meant that black and Indian students were educated together in a program that made little distinction between the differing desires and abilities of each group, and Hampton had a continual struggle to maintain an equilibrium between them.

The Carlisle Indian Industrial Training School in Carlisle, Pennsylvania, founded in 1879 on the Hampton model by Richard Henry Pratt, a longtime friend and former army associate of General Armstrong, is perhaps the most famous of the other schools, although there were many more, both in the east and in the west, that adhered to the policy of enforced acculturation with an equal if not greater exactitude. Carlisle was a flagship school for Bureau of Indian Affairs policy; like Hampton, it was well funded, well attended, and closely supervised. But it did not have an explicit interracial factor except, of course, between its students and its faculty; the substance of differences between students of different Native American nations did not reach the same level of official concern as did that between Native Americans and blacks. "Indians from more than seventy tribes have been brought together and come to live in utmost harmony, although many of them were hereditary enemies," blithely stated the 1902 catalogue. "Just as they have become one with each other through association in the School, so by going out to live among them they have become one with the white race, and thus ended the differences and solved their own problems."[37] Carlisle historian Lonna M. Malmsheimer has pointed out the human implications of such an ideology:

> It involved first of all an education in white racial consciousness: the children of culturally diverse tribes had to learn that they were Indians, the very same kind of people as their "hereditary enemies." Concurrently they learned that by white standards they were an inferior race, which led in turn to the cultivation of race pride to spur competition with whites. One of Pratt's most important reasons for the development of Carlisle's famous athletic program was to prove that Indians were not inferior. Finally, they learned that the ideal white man's Indian would "become one with the white race . . . solving their own individual problems." That such problems may have required Indians to become far more individualistic than any of their middle-class white contemporaries never seems to have occurred to Pratt.[38]

The other schools usually enjoyed fewer material resources and a lower level of visibility, and they evinced more circumscribed pedagogical goals tailored to their more local identities. Nevertheless, it would be a mistake to imagine that comparative shelter from the spotlight in Washington resulted in an ethos substantially different from that of the leaders. Rather, smaller and relatively more homogeneous student populations probably provided less of an opportunity to

stage or imagine the politics of difference. In all, the numerous Indian schools across the country (Pratt had recommended 500, but there were fewer than that) accounted for a major strain in the orchestration of late Victorian, Anglo-Saxon racialist theory and domestic virtues into a truly national hegemony. Hundreds of easterners took jobs as teachers and administrators in the system; thousands of Indians from the western tribes, including the families of the children if and when they returned home, were exposed to their teachings; and millions of taxpayers and private donors applauded the results.

A series of remarkable autobiographical essays and stories published between 1900 and 1902 by Gertrude Bonnin, a Yankton Sioux whose native name was Zitkala-Sa, or Redbird, shows the degree to which a provincial school, White's Manual Institute in Wabash, Indiana, enforced the same, or even a greater, conformity to white sentimental domestic culture, despite its distance from major white social centers. It is essays and stories like hers, taken along with the hundreds of available photographs, that help to make plain the scope of the cultural reorganization and consolidation then underway. Lacking such supplements, it is difficult for a contemporary reader of nineteenth-century fiction to grasp how vast was the interlocking chain of sentimental influence in the late nineteenth century and to appreciate how hard people were trying on many fronts to name its multiple functions. For her part, Zitkala-Sa's stories cover so exactly the kind of situation dramatized in the before-and-after photographs at Hampton that they seem almost uncannily to be the stories of Carrie, Annie, and Sarah themselves, revealing what the captions hide about what they have just gone through. Hers is an authentic voice of Indian history, but it is narrated in a distinctly gendered, individualistic, emotionally luxuriant, and acculturated idiom, one more reminiscent of Ellen Montgomery in Susan Warner's *The Wide, Wide World* than of the great, terse speeches made by the defeated Indian chiefs of the era, such as Chief Joseph.

Zitkala-Sa was one of the first Native Americans to begin to write down their personal narratives as well as to record some of the oral tradition of their tribes, in an attempt to preserve their history and what remained of their culture. "By the end of the nineteenth century," writes Dexter Fisher, "a written literature based on tribal oral traditions was beginning to emerge that would reach fruition in the 1960's and 1970's in the works of contemporary American Indians."[39] If so, it is probably some kind of unutterably triumphant index of the absolute penetration of the middle-class culture disseminated by these schools and represented by the genteel tradition in American letters that these very early writings by a Native American were suitable to be—and were—published in *Harper's* and the *Atlantic Monthly*.

When children arrived at an Indian school after the long train ride east from

the reservation, the local newspapers were apt to report the event in terms like these from an 1879 article in the *(Carlisle, Pa.) Valley Sentinel:*

> About twelve o'clock on Sunday night Captain Pratt arrived at the junction with eighty-six, Sioux children . . . varying in age from ten to seventeen. Their dress was curious, made of different cheap material and representing all the shades and colors. Cheap jewelry was worn by the girls. Their moccasins are covered with fancy bead work. They carry heavy blankets and shawls with them and their appearance would not suggest that their toilet was a matter of care. Some of them were very pretty while others are extremely homely. All possessing the large black eye, the beautiful pearl white teeth, the high cheek bone, straight-cut mouth and peculiar nose. The school is made up of 63 boys and 23 girls. The reason that there were more boys than girls is that the girls command a ready sale in their tribes at all times, while no value is attached to the boys. About 3000 savages assembled at the agency the night previous to the departure of the party and kept up a constant howling throughout the night. On the cars and here they have been very orderly and quiet. . . . The majority of the party are made up of the sons and daughters of chiefs. . . . The boys will be uniformed in gray material similar to that worn by the two Indians and instructors who have been here for some time. The girls will wear soft woolen dresses.[40]

This particularly bizarre combination of society page, fashion reportage, and outright racist fantasy can only be accounted for as an amalgamation of semiotic traditions plundered from the women's sections of the newspapers and the periodical press. The writer, strained beyond original expression by the idea as well as the appearance of the children, has resorted, as if by some lucky instinct, to the very traditions of sentimental domestic representation that are about to play such a major political role in the children's actual lives. But of course, the conjunction of these terms is not arbitrary. Rather, this initial representation marks the exact social space into which the children are going to have to learn to fit. It bears only one major difference from the social space of sentimental characters: when children are torn from their parents in domestic fictions, from Charles Dickens to Kate Wiggin, it is the occasion of nearly unbearable grief; but here the same grief is not unbearable—it is literally *unhearable,* as in the "constant howling" of "3000 savages."

At this point, also, a photographer would make a "before" picture, such as the one we have examined. These pictures, and their corresponding "after" shots, were collected to be sent to recruiting agents, benefactors and potential benefactors, political figures, and federal bureaucrats; they were also sold as part of stereographic slide collections used for popular and family entertainment. Once,

from Carlisle, an especially vivid set of three pairs was sent "as a complimentary gift to each contributor who donated enough money to 'pay for one brick,' in a new dormitory at the school."[41] The pictures were also sometimes sent to the children's parents back home in an attempt to allay their anxiety. However, like slave photographs and photographs of black "nursemaids, they were unlikely to accomplish this last purpose.

In her autobiographical story "Impressions of an Indian Childhood," Zitkala-Sa vividly represents the deep pain of parting that she and her mother felt when she left the reservation with the recruiting agents of White's Manual Institute. She was eight years old; the missionaries promised her "all the red apples she wanted" and "a ride on the iron horse." Prior to their appearance, she recalls, she and her mother had lived a closely united although far from simple life. Their straightforward daily routines of cooking, fetching water, sewing bead-work, watching the plants and animals around them, telling and retelling the old stories, sporting, and ministering to their neighbors were punctuated by moments of memory so terrible for the mother that they must never be spoken of: she tells the child, "My little daughter must never talk about my tears." Years earlier, during an enforced removal of the tribe to a remoter location, Zitkala-Sa's little sister and uncle had died, a direct casualty of the relocation and a constant personal reminder of the cruelty of "the paleface." Her mother had not ceased to mourn, nor was she able to feel secure in the place where they had since made their home. Zitkala-Sa's lighthearted predictions about the future were sometimes answered by her mother's worried proviso, "if the paleface does not take away from us the river we drink."[42]

Nevertheless, her life within and without the tipi was full of pleasant moments and a special kind of linguistic tenderness between mother and daughter that epitomizes within the stories the broad differences in child rearing practices between the Native American tribe and the conquering white culture. Zitkala-Sa reports many incidents that convey the extraordinary forbearance and gentleness of her mother's customary use of words. To use the terms that Margaret Homans has illuminated in *Bearing the Word*, Zitkala-Sa portrays herself and her mother as inhabiting a virtually limitless domain of literal, pre-oedipal, prefigural speech: "At this age I knew but one language, and that was my mother's native tongue." Other members of the tribe reinforced this rich, essentially linguistic security; the old ones called her "my little grandchild" and "little granddaughter." She recalled the physical refuge her aunt provided her too: "[She] dried my tears and held me in her lap, when my mother had reproved me." Even the pace of speech was slow enough for many tones and the implications of many kinds of silence to be heard, as people measured their requests and waited patiently for replies. The most important social rule that the child was taught was

not to impose herself upon others, but to "sense the atmosphere" into which she entered. " 'Wait a minute before you invite anyone,' " her mother would caution her. " 'If other plans are being discussed, do not interfere, but go elsewhere.' "[43]

With their figure of the apples, the missionaries spoilt this paradise and came between the mother and the child. Zitkala-Sa wanted to go with all her friends to the "wonderful Eastern land" that she had not seen, to the place of knowledge that forfeited this garden in which she had been raised: "This was the first time I had ever been so unwilling to give up my own desire that I refused to hearken to my mother's voice." Yet even still, the mother was required to give her consent, and she eventually did so, apparently with all the foreknowledge that the child herself was unable to command: "Yes, my daughter, though she does not understand what it all means, is anxious to go. She will need an education when she is grown, for then there will be fewer real Dakotas, and many more palefaces. This tearing her away, so young, from her mother is necessary, if I would have her an educated woman. . . . But I know my daughter must suffer keenly in this experiment."[44]

Without such thoughts, the child prepared for the parting: "I walked with my mother to the carriage that was soon to take us to the iron horse. I was happy. I met my playmates, who were also wearing their best thick blankets. We showed one another our new beaded moccasins, and the width of the belts that girdled our new dresses." The mother's state of mind as the carriage departs is not directly represented, but that does not mean that it is simplified or slighted. Instead, too distressed to find words, the silent child mirrors the magnitude of the loss in miniature. The little girl recalls, "[When I] saw the lonely figure of my mother vanish in the distance, a sense of regret settled heavily upon me." She continues,

> I felt suddenly weak, as if I might fall limp to the ground. I was in the hands of strangers whom my mother did not fully trust. I no longer felt free to be myself, or to voice my own feelings. The tears trickled down my cheeks, and I buried my face in my blanket. Now the first step, parting me from my mother, was taken, and all my belated tears availed nothing. . . . We stopped before a massive brick building. I looked at it in amazement, and with a vague misgiving for in our village I had never seen so large a house. Trembling with fear and distrust of the palefaces, my teeth chattering from the chilly ride, I crept noiselessly in my soft moccasins along the narrow hall, keeping very close to the bare wall. I was as frightened and bewildered as the captured young of a wild creature.[45]

But she wasn't, of course, the young of a wild creature; she was simply a small child who was being treated like an animal. In as much as this account is mythic,

it is the self-congratulatory myth that modern western culture has been telling itself about language since its inception: that educated speech begins when the bond with the mother is broken. With reason, then, after this "first step," the narrative turns entirely to Zitkala-Sa's accommodation to school. As a sentimental writer, she has learned her literary lessons well. On the other hand, this is not merely myth but heartbreak, barely achieving years later the delineation of speech. The "howling" of 3,000 "savages" on another of these occasions is yet another rendition of the same intention: to pursue the semiotic of physical closeness and mental connection even into where the law of the great white father has made its terrible cut. It was the destiny of Zitkala-Sa as a real-live, nineteenth-century Native American child to play out this constitutive Wordsworthian drama in the most literal of ways. It would be three years before she saw her mother and her home again.

On the train, as she recalls in "The School Days of an Indian Girl," further violation followed, this time not only of verbal but also of visual space, a graphic example of the power of the white woman's eye which looked at but did not see humanity:

> Fair women, with tottering babies on each arm, stopped their haste and scrutinized the children of absent mothers. Large men, with heavy bundles in their hands, halted near by, and riveted their glassy blue eyes upon us. I sank deep into the corner of my seat, for I resented being watched. Directly in front of me, children who were no larger than I hung themselves upon the backs of their seats, with their bold white faces toward me. Sometimes they took their forefingers out of their mouths and pointed at my moccasined feet. Their mothers, instead of reproving such rude curiosity, looked closely at me, and attracted their children's further notice to my blanket. This embarrassed me, and kept me constantly on the verge of tears.

But by far the worst moments had to do with sound, so different from her quiet mother's world. She recalls her arrival at the school: "The strong glaring light in the large whitewashed room dazzled my eyes. The noisy hurrying of hard shoes upon a bare wooden floor increased the whirring in my ears. My only safety seemed to be in keeping next to the wall." Just at this point, the regime of sentiment made its dreadful entrance:

> As I was wondering in which direction to escape from all this confusion, two warm hands grasped me firmly, and in the same moment I was tossed high in midair. A rosy-cheeked paleface woman caught me in her arms. I was both frightened and insulted by such trifling. I stared into her eyes, wishing her to let me stand on my own feet, but she jumped me up and down with

increasing enthusiasm. My mother had never made a plaything of her wee daughter. Remembering this I began to cry aloud.

Zitkala-Sa, doubtless an exceptionally pretty girl by Anglo-Saxon standards, had just become, though she did not know it yet, an ersatz Victorian child, the doll-baby of the Hampton photographer, the pet of her female tamer. It would take her many years to figure out what had happened, and more to learn how to respond. At the time, all she understood was that she had pleaded, "but the ears of the palefaces could not hear." At night, she recalled, "[I climbed] the upward incline of wooden boxes, which I learned afterward to call a stairway. . . . I was tucked into bed with one of the tall girls, because she talked to me in my mother tongue." But to no avail: "I fell asleep, heaving deep, tired sobs. My tears were left to dry themselves in streaks, because neither my aunt nor my mother was near to wipe them away."[46]

Meanwhile, no violence against her sense of personal integrity passed unreckoned. One recalls the dresses in the "after" photograph of Carrie, Annie, and Sarah with greater comprehension for having read Zitkala-Sa's initial reaction to the school dress code: "The small girls wore sleeved aprons and shingled hair. As I walked noiselessly in my soft moccasins, I felt like sinking to the floor, for my blanket had been stripped from my shoulders. I looked hard at the Indian girls, who seemed not to care that they were even more immodestly dressed than I, in their tightly fitting clothes." She became a bright but rebellious pupil. Sometimes she managed a small revenge that gave some satisfaction. Once, she broke a jar in which she had been ordered to mash turnips for the students' supper. Another time, after a nightmare inspired by vivid religious instruction about the danger of the devil, she scratched a hole in *The Stories of the Bible* where his frightening picture had appeared. But in general, the pain of that period was unmitigated and enduring; it eluded, she felt, even her considerable later powers of expression. She wrote, "The melancholy of those black days has left so long a shadow that it darkens the path of years that have since gone by. Perhaps my Indian nature is the moaning wind which stirs them now for their present record. But, however tempestuous this is within me, it comes out as the low voice of a curiously colored seashell, which is only for those ears that are bent with compassion to hear it." This failure, I think, is debatable, for the lovely low voice of these tales not only speaks her own story but tells the sorrow of a hundred silent pictures, of which the "before and after" Hampton photographs are but two. On the other hand, her voice was certainly now a "shell," for mother and daughter were never to be completely comfortable together again.[47]

Clearly, by the time she came to write these autobiographical stories, Zitkala-Sa's self conception had been so effectively ensnared within the codes of sentiment that there is nothing Native American in them that is untouched

by Western representations. Even her own increasing inability to straddle the contradictions between the two societies is figured within her autobiography again and again as nothing more or less middle-class than an increasing inability to *read*. To take a single instance, when she returned home on a visit,

> My mother was troubled by my unhappiness. Coming to my side, she offered me the only printed matter we had in our home. It was an Indian Bible, given her some years ago by a missionary. She tried to console me. "Here, my child, are the white man's papers. Read a little from them," she said most piously. I took it from her hand, for her sake; but my enraged spirit felt more like burning the book, which afforded me no help, and was a perfect delusion to my mother. I did not read it, but laid it unopened on the floor, where I sat on my feet. The dim yellow light of the braided muslin burning in a small vessel of oil flickered and sizzled in the awful silent storm which followed my rejection of the Bible.[48]

Nonetheless, even at this early point in her development as a writer, the memories she nourished of her childhood show an acute sensitivity to what she had lost of the territory outside of reading. This included an awareness of her mother's and her own personal struggle against the renunciation of their tribal society and traditions, a sacrifice exacted by the dictates of a sentimental education and by the gratuitous cruelty of those who used force to encourage her and her companions to comply. Although the moral structure and often the melancholy tone of Zitkala-Sa's stories merge with those of the prototypical Victorian sentimental heroine, and many of the remembered incidents resonate with those of the blond girls of popular fiction, their tendency is nevertheless iconoclastic. Unlike Ellen Montgomery, the heroine of Warner's *The Wide, Wide World*, Zitkala-Sa was able to find through her tears no virtue or transcendence in the Bible, no soul sister in the kitchen where she must labor, no dashing suitor in the dazzling institutional halls. Whereas Warner's white heroine gains much, eventually, by subscribing to a program of inspirational reading and the "tender violence" of her rather sadistic and didactic mentor, the Native American heroine nearly loses her health and her spiritual footing by her determined and lonely adherence to the lessons of her books.

At enormous personal cost, Zitkala-Sa graduated from White's Manual Institute; completed two years of Earlham College in Richmond, Indiana; taught at Carlisle in Pennsylvania; and studied violin at the Boston Conservatory of Music. She even embarked on a literary career, writing these sketches and short fiction that spoke within and to sentimental forms. She received reviews like the following, published in the "Persons Who Interest Us" column in *Harper's Bazaar*:

A young Indian girl, who is attracting much attention in Eastern cities on account of her beauty and many talents, is Zitkala-Sa, . . . Zitkala-Sa is of the Sioux tribe of Dakota and until her ninth year was a veritable little savage, running wild over the prairie and speaking no language but her own. . . . She has also published lately a series of articles in a leading magazine . . . which display a rare command of English and much artistic feeling.[49]

But following an extraordinarily successful three-year period as the beautiful and famous Indian authoress and "the darling of a small literary coterie in Boston who also gave dramatic readings of Longfellow's *Hiawatha*" and having had portraits made by the famous Fifth Avenue photographer Gertrude Käsebier— some in which she looks uncomfortable, wearing a high-waisted white dress such as New York debutantes wore and set against a background of flowered wallpaper with her book or violin on her lap or an Indian basket clutched to her heart; others in which she looks more comfortable, set against a blacked-out background in stereotyped poses in Indian dress—Zitkala-Sa quite suddenly rejected the slippery pathway of white women's style of achievement and white men's style of praise.[50] Forsaking New York and literature, she married a Sioux, returned to the reservation, and became, eventually, an early and pugnacious Native American activist, lobbying in Washington, D.C., for the rights of her people.

The coming to consciousness that underlay this eruption is foreshadowed in the last of her early autobiographical stories, entitled "An Indian Teacher." In it, Zitkala-Sa, by then herself a teacher at Carlisle, literally forsakes the pseudo-literacy of "the white man's papers" and rebels against her years of sentimental indoctrination. Here, I think, she ceases to apply the model of white supremacist domestication and begins to seek another, sterner tongue. And so ends the extraordinary account of the struggle of one unintended reader, one who was later to become—in marked contradiction to the quiescent, feminized, and assimilationist standards in which she had been trained—a quite unintended kind of success. She writes,

In the process of my education I had lost all consciousness of the nature world about me. Thus, when a hidden rage took me to the small white-walled prison which I then called my room, I unknowingly turned away from my one salvation. Alone in my room, I sat like the petrified Indian woman of whom my mother used to tell me. I wished my heart's burdens would turn me to unfeeling stone. But alive, in my tomb, I was destitute! For the white man's papers I had given up my faith in the Great Spirit. For these same papers I had forgotten the healing in trees and brooks. On account of my mother's simple view of life, and my lack of any, I gave her up, also. I made no friends among the race of people I loathed. Like a slender tree, I had been uprooted from my

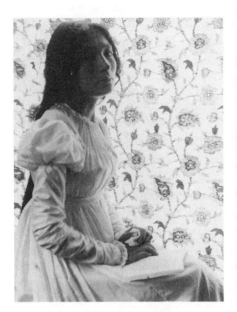

3.3. *Zitkala-sa in New York society dress* 3.4. *Zitkala-sa in Native American dress*

mother, nature, and God. I was shorn of my branches, which had waved in sympathy and love for home and friends. The natural coat of bark which had protected my oversensitive nature was scraped off to the very quick. Now a cold bare pole I seemed to be, planted in a strange earth. Still, I seemed to hope a day would come when my mute aching head, reared upward to the sky, would flash a zig-zag lightning across the heavens. With this dream of vent for a long-pent consciousness, I walked again amid the crowds.

At last, one weary day in the schoolroom, a new idea presented itself to me. It was a new way of solving the problem of my inner self. I liked it. Thus I resigned my position as teacher; and now I am in an Eastern city, following the long course of study I have set for myself. Now, as I look back upon the recent past, I see it from a distance, as a whole. I remember how, from morning till evening, many specimens of civilized peoples visited the Indian school. The city folks with canes and eyeglasses, the countrymen with sunburnt cheeks and clumsy feet, forgot their relative social ranks in an ignorant curiosity. Both sorts of these Christian palefaces were alike astounded at seeing the children of savage warriors so docile and industrious. As answers to their shallow inquiries they received the students' sample work to look upon. Examining the neatly figured pages, and gazing over their books, the white visitors walked out of the schoolhouse well satisfied: they were educating the children of the red man! They were paying a liberal fee to the government

employees in whose able hands lay the small forest of Indian timber. In this fashion many have passed idly through the Indian schools during the last decade, afterward to boast of their charity to the North American Indian. But few there are who have paused to question whether real life or long-lasting death lies beneath this semblance of civilization.[51]

In this story, Zitkala-Sa has presented as finally finished the task that previously, as a sentimental reader, she could not accomplish, or even imagine. Her long slavish education is over; she has escaped from the schoolroom and chosen a new path: "It was a new way of solving the problem of my inner self. I liked it." She has set herself a whole new course of reading which, it is implied, will be of a different order. And her myth of origin has also undergone a subtle but crucial change: in recognizing how falsely "figured" were the students' "pages," how superfluous "their books," and how unnecessarily she has forfeited her mother, nature, and God, she renounces, at least experimentally, the treacherous dream of Western romanticism, of restoration through sentiment to the pre-linguistic garden of authentic expression, which, apparently, was what had been taught to her to motivate her studies and offer restitution for her loss. With her new insight, she can bear to recognize not only how thoroughly she has been "uprooted" but also how small were her chances of getting replanted in any good earth had she continued on the same path.

Henceforth, in the city, armed with this perception, her clearer vision can become truly historical for the first time. It is also redemptive; she can now "look back upon the recent past [and] see it from a distance, as a whole." That this new center, like the earlier one, will not hold is knowledge buried in the future. In her "hidden rage," she is potent and prophetic. Given the time at which she wrote, her renunciation of sentimental fiction—and that in many senses—was clearly a precondition of choosing "real life" over "long-lasting death." But given the time in which we now must read, the almost total disappearance from our literary history of the achievement of antisentimentalism in women writers like Zitkala-Sa can only propel us deeper into illusion.

In *The Feminization of American Culture,* then, Ann Douglas was not wrong to link Victorian domestic literary pietism causally to the depredations of mass culture, but she was misguided in her animus against the women as women. The women's culture of 1820 to 1870 that she derides was dangerous not because it was *feminine* but because it was *racist,* just like the culture of the men. This point was made often by black women intellectuals of the time. The dominant cultures's successful appeal to the sentimental reflex—characterized by the bipartite structure of (1) impoverishment of the sense of history and (2) reliance on purely emotional remediation—does not depend only on the years of private

behavioral tutoring delivered to individual readers by the authors of domestic novels. It also depends on the widespread cultural acceptance of that reflex as the normative, public disposition toward the socially stigmatized. Sentimentalization is a communal, not just an individual, disposition. In fact, it expands within the group to make individual awareness unlikely, just as if our whole society, without comment, blithely encouraged our children to play "concentration camp," or "gas chamber," or, indeed, "cowboys and Indians"—in the quiet twilight streets after dinner, with Native Americans and Holocaust survivors alongside our fond selves as witnesses. As long as the arena of the sentimental encounter is imagined mainly as a private, contained, bookish, house-bound space—typified either by "the basement" of Jane Tompkins's anecdote about living in an apartment in the home of an important nineteenth-century American woman writer without knowing anything about her work or by the figurative attic of "my grandmother's girlhood legacy," as in Ann Douglas's confession of treasuring the icons of Victorian domestic sentiment—the deeper tracings of its terrorism upon nonreaders and outsiders cannot be conceived.[52]

Sentimental "power" struck its outright victims differently from its middle-class audience. We are fortunate to have some record of the reactions of those on the receiving end of the racially instrumental side of a nineteenth-century domestic education, in both written and photographic form. From this record we can at least partially assess both the disarray it produced on impact and the strategies of resistance that appeared in its wake. In a major reconsideration of the political history of the domestic novel in England, *Desire and Domestic Fiction,* Nancy Armstrong reasons that "as the official interpreters of the cultural past, we are trained, it appears, to deny the degree to which writing has concealed the very power it has granted to this female domain. It is no doubt because each of us lives out such a paradox that we seem powerless to explain in so many words how our political institutions came to depend on the socializing practices of household and schoolroom."[53] In *Landscape for a Good Woman,* Carolyn Kay Steedman recalls one instance of the power of this "female domain":

> Upstairs, a long time ago, she had cried, standing on the bare floorboards in the front bedroom just after we moved to this house in Streatham Hill in 1951, my baby sister in her carry-cot. We both watched the dumpy retreating figure of the health visitor through the curtainless windows. The woman had said: 'This house isn't fit for a baby.' And then she stopped crying, my mother, got by, the phrase that picks up after all difficulty (it says: it's like this; it shouldn't be like this; it's unfair; I'll manage): 'Hard lines, eh, Kay?' (Kay was the name I was called at home, my middle name, one of my father's names).
>
> And I? I will do everything and anything until the end of my days to stop

anyone ever talking to me like that woman talked to my mother. It is in this place, this bare, curtainless bedroom that lies my secret and shameful defiance. I read a woman's book, meet such a woman at a party (a woman now, like me) and think quite deliberately as we talk: we are divided: a hundred years ago I'd have been cleaning your shoes. I know this and you don't.[54]

How can we tell a "good woman" from another kind? What kind of house is "fit for a baby?" How should such a woman raise her child? Armstrong demonstrates that it is a notable feature of English-speaking culture over the past two centuries that not only has it been bent on supplying definitive, professional, and prestigious answers to these questions but it has produced and sustained an enormous imaginative literature designed to keep the urgency of these always already answered puzzles in the forefront of consciousness. This is the tradition of domestic fiction and the plot that Zitkala-Sa tried to disrupt by adding her own Native American stories to the narrative.

But it would be imperceptive to maintain that this tradition concerns domestic matters "merely" or domestic fiction "merely." Since the mid-nineteenth century, many of the most central political engagements of our society have been shaped and even fought upon that ground—all the while, just as in the nursemaid photographs, passing themselves off instead as romantic engagements, private affairs of kith and kin, heart and hearth. Armstrong closes her study of the English tradition by reminding us that "if one stresses the particular power that our culture does give to middle class women rather than the forms of subordination entailed in their exclusion from the workplace and confinement to the home . . . then there is clearly a great deal of work to do."[55] The development of an aesthetic of sentiment, therefore, is largely the story of how the values of white middle-class women came to occupy both the "private life" and the "public stage" of popular consciousness, to borrow Mary Kelley's terminology.[56] It is the story of how specific social formations, composed of women as much as men, learned to use a wide variety of representations of the "good woman," including photographs, to identify, enlarge upon, and then protect their interests. It is additionally, I have been arguing, the story of how photographic representations of—*and by*—"the good woman" actively and materially empowered the many "massive" and "amazing" brick buildings where the curriculum of race was the subject of merciless indoctrination in the last quarter of the nineteenth century.

4

Ah looked at de picture a long time and
seen it was mah dress and mah hair so Ah said:
"Aw, aw! Ah'm colored!"
 Den dey all laughed real hard. But before
Ah seen de picture Ah thought Ah wuz just
like de rest.
—Zora Neale Hurston,
 Their Eyes Were Watching God

Black and White and Color
The Hampton Album

. .

The theater of force founded in sentimentalism's power to natu-
ralize the violent text is nowhere more evident in the nineteenth century than
in the work done by photography in institutions such as schools, missions, hos-
pitals, agencies, and armies. Frances Benjamin Johnston's professional career,
along with those of many of her female colleagues, thrived upon these opportu-
nities. Upon returning from photographing the *Olympia* in August 1899, John-
ston plunged almost immediately into another assignment, a commission from
Hollis Burke Frissell for photographs of the Hampton Normal and Agricultural
Institute in Hampton, Virginia. Johnston earned the opportunity to photo-
graph at Hampton with the same credential she had demonstrated to Dewey:
the ability of a "lady" to domesticate violent conflict.

When Johnston arrived at Hampton in December of 1899, debate was raging
over the role of African American soldiers in Cuba, Hawaii, and the Philippines.
Americans ventured a war of conquest overseas at a time when violent racial
repression in the United States had reached a terrifying intensity. The period
between 1889 and 1893 saw a record number of reported lynchings: 579 blacks
and 260 whites. Between 1899 and 1903 the number of reported lynchings de-
creased overall, to a total of 543, but the ratio of black to white victims increased;
only 27 of the 543 in those years were white.[1] American aggression in the Phil-
ippines was openly linked to the domestic racial struggle, and many of the racial
prejudices, stereotypes, and insults common at home were quickly exported to

the Pacific. Jim Zwick, manager of a website on American anti-imperialism, observes that racialized imperialism "put African Americans in a particularly difficult position":

> Should they support the war and imperialism to prove that they were patriotic citizens who deserved respect at home? Or should they oppose policies that they thought would result in the extension of oppressive Jim Crow laws over other peoples of color in the colonies? Not surprisingly, the African American community was deeply divided over these and other questions raised by the war and imperialism.[2]

Newspapers, fraternal societies, church groups, and other organs of expression in the African American community, including those at the Hampton Institute, devoted time and space to the political implications of this debate:

> Should they continue to support the Republican Party because of its former role in ending slavery despite its new commitment to imperialism? Or should they support the Democrats with their anti-imperialist position even though they were leading efforts to disfranchise Black voters in the South?[3]

Few doubted that the image of the United States citizen as a fighting man was of great significance, certainly not Johnston, fresh from her work aboard the *Olympia,* or the African American students at Hampton, whose founder had led black troops during the Civil War. It was also clear that native defeat in the Philippines could be read as a sign of white racial superiority, which, many understood, would have a direct impact on Jim Crow and its supporters' effort to strangle the rights of black citizens at home.

Black troops who served in the Philippines immediately observed the powerful analogies between what was going on in the Pacific and what was going on in the South. "To some Negro soldiers," Willard B. Gatewood Jr. observes, "references to Filipinos as 'niggers' and the drawing of the color line which had accompanied Americanization of the Islands indicated what was in store for the 'little brown brothers' under American rule."[4] For instance, William Simms, a black serviceman, wrote home in 1901: "I was struck by a question a little [Filipino] boy ask me, which ran about this way: 'Why does the American Negro come . . . to fight us when we are much a friend to him and have not done anything to him. He is all the same as me and me all the same as you. Why don't you fight those people in America who burn Negroes, that make a beast of you?'"[5] Many African Americans were torn between their own patriotism and a sense of racial solidarity. "Our racial sympathies would naturally be with the Filipinos. They are fighting manfully for what they conceive to be their best interests," wrote one "Colored American" in 1899. "But we cannot for the sake of sentiment turn our back upon our own country."[6]

None of this controversy penetrates the pristine world of Johnston's Hampton images. Instead, they sublimate all marks of domestic racial struggle into the appearance of social harmony. Neither the conviction that "The Negro Should Not Enter the Army," as an editorial claimed in the *Voice of Missions,* the missionary organ of the A.M.E. church, nor the doubt entertained by the War Department about whether "if brought face to face with their colored Filipino cousins [colored volunteers] could be made to fire on them" seems to have any bearing on her images.[7] Johnston's 1899 Hampton photographs ignore the contemporary debate over the pros and cons of participation in American imperialist ventures that was on so many minds, both black and white. In her images, the only war in evidence is the Civil War, and it is a mere ghost of struggles long past. Male students in her Hampton pictures sometimes wear cadet uniforms, but one is led to believe this must be for sentimental or decorative purposes only, not an actual reference to anything military.

Ten years earlier, in 1888, the Hampton authorities had braced for an attack by the Commissioner of Indian Affairs, who had received complaints that the Native American program was unhealthy and repressive. But the school emerged from an investigation by the Board of Indian Commissioners with renewed prestige that was not to founder seriously until the early years of the next century, when, under a new Native American policy, Congress withdrew the government subsidy for the Indian school. From 1888 on until after the turn of the century, Hampton also come under extensive attack by national black educators, who felt that it inculcated and enforced a dangerous political quietude, even as the toll of racial violence mounted against the country's black population. The issue went to the core of the meaning of education—whether it be "industrial," as the school's founder Samuel Chapman Armstrong envisioned, or "academic." As educational historian James Anderson explains,

> In many ways, the so-called academic subjects were used to inculcate a servile mentality more than the practical work. Traditional academic courses were modified to relate closely to the roles expected from the children as adults. History was viewed mainly as a device of raising the children to accept the accommodationist leadership in the South.[8]

The textbook that General Armstrong used in the political economy course that he taught had a decided point of view on the accommodationist uses of history:

> The most pernicious quack, who peddles nostrums, is he who attempts to excite the multitude by declaring that "all the ills that flesh is to heir" come from the employers of labor. People of this sort hold it as an axiom that there is an unending feud between capital and labor; and that the former ever seeks to extinguish the latter. Some of these mischief-makers, assuming this state-

ment to be true, are logical enough to declare that labor should try to extinguish capital. This is the doctrine of communism. Now if there be two things in this world between which the utmost amity should exist, and between which the most intimate reciprocal relations do exist, they are Capital and Labor.[9]

After Armstrong died in 1893, the principal who succeeded him, Hollis Burke Frissell, carried this vision forward.

> There must always be here the double standard of judging students, by which their moral worth is taken into account even more than their intellectual achievement. What will this student do for the building of his race? is the question we are obliged to ask everyone placed under our care. During the past year students have been asked to leave the school whose scholarship was of the best, because it was felt that they lacked in moral earnestness. . . . At the last anniversary exercises, a young man spoke as valedictorian of his class who by no means led his fellows in scholarship, but had notably taken the lead in Christian Manhood.[10]

It was then alleged, by W. E. B. Du Bois and others, that the "widespread adoption in the South [of Armstrong's program] by the end of the century helped retard Black achievement in higher education for decades."[11]

But Johnston turned her back on this debate as well. At Johnston's Hampton, black and Indian life is untouched by the venality of labor exploitation. The views she made with her camera were fully in line with the stated goals of Hollis Burke Frissell. From Johnston, the Hampton administration got the averted gaze it sought, and from Hampton's leaders, New South businessmen and northern industrialists got the assurance they sought that black militance could be diverted.

When Johnston arrived at the Hampton Institute in 1899, it is fair to say that the reputation of the school was then at its most impressive. In his autobiography *Up From Slavery,* published in serial form in *Outlook* magazine in 1900, and thus contemporaneous with Johnston's photographs, Hampton's famous alumnus Booker T. Washington recalled the electrifying effect of news of the simple existence of the school upon many Southern freedmen, who heard about it through the grapevine:

> One day, while at work in the coal-mine, I happened to overhear two miners talking about a great school for coloured people somewhere in Virginia. This was the first time that I had heard anything about any kind of school or college that was more pretentious than the little coloured school in our town.

As they went on describing the school, it seemed to me that it must be the greatest place on earth, and not even Heaven presented more attractions for me at that time than did the Hampton Normal and Agricultural Institute in Virginia, about which these men were talking. I resolved at once to go to that school, although I had no idea where it was, or how many miles away, or how I was going to reach it; I remembered only that I was on fire constantly with one ambition, and that was to go to Hampton. This thought was with me day and night

Perhaps the thing that touched and pleased me most in connection with my starting for Hampton was the interest that many of the older coloured people took in the matter. They had spent the best days of their lives in slavery, and hardly expected to live to see the time when they would see a member of their race leave home to attend a boarding-school. Some of these older people would give me a nickel, others a quarter, or a handkerchief.[12]

At the other end of the social spectrum Hampton also drew serious attention. There was an "enlightened and liberal" board of trustees. President James A. Garfield was a backer; so were Dr. Mark Hopkins and many former abolitionists who succeeded to political and educational positions of influence after the war. Beginning in 1873, the Hampton Student Singers, and afterwards the Hampton Quartet, sang and played on fundraising tours throughout the country, and for President Grant at the White House and in Steinway Hall in New York.[13] In fact, it was to advertise the existence and success of Hampton to an even broader, international audience that Frissell engaged Johnston to take the 1899 set of photographs. Her commission was thus a public relations assignment. The photographs were wanted to comprise part of an exhibition of contemporary American Negro life, to be shown at the Paris Exposition of 1900, where they eventually won much acclaim. Later Johnston's work was used for fundraising and publicity by the Hampton administration and to illustrate articles by Booker T. Washington on black education.[14]

Johnston's most pertinent assignment occurred just seven or eight months before her work at Hampton. In April and May of 1899, she photographed the segregated Washington, D.C., school system for the Paris Exposition of 1900, devising ways to transport her heavy and awkward equipment and to handle typical school groupings and settings in a formally pleasing manner. In six weeks on the job she made over 700 6½-by-8½" or 8-by-10" negatives. Undoubtedly the high quality of those photographs, as well as personal contacts in Washington, helped Johnston to garner the Hampton assignment. Johnston went on to base a significant portion of her career upon the two school assignments she undertook in 1900. She published the D.C. school photographs in a series of sixteen booklets on progressive education, entitled *The New Education Illustrated*,

4.1. *Hampton Institute panorama*

and after working at Hampton, she continued to photograph black and Native American education at the Carlisle Indian School, Tuskegee Institute, and its spin-off schools at Snow Hill and Mt. Meigs, Alabama.[15]

The Hampton images are among Johnston's most beautiful and most complex work. It is largely for them that she is known and appreciated today, although she maintained an active photographic career for another forty years, until she was seventy-six years old. Very much like Walker Evans, Johnston accomplished her most profound work on a journalistic assignment in a very short and concentrated span of time.[16] But as Lincoln Kirstein correctly wrote, the Hampton photographs, although taken over a short period of time, "comprise a body of work almost inexhaustibly revealing."[17] They seem, initially, to open a window on the past, a black and Native American past rare in the record, and, in the words of another observer, "to document the essence of the people and the institution."[18]

They are also hauntingly beautiful. The powdery silver winter light of the platinum image translates even into their printed reproductions, and the dignified placement of bodies and buildings echoes, for some viewers, the solemn compositions of Thomas Eakins or Seurat.[19] As if transported by a kind of photographic "You Are There," critics have been tempted to receive these images as a rare objective "peek," the devoted "thusness" of these detailed and stately forms as an icon of the past. After all, in these images one sees the people who lived it, and there stand the buildings where the past took place.

And yet, a closer acquaintance with the characteristics of Johnston's photog-

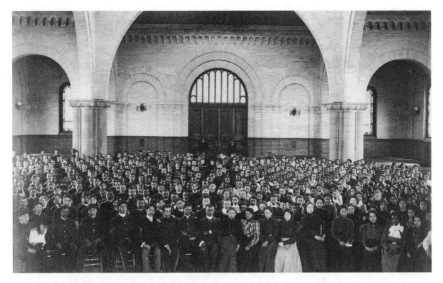

4.2. *Four hundred students in Memorial Chapel*

raphy as a medium of communication, and with the characteristics of photographs as historical evidence generally, implicates the directness as facade and undermines the transparency of the "spirit of fact"[20] that seems to inform this body of work. The past, while undeniably recorded in the Hampton images, is not so straightforwardly legible. The photographs, like most photographs, are disingenuous. Although they are formally beautiful, they appear to have been made without recourse to artifice, in the sense of cunning or craft.

It is understandable why a claim of transparency has been staked for them; as one critic put it, "[the photographs] radiate such innocence and good hope that they make me want to cry."[21] Yet it requires a far more strenuous reading before one may move from this photographic text to a world gone by. As Alan Trachtenberg has written concerning Civil War photographs, "the closer we look . . . the more does their incontrovertibility come into question. They are, we learn, vulnerable to exactly the same obscurities of other forms of evidence. The simplest documentary questions of who did what, when, where, and why may be impossible to answer. And much more consequential matters of meaning and interpretation, of narrative and ideological tropes, of invisible presences and visible absences, have rarely even been asked."[22] Johnston's photographs bury their art in a facade of inevitability. Thus what we learn of the past by looking at photographic documents like the Hampton album is not "the way things were," to use the essentializing phrase. Instead, what they show us of the past is a record of choices. What a photograph represents is a solution to a clash of forces that we must learn to see.

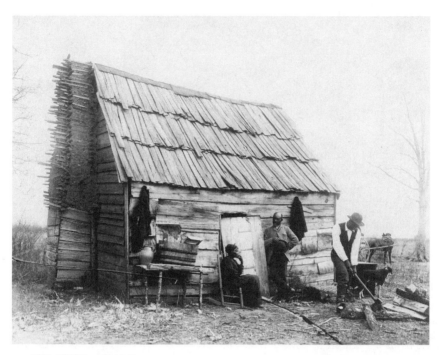

4.3. *"The Old-Time Cabin"*

The questions we must ask of the Hampton photographs are, therefore, paired ones: not only (1) What does the album inscribe of "American Negro Life"? but also (2) What rhetorical structures substantiate this inscription?"; not only (1) Why do these images seem "inexhaustibly revealing"? but also (2) What is there about the systems of meaning upon which these images rely that is in excess of the photographic subject as it is visibly framed?

A single extant photograph shows the Hampton Institute photographs displayed at the "Contemporary American Negro Life" exhibit at the 1900 Paris Exposition and matches a written description of the exhibit. But this image does not reveal any more about the details of their display and reception beyond published reports that they were "arranged by subjects and mounted on the moveable leaves of a large upright cabinet" and that they won widespread approval, including a Grande Prix.[23] We do not know how they were sequenced or what text, if any, accompanied them, though the overall aims of the exhibit were explained in a January 1900 editorial in Hampton's official journal: "It is part of the plan of the exhibit to contrast the new life among the Negroes and Indians with the old, and then show how Hampton has helped to produce change."[24]

The Hampton Institute photographs as a group come to us not directly from Paris, but by way of a "plump, anonymous, leatherbound album, old and scuffed," discovered in a Washington bookshop during World War II by Lin-

4.4. *"A Hampton Graduate's Home"*

coln Kirstein and donated by him twenty years later to the Department of Photography of the Museum of Modern Art.[25] Of the 159 platinum prints in the album, the museum exhibited 44 in 1966 and reproduced them in a critical catalogue entitled *The Hampton Album,* edited by Kirstein, which has been my chief source for the present study. Since this is an edited selection, itself excised from an anonymous album about which it is unknown how faithfully it represents the Paris Exposition project, I will refrain from drawing conclusions here that reach beyond the scope of the sample. But although the album—composed, as Kirstein says, "with love and care"—may or may not represent the composition of the actual exhibition, it does point to the thoughtfully constructed nature of the set of images.[26] The tenacity of overarching organizational principles is legible in the original album and even in the smaller grouping.

In the original album, as Kirstein describes, each individual print is deposited over a tissue paper bearing a title. These titles are reproduced in the MoMA edition; they were probably, although not necessarily, provided by Johnston, who had the practice of captioning her pictures. They include such pairings as "The Old Folks at Home" and "A Hampton Graduate at Home," "The Old-Time Cabin" and "ERA Hampton Graduate's Home," and individual images such as "Primary class studying plants, Whittier school," "Class in American history,"

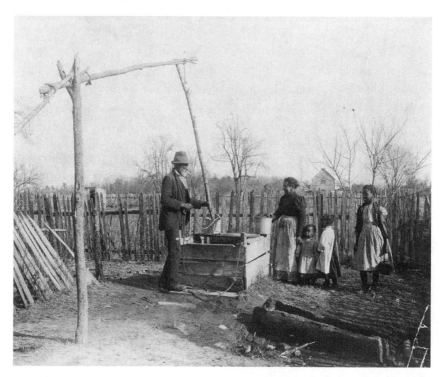

4.5. "The Old Well"

"Geography. Studying the Cathedral Towns," "A Sketch Class at Work," "Agriculture. Plant life. Study of plants or a 'plant society,'" "Trade School. Mechanical Drawing," and so on. Far from random or unreflectingly archival, Johnston's Hampton views are amenable to categories of naming and thereby to groupings or sequences, many of which are still discernible in the smaller edited sample because of their internal coherence. The naming immediately inserts the visual images into a linguistic order, which reduces the nearly infinite semantic possibilities that the images would have without words. After the naming, we are licensed to read the images in fewer ways. On the other hand, it is this entry into verbal language that makes the images denotative. It means that the rhetoric within which Johnston represents Hampton can be decoded.

The logic of the title sequences, in the order reproduced by MoMA, reads as follows: an initial view of the Hampton campus, introduction to the student body, daily life before and after a Hampton education, continuity through the grandchildren of Hampton graduates at school, the curriculum, extra-curricular activities, field trips, and graduation. As a shooting script, such categories project a particular kind of spatial and temporal plot upon the material. They show the where, what, and when of a very concrete, very substantial Hampton. A sec-

4.6. *"The Improved Well"*

ond characteristic of the shooting script is its explicit hermeneutic of black history as progress initiated by the action of the Hampton Institute and illustrated by the "before" and "after" Hampton shots. As *tableaux vivants* choreographed by the photographer and enacted by a willing body of students and faculty, the images and titles represent material accomplishment and the solidity and measurability of development.

In the accompanying images the people are collected and composed in groups before the shutter opens upon them. In the English class the declamation is well underway, in the trade school the mechanical drawings are begun, and at the greenhouse the culture of plants is already in progress. Such exposures favor the interruption of what is already in place over its preparation and buildup. They privilege achievement over transition, accomplishment over struggle, and the gentler work of elaboration over the brutal labor of beginning. We see nothing of how the things and the people in the pictures got where they are, but we see the substantial, well-equipped air of the uniforms, campus, and classrooms. If the "old folks" are shown to live in crude, eighteenth-century-style cabins, the graduate of Hampton has leapt into the nineteenth century with a clean, scientifically built house, modern floor covering, and a Rocky Mountain landscape

4.7. *"Geography. Studying the Seasons"*

oil painting hung over the shawl-covered shelf. Once again, the image presents a fait accompli and scant information on how it was achieved, except for the almost magical invocation of the name Hampton.

One recalls that Hampton students were instructed in the trades; perhaps the owner built this excellent house himself. The photograph that MoMA and many subsequent photographic editors have chosen as emblematic of Johnston's work shows Hampton students building a beautiful staircase for the treasurer's house, so, evidently, they were skilled carpenters. But even this scene of work is startling for its stillness. No sawdust, no disorder, no movements accompany the silent builders. Like the other lessons, the staircase is almost finished. Labor, trained at Hampton, these images imply, bears fruit with the ease—and freedom from conflict—of a tree in Eden.

In these images, even the Hampton education itself, as an activity, is conceived as occurring in a similarly stolid, full-blown, productive, and domesticated fashion. According to the album, learning happens *in* the classroom, *during* the fieldwork, *at* the lecture, or *in* the extracurricular activity. It is not to be sought along the hallways, halfway down the path, or after hours. In part, this, and the previous fixities, may be seen as an effect of the medium. Johnston's camera was so ineffective at capturing motion that it is hardly likely she

4.8. *"Geography. Studying the Cathedral Towns"*

could have thought in wildly kinetic terms. There are a number of instances in the photographs when something moves too fast for her camera to record it, and it registers as a blur. However, the quietness and cooperativeness of the Hampton she portrays is so exaggerated and entire, even in terms of her equipment, as to be a striking part of her presentation. The photographs are presented as if the work at Hampton were in media res; but the thing itself, the work that is going on at Hampton, is as calm as "a fly in amber."[27]

The conclusion that this calm, the deepest rhetorical supposition of the Hampton views, is not a *necessary* given but a *chosen* one is supported when one compares the Hampton views with some of Miss Johnston's Washington, D.C., school system images, which were nearly contemporaneous with the Hampton views and were in fact exhibited along with them in Paris, where both won major awards. As with the Hampton job, Johnston made the pictures of the Washington school system on commission; they were intended to show "The New Education" in practice. As official representations of educational innovation, both the Washington and the Hampton series were intended to serve the same interpretive and promotional functions.[28]

But the white children in the racially segregated Washington school system twist and turn in their places; they do "stretching and yawning" exercises at their

4.9. *"Agriculture. Mixing Fertilizer"*

desks; they ride in a bevy on public transportation; they attend an exhibition of fine prints at the Library of Congress. One can easily imagine a rowdy corridor in those schools. This is not to say that the Washington school system images are not staged. Like the students at Hampton, the students in Washington fairly glisten with well-scrubbed preparation for the lady photographer. They seem arguably conscious of the presence of the photographer in nearly every frame, and many of them look into the camera. Even the purported action image entitled "Boys on Their Mark at a Central High School Boys' Track Meet" is visibly staged; the overly dramatic poses of the timekeeper and the man firing the starting gun as well as the singularly fascinated attention of the onlookers give this staging away by their exaggeration. On the whole, the students in the Washington school series are younger than the students photographed at Hampton, and perhaps they are more difficult to keep still. But this alone is not sufficient explanation for the different coding of the images—first, because Johnston photographed equally young students at Hampton, more statically, and second, because Johnston photographed equally old students in Washington, more dynamically.

At Hampton almost all eyes, even those of the littlest students, are glued up front and concentrate on the teacher or other authority. Also, at Hampton the

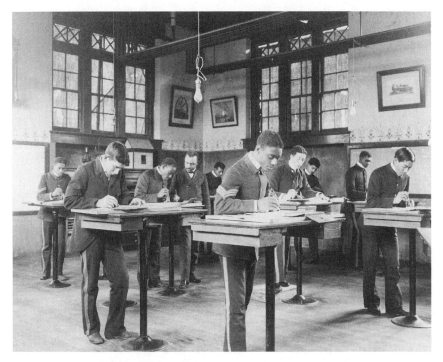

4.10. *"Trade School. Mechanical Drawing"*

extent of physical exercise represented for the kindergarten seems to be to go outside and salute the flag, while the grown-up football team (as opposed to the Washington boys' track meet) is shown not in skirmish upon the field but at rest in the quad, in a team picture that looks, but for the color of the athletes, like an illustration for *Dink Stover at Yale*. It is evident that possibilities for other images existed at the school and lay within Miss Johnston's technical compass but not within the rhetorical repertoire she drew upon for this assignment. The essential point is not that both sets of images were and had to be staged, but how they were differently staged. In fact, the Hampton assignment gave scope for a much more animated presentation than Johnston produced precisely because of all the fieldwork and practice of mechanical trades in the curriculum. Johnston focused on this aspect of the school, but in her hands it became a diorama.

Somewhat prior to Michel Foucault's wide-ranging analysis of the functioning of power in modern institutions, the American sociologist Erving Goffman established the existence of multiple loci of private resistances to the official schedule in what he called "total institutions," among them "institutions purportedly established the better to pursue some worklike task and justifying themselves only on these instrumental grounds: army barracks, ships, boarding schools, work camps, colonial campgrounds, and large mansions from the

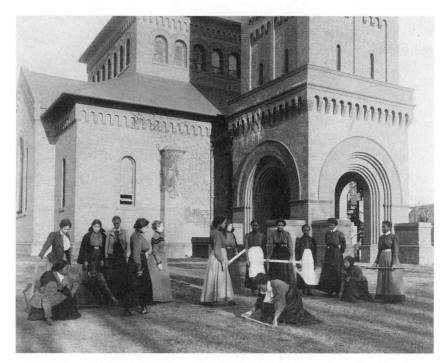

4.11. *"Arithmetic. Measuring and Pacing"*

point of view of those who live in the servants' quarters."[29] Goffman termed these patterns of resistance the "underlife" of the institution, and he argued that such resistance was crucial to the maintenance of a sense of humanity in those who were subject to the official agenda. To a great extent, these resistances have to do with an interruption of the predictability of schedules, throwing what is supposed to happen out of synchrony with where and when it is supposed to happen. These resistances mean that much of the learning that goes on in total institutions like Hampton occurs beyond bounds and out of place. They also mean that Hampton must have provided terribly important instruction in the interstices, during the rush on the way to class, as well as while students were at their desks. Yet, none of this kind of learning, none of these crucial ways of knowing is included in Johnston's script. The controlling tropes that Johnston uses—of station, stillness, and solidity—disallow it.

Booker T. Washington, on the other hand, recognized how important education "in between" could be. Interestingly, although he spoke about it many times in his autobiography *Up from Slavery,* he never seemed to find an appropriate place to put these recognitions in his story. Although he mentions them, the things he had learned "beside the point" were disjunctive with the writing style in which he had been educated, and his recording of them contributes to

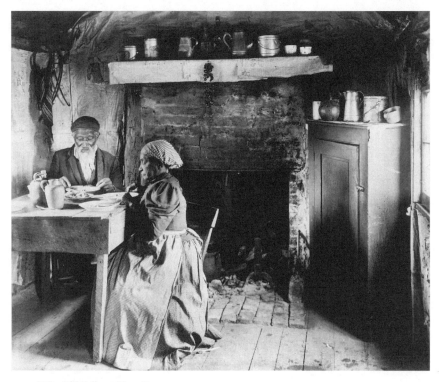

4.12. *"The Old Folks at Home"*

the bumpy tone of the autobiography. For example, directly after an encomium
to the "Christlike" General Armstrong, who, Washington said, wanted to "as-
sist in lifting up my race," the book moves on to describe "the matter of having
meals at regular hours, of eating on a tablecloth, using a napkin, the use of the
bathtub and of the tooth-brush, as well as the use of sheets upon the bed," mat-
ters which, he said, were "all new to me." [30] "Almost the most valuable lesson
I got at the Hampton Institute," he reports, "was in the use and value of the
bath." [31] The effect of this juxtaposition is maladroit, seeming as if the writer does
not recognize a difference in importance between speaking of Armstrong and
speaking about learning to take a bath. It might also seem an inability to regis-
ter the appropriate tone. But I would argue that what the juxtaposition more
truly reflects is the difficulty of splicing the heterogeneity of learning into the
profoundly controlled curriculum and ordered sense of person that Hampton
promoted. Even though he cannot make this recognition fit smoothly into his
text, Washington insists upon the value of what is "out of place." Given a simi-
lar opportunity, Johnston fails to make the corresponding appropriation. Those
who resist celebrating the immensely disciplined kind of Victorian temperament
that could underwrite the Hampton program of education through "tender vio-

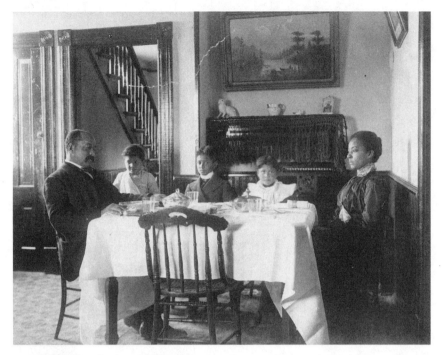

4.13. *"A Hampton Graduate at Home"*

lence"—as the founder, Armstrong, put it—are neither imaged nor imagined by the photographer.[32] They must resist invisibly. In an ominous, familiar, over-determined, and claustrophobic formula, the concept of *race* in the Hampton of Johnston's camera is homologous with a principle of *place*.

Time, at Johnston's Hampton, is quiet too. It seems almost to stand still and wait, with an exquisite tenderness, for the forsaken races to catch up. Various critics who have written on the Hampton photographs have expressed a feeling of the palpability of the minute in these images and a coordinate intimation of redemption. "In them," Kirstein wrote, "hearts beat, breath is held; time ticks. Eyelids barely flutter. Outside of Hampton there is an ogre's world of cruel competition and insensate violence, but while we are here, all the fair words that have been spoken to the outcast and injured are true. Promises are kept. Here is the promised land."[33] Booker T. Washington reported a similar sense that in his experience time was pregnant at Hampton. But for Washington, it was thick because it was packed so full:

> Every hour was occupied in study or work. Many [of the students] were as poor as I was, and, besides having to wrestle with their books, they had to struggle with a poverty that prevented their having the necessities of life.

4.14. *"Stairway of Treasurer's Residence"*

Many of them had aged parents who were dependent upon them, and some of them were men who had wives whose support in some way they had to provide for. . . .

 And the officers and teachers, what a rare set of human beings they were! They worked for the students night and day, in season and out of season. They seemed happy only when they were helping the students in some manner.[34]

Washington, in fact, exhibited a truly Franklinesque attitude toward Hamptonian time:

 The debating societies at Hampton were a constant source of delight to me. . . . These were held on Saturday evening; and during my whole life at Hampton I do not recall that I missed a single meeting. I not only attended the weekly debating society, but was instrumental in organizing an additional society. I noticed that between the time when supper was over and the time to begin evening study there were about twenty minutes which the young men usually spent in idle gossip. About twenty of us formed a society for the purpose of utilizing this time in debate or in practice in public speaking. Few persons ever derived more happiness or benefit from the use of twenty minutes of time than we did in this way.[35]

4.15. *Stretching and yawning at a Washington, D.C., school*

The complexity of Washington's tone is not to be underestimated. Irony is refused to the invocation of the burdens under which the students labored; his admiration for the teachers who worked so hard is genuine. Respect for work, he asserts repeatedly throughout the text, is the major thing he learned from his Quaker-inspired education. Yet the creative use of twenty minutes is carefully specified, regarded with wonder, and insisted upon with special pride. What is missing from the passage is any overt class awareness, awareness, for example, that the teachers working so hard was different from the students doing so since the work *signified* differently in each case. The working black was "the mule of the South," the working white a prodigy.[36] But implicit within the debating story are the materials for a critique of race and class. The debaters are hungry for time because they are in training to break through the color line. Yet their resources are so few and their desperation so great that they must recycle even twenty wasted minutes in order to compete.

In telling his story, Washington dwells upon the dignity of all the participants. But it is precisely this need to assert dignity, repeated and multiplied throughout *Up from Slavery,* that points to the danger that it might be denied. The tone of *Up from Slavery* is so interesting because its attempt to be univocal fails. Addressing a white audience, Washington writes in a simplified, subdued manner that represents, evidently, the space he feels he has been offered for discourse

4.16. *Saluting the flag at Whittier Primary School*

and the capacity he believes whites have for listening, much as one shouts in a shorthand code to a hard-of-hearing elderly relative. Yet his own stories resist the monotone of his mask; they are vivid, appalling, pathetic, and sublime in turn and all at once. Out of this complicated richness, they speak with a timbre and an authority that cannot be regulated. The complex voice makes it difficult to know who gets the last laugh—the readership who demanded a guileless address or the author who was willing to give it to them. *Up From Slavery* constructs a fragmented, contradictory black subjectivity, working from the "inside" out.

With their indifference to the political debate over the war, Johnston's images also construct a black identity from an external vantage point, one that portrays that identity as a consistent sensibility—the students appear uniformly eager, virtuous, energetic, and receptive. Unlike Washington, Johnston succeeds in eliciting a unified tone from a series of vignettes that strikes the same progressive note in frame after frame. The fact that she can do this perhaps reflects a greater degree of artistic control and organizational skill. The remarkable continuity of the pastoral mise en scène from one image to the next is largely due to her active shaping, selecting, and refining. The Hampton that we see is a Hampton she envisioned. At the same time, however, it is a vision of Hampton that synchronizes

extremely well with the official image, and it represents excellently the kind of socially passive black identity the school itself was attempting to construct.

There *were* other ways to imagine the good uses of the Hampton-Washingtonian industrial education. Sergeant Major John Galloway and his buddies in the Philippines, as self-consciously African American soldiers, were at that very moment considering them. "We received the copies of the *Planet* sent to us at this point," he wrote in thanks to the *Planet*'s editor. "You can imagine how much we appreciated them when we had not seen a paper of any kind for weeks, and as for an Afro-American paper, I can not remember when I last laid eyes on one." Galloway continued,

> The address of Mr. [Booker T.] Washington is the talk of the camp. Since coming here the boys' bosoms have expanded greatly. Their ideas have indeed broadened. They all say in chorus that Mr. Washington's ideas are destined to revolutionize America educationally, and as to the Negro, we feel the depth of his advice and feel the path of action outlined by him is the only practical one for colored youth.

But what was practical about it was much more apparent in the Philippines than in the United States. Galloway had discovered there that:

> Our young men who are practical scientific agriculturalists, architects . . . engineers, business men, professors and students of the sciences and who know how to establish and manage banks, mercantile businesses, large plantations, sugar growing, developing and refining . . . will find this the most inviting fold under the American flag. Cuba does not compare with the Philippines. Another thing, too, when they secure missionaries and teachers for the schools here, see that they get on the list. They must be represented here. White men have told them we were savages. We need to be in evidence to convince the Filipinos of our status. I do all in my power to picture ourselves to them in a good light, but positions of influence among them is what will tell. They extend to us a welcome hand, full of opportunities. Will we accept it? [37]

Galloway was impressed by the "welcome hand" the Filipinos "extended to us." But of course, what Sergeant Major Galloway was failing to consider is that it was not up to African Americans themselves either to succeed or fail in making use of the "opportunities" opened by imperial war and colonization. The military struggle was waged in the first place so that Anglo-Saxons would control these opportunities. Resonantly, there is nothing in Johnston's Hampton photographs that so much as hints that there might be a grander scope and profit in the practical education the Hampton students were receiving if they went as capitalists abroad.

Protest was also already making itself heard from within the institute itself.

In 1878, Hampton's Alumni Association presented a petition to the faculty and administration, asking them to reconsider how they treated black alumni differently from white philanthropists at the commencement exercises. The petition read in part,

> The graduates of this institution have been insulted and have had our feelings mortified by public rumors and newspaper articles to the effect that the officers and teachers of this Institution do not accord to the colored visitors the courtesies and hospitalities due them as a race. . . . We the graduates of this Institution, after returning in compliance with the call of our Alma Mater, have had our feelings wounded most grievously by being barred from some of the privileges that ordinary white visitors enjoyed.[38]

We know that Johnston's serene renditions pleased the Hampton administration and trustees. The rationale behind Hampton and Tuskegee and their sister institutions throughout the South, was to hone the students' teaching credentials and teach them how to teach others the principles of scientific agriculture and mechanical trades, so that, as small businessmen and members of the petite bourgeoisie, southern blacks could survive independently. As that happened, they would begin to garner a certain level of material solidity, which in turn would slowly but eventually yield them a political place in the nation. Johnston's view of Hampton fits happily into this sanguine plan.

Yet the agricultural and industrial world in which the Hampton training was supposed to equip the students to survive and prosper was rapidly industrializing on a massive scale. In the second half of the nineteenth century, economic, political, and social structures underwent unprecedented, rapid, and fundamental change. The individualized, small-scale, low-capital, unmechanized operations that Hampton taught—the kind of work that would fit easily into a pastoral setting—was in actuality outmoded almost as soon as it was learned. It was training for a second-class career at best and more likely for domestic service or low-level, nonunion labor. At worst, as the thirty years after Johnston made her pictures were to show so savagely, it was training for nothing at all, since black farmers all over the South would lose their land in a rapid downward spiral of tenancy, debt, and depression. Thousands more, migrating north, would find a market for their labor and skills not as independent small businessmen at all but as an increasingly degraded industrial workforce. Nor did the teacher training received at Hampton enable the graduates to "uplift their race" out of this predicament.

The utopian quality of the Hampton album thus reflects not only an artist's individual expertise but also a commonly held perspective, that is, an ideology. "It cannot be exaggerated, the degree to which we believed in the innocence of the United States," wrote Rebecca West of the European view of the United

States in 1900. "We fondly believed that the black man's sufferings were over now that the North had won the Civil War, and that the Red Indian was still better off if he were in tutelage to the white man."[39] Here is not so much a picture of the state of American race relations as it is the record of an emotional and intellectual tropism to a past gone by, presented as a vision of social progress. Like William Morris's program of medieval crafts, the curriculum at Hampton was an exercise in seductive nostalgia, a gorgeous veil that helps account, I would argue, both for the remarkable quiet radiance of Johnston's views and for the admiration with which they were received. "The 1900 Paris Universal Exposition contained many signs of the new technological age to come," Rebecca West recalled. "For the first time the public were shown such new inventions as X-ray photography, wireless telegraphy and automobiles, then about five years old. The entire exhibition was run by electricity and visitors toured the site on an electrically powered moving platform with three tiers, each rolling at a different speed. In contrast, much of the arts on display looked backwards rather than forwards."[40] Johnston's photographs are consonant with the tone of the entire arts exhibition as West described it. The new technology, and the new social and labor relations that came with it, are nowhere in evidence in the images.

At Hampton Johnston photographed a myth on the eve of its explosion. Johnston, the school officials, the students, and the international audience at Paris were all complicit, to varying extents, in creating and accepting the particular thrust of this representation. This fact should be seen partly as an index to the horror of what the myth repressed and partly as a sign of white supremacy, like the "nursemaid" photograph by George Cook, which constructed a similar domestic myth. A generation after the Civil War, with its 600,000 battlefield dead, it was evidently much more attractive for both Europeans and white Americans to believe that contemporary black life was like life at Hampton than to attend to evidence of its catastrophic disintegration, such as the rising incidence of lynching and other racial violence during and after the Reconstruction era, the period in which Johnston, the school authorities, and both those who are pictured in the Hampton photographs and their audience actually came of age.

Frances Benjamin Johnston was a creative, hardworking woman, supporting herself on her own income from photojournalism and lecturing, the kind of successful entrepreneur that Hampton itself was eager to nourish. Perhaps her well-known respect for hard work—she called it "a talent for detail"—was even one of the things that recommended her to the authorities of a Quaker-backed school to represent their institution. Yet knowing work as well as she did—and a kind of work that, as she herself emphasized, was a rare accomplishment for a woman—she was still capable of seeing the labor at Hampton as chiefly bucolic. On the other side of her camera, Booker T. Washington knew work from a different point of view. After all, he had first heard of Hampton while working in

a mine, while she had been invited to the campus as the official photographer chosen to represent the school in an international exposition. Washington remembered the students' frantic struggle before class to get all the shoes shined, all the buttons buttoned, all the many pieces and parts of the Victorian costume presentably assembled—sometimes even to get the shoes to wear and the buttons to button in the first place, while "struggling with a poverty that prevented their having the necessities of life." It is this knowledge that seeps through the cracks in Washington's address and so often heaves his sentences awry. But Johnston's camera shows nothing of such exertion except its outcome. She portrays the scene that she enters as already fundamentally composed. Her task, which was certainly hard, was to arrange the students in orderly rows and graceful groups. Their task, which was infinitely harder, was to present themselves in the first place in a such a way that she would be able to arrange them.

The difference between the external representation and the internal experience of effort in these tableaux may not be ascribed to technical limitations, the age of the students, the official character of the commission or a fundamental inability to imagine alternatives. It is most usefully attributed to the blindness of selective attention that results from the schisms of race, class, and gender. In a sense, while Johnston's beautifully controlled camera records her wishes, her averted gaze also betrays her. In learning to read the conscious rhetoric of the Hampton album as a record of choices that ignores certain possibilities and presents others, what we are analyzing is the warp and woof of the social, political, and economic fabric that underlay the image of Hampton and the reality of Hampton, making them both possible. In decoding the place and the scope of action allowed to the students in Johnston's photographs, we are decoding at the same time a representation of the dominant ideology of racial place and scope; blacks and Native Americans might have a circumscribed place and accomplish some movement, but not too fast. In other words, what the images present is not Hampton "as it was" (an impossibility) but Hampton as it had meaning for the dominant culture. In analyzing the configuration of what wins and what loses out in Johnston's images, what we are reading are traces of the conflicts that were responsible for the way the past was lived and a record of the ways in which the late nineteenth century mind applied ideology to life.

In at least three ways Johnston intentionally adopted what can be called a white patriarchal stance toward both Hampton and photography. White paternalism was the recognized modus operandi of the school. At the Hampton of this era, racial "mutuality" meant that the whites had to stoop and the blacks and Native Americans had to stretch. In telling what he learned there, Booker T. Washington wrote, "No white American ever thinks that any other race is wholly civilized until he wears the white man's clothes, eats the white man's food, speaks the white man's language, and professes the white man's religion."[41] Johnston

had no problem with the official view of the function of the school, with the school authorities, or with the propagandistic aspect of her assignment. As we have seen, she succeeded to an extraordinary degree in making even the deep-lying rhetorical structures of her Hampton images coincide with the dominant narrative.

Johnston was also a photographer for hire. She had not sought to photograph Hampton out of a personal expressive need, but had won the opportunity in a competitive professional world. Photojournalism was overwhelmingly dominated by males, and although Johnston was always proudly vocal about succeeding as a woman within the professional structure, that structure was not one that she ever challenged in any direct way. The photographs themselves present the lucid, coherent, seamless kind of surface that feminist theory has identified as being congruent with patriarchal discourse.[42] Although the tableaux are obviously staged, the medium within which they appear to us is coded as a transparent window on the past. The fixity of motion within the scenes is replicated by the determined fixity of the camera, which, except in a few important instances to be discussed later, always takes a middle distance, head-on, straightforward, comprehensively wide-angled, controlled, and predictable position that is also characteristic of the established symbolic order.

However, this very same transparent, uniform, and reliable representation reveals the ideological orientation that underwrites Johnston's practice of the medium. Such a revelation does not occur because a uniformity of technical style is inherently *male;* Johnston is obviously a woman photographer, highly competent in mechanical technique and the creation of a flawless surface. Nor does this revelation occur because Johnston is trying somehow to undermine the patriarchy of her time in favor of some redemptive maternal text. It is most likely that such an idea would have been anathema to this never-married, competitive, self-styled "greatest woman photographer in the world."[43] It occurs because such a perfect surface, as a sign, per se, colludes with the established patriarchal style, the mode of uniformly predictable social discourse within which both white men and women made nineteenth-century racial culture. But the universal representation that this mode claims to provide can never be completely achieved in any photograph, and the semiotic resists her. Once the edges of the ideology are glimpsed, however momentarily, as a style, it can no longer be believed to be inevitable, despite her own intentions.

As we have seen, there is not the slightest reason to believe that Johnston had any antithetical purposes in mind when she photographed at Hampton. By working as a photojournalist and by accepting the assignment from Hampton, she knew she was considerably enlarging the middle-class white woman's sphere of domestic action. However, such expansion of the white woman's place had been largely accepted and was a major pattern of female behavior in the post–

Civil War decades, amply represented in the clubwoman movements and in the leadership of women in social welfare reform, in the role of "housekeepers" to the world.[44] Along with articles written by Johnston about her career as a woman photographer, in the 1890s the *Ladies' Home Journal* published numerous accounts by determined and philanthropical women on prisons and slums, reporting "where I went and what I saw" to the publication's domestic readership. Socially speaking, Johnston, unofficial "court photographer" of the White House, was, and wished to remain, a lady.[45]

But because it *was* as a white lady that Johnston wielded her camera, her situation vis-à-vis Hampton reproduces an especially dense intersection of racial, class, and gender issues. Her act of photographing made possible a social moment in which the photographer's representation of the school, the self-representation of the students and faculty, and the self-representation of the photographer gave form not only to dominant but also to repressed and schismatic truths. In this way, simply in going to see, in organizing what she saw, and in recording what she orchestrated, Johnston became a witness beyond herself.

The Hampton album, in fact, is especially rich in localized but unacknowledged spots of contradiction to the organizing narrative. The multiple *puncti* signal a high level of semiotic presence, which accounts for the perception of Kirstein and others that the photographs are "inexhaustibly revealing." They are "inexhaustible" precisely because they use up semantic systems before they are fully explicated; and they are "revealing" because, like parapraxes, they uncover the boundaries of the social construct that underlies them. What is left in excess of hegemonic meaning in the images is painful, plentiful, anarchic, and sometimes even exhilarating, though never deliberate. In an important sense, what reading this excess does is to establish the photographic text as a locus of ideological critique, as well as a mode of ideological transmission, such as we saw earlier. The photographer's mise en scène, her choice of group arrangements and camera angles, and the body language and self-presentation of the photographed subjects construct a submerged text that is analogous to the unconscious in Freudian theory, to maternal language in Kristevian semiotics, and to the Real in Lacanian psychoanalysis, in the challenge it allows viewers to make to the dominant story.

Johnston's photograph titled "Literature—Lesson on Whittier. Middle Class. 1899" shows a small English class in the midst of a student presentation on John Greenleaf Whittier, one of the supporters of Hampton. On the right-hand side of the picture frame, nine young men sit in rapt but relaxed attention in chairs that have been moved to the edge of the classroom to make a grouping that is more informal than the ordinary arrangement. Standing behind them are three more students and two white teachers, a woman and a man. All the students

4.17. *"Literature. Lesson on Whittier"*

wear military dress, but these garments seem like mere decoration, since there is
no reference to the contemporary war in any other photograph. The shiny but-
tons, the high white collars, and the stripes on the legs of their trousers empha-
size the straightness of torsos and the precision of coordinated postures. On the
left-hand side of the picture frame, a single student stands behind the teacher's
table at the front of the class and reads his report. The legs with stripes, the but-
tons, the collars, and the eyes all point to him. At the back of the room the
tallest student inclines his head and shoulders forward, as if the better to hear
what his classmate is saying. In the center of the classroom a portrait of Whit-
tier stands on an easel. Above it, slightly to the right, is a portrait of George
Washington, nearly ubiquitous in the rooms at Hampton. These three figures
are related metonymously, by proximity, in a chain of associations that reads:
student, poet, father. At the extreme right and left boundaries of the group, two
students tip their heads to one side in a slight, yet discernible, pantomime of
intense and pleasurable attention. They enclose the student group within this
sign. The disruption of the ordinary classroom seating plan and the presence of
a student speaking in the teacher's place strongly suggest a break in discipline.
The explanation the image offers for this release is the fact that they are study-
ing a poet. In this class it is the skills of culture, rather than those of earning a

living, that are being exchanged. The atmosphere is manly. There are no women students in the class, and the predictably female English teacher is carefully balanced by a male. The suggestion is that along with geography, arithmetic, and agriculture, at Hampton they know that culture, too, is very important. The listeners certainly look as though they give poetry its due. But while intensity and seriousness have their place, they are evidently to take a more genteel, leisured, almost clubby form than they do in other classes—the imagined internalized shape, perhaps, of culture itself. Except for the uniforms and furnishings, a literary paper being read before gentlemen in a private drawing room would not look very different from this scene; the class is a practice session for such gracious literary opportunities. All this they are exhibiting expressly for the camera.

Yet the poet chosen is Whittier, a radical known as "the slave's poet." Whittier's personal connection with Hampton partly explains his presence. Because of his role in helping to found Hampton and his continued moral and financial support, Whittier must have seemed a kind of poetry mascot for the school, almost, perhaps, like one of the family, their very own poet. An anonymous review published in 1891 exemplifies what certain Whittier fans of that era believed:

> Whittier is what he is by means of his unmatched power to touch at the depths and stir to the heights man's and woman's spiritual nature. He is the poet of the purest affections, the sublimest aspirations. He is the poet of the conscience. He is the poet of divine fatherhood and human brotherhood. He has made the family fireside glorious. He has inscribed on many a page of this work-a-day life of our errata which, spelled out as seen through tear-dimmed eyes, take shape as follows: "For 'home,' read 'heaven.'"[46]

The message that home is heaven was perfectly aligned with what Hampton was trying to teach.

But the gentle virtues of private life and domesticity had not been Whittier's only message. It has been estimated that perhaps a third of Whittier's poems are concerned in some way with slavery. In the collected works there are ninety-three poems under the title "Anti-Slavery" alone and many more that make distinct reference to slavery. For a period of more than twenty years, Whittier was a vastly successful propagandist for abolition, one credited with affecting "thousands of common readers who were rarely touched by sermons or newspaper editorials."[47] Early on in his abolitionist career he appealed directly to the most primal level of revulsion against slavery in his poem "The Slave-Ships":

Hark! From the ship's dark bosom,
The very sounds of hell!
The ringing clack of iron,
The maniac's short, sharp yell!

The hoarse, low curse, throat-stifled;
The starving infant's moan,
The horror of a breaking heart
Poured through a mother's groan.[48]

By 1843, he was writing powerfully of the religious hypocrisy underlying the slave commerce:

A Christian! going, gone!
Who bids for God's own image? for his grace
Which that poor victim of the market-place
Hath in her suffering won?

My God! Can such things be?
Hast Thou not said that whatsoe'er is done
Unto Thy weakest and Thy humblest one
Is even done to Thee?[49]

Soon the threat in his poems was no longer veiled, even through negation.

The blast from Freedom's Northern hills, upon its Southern way,
Bears greeting to Virginia from Massachusetts Bay:
No word of haughty challenging, nor battle bugle's peal,
Nor steady tread of marching files, nor clang of horsemen's steel.
No trains of deep-mouthed cannon along our high-ways go;
Around our silent arsenals untrodden lies the snow;
And to the land-breeze of our ports, upon their errands far,
A thousand sails of commerce swell, but none are spread for war.[50]

And shortly, despite his Quaker pacifism, Whittier was exhorting his readers to take up arms, in "The Sentence of John L. Brown":

Speak out in acts. The time for words
 has passed, and deeds suffice alone;
In vain against the clang of swords
 the wailing pipe is blown!
Act, act in God's name, while ye may!
 Smite from the church her leprous limb!
Throw open to the light of day
 The bondman's cell, and break away
The chains the state has bound on him![51]

Southerner Robert Penn Warren later wrote that "Whittier was without much natural taste and almost totally devoid of critical judgment" and that "in poetry he could only pile up words as a mason piles up bricks; he could only repeat, compulsively, the dreary cliches; his meter-making machine ground on, and nothing that came out was, he knew, real."[52] But this is overly harsh. Whittier did place his "meter-making machine" in the service of political action, and what resulted, the end of slavery, was real enough. In addition to their mutual study of masonry, then, Whittier and the Hampton students also had in common a generally pro-black political positioning and a recent history that was deeply implicated in social violence.

However, that radical voice, especially as it constituted evidence of how slavery touched Hampton, was not the voice that Johnston intended to depict. Johnston portrays a Hampton where black Americans' troubles are essentially over and the only thing left to do is to catch up. Here is a Hampton where the unmodulated, raw emotions of the Civil War are faded history, and the Spanish American War is not even on the horizon. The students she photographs are the sons and daughters of "freedom's first generation," but nothing about their appearance reveals this fact. Instead, the invisibility of the marks of slavery seems to be part of the point. Only one of the images of the Hampton album refers directly to the Civil War and in that a group of well-dressed black gentlemen and ladies, who look as though they might be on a picnic, gather curiously around a canon at Fort Monroe as if they are staring at a sideshow freak.

On the blackboard in the English class, elaborate chalk drawings of domestic scenes accompany lines inscribed from two of Whittier's poems. I have been unable to identify one of the poems. Under a magnifying glass the title looks like "Memory Lane," but there is no poem by that title in Whittier's collected works. The other poem is the famous "In School Days." Chalk drawings were probably an ordinary feature of the nineteenth-century classroom, not a special display for Johnston. But the particular choice of poems they illustrate was made for the day she came to photograph and has a representative function. The teachers chose from the body of Whittier's work these two poems to indicate in the photograph for Paris what their classroom was about. The text of "In School Days" reads as follows:

> Still sits the school-house by the road,
> A ragged beggar sunning;
> Around it still the sumachs grow,
> And blackberry-vines are running.
>
> Within, the master's desk is seen,
> Deep scarred by raps official;

The warping floor, the battered seats,
The jack-knife's carved initial;

The charcoal frescos on its wall;
Its door's worn sill, betraying
The feet that, creeping slow to school,
Went storming out to playing!

Long years ago a winter sun
Shone over it at setting;
Lit up its western window-panes,
And low eaves' icy fretting.

It touched the tangled golden curls,
And brown eyes full of grieving,
Of one who still her steps delayed
When all the school were leaving.

For near her stood the little boy
Her childish favor singled:
His cap pulled low upon a face
Where pride and shame were mingled.

Pushing with restless feet the snow
To right and left, he lingered;—
As restlessly her tiny hands
The blue-checked apron fingered.

He saw her lift her eyes; he felt
The soft hand's light caressing.
And heard the tremble of her voice,
As if a fault confessing.

"I'm sorry that I spelt the word:
I hate to go above you,
Because,"—the brown eyes lower fell,—
"Because you see, I love you!"

Still memory to a gray-haired man
That sweet child-face is showing.
Dear girl! the grasses on her grave
Have forty years been growing!

He lives to learn, in life's hard school,
How few who pass above him

Lament their triumph and his loss,
Like her,—because they love him.[53]

On one level, the teacher's choice is marvelously apt. The Hampton that we have seen represented by Johnston is perfectly in tune with what is expressed in such a poem. The poem is a virtual mirror of Hampton. In it the regularity of timing and the punctuality of rhyme reproduce that whole sense of beneficent school-room discipline that was central to the Hampton program. The nostalgic haze that is immanent in the Hampton images is also made explicit in the poem; in both we can see that the best and dearest things in life are going on at school. At school, the Hampton students are studying a poem that tells them all that they already know about school. Even the "winter sun" in the two settings is the same. It glows and caresses objects in the real-life room—like the varnish on the door, the rim of the teacher's seat, the legs of the students' chairs—in the same way it touches and transfigures the schoolroom in the poem. Whittier's vision and the Hampton classroom shade into one another. The listening students themselves will go forth from this classroom to become grey-haired men like the man in the poem, who struggles for a place in the world. Like the speaker in the poem, they will remember that in their youth a gentle love touched them, a love that came from those who did not want to "go above" them. In the future they will win and lose in the competition of life, and unloving people may surpass them. But the memory of school days, perhaps even the memory of the Whittier poem itself, transfigured by hindsight into something powerful and holy, will keep them, like the speaker, loved and safe. Hampton and the poem promise that everything will be fine.

The poem, however, does not read entirely in good faith. Whereas the "grey-haired man" invokes the "tangled golden curls," the "brown eyes full of grieving," and the "blue-checked apron" of the girl as uncorrupted, replayable shards of a sacred past that memory still shows him, at the same time, he condescends to the image of the girl. He projects the scene for us from his memory, in which he still stands before her in all his boyhood innocence, "His cap pulled low upon a face / Where pride and shame were mingled." But, inappropriately, during the replay he refers to "her tiny hands." To neither child would those hands have seemed small, only to a belittling adult. "Dear girl!" he calls her, from a position of assumed superiority that comes only partly from the fact he is still alive while she lies in her grave. Even more it comes from the fact that he is uncomfortable with the girlish love she offered and he longed for, and that turned out to be surprisingly important to him who sacrificed it. It is difficult for him to know what tone to take toward the girl.

Unlike the girl, he tells us, he has "lived" and "learned" and been at "life's hard school," to which he refers parenthetically, in a rapid phrase that rather meaning-

lessly finishes out the meter but sounds wise. Sadly, with great self-satisfaction, he tells us "How few who pass above him / Lament their triumph and his loss, / Like her,—because they love him." Yet the singsong closure of the final stanza diminishes his real confusion, which is what to think about that girl. The "I'm up and you're down" momentum within which he envisions the world is not inevitable. It had been significantly balked, although he does not catch this aspect of his own memory, by the counterforce of a girl who "her steps delayed / When all the school were leaving," who went against the current. The very immobility of this memory of her and the fact that he cannot place it satisfactorily in the seesaw of status point to her real meaning for him. She signifies an alternative, antihydraulic vision of human relations, a vision he remains unconscious of and incapable of enunciating. In the purity of her capacity directly to love she is still "above" him, and he is still forsaking her even as he memorializes her.

The poem from this perspective is not so simple, and the Victorian pieties that Whittier expresses about how life is arranged can newly be seen as having a contradictory and challenging aspect. Yet it is quite evident that this complex reading is not what the students in the Johnston photograph are listening to. They are too at ease, too obviously uplifted. They too, like the speaker, are learning to climb, to be climbed upon, and perhaps to condescend to girls, who have not even been admitted to the classroom. The poem contains one of Whittier's most well known and often quoted stanzas: "I'm sorry that I spelt the word: / I hate to go above you, / Because,"—the brown eyes lower fell,— / "Because you see, I love you!" By 1900, this single stanza had the energy to break free of the rest of the poem; many people who did not know the whole poem could quote these lines. If we consider these lines in relation to race, as the Hampton setting seems to require, it becomes evident that the stanza addresses race relations as much as it does class and gender. What presents itself as a meditation on love is also a reflection on the seemingly unstable but practically unchangeable social hierarchies that are imposed by men upon women, by the educated upon the uneducated, and, by analogy, by the white race upon the black. In all these contexts, the poem affirms that the familiar rule obtains: someone is on top and someone is on the bottom. People may "hate to go above" you, but they will anyway; others will do so happily. Because the world they must enter is like this, the Hampton students themselves are justified in "going above" whomever they can. The figure of a girl who wants to abstain is totally unviable in this universe. In the poem, she dies. In the photograph, she is not even present. The only possible reference to her is the grown-up, white, female English teacher, that quintessential spelling-bee winner, who is already impossibly far "above." It should be noted that "home" can never be "heaven" when gender relations are so confused.

The angry political voice of Whittier's abolitionist poems is so completely ex-

cluded from the classroom that if one did not know it existed one could not learn it from the picture. The complex underside of the domestic Whittier is visibly denied by the students' genteel postures in favor of paternalist conformity to an ideal of Victorian culture and social competition. The mimicry of the class-room in the poem on the blackboard sets up a mirroring relation that reveals delimited, overdetermined social patterns in both the poem and the classroom. These coordinates establish the basis for the negativity of this image. Its uni-fied, coherent, finished surface shatters as we recognize and then supply what they conceal or indicate. Recognizing these absences and breaking through the mirror, we disclose a partialness in the classroom that Johnston never meant to show but nonetheless recorded. We see past the edges of what the Hampton faculty and administration knew or would say. We see into the students' desire, and what they, too, don't want to recognize. We see the triumph and the cost of the Hampton experiment, the kinds of choices that had to be made, the kinds of adaptations required. We see endlessly into, and beyond, the frame because we see what it contains as a product of decisions that might have been made otherwise. Small signs on the edge of rhetoric, but dependent on it dialectically, alert us to meaning that the framing devices of language and ideology can never completely encode.

The question arises of how deliberately Johnston might have imagined the pos-sibility of a critique of gender to be embedded in her photographs. While I think it is beyond doubt that her intention was to supply only supportive readings of Hampton, I think there exists evidence that her own attitude toward Hamp-ton's construction of gender might not have been entirely straightforward. In a self-portrait made in 1896, only three years before she worked at Hampton, Johnston presented herself in an attitude of rebellion toward much that Hamp-ton stood for in that domain. In the self-portrait, she sits cross-legged, wearing a man's cap, surrounded by the bric-a-brac in her own artist's studio, drinking beer and smoking a cigarette, with her skirts pulled up above her knees to reveal some very pretty legs and elegant shoes. Just as in the Hampton photographs, the pose is tendentious, rather than natural. She would not have actually sat that way and done all of those things at one time, but she wishes to signify a pleni-tude of rebellion against Victorian social conventions. The photograph states that as an artist, Johnston is not, and does not wish to be, ladylike.

A second, undated self-portrait that was evidently made at around the same time pictures Johnston dressed to kill, as the Victorian lady par excellence. She sits languidly in a heavily carved armchair and stares seductively at the viewer. She is wrapped in a heavy fur stole, her chin rests upon her carefully gloved hand, the ornate high collar of her blouse tickles her chin, and on her head she sports a ridiculously elaborate hat with double plumes that resemble a bifurcated

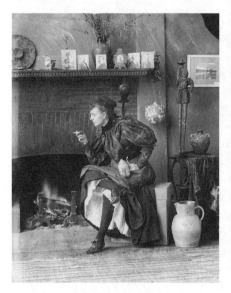

4.18. *Frances Benjamin Johnston, self-portrait as New Woman*

4.19. *Frances Benjamin Johnston, self-portrait as Society Woman*

eruption of Old Faithful. Both self-portraits are sport; both have their roots in social identities that Johnston lived but wished not to assume in strict permanence. The portraits mock exactly what the Hampton images celebrate—the fully pious placing of the social self in one or another niche, class, or role. Johnston's Hampton photographs and her self-portraits are both about mobility. But for Hampton students, mobility means a cumbersome, slow climb to the same middle-class way of life that Johnston was trying to escape. For Johnston, mobility means the quicksilver switch of identity that could be hers by right of class privilege and artistic talent and that must not seem to cost her much.

Picturing herself in this way, she could not have given the kind of education she saw at Hampton her unreserved approbation. Thus, in order to comply with the demands of the assignment to picture Hampton in its most flattering light, Johnston could only have distanced the black and Native American students she saw from her sense of herself. If she and they had differing needs, it must be because she and they were fundamentally different on the grounds of race and class. Hampton might be all right for them, but not for her.

As a female artist in conflict with the strictures of her own position, striving to loosen her own bonds, Johnston seems unaware of an analogy, however tenuous, between her desire for freedom and theirs. The white, Victorian, un-

married woman artist was more conscious of being caught in a density of feminine proscriptions than was usual for other white Victorian women. In her essay "Articulating Race and Gender in a Theory of Social Formations," Hazel Carby has suggested that the social construction of gender has important repercussions for such a consciousness, ones that extend far beyond the internal psychological issues it raises. This is due to the fact, she argues, that "the ideology of the dominant class offers women their gender definition as the situation through which race and class are lived."[54] That is, for white middle-class women like Johnston—even when they were working women—their class and racial positions were defined through their social experience of gender. There are certain complications associated with this gender system. With conformity to social custom comes "natural feminine superiority," but a dangerous consequence of rebellion is loss of the privileged status of "womanhood." Since it is as white women that such women as Johnston are expected, and come to expect, to read themselves in every relation to others, maintaining their feminine self-definition is inextricable from monitoring their social consciousness. Engaging in uncondoned social action may mean the loss of the crucial self-definition and social position "woman." If and when the "bonds of womanhood" become intolerably constricting, as they did for Johnston, the pressure for greater freedom of action can lead also to an extension of the woman's political activism.

But more often, as for Johnston, it does not. In open rebellion against her own domination as a woman, Johnston might have been personally interested in what she could learn from the men and women she photographed, who were of races and classes different from hers but subordinate to white, patriarchal power. In an unmapped, subterranean sort of way, the young white woman photographer might have begun to formulate a sense of community with the newly freed subjects of her photographs. Perhaps the setting of a school was even especially suited to bring such feelings of identification forward, for a school is an institution that both exaggerates and intensifies dependency (especially for Hampton's adult enrollment) and at the same time legitimates and normalizes the desire for power, escape, and transcendence. It may be easier to empathize with the aspirations of others in a school than to feel the same bond on more open ground. In school, after all, everyone of any race or class or gender is expected to aspire; and in school, as everyone recalls from his or her own childhood, the pain of failure is ever present and visible on the surface.

But the critique of Hampton that might have taken shape before Johnston's lens in the English class seems to have slipped by. If it is there, it is there purely in an unconscious manner. Any moment in time is heterogeneous. It holds evidence of the success and the failure of our worldview to fit the facts of our lives as they are lived. This is why the act of making a photograph out of a social moment can and does create contradictory signs. Since our lives are contradictory,

the photograph will record those contradictions. Insofar as Johnston's photographs are powerful documents, I think one explanation for their power rests in her use of the situation at Hampton as a stage for projecting a hidden protest at the way things were supposed to be. It was a flawed protest, however, formulated around a domesticated vision of gender that built upon the operations of race and class.

In analyzing Johnston's work, therefore, one must be very careful in how one applies the reasonable assumption that it contains a critique of her world. As with many nineteenth-century, white, middle-class woman pioneers in the professions, what looked to her like women's issues and what she saw as their solutions are not necessarily what seem so now. White, middle-class women reformers were deeply bound by race and class. One must guard against creating an image of Johnston that mirrors late-twentieth-century styles of political activism. One must also not assume that the barriers of race and class were less significant at that time for being, perhaps, more apparent. On the other hand, it would be equally injurious to overlook the feminist statements she was making. It would impoverish the reading of the photographs because it would prevent asking what she, as a privileged white woman did or did not do with her "secret eye," the pattern that, in turn, holds the meaning of her contribution.

We know that Johnston was interested enough in the woman suffrage movement in 1900 (the same year she exhibited the Hampton photographs) to travel to the home of the eighty-year-old crusader Susan B. Anthony and photograph her in her study. These photographs were later published and widely distributed on the *Anthony Calendar* of 1901, a calendar that commemorated the equal rights struggle for American women. Pete Daniel and Raymond Smock call the Anthony portraits "the most interesting study Johnston did of an American woman," and their judgment is borne out, I believe, by the enormous presence that Johnston's images have underwritten for Anthony.[55] But they are also fascinating specifically for what they help us to discern about Johnston's own attitude toward Anthony.

In the portrait entitled "Susan B. Anthony in Her Study," Anthony sits in profile at a beloved desk crammed with papers and memorabilia. Covering the walls, the desktop, the writing surface itself, are photographs of women, many of them autographed, all of them obviously cherished. These women—friends, associates, and heroes—are those who have figured in the great struggle for which Anthony's study is now a shrine. As the elderly leader sits for her portrait, a sense of history, the pride of achievement, and the urgency of what is yet undone contend with one another in Anthony's portrayal of a self that is posed between the multivolume *History of Woman Suffrage* on the one hand and the week's unrelenting correspondence on the other. Sitting thus, Anthony is ab-

4.20. *Susan B. Anthony in her study*

sorbed into the ramifications of her own vitality; the picture enacts Anthony's powerful consciousness of history being made.

The photographer seems aware that Anthony must soon be translated from life to image herself, and she conspires to make a perfectly remarkably pictorial statement of Anthony's own place in the gallery of women. She has draped a black cloth over a wooden structure behind Anthony's head. Formally, this black background places Anthony's sidelit profile and white lace collar into brilliant relief; it is the aesthetic center of the image. But semantically it has another function. It takes the highlighted portrait of Anthony and makes a visual analogy between her photograph and the score of other photographs of women with whom it is in line along the wall. By flattening out the planes, it produces the visual illusion of Anthony's portrait as one more, and the largest, among them. In Johnston's photograph, Anthony is metamorphosed into a photograph on her own wall before she has ceased to be a living woman seated at her desk. She takes her place in history as Johnston takes her picture—not just *because* of Johnston's picture, which is, of course, of historical importance, but because of the way Johnston envisions her.

This respectful attitude is, arguably, quite deliberate, for it is unlikely that the

4.21. Johnston at her desk

posing and the framing would have occurred the way they do without choice. Perhaps even the black cloth itself, the symbol of the photographer and an indispensable element of her equipment, was Johnston's own. Here, it stands in for Johnston, being a sign that she, a photographer, has rearranged things. Because of this black cloth, Johnston is more apparent in this image than in nearly any other, save for her self portraits. For whatever reason, she is unusually willing to have traces of herself represented in her portrait of Anthony.

The thoughtful presentation of Anthony in her study compares with Johnston's photographs of herself in her own working environment, the studio she built for herself in back of her parents' house in Washington. There, like Anthony in her study, Johnston sits at a desk surrounded by images. There are photographs—presumably of friends, associates, and heroes—and current posters, whose fashionable graphics display images of the New Woman. Johnston's pose is assertive and businesslike; she holds a pen and correspondence in her hands. In all, the two images seem remarkably similar, perhaps even intentionally so. Yet, one eloquent distinction is to be made: the photographs with which Anthony surrounds herself are chiefly of women; those in Johnston's studio are chiefly of men.

The inevitable semantic ambiguity of photographs and the photographer's lack of complete control is sometimes offered as an argument against putting

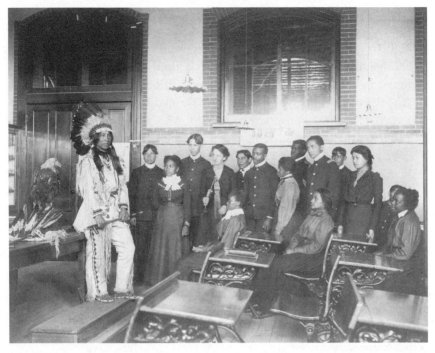

4.22. *"Class in American History"*

much historical weight upon the interpretation of photographic evidence. It is as if because photographs can mean more than one thing, they must mean nothing. And yet, we do have another choice, which is to bring to photographs the same wary sifting and comparing of detail that is habitual in interpreting other forms of evidence. As in more traditional historical documents, the presence of contradictions does not mean the absence of meaning—potentially, quite the opposite. In fact, as I have been arguing, it is only through understanding the choices that have been made between alternatives—learning what won out, what was lost, how it happened, and at what cost—that the meaning of the past can appear. I believe the fact that Johnston's camera can record more complexly than she directs it to is the key, not the barrier, to their usefulness for understanding the past. Since her photographs allowed her to show more than she was willing or able to express otherwise, they give us an invaluable opportunity to compare what she felt was appropriate for public exhibition with what she felt she needed to deemphasize and with what she apparently never saw.

Let us consider at some length the well-known image entitled "Class in American History." Of this image, Lincoln Kirstein wrote, unforgettably,

> We behold a live Indian in full tribal regalia, posed on a model-stand, glorious as a thunderbird, isolated and strange as if he were stuffed and cased be-

hind glass in the old Smithsonian Institution, that "attic of America." An Indian boy, uniformed in the official Battalion blue-and-gold version of a U.S. Trooper's dress, regards his blood-brother with awe. Behind perches another masterpiece of taxidermy, an American eagle, as ferociously disinfected and harmless as the patient students themselves. On the wall behind is a print of a Remington painting: cavalry, on their rough-riding way to exterminate the rebellious Piute or Ojibwa. Miss Johnston betrays no ready resentment. The Indian youths in their starched collars survey the scene as if it were still-life, which is exactly to what she has been able to reduce the spirit in this odd happening.[56]

Kirstein is sharply aware of emotional undertow. Socially speaking, the picture is a virtual maelstrom of conflicting currents. It would be reasonable to think that someone or something was to blame for such cacophony, and Kirstein, therefore, goes out of his way to exclude Johnston. "This is by no means to suggest that there lurks some secret, unsuspected or condign parody in Miss Johnston's prescient lens. She has merely the taste to arrange what she finds."[57]

But whereas it is comforting to know that Johnston did not think up this tableau and reassuring to be told that the multiple faux pas of this rather preposterous image were generated by the participants themselves, it is not an adequate explanation of the image. Kirstein wishes to place its confusion to the account of "history" itself:

> Her subjects continue their essential lives, independent of her or our observation, locked in the suspension of time, like flies in amber, but nevertheless alive in the translucent air of history. They stand as metaphor or parable in their sturdy dreaminess, their selfless absorption in self-improvement. It is a measure of Miss Johnston's vision that she enables us to spy upon so many anonymous, long-vanished individuals, who still so vividly speak to us in public of their proper private longings for a shared social paradise. Despite her camera's candor, her entire incapacity to trim or trick, we must know it was not, nor by no means yet is, any earthly heaven. But she did capture, to an almost magical degree, the better part of an historic aspiration in its innocent and necessary striving.[58]

But the "air of history," as we have seen, is not "translucent"; her subjects are not living their "essential lives" and "private longings" in public; and they are neither "independent of our vision" nor of hers. Who she was and the audience she stood for had everything to do with how her subjects presented themselves and how she pictured them. Their "necessary striving" may have been part of an "historic aspiration," but it could not have been "innocent." And Johnston's camera, as we have seen, did indeed harbor "some secret, unsuspected or con-

dign parody." In the effort to account for what is today an unthinkable image, Kirstein gives away all of the tools needed for analysis, one by one.

What remains is the sense that the image needs explaining. Kirstein is correct, I think, to turn to history, but it is a history that is not transparent, that itself needs to be unpacked. As Robert Engs has commented, in his essay on Hampton entitled "Red, Black, and White: A Study in Intellectual Inequality," from 1878 until 1912 Hampton Institute carried on a highly unusual program of multiracial education.

> During the thirty-four years of black and red education, all of the absurdities, hypocrisies, contradictions, and injustices inherent in American racial attitudes could be discovered at the Institute and in the lives of its Negro and Indian graduates. It is not that Hampton failed in its mission to "civilize" its students. Rather it was that American society refused to accept either blacks or Indians on the basis of equality, no matter how "civilized" they might be.[59]

What is rising up in this photograph are the "absurdities, hypocrisies, contradictions, and injustices" of that history; so much is clear. But the significance, the meaning, of these absurdities is not spontaneous. It must be retrieved from where it has been consigned, underneath the self-evident paternalistic surface of the print. The ideological and the semiotic level in this image are in particularly strong contention with one another. The competition, here, between what can and cannot be spoken is at a higher pitch than anywhere else in the body of Johnston's work.

In the image there is once again a break in the normal schoolday discipline, marked by a disruption in seating. A Native American in ceremonial dress, holding a peace pipe, stands on a bench at the head of the classroom, in front of a stuffed American eagle, and presents himself as an exhibit. The Remington print hangs on the wall to his side, directly in front of us. The Native American meets the gaze neither of the students nor of the viewer of the photograph, but looks off at an angle into the distance. Managing the lines of vision in this way, he offers himself fully as an object to be stared at, while refusing any access to his own subjectivity. The Native American, as if in an ancient tribal test, is able to make his personhood invisible at the same time as he exposes his body so cruelly. This places us, the viewers of the photograph, into a parallel relationship with the students in the class; they look at the Native American, and we look at the Native American, and the Native American does not look at us. But the triangulation is not equally weighted, for we, the viewers, also look at the students, while they cannot look at us. Thus, the photograph exaggerates our access to the Native American and the students. In it, they *both* are objects of our gaze, open to our visual pleasure. The students, however, seem defenseless in the openness of their looking; from their postures and their expressions, we can tell what they

look at and that they wonder. Meanwhile, the Native American is closed; we do not know what he looks at, and we cannot touch his emotion except as a stuffed dead thing. He is alive, yet what makes him alive, how he endures his situation, is unknowable.

A second triangle is inscribed in the image. It runs from the viewer to the eagle to the Remington print. All are official symbols of the United States. The eagle is obviously so, the viewer only slightly less obviously. One merely has to remember that the photograph was made for the American pavilion at the International Exposition to recall the functionary character of its imagined audience. The intended viewer, in whose place we stand, officially represents the United States to the world. The third point is the Remington print. Emblematic of current American expansionism against peoples of color, into Native American lands on the North American continent, and abroad, in the Philippines, the print depicts a scene of military conquest. The triangle of official America is wider than, and circumscribes, the triangle of the Native American, the students, and the viewer, but the viewer is at the apex of each. Thus, the Native American, black, and white drama of the schoolroom is contained and encoded within a set of symbols of our national identity, and of personal identity, that situates us, the viewers, in the ministerial and powerful place. We are the link between both triangles, the place where they intersect. We are, in Lacanian terms, the "subject supposed to know," for whose sake the image is made.

In the name of the powers that be, the picture explains that the American conquest of the Native peoples is complete. Our native savage has been tamed enough to be safely shown alive to a high school class, like other live exhibits of natural history. Just as the black students throughout the Hampton album exhibit no debilitating marks of slavery, the Native American students in this image betray no dangerous resentment. If the three Native American boys in the back of the group do not seem to stare at the exhibit with the same open curiosity as their black classmates, at least, like the others, they stare at, and not past, the Native American on display, as they are supposed to do. As is generally so in the Hampton images, on an ideological level the image signifies that everything is under control.

What disrupts the adequacy of this explanation is first and foremost the tremendous and mysterious presence of the Native American on display. The students cannot return our gaze and, therefore, strictly speaking, are objects rather than subjects within the discourse of the image. But they play the part of actors with their subjectivity intact. As they bounce their questioning faces against the display of a Native American in their class, they do not enact the explicit role of objects. Although they must be aware that they will eventually appear in a photograph to be looked at, they are objectified unknowingly, as it were. On the other hand, the Native American takes upon himself explicitly the role of

object. He exaggerates it, he deepens it, and by so doing, he transcends it. The trajectory of *his* averted vision removes his subjectivity beyond the frame. In a consummate outwitting of the camera, he makes it plain that we can capture his body only. His spirit will escape. Since we, the viewers at the single apex of the double triangle, stand for American policy as well as private vision, it is clear that this Indian has eluded the official grasp as well.

"Class in American History" is therefore a deeply ambiguous image. It illustrates on the one hand that the authorities at Hampton have correctly gauged both the political situation of the nation and the educational and ethical needs of the students. On the other hand, it offers insistent, unintended evidence that Hampton does not know what it is doing. Johnston, as the maker of this contradictory image, might seem to lack consciousness. As I argued earlier, I believe that is indeed the case. But her own repression of the political meaning and social violence of what she saw at Hampton is one reason, I believe, that the photographs are still so powerful. The social moment that Johnston recorded is as complex as any in our history, and Johnston had the rare ability to orchestrate while refraining from narrowing that complexity.

In the *Hampton Album* two more Native American pictures appear on the page facing the "Class in American History." This page is unique in the MoMA album because, like the original album, it contains individual portraits; everywhere else students appear in groups. These two Native Americans are therefore doubly isolated: first, because theirs are single images, and second, because as a reference to individuals within a powerful group aesthetic, they are thereby distinguished from it and placed outside of it. The excision of the images from the group is enhanced by a number of different textual procedures. First, although the portraits are printed two to the page, as no other page is printed, the actual space taken up by the image of each of person is much larger than that occupied by any person in any other picture. Around each portrait, also, is a border of white page. This in itself is not different from any of the other photographs in the album except in its effect. Whereas the border of the group portraits functions to unify the many people within the picture as a single group, the function of the borders of the two single portraits printed side by side is to further separate the images from one another. As a result, the singularity of the Indians is emphasized both by the relatively much larger size of their individual images and by the creation of an abstract boundary between them.

Second, the backdrop against which the portraits are taken appears to be the assembly room stage curtain or some other such featureless drapery. In every other photograph in the album the subjects are presented inside a painstakingly elaborated scene. It is, in fact, because the varied backgrounds are so spectacularly detailed that the compositions come to be so full of meaning in resonance

4.23. *Adele Quinney*　　　　　　　4.24. *John Wizi*

with the carefully placed groups. Only these two portraits are dispossessed of
the visible contextualization afforded every other photograph.

The third thing that distinguishes these two images is the written text that
Johnston apparently supplied for them. It reads: "Far left: 'Adele Quinney.
Stockbridge tribe. A girl whose every physical measurement is artistically cor-
rect.' Left: 'John Wizi. Sioux. Son of Chief Wizi of Crow Creek. S.D.'" By itself,
the visual rhetoric that serves to differentiate the pictures of this Indian boy and
girl from the pictures of the group also serves to offer the images to the viewer
as a pair. That is, the pictures construct a situation in which the two Native
American students are not "the same" as the others because they are solitary.
But because they are alone together in that difference, the pictures indicate that
these two students are "the same" as each other. Furthermore, they are pictured
against the same backdrop and seated in the same chair; the light in the images is
the same; and they are photographed according to the same photographic for-
mula: the three-quarter frontal, close-up torso view, hands in lap, unsmiling,
attentive expression, and eye contact with the photographer, which is relayed by
implication to the viewer. And in the context of the many coeducational group-
ings in the repertoire, the choice to isolate a boy and girl increases even further
the chance to find them legible as a pair, even though the viewer is unaware, of
course, of the actual social relations between the two living subjects.

But Johnston's written text splits this matching in a particularly instructive

way. The caption relates John Wizi to his tribe; to the geographical/political location of Crow Creek, South Dakota; to his father, Chief Wizi; and, by means of his father's chiefdom, to patriarchal authority, both within the tribe and within the larger white nation that competed with it. John Wizi's caption, therefore, encodes the boy within a detailed sociopolitical system, where it becomes possible to speculate about his specific history and the effect of the school upon it. Although John Wizi's solitary image is isolated from all the images of groups of people at Hampton, it is not removed from a fuller social context.

The image of Adele Quinney, on the other hand, is differently assigned. The caption identifies her as a member of a tribe, but that tribe has no specified location, and no familial, social, or political position within that tribe is named in relation to her. Unlike the caption for Wizi, the caption for Quinney separates her thoroughly from her social context. In the place of specific information about her social role is offered the brutally objectifying information that her "every physical measurement is artistically correct." This observation may have been supplied to confound the racist suppositions of physical anthropology then coming into vogue, or it may have been simply a dissociated artistic observation; it is not possible to determine. But the effect is to institute a disjunction between the two portraits that is of great importance in reading their meaning to the album.

Despite careful coding of the images as "the same in their difference," the captions show that the portraits of the Indian boy and girl are far from equally placed. The momentum of the depiction of the masculine "Other" is toward his capacity to reproduce social relations, with himself as a subject. The caption assures Wizi an unerased social identity, by virtue of which, no matter what his future life decisions, he will figure as an actor in relation to his own people and also, remotely, to the American nation as a whole. But Quinney is vouchsafed virtually no social identity that adheres to her beyond the representations of her own body—how her features are formed, how she holds her head, her general posture and bearing, and, by extension, the clothes she chooses and the style with which she carries them. The feminine "Other" is doubly remote from subjectivity as defined by the dominant culture: as a Native American, she is at one remove from "civilized" instrumentality, but as a female Native American, she is an exotic object to be appraised.

The white border between the two prints in the MoMA layout takes on a special function from this information, which is transmitted below the enunciatory level of the text. The "abstract boundary," as I termed it before, that separates the two images, makes a symbolic as well as a formal statement. It stands for the gulf of gender. A powerful verbal pun lies hidden in the caption for the photograph of the classroom on the facing page: it is a photograph of "class in American history" if there ever was one. Similarly, the featureless strip between the images

of Quinney and Wizi is a visual pun of a very high order. The blank separation of these two portraits is like the mute distinction of sexual privilege, as major as that of class or race, which is sublimated but powerfully operative in the image and its caption.

It is interesting to compare the photograph of Adele Quinney to the photograph of the Native American on exhibit in "Class in American History." In the group photograph, we noted how the Native American managed to outwit the alienating force of Johnston's camera by taking upon himself the conscious role of exotic object and intensifying it. In this he is aided by the irony of the scene into which he was placed. By increasing the force of his own objectification, the Native American demonstrates its inappropriateness and counteracts it. Adele Quinney gets no such help from the relatively contentless surroundings in which she is photographed. Nor does her facial expression or bodily posture imply that she is aware that she must make a defense. In contrast to the Native American man in tribal dress, the Native American woman in Victorian dress gives access to the camera. She seems somewhat wary but also proud, and she shows that pride and self-respect in her face. This is different from the Native American man in the classroom, whose facial expression we cannot determine, whose emotion is wholly inward.

In presenting herself and her quiet pride for the viewer's pleasure, the young woman performs an act that is deeply concordant with the prescribed gender role of white women. In mainstream Victorian America, such women, as opposed to men, were *supposed* to be proud to be objects of visual pleasure.[60] Indeed, the fact that she can present herself in this way to the white woman's camera—in the clothing and posture determined by white womanhood, in the mode of "to-be-looked-at-ness," to use Laura Mulvey's term, or "as" a white woman—is a minor triumph of sorts for the theory and authority of the school. Native American women in native dress and tribal surroundings hardly ever drew such calm, unexoticizing attention in the white media as is bestowed by this photograph. Quinney trustingly presents herself as a *female object*—a posture that is entirely in keeping with and supportive of her wish for social personhood. And Johnston's subtle, humanistic camera work enhances this stance.

But Johnston's caption aggressively undercuts it with words that contradict the understated nonexceptionality of tribal womanhood portrayed in the photograph. In its place, Johnston instructs the viewer to see that Adele Quinney *is* an exception as an object of beauty—not because she is *exceptionally* beautiful, but because she is *correctly* beautiful. Evidently, Johnston chose to photograph her not because of what she was (a beautiful girl) but because of what she was not (an "aboriginal" type). Because she is a Native American, she is not simply a *female* object—as a well-bred, pretty white woman would be—but an *Indian* object; and as such she cannot figure as the normal "woman" she so clearly thinks

herself to be. Unlike her male companion on the album page, John Wizi, who also looks quietly and confidently out at the viewer, if a touch less openly, Adele Quinney gets enmeshed in no other knowable social framework but that of her objectified body.

With this in mind, it is moving to notice that Quinney is also present in the "Class in American History." Standing far to one edge of the little group of students who stare at the live exhibit, Quinney looks even prettier than her own portrait showed her to be. The expression on her face is just as open as it was in the portrait, and just as complicated, but rather sadder. She looks at the costumed Native American as if something displeases her or makes her uneasy, but she doesn't seem to know exactly what.[61] She stands quietly and obediently; she stares down at the middle of his chest rather than up at his face like most of the others; she steadies herself with one tense hand against the edge of her classmate's desk. His calculated self-protection is worlds away from her. She seems not to suspect how seriously the transformation of a member of her race into a classroom exhibit of exoticism and military defeat might unnerve her, although, quite obviously, it does not delight her. But even more deeply buried than that unease about what is being done to him or to her own education is the suspicion that any insult might come her way through the graceful and open goodwill with which she offers herself to the school, to the camera, and to the eyes of history.

Given her class and racial position, it is unlikely that Johnston registered much about the meaning of Quinney's complicated aspect beyond noticing it as a point of design in the grouping as a whole. Quinney is the last figure standing on the edge of the group. The interesting outline of her leg-of-mutton sleeve, the backward thrust of her left shoulder, and even the angle of her face, which mirrors (reversing) that of the costumed Indian himself—all help to bring a formal sense of closure to the scene, like the final mark of a parenthesis. A photographer as good as Johnston would probably have sensed instinctively the value of Quinney's presence on the level of design, if only for a fraction of a second. But Johnston's camera, stopping time, performs work for Johnston and for us, which, if unaided, she probably could not have accomplished herself. The photograph captures and restores to us fleeting relations of expression that could barely have been seen, much less analyzed, at the time. By permitting contemplation, the photograph supersedes Johnston's own instincts and opportunities and escapes the depletion of her narrative frame. In it, we can find a Quinney probably missed by the photographer, a Quinney who contradicts, in fact, the thrust of Johnston's complacent caption, a Quinney who communicates more than Johnston intended.

We owe our vision of this contradiction in the first place to the brilliant complexity of Johnston's practice of photography—a practice that seeks and believes

in mastery even though it cannot be fully regulated. Because of her dedication to control, design, and detail, the vitality of the past itself becomes legible in her photographs beyond her own analysis. Here is history not simply as a static thing, the frozen image of a group of long-dead students in an antique classroom staring at a long-dead Indian. Here also is history as movement, a flash of insight into the choices made by a group of people at the moment of exposure—what they did and the possibilities that, simultaneously, they were holding at bay.

We never saw the photographs then and never
thought that it would make a difference in the world
of dreams, that we would become his images. . . .
But it did make a difference, we were caught dead in
camera time, extinct in photographs, and now in
search of our past and common memories we walk
right back into these photographs, we become the
invented images.
—Gerald Vizenor,
 "Socioacupuncture: Mythic Reversals
 and the Striptease"

Käsebier's Indians

By now it can come as no true surprise that what anthropologist Mary Louise Pratt has called the "imperial eyes" of Euro-American travel writing of the seventeenth to the nineteenth centuries—a way of seeing founded upon the distinctions of self/other, subject/object, master/slave relations—spilled out of the realm of the printed text and into the new domain of print photography.[1] In the context of late-nineteenth-century U.S. imperialism, middle-class white American women photographers, like earlier Euro-American women travel writers, mediated the politics of racial subjugation through what they felt, in accordance with the history of domestic sentimentalism, to be their prerogatives in looking.

It is helpful to see what resulted as a gender-based division of labor in the visual sphere of cultural production. To colonial administrators and scientists (that is, anthropologists, ethnologists, public health officials, etc.), not to mention generals, police, politicians, and educators—all mostly men—fell the task of inscribing ever finer webs of visible signs and distinctions upon colonized bodies, in order better to regulate the lives of non-Anglo-Saxons who had newly fallen to their charge. This charge produced all the detritus of the scientific visual positivism that characterizes the managerial equipment of this period: the spatialized grids describing four stages of human evolutionary development, from barbarism to civilization, and a world map that categorized nations and tribes

by their purported level of evolutionary progress; the census reports that enumerated the existence of innumerable "tribes" in the Philippines, each one less capable of self-government than the last; the anthropometric charts that pitted the world's peoples against one another, facial angle to facial angle; the police files bursting with frontal and lateral mug shots of criminal physiognomies or multiple exposures of images of convicts twelve deep on a photographic plate, in a tower of cumulative threat that documented the need for civil protection; and so on.

To women observers fell the cognate (not opposite) visual task of refashioning the painful effects of these violations into the image of the tender empathy that allegedly accompanied domestication. This responsibility yielded images such as the ones we have been examining: deceptive reconstructions of military aggression as masculine recreation in the Philippines; phantasmic "before and after" Indian school photographs, documenting the ostensible conversion of a variety of "savages" to a variety of "civilized" regimes; complacent publicity concerning African Americans' political acquiescence to Jim Crow at the American Negro Life exhibition at the Paris Exposition in 1900; and racialist defense of the boundaries of the Anglo-Saxon family in studio portraiture of white mothers and children.

Pictures of domestic sentiment are often lovely, unlike the "instrumental" photographs of scientists and administrators. Critics have largely failed to analyze the dialectics of the relationship between the two kinds of photography. But the women who found a voice in the discursive structures of turn-of-the-century American society by making such photographs did so through its relative need for their blindness while the instrumental grasp of the image was growing ever tighter. Whether they traveled around the country or around the world "on assignment," like Johnston, or perched in a studio in New York, like the next three women photographers examined in this book, women with the ability to picture sentiment served a particularly useful function in expanding the nation's familiar sense of destiny. It was they who actively narrated the "anti-conquest," a phenomenon whose origin Pratt identifies in Anglo-European travel writing: the denial that when one looked at the nation's new populations, it was conquest that stared back.

Anti-conquest, as Pratt uses the term, refers generally to

> strategies of representation whereby European bourgeois subjects seek to secure their innocence in the same moment as they assert European hegemony. The term "anti-conquest" was chosen because, as I argue, in travel and exploration writings these strategies of innocence are constituted in relation to older imperial rhetorics of conquest associated with the absolutist era. The main protagonist of the anti-conquest is a figure I sometimes call

the "seeing man," an admittedly unfriendly label for the European male sub-ject of European landscape discourse—he whose imperial eyes look out and possess.[2]

All such strategies of representation evade responsibility by casting guileless wonder over the appearance of the "Other." But when this representation of anti-conquest is produced by the "seeing woman" instead of the "seeing man," it puts into play a particularly subtle component of the late-nineteenth-century Anglo-European sex/gender system. It invokes the determined, though unarticulated, *alliance* of middle-class women and men who share both their white race and their class.[3] Late-twentieth-century feminism more often uses the culturally con-structed binarism of masculinity and femininity to signify rivalry between men and women. But, as Pratt observes, "in terms of the gender system," a woman's anti-conquest story "is less an antithesis to male rhetoric of discovery and pos-session than its exact *complement,* an exact realization of the other (Other) side of male values whose underpinnings it shares."[4]

Pratt's analysis of gender's function in Euro-American travel writing is useful for interpreting the opening of the profession of photography to American women after Reconstruction, black migration north, and European immigra-tion to the eastern cities and during the turn-of-the-century imperial thrust into the Caribbean and the Pacific. In the sentimental tradition of nineteenth-century American photography, the fact that the camera is a machine allowed one to assert neutrality while at the same time taking possession of the scene by configuring and recording when and as one wished. As the early-nineteenth-century commentator Jules Janin explained, a photograph was actually "not a picture"; it was "the faithful memory of what man has built throughout the world and of landscapes everywhere."[5] The photographer's field was not "his-tory and poetry," explained daguerreotypist Albert Southworth, "but observa-tion of nature, cause and effect."[6] Similarly convinced of their objectivity, artist and inventor Samuel F. B. Morse declared photographs not "copies of nature but portions of nature herself."[7] Photography was acclaimed by both its prac-titioners and its audience as the very "spirit of fact," a "mirror with a memory." With photography characterized like this—"memory," "observation," "nature herself"—it followed that the photographer was not really responsible for what the camera showed; he or she only recorded what *was.* The woman's camera, like her travel narrative, was no different from the man's in this respect, for, as Pratt explains, it "share[d] the same imperative for innocence." However, the domestic-woman-turned-photographer had an edge over her male counterparts in regard to this alibi. For her, as for the woman travel writer, making a record augmented what was already accepted as her special feeling "for the soul of the subject itself." As Pratt observes, the gender division implies that for a woman

"the imperative is fulfilled in a different way: [the woman] claims an innocence already given by her gender."[8]

The always already good manners of the True Woman produce consent for conquest by presenting conquest as consent. No matter how much this cohort of women photographers asserted their independence from male colleagues, as they often did, domestic sentiment aligned the women of the dominant class *with* the men of their class and *with* the dynamics of conquest rather than against that narrative and with the women of the subaltern class. In fact, as we have seen in Johnston's work at Hampton in the previous chapter, should this alliance have begun to weaken—should these white women have begun to assert that they saw what "Other" women saw—they would have lost their ability to retain their "whiteness" in relation to "white" men, and with it the professional credibility of their insight as "women."

A strategy that opened professional doors by appealing to the True Woman's particular ability to portray insightfully the domestic relations of race and class was not without hazard for the middle-class white woman photographer herself, however. The woman with a camera may have found unprecedented opportunities for a meaningful public voice in turn-of-the-century American social discourse, but to wield the camera as a woman was also to be subjected—as a woman—to the ways in which the dominant culture put one's self and one's work into circulation. The sex/gender system that placed loyalty to the white race and the middle class above a common sisterhood of gender retained the second-class citizenship of women, reflected in the white male quest for supremacy. For instance, exploitation of their supposedly "natural" insight required that women photographers disguise or make invisible the quite strenuous activities they often undertook in order to produce this natural seeing. If the middle-class white woman photographer was encouraged through her practice of photography to insert her own family narrative into the public sphere, she was also in danger (like the white mistress) of seeing only, and being seen only, within the terms of that narrative. Her brave production of new ways of seeing became at the same time the production of new ways of *not* seeing her own potential vulnerability.

Our discussion of domestic photography as a theater of force cannot be complete, therefore, without considering its reflexive dimension. Many late-nineteenth-century American woman photographers consciously struggled to expand the boundaries of their own lives but finally failed to address the racism and economic interests that circumscribed them. Some, in making common cause with the culture of white supremacy, thrived professionally but effectively undermined their own personal lives, for they too consumed as well as transmitted its "reality effects." The following three chapters interpret the intersection of white supremacy and domestic vision in the work of three middle-class

white women photographers: Gertrude Käsebier, Alice Austen, and Jessie Tarbox Beals—all living and working in New York in the late 1890s and early 1900s. Again, the object here is not to detract from their very substantial accomplishments as photographers, but to examine them more closely. Only when this is done and when the work of black, Native American, Asian, and Hispanic women photographers of the same generation is also recovered—that is, when the "innocent eye" can be articulated across the whole range of women's cultural production in photography—will the critical history of their era be written.

In the late 1890s, Gertrude Käsebier, a white, middle-aged, middle-class, Long Island housewife, the wife of a shellac importer and the mother of three grown children, rapidly became one of the foremost society portrait photographers in the United States.[9] Käsebier was outstandingly successful but not unique as a woman in the field of portraiture. In the United States, the end of the nineteenth century was an especially rewarding time for numbers of women like her, who rode a wave of public interest and support unlike anything that had buoyed women in the business of portrait photography before. Yet, as I have been arguing, to look back at the turn-of-the-century woman photographer solely on the grounds of gender—that is, either because she was a women or because she aided the visualization of gender—vastly oversimplifies the situation. Gender is never simply a preexisting, transparent, and independent sign; it is one part of an interlocking system of social and cultural control. In the United States in the late nineteenth century, the designation "lady" was a complex and highly contested social entitlement. Its tightly controlled distribution was directly related to the determination of upper- and middle-class native-born whites to maintain an uneven balance of social power over blacks, Native Americans, and Eastern European immigrants. In thousands of individual portraits and family photographic sessions, and in millions of family albums, photographs helped perform this cultural work. As portraits of the genteel woman actively *invented, inscribed,* and *disseminated* an exclusionary rhetoric of gender, images of the "Other" woman constructed simultaneously what Allan Sekula calls a "double system . . . of representation capable of functioning both *honorifically* and *repressively* . . . [to] establish and delimit the terrain of the *other* [and] to define both the *generalized* look . . . and the *contingent instance* of deviance and social pathology." This general archive, he explains,

> contains subordinate, territorialized archives: archives whose semantic interdependence is normally obscured by the "coherence" and "mutual exclusivity" of the social groups registered within each. The general, all-inclusive archive necessarily contains both the traces of the visible bodies of heroes, leaders, moral exemplars, celebrities, and those of the poor, the diseased, the

insane, the criminal, the nonwhite, the female, and all other embodiments of the unworthy.[10]

Therefore, an uncritical enthusiasm for integrating the work of late-nineteenth-century American women portrait photographers into the visual canon risks reinstating the limits of a socially predatory, nineteenth-century gaze. Because what Sekula calls the "shadow archive" is inseparable from the general archive, there are urgent questions to pose about the work of nineteenth-century white women portrait photographers. We need to know why and how each of these women made the *particular* portrait images she made and what kind of cultural consolidation her vision underwrote in the social formation to which they were addressed and into which they were accepted.

Gertrude Käsebier, for one, began her career by producing immensely popular images of feminine domesticity. The extraordinary growth of Käsebier's reputation between 1898 and 1902 was based largely on her production of an exemplary series of photographs of white mothers, photographs that glorified white women's role within the domestic sphere. However, Käsebier did not always admire the wealthy women who sat for her portraits. The Käsebier family recounts as a typical story one about a sitting with the daughter of Thomas Edison, who kept changing her dress and fussing with her pose before Käsebier's camera until Käsebier sent her home without taking her picture at all. "'But Madame Käsebier, you haven't made a single picture,' she complained. 'I know,' lamented the photographer. 'There is nothing there.'"[11] Käsebier's understanding of gender divided women into two groups: the good women and the women who

5.2. *"The Hand That Rocks the Cradle"*

had nothing to photograph. As we see in the anecdote, Käsebier preferred to use photography to emphasize the special character of those exceptional women who, like exceptional men, *did* "have something there" and *were* able to reflect her "Ideal" vision of Anglo-Saxon high culture.

For Käsebier, as for many who were concerned about the low white birth-rate at the turn of the century, such exceptional women were mothers. They earned her respect especially if they were admirers, as was she, of the movement for early childhood education, championed by Peabody, Froebel, and Dewey, among other Progressives. Craig Owens, writing about images of women in his essay "Posing," offers a psychoanalytic interpretation of how this interest in motherhood could lay an exclusionary basis for portraiture in photography. The representative images of mothers that Käsebier produced were what Owens calls "icons." They were phallic women, women who had wholeness, integrity, and power. Käsebier's elevation of some female subjects over others might also be attributed in part to the fact that not only was the good woman a mother but, as Owens points out, she was

> not just any mother, but the *phallic* mother of which both Freud and Lacan . . . speak, a mother whose attribute is wholeness, completeness or, as this is valorized in the West, *virginity*.[12]

5.3. *"Mrs. R. Nursing Baby"*

Käsebier's women configured virtue, but they did it through the attributes of an identifiably white Western cultural ideal.

One of Käsebier's earliest and most widely admired sets of images makes her vision of heroic white motherhood explicit. "The Manger," made in 1899, was widely exhibited and reprinted. In this platinum-print nativity scene, the manger is wreathed in white gauze and swathed in obliquely falling sunlight, a formal study in the contrast of dark and light, of white on white, and of transparency. All is peace and contentment. The Virgin is adoring her baby, and there is a won-

derful quality of integrity and invulnerability about the delicate image of the woman.

The baby Jesus Himself, in fact, isn't actually pictured in the image. Only his swaddling clothes are visible, perhaps because, in actual fact, it was hard to manage a baby inside the layers of gauze. But it isn't really necessary to see Him. The idea of Him is enough to signify the whole construction of the Virgin Mother.

Käsebier had an alternate title for this image of "The Manger"; she also called it "Ideal Motherhood." In 1900, Käsebier made another image, entitled "Real Motherhood," which she apparently intended to complement "Ideal Motherhood." This photograph was an image of her own daughter Hermine and Hermine's newborn infant, Charles. This image is also ethereal and swathed in white. Käsebier, speaking about it later, said,

> while posing my daughter there suddenly seemed to develop between us a greater intimacy than I had ever known before. Every barrier was down. We were not two women, mother and daughter, old and young, but two mothers with one feeling; all I had experienced in life that had opened my eyes and brought me in close touch with humanity seemed to well up and meet an instant response in her, and the tremendous import of motherhood which we both realized seemed to find its expression in this photograph.[13]

5.5. *"Mother and Child (Mrs. Ward and Baby)"*

To a more detached observer, the photograph itself—small, grainy, out of focus—might not seem to have the kind of importance that this description assigns it. But evidently, the image was an icon of the kind that Owens cites, a sign or figure for something else, which was not the literal but the spiritual experience that passed between mother and daughter. Käsebier herself wrote of that experience as the one that summed up "all that I had experienced in life" and put her "in close touch with humanity." That is to say, photographing her daughter as a mother made Käsebier into such a mother as Mary, intercessor for us all. "Real Motherhood" was "Real" because it brought one closer to this religious spirit of communion with humanity.

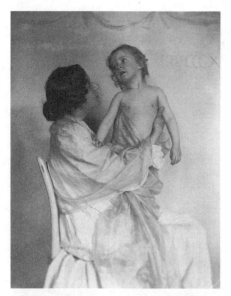

5.6. *"Adoration"*

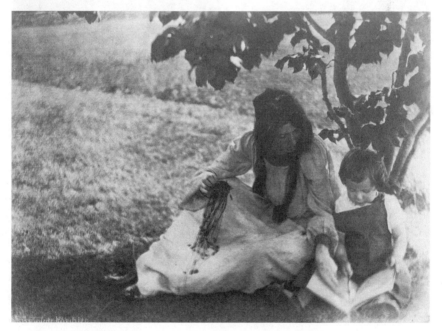

5.7. *"The Picture Book"*

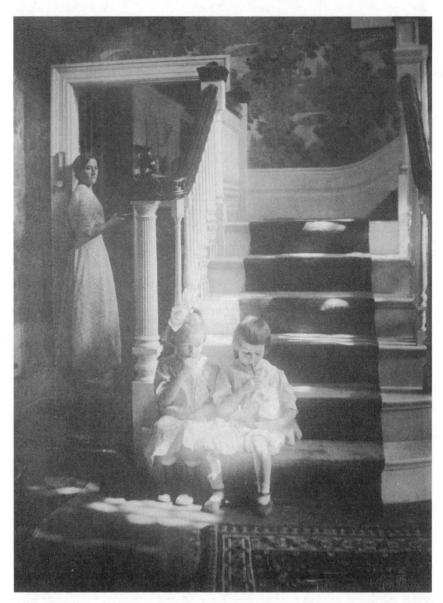

5.8. *"Lolly Pops"*

"Real Motherhood" set a pattern for Käsebier's subsequent work, both for-
mally and intellectually. Henceforth, she would find the "Ideal" in the actual, or
"Real." In many similar images Käsebier shows the mother/virgin calmed and
absorbed by the child. The child, sustained by just the right mixture of maternal
shelter and freedom, looks outward toward the world while the photographer,
as *universal* mother, looks at them both. Käsebier's images thereby re-create for

the viewer who looks through her eyes a viewing position parallel to that of the Virgin Mary, she who recognized "the tremendous import of motherhood.

However, if making photographs of motherhood taught the photographer to see and feel like the Virgin Mary, the photographs themselves, as objects, were also inscribed in another exchange. Julia Kristeva points out that "the themes of motherhood, the woman's body or the mother (Mona Lisa and the Virgin), . . . [establish] the major segments of . . . [the visual] economy which was to determine Western man's gaze for four centuries":

> Body-objects, passion for objects, painting divided into form-objects, painting-objects: the series remains open to centuries of object-oriented and figurable libido, delighting in images and capitalizing on artistic merchandise. Among this machine's resources figure the untouchable mother and her baby-object, just as they appear in the paintings of Leonardo, Raphael, and others.[14]

Käsebier's mother-and-child photographs produce value for this "machine." Her devoted Mary-objects, her luminous child-objects, her luscious platinum image-objects were, as Kristeva says, "capitalized upon as merchandise" and formed the broadest and deepest foundation of Käsebier's professional reputation. In anthropologist Gayle Rubin's terms, Käsebier's work can be seen as facilitating by exchange the kinship relations within the tribe, or class, of those to whom they were precious objects of an ideal white motherhood. As icons that also pictured sisters, mothers, and wives, they were an integral part of the "traffic

5.10. *"Real Motherhood"*

in women" whereby exclusive Anglo-Saxon kinship relations were sustained. Käsebier's camera was a channel of consolidation for an emerging class that wished not only to control the distribution of wealth but also to keep within its own group the distribution of the signs of woman.[15]

One pair of images, "Blessed Art Thou Amongst Women" (1899) and "The Heritage of Motherhood" (1904), is a particularly eloquent evocation of the Käsebierian portrait of the good woman. "Blessed Art Thou Amongst Women," an elegant picture of Käsebier's friend, Agnes Rand Lee, and Lee's young daughter Peggy is Käsebier's best known photograph—one of her most beautiful and most deservedly celebrated images. Agnes Lee was the author of several poems about motherhood and of a children's book entitled *The Round Rabbit*. Käsebier shows her in her lovely home, dressed in the long, flowing, white robe favored by those involved in the Arts and Crafts movement and influenced by the progressive ideas of William Morris. Käsebier's mothers virtually always wear white, the female equivalent of the "imperial white" of Dewey and the sailors on his ship. As do all of Käsebier mothers, Agnes Lee bends solicitously toward her child, whom she is simultaneously sheltering and encouraging to go forward.

The young girl, Peggy Lee, is portrayed as being at a threshold. She seems eager, confident, yet hesitant, for a moment, before crossing it. Behind them

5.12. *"The Heritage of Motherhood"*

hangs "The Annunciation," a painting by the English Arts and Crafts artist Selwyn Image. The Annunciation scene is framed by the biblical quotation, "And the Angel came in unto her, and said, Hail thou that art highly favoured, the Lord is with thee: blessed art thou amongst women." The deep space behind the two figures is mirrored by an equally deep space in front of them, eloquently suggesting the progression of time and the future of the child. The implication is that, as her mother has been blessed amongst women by becoming a mother and having her, the daughter will cross the threshold into motherhood where another annunciation and another blessing of another child await her. The bond between mother and daughter, the continuity of life, and the enveloping safety of the Christian tradition are all magnificently figured here.

Yet, a few months after this consummately beautiful photograph was made, Peggy Lee, the little girl in the picture, died of an infectious disease. Her sister was also afflicted and, although the sister lived, she was permanently handicapped. Their father, photographer Francis Watts Lee, became distraught. Lee, like the painter Selwyn Image, was a deeply religious Christian and apparently believed that the tragedy was a punishment for his sin of not having become a clergyman. Eventually, the marriage between Agnes Lee and Francis Watts Lee collapsed under the strain of such grief, and the couple divorced.

At exactly the point when the marriage was coming apart, Käsebier took a second photograph of her friend Agnes Lee and entitled it "The Heritage of Motherhood." It is also an extraordinarily powerful image, but this time sad and frightening. The despairing title given it by Käsebier adds to the menacing effect. Käsebier said she had waited "for fifteen years" to secure such an image, because she had not wanted "to pose a model for it, but to gain her inspiration from some unconscious sitter posing for a portrait."[16] In the image Agnes Lee is still wearing the long flowing white dress of the Arts and Crafts movement, but all its former elegance is gone. It looks more like a nightgown, creased and disheveled, as if it was too much of a chore for the woman to get dressed. Over it she has wrapped a black shawl, which clings to her body in a close embrace that is, awfully, the last visible remnant of the living child who stood at the threshold in a black dress in the earlier picture. The space of the future, so brilliantly orchestrated in the earlier picture, is now gone. Nor does any reassuring or confident image of the blessed story stand behind the grieving woman. The frame of a domestic household is entirely gone. Agnes Lee, her now-empty hands folded in front of her, sits outside in an unidentifiable and featureless landscape from which the light is gradually being withdrawn as the sun is setting. Käsebier's contemporary, critic Joseph Keiley, spoke for many when he called this photograph "one of the strongest things that she has ever done, and one of the saddest and most touching that I have ever seen."[17]

"Blessed Art Thou Amongst Women" was a platinum print, a subtle and stable medium; but "The Heritage of Motherhood" was made by the gum bichromate process. With the gum bichromate process—which often ended up looking textured like charcoal, pastel, or paint—the photographer could manipulate, intervene in, or literally peel away sections of the image-bearing emulsion before it finally dried. And Käsebier did intervene in some prints of this image. In some Käsebier drew three crosses in the background, giving the suggestion of a Lamentation scene; in other prints she took the crosses out. I think perhaps she even made marks on the landscape with her own hand, as she had done in other images, such as "The Bat" (1902), digging into the emulsion and attacking its flawless, mirror-like integrity since by itself the figurative language of Christianity, symbolized by the crosses, did not seem adequate to express the enormous grief and sense of abandonment. Agnes Lee is a female Lear on a heath that is no longer a recognizable human habitation, a churning sea that is endless and empty, a desert of maternal hope.

One cannot help but wonder at the bitterness of the title. If *this* is the heritage of motherhood, what do women have to look forward to? Like Käsebier's other famously ironic and angry titles—"Marriage—Yoked and Muzzled," for a photograph of two oxen yoked together; and "Where there is so much smoke,

5.13. *"Marriage—Yoked and Muzzled"*

there is always a little fire," for a group of women talking animatedly amongst themselves—this image reaches past gender-appropriate deference and bitingly, though still sentimentally, articulates a fierce protest of women's lot in life.

During the time that Käsebier was making these studies of motherhood and photographing with such exquisite sensibility the plenitude and the subsequent destruction of her friend's maternity, she was also photographing the Sioux performers who came to New York City with the Buffalo Bill Wild West show, on its yearly pilgrimage to Europe. She told the story that one day, in 1898, she looked out the window of her Fifth Avenue studio and saw a troupe of the performers marching through the streets below to Madison Square Garden where they were to perform. Immediately, she was seized by memories of the Native Americans she had known in her Colorado childhood, and, in the grip of nostalgia, she wrote to Buffalo Bill, asking if some of the Sioux could come to her studio to be photographed. They came.[18]

The Indian Wars and the defeat at Wounded Knee were a scant eight years in the past, but now that Native Americans could no longer be construed as a military threat, they were rapidly becoming romantic figures for many white Americans. As Käsebier's biographer Barbara Michaels has observed,

artists, and then photographers, had been picturing them since early explorations of the New World, with varying attitudes ranging from anthropologi-

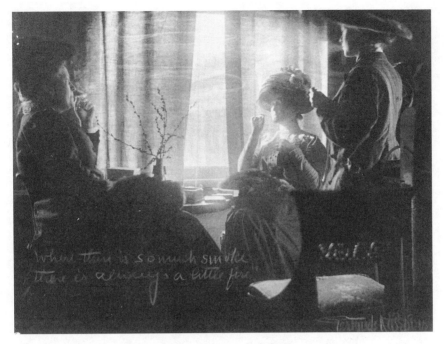

5.14. *"Where there is so much smoke there is always a little fire."*

cal to romantic. But especially after the massacre of the Sioux at Wounded
Knee, South Dakota, in 1890, Americans came to realize that the old Indian
ways were doomed. Instead of being viewed as a threat, Indians began to be
seen as an endangered species. Käsebier was at the forefront of sympathetic
interest in Indian arts, crafts, and culture that burgeoned from the mid-1890's
through the first two decades of the twentieth century, as shown, for instance,
by Indian images and motifs in the Arts and Crafts movement, as well as by
photographs.[19]

Käsebier was among those who were caught up in this romantic infatuation,
even though (or perhaps because), as her mother told an interviewer in 1907,
when Gertrude was a small girl in Colorado, Indians were out of favor:

> We always had to keep on the watch for hostile Indians. I don't see why
> Gertrude likes Indians so much now. She has not them to thank that she is
> here to-day. I can not help feeling from my own knowledge and experience
> that the only good Indian is the dead one.[20]

It was, in one way, a social coup for Käsebier to get the Sioux performers
to come and pose. It was, in another, a chance for Käsebier proudly to dem-
onstrate her own social independence, for, although she had been warned by

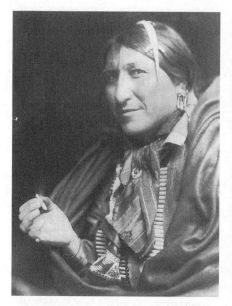

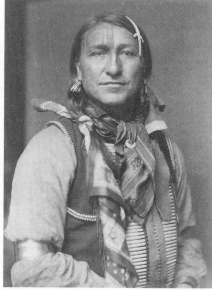

5.15. *Joe Black Fox*

5.16. *"American Indian Portrait" (Joe Black Fox)*

friends not to entertain the Sioux in her studio or else they would return and continue to come without notice, her answer to this racist remark was apparently: "Let them come. I shall be glad to see them."[21] Käsebier liked to think of herself as a progressive woman, always ready for an adventure.

And the Sioux did indeed keep returning to Käsebier's studio over the years, as invited guests. From that initial sitting in 1898 to around 1912, Käsebier often played hostess to Buffalo Bill's troupe, both in her photography studio on Fifth Avenue and at her home on Long Island. The resulting portfolio of portraits contains some of Käsebier's most highly regarded work. It has been remarked that her portraits of Native Americans stand up well as empathic documents against others taken by white male photographers of Native Americans who were her contemporaries, such as Edward Curtis, William Henry Jackson, her colleague Joseph Keiley, F. S. Rinehart, Karl Moon, and others. But the emotional tone and ideological substance of these visits—and with it the point of view of the portraits—needs to be examined, rather than assumed.

In an essay published anonymously in *Everybody's Magazine* in January 1901, a speaker who could be none other than Käsebier herself narrates the story of that first sitting.[22] She does so in a language that was already embedding the Sioux in a web of stereotypical binary allusions, such as nature/culture, savage/civilization, before they are even introduced to view:

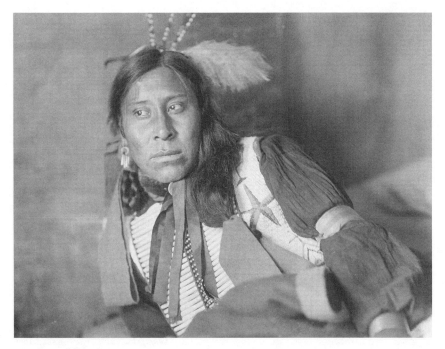

5.17. *Samuel Lone Bear*

The "Wild West" parade was passing along the avenue. A woman looked down upon it from a studio window and saw Indians, real live Indians, tricked out in gaily colored finery, and astride of wiry little horses.

The mere sight of their painted dignity was enough to revive for her the fascination of the Plains. She longed for a breath of the prairies, for a far horizon, a dome of blue sky above, the majesty of the storm in the open. She heard again the bark of the coyote; saw the great herds of buffalo, with their clumsy, shambling gait; the wary antelopes, the eagle, winging its way; the bands of roving red men, still free to come and go at will, with never a thought of "reservations."

She remembered, too, as in a dream, how a child had once been hidden by a frightened mother beneath the seat of just such a "Deadwood Coach," while rifles cracked, and bullets sang through the air, and Indians, mad with fire-water, woke the echoes with their savage yells. Quite as distinct were the Indian papooses, who had made such delightful playfellows, and the absorbingly interesting houses, which had but one room and were covered with skins.

Inexorable brick walls crowded out the visions as the cavalcade passed out of view. But the artist instinct reinforced the inward plea for some more tan-

gible remembrance of those days when nature was on every side, instead of at the end of a railway journey; and the impresario who was responsible for awakening such recollections was soon in receipt of a letter requesting that some of his Sioux braves might be allowed to pay a call on an old friend of their tribe at ten o'clock next morning—and incidentally sit for their portraits.[23]

It is difficult to imagine how Käsebier's Native American subjects could extricate themselves from such a framing. It is also difficult to imagine how, given that Käsebier awaited them in such a frame of mind, she could see beyond her own stereotypes to the "individuals" whose sensitive portraits she was credited with making. The *Everybody's Magazine* article continues:

> That letter had more effect than its author anticipated. It is considered an honor on the reservation to go out with the Show, and when, that night, from this picked band were selected the few personages who were to represent their tribe before one who had visited in their teepees and played with their papooses, the occasion plainly called for all the resources at hand. The Indians of the "Wild West" aggregation arose next morning at daybreak; all the finery of the whole band was cast into a common lot and divided among the favored few; these arrayed themselves with the help of their comrades, and so earnestly did they apply themselves to this weighty business that it was all completed sometime before the city's breakfast hour.

The chaperon upon whom was laid the responsibility of watching out for their behavior urged the necessity of waiting until the hour set, and for a time his authority prevailed. But after eight o'clock impatience could no longer be restrained, and a file of outwardly calm and grave Indians left their quarters, headed uptown.

An hour later, the hostess arrived at her studio, having hastened in on an early train from the country that she might have plenty of time to prepare something more substantial than cordiality for the three or four guests whom she expected to "take tea" with her at ten.

She opened the door, and with difficulty suppressed an exclamation of mingled surprise and pleasure. Her request for Indians had been generously complied with. Seated in a large circle around the "model-throne"—which was occupied by the chaperon as chief—were nine of the most gorgeous braves she had ever beheld.

There were Iron Tail and High Heron, Has-no-Horses and Sammy Lone Bear, Joseph Black Fox and Red Horn Bull, Shooting Pieces, Philip Standing Soldier, and Kills-close-to-the-Lodge. They wore feathered head-dresses that were marvels; short jackets fairly covered with elaborate designs in solid beadwork; flannel shirts of vivid red, blue, and green; blankets beaded and decorated with patterns of United States flags; moccasins edged with beads or dyed porcupine quills; and furs of otter skin. Brass and silver bands and silver rings stood out against the copper-brown of their arms and fingers.

Some of them, like Iron Tail and Kills-close-to-the-Lodge, were typical of the wild Indians. They had never been to the schools; they were still a part of the wild life, undegenerate, tall and straight like pine trees. In sharp contrast, to a practised eye, were the young educated bucks, dandies with feathers in their hair to signify that they were looking for wives, beauty-spots of gold in their white front teeth, able to write a little, and to speak a comical broken English. But they showed, especially the older men, such real beauty of figure and wild grace, such stolid dignity and apparent unconsciousness, such impenetrable reserve, melting into naive and childish interest before cigarettes and picture-making![24]

This account is larded with stereotypes and unconscious condescension. The Indians are "bucks"; they are "tall and straight like pine trees"; they need a "chaperon" whom they good-naturedly overwhelm, like a crowd of energetic but decent schoolboys; they cannot contain their excitement but, like children, they show up in the studio too early; and they have cast all their "finery" into a common pool, where it is meted out to the "favored few,"—a "weighty business," indeed! Käsebier continues confidently on in this vein, all unaware:

"The artist, meanwhile, had begun to weary of beadwork and feathers.

"I want a real raw Indian for a change," she declared. "The kind I used to see when I was a child."

Quite at random she selected Iron Tail, and proceeded to divest him of his finery. Feathers and trinkets were removed, and amid a dead silence she placed him before the camera and secured the most remarkable portrait of the whole collection. He never said a word, but obeyed instructions like an automaton. In the wonderful face which serves as a frontispiece to this issue, it is perhaps not fanciful to read something of the misery which he was really undergoing. For the truth was that every feather represented some act of bravery either on his own part or that of his ancestors. This superb old Sioux (who probably took part in the Custer fight nearly a quarter of a century ago) had been a mighty man of battle; the number of his plumes stood for enemies slain; they were like a Medal of Honor, or a Victoria Cross, or the Order of the Legion; and to be stripped of them before his comrades was as if a captain's sword should be broken in the face of his men. Without sentimental exaggeration, it was a tragedy to the veteran. When the portrait was handed to him some days later, he tore it in two and flung it from him. Luckily, however, an explanation and a second sitting in full regalia entirely restored his peace of mind.[25]

Käsebier believed that her view of the Sioux was "without sentimental expression," but it is difficult, actually, to know where to begin to unpack the derogatory and almost absurdly confused sentimental allegations of this passage. If the troupe of Native Americans had "pooled" their finery into a "common lot" earlier that morning, then Iron Tail's costume could not have represented the Native American equivalent of the "Medal of Honor, the Victoria Cross, and the Order of the Legion." Instead, he had to have been wearing exactly what she originally saw—a costume.

Recent feminist deconstructive criticism of the gaze in Anglo-American visual theory has illuminated two of the major forms of the social empowerment of looking: (1) the male gaze, and (2) female spectatorship.[26] The advantages of this latter form we can see very forthrightly in Käsebier's own works. Missing, however, in feminist visual theory, is much concerted examination of the multiple ways in which those who are being photographed in order to be placed more securely into racial or ethnic social positionings—positionings which are not of their own making or in their own interests and from which their subjectivity is erased—may comprehend and strategically deflect the force of scopic aggression. Käsebier herself does not offer such an examination. However, it is possible to put her description of the sitting to this use. Such an analysis entails a shift of focus from the power that women wield behind the camera to how that

5.19. *Iron Tail* 5.20. *Profile of Iron Tail with headdress*

power is registered, absorbed, and protested by the subjects in front of the lens. As a result, it becomes possible to see even domestic portraiture and sentimental documentary photographs less narrowly, as a literal record of those "Others" who appear within the frame, and more broadly, as the mirror image of those other "Others" who actually produced them.

It seems safe to surmise that the purpose of Iron Tail's costume must have been as much related to masquerade and disguise as to any actual show of military might. After all, Iron Tail was currently *reenacting* for Buffalo Bill the defeat of his people as a popular spectacle, one that was patently false. As Craig Owens extrapolates from Jacques Lacan's brilliant analysis of the psychology of resistance to visual domination, the photograph is a "record of a previous arrest," one in which the subject "freezes" or poses *as* he or she whom the photographer wishes to see and becomes "an object *in order to be a subject.*"²⁷ Iron Tail evidently had taken account of Käsebier's camera and then taken such a pose. When Käsebier suddenly decided, on the basis of her assumed knowledge of the Sioux, that she wanted "an Indian in the raw" and proceeded to strip Iron Tail of his clothing, it would have been this disguise, too, that she was wanting to remove, but not to arrive at some transcendental truth of nature, as she seemed

to assume. For what does Käsebier really know of the "Indian in the raw"? And what does she really want to know?

The disguise was, in a profound way, assumed for her. The tribal dress, re-assembled as a bricolage of trinkets, was not a sacred statement. It was expressly adopted earlier that morning in order to give a white woman "an Indian" to photograph. When Käsebier removed this disguise, thinking that she was re-moving "the savage" from "the man," what she was really doing instead was removing "the man" from her studio, for she was denying him his own place in the careful decorum of a cross-racial encounter. There was no "real Indian" who could be displayed for the white lady's camera, for she could see only a simulacrum. In fact, his decision to masquerade *was* "the Real" of "the Indian." It *was* himself in the raw, the late-nineteenth-century Native American in his raw predicament. But it was also his knowledge of this reality, expressed in his agreement to participate in *her* imaginary, that Käsebier refused to recognize.

And when, upon returning, Iron Tail ripped up the photograph and sat again for her camera "in full regalia," would it be that such a lady was now getting a "true" picture of him, as she seems to have thought? Or would it not be that in restoring the simulacrum of himself to his image he has restored the blind spot of sentimentality to the photograph as his own protection against the lack of penetration of her gaze?

"Iron Tail," charged a writer in the newsletter of the Carlisle Indian Indus-trial School in Pennsylvania, where Iron Tail had gone to visit his son, who was a student there, "would in a minute adopt the civilized dress in its entirety if it paid him better to do so, than it does to wear the clothes in which he now adorns himself." [28] Iron Tail might "become a proper citizen," continued the writer, if he could be "properly encouraged." But no, "Buffalo Bill pays him 20, 30, or pos-sibly 50 dollars a month for several summer months, and all expenses, to remain Indian, to wear the scalp-lock, blanket, and all the glittering toggery in which it is possible for an Indian to bedeck himself." [29] In Buffalo Bill's costume trunk Iron Tail evidently had both buried a "real" Indian and found a real American way to continue to be an Indian—that is, to *pose* as an Indian. It was merely logi-cal, although it seems a special irony, that this particular Indian masquerader would later become a model for the Indian head nickel, such ethnic simulation having become such a common coin of the twentieth-century landscape.

In "Socioacupuncture: Mythic Reversals and the Striptease in Four Scenes," Gerald Vizenor reminds us that in Western culture the striptease is a "contradic-tion," for "at the final moment of nakedness a 'woman is desexualized.'" From Barthes's writing on the striptease in *Mythologies* (1972), Vizenor takes the point that the striptease ends where sexuality might have begun, explaining, "The spectacle is based on the 'pretense of fear,' as if eroticism here went no further

than a sort of delicious terror, whose ritual signs have only to be announced to evoke at once the idea of sex and its conjuration."[30]

But tribal cultures, Vizenor continues, are "colonized in a reversal of the striptease." This means further dissimulation even within the context of conquest. "Familiar tribal images" are "patches on the 'pretense of fear,'" Vizenor writes. "There is a sense of 'delicious terror' in the structural opposition of savagism and civilization found in the cinema and in the literature of romantic captives." Hence, these artifacts of Western sexuality are artifice, not eroticism:

> Plains teepees, and the signs of moccasins, canoes, feathers, leathers, arrowheads, numerous museum artifacts, conjure the cultural rituals of the traditional tribal past, but the pleasures of the tribal striptease are denied, data-bound, stopped in emulsion, colonized in print to resolve the insecurities and inhibitions of the dominant culture.[31]

Vizenor is arguing that the colonizer *dresses* the Indian in a ragged array of fetishized objects and articles in order to experience the titillation and the terror that in a more customary striptease would be produced by *undressing*. But then, the colonizer fails to harvest the " 'delicious terror' of sexual experience rooted in the structural opposition of savagism and civilization" that has been proposed by this inverted striptease. After the first stage of arousal, "the pleasures of the tribal striptease are denied, data-bound, stopped in emulsion, colonized in print to resolve the insecurities and inhibitions of the dominant culture." The contact that was sought is undermined by the arrest of desire—the way that the colonizer realizes his unconscious motives along with the plunder and rape of the tribal women. So, not only does the colonial power *reverse* the striptease, but it renders it simultaneously *perverse*.

This refusal to expand rituals of participation in another culture beyond such exploitation effectively denies the colonizer any potential for cultural exchange —a potential that, according to Vizenor, ought to be there in the "mythic satire" of striptease. In other words, when Kevin Costner binds the feathers into his hair in the film *Dances with Wolves* and puts on the attributes of "the Indian," this is a more effective come-on for a white audience than if he had slowly removed all his clothing piece by piece. But then, paradoxically, as the white audience is released into the logic of its own desire by the film, the narrative systematically subverts the sexual promise of erotic cross-dressing by dissolving into an orgy of American army violence or by arresting its forward momentum in a kind of compulsion to repeat the moment of the border crossings, continuing simply to dress and redress Costner as red, then white, then red—a veritable Native American Tootsie. Like Käsebier's camera, it seems, the psychological apparatus of Anglo civilization is always already poised to defend against the phantasm of

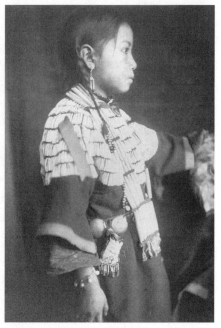

5.21. *Mary Lone Bear* 5.22. *Mary Lone Bear, profile*

the savage that it has itself elicited and desired. After all, Käsebier welcomed the Sioux into her studio because they were in costume. And Iron Tail, apparently, insisted on his costume at least partly in order to invoke the familiar in a strange setting—the familiar which was the customary perversion in the colonizing eye.

If this perversion is not demonstrated clearly enough in the Iron Tail portraits alone, it is further detailed when we consider as well the evidence of Käsebier's photograph of Mary Lone Bear. Of this portrait, Käsebier wrote,

> From the standpoint of rarity, the children's pictures are by all odds the most valuable, for there is a most lively superstition, on the part of the Sioux at least, that to paint or photograph a child will bring about its death. Only by reason of special friendship was it possible to picture the children, and even with this aid it took three years before they could be persuaded to bring little Mary Lone Bear to the photographer.[32]

Over the years, Käsebier developed that "special friendship" and was able, finally, to photograph a child. Käsebier's portrait of Mary Lone Bear shows a child who is suspicious, but adequately calm, before the camera. She seems willing to expose herself and her dress to the white woman's gaze but unclear as to what the foundation of her action is. Unlike Iron Tail, Mary Lone Bear possesses

no American theory of mimicry and masquerade with which to look back at the camera looking at her. She seems, fundamentally, to lack a pose.

But then, as it turns out, Mary Lone Bear did die approximately six weeks after Käsebier finally took her picture. And Gertrude Käsebier makes the following joke in print: "When the photographer next appeared, the mothers fairly ran from her with their children."[33] We must conclude from her comment, I think, that Käsebier's own savagery is exposed by this incident. Domestic sentiment did not extend intact across racial lines. The same lady photographer who produced the bitter and heartbreaking portraits of her white friend Agnes Lee at the death of Peggy Lee could not imagine the grief of "the mothers" at the death of Mary Lone Bear. Käsebier preferred to masquerade as the Virgin Mary, posing as the Great White Mother who was "in close touch with humanity," than to make Native American motherhood "Real."

Käsebier had sufficient opportunity to observe the effect of Mary Lone Bear's death on her family. Sammy Lone Bear, one of Mary Lone Bear's brothers and one of Käsebier's original sitters in 1898, became a friend of the Käsebier family. He was a frequent visitor for many years to Käsebier's home and studio. Indeed, Sammy Lone Bear appears to have developed a serious crush on either Käsebier or one of her daughters or granddaughters. Many letters came from him, including one that read:

> My Dear Friend, I received your kind letter on the 1st. Was more than glad to hear from you and that you were well. This leaves me enjoying the Same Blessings. I had not thought that you had forgotten me whatever because I waited very Patiently for an Answer. Now I am waiting for your Picture. Then I will send you mine next week. . . . Now I will tell you what s.k. means. a sweet kiss. Now . . . as my whole heart is Entirely upon you, I hope yours will still grow stronger toward me. Now, may the snowy wings / of Innocence and / love / Ever protect and guide the[e] through / life and allow me to Remain / Your true friend / I am truly yours. / P.S. don't show [it] to _____ .[34]

Sammy Lone Bear did not want someone in Käsebier's household to see what he had written. In her article in *Everybody's Magazine*, Käsebier comments uneasily upon the letter. She thinks he must have consulted "either a friend or a 'Ready Letter Writer'" and that, in its courtship mode, it "showed some interesting considerations as to the effects of our civilization upon our Indian wards."[35] In other words, Gertrude Käsebier expected to be able to objectify Sammy Lone Bear with her photography with impunity, and she certainly meant him no harm. But she did not expect that he was looking back. Even when the Sioux sat in her own studio drawing pictures during a sitting, she did not imagine any of them holding the power of the gaze.

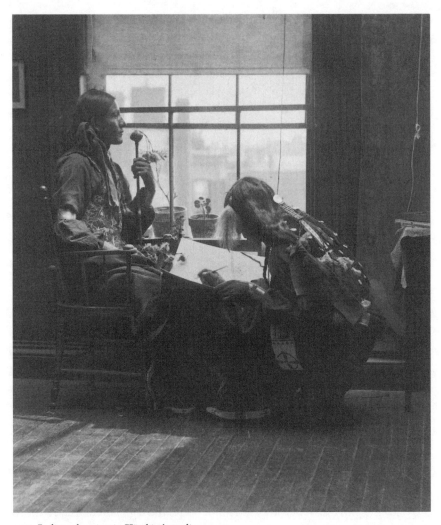

5.23. *Indians drawing in Käsebier's studio*

Sammy Lone Bear's writing and the pictures that he drew for his photographer, including one of himself with the caption "catch girls," recontextualized Käsebier's photographic sessions in a way that was unacceptable to her. Everything that Käsebier felt about herself and her own daughter and "white" motherhood in general depended upon the fact that for Käsebier, and for the culture she represented, *Indian* motherhood could have no similar heritage. The girl that Sammy Lone Bear wanted to "catch" could not be in Käsebier's family.

Gertrude Käsebier's Native American portraits participated in and helped to sustain a white racial-cultural consolidation, through the control and management of a symbolic economy of female sexuality. In this process, sentimentalized

5.24. *"Catch Girls," by Samuel Lone Bear*

images of womanhood first were created and then were circulated as a kind of password, or code, among the kin, a code that could be freighted with messages about racial superiority and inferiority. Finally, portraits of the Sioux defined those on the other side of the kinship line.

In point of fact, it seems to me that in this instance both Käsebier herself and the critics and journalists who praised her work were perfectly aware of the racialized status of her vision. Furthermore, at least one time a group of Native American sitters did what they could to disrupt and destabilize the inferior position to which their manhood was assigned. To study domestic vision in the age of United States imperialism, one needs to consider whether the opportunities that late-nineteenth-century white women portrait photographers in the United States were able to seize *were* theirs, after all, simply on the merit of their genius. Is it not possible, instead, that opportunities grew abundant for photographers like Gertrude Käsebier because their particular ways of employing the camera strengthened both the fantasies of white cultural superiority and the realities of white male domination that infused late-nineteenth-century family life?

Was the subsequent erasure of the history of women's portrait work merely the result of misogyny? We ought to consider, rather, that by the late 1920s, when anti-immigrant sentiment had won an apparent victory, seen in the increasing restrictiveness of U.S. immigration laws, and, as Walter Benn Michaels writes, "Our America," seemed more secure, the imperative for strengthening the white women's gaze at the white mother as an apotropaic sign of white male dominance also diminished.[36] Perhaps *that* is why it became desirable—for *both*

the women and the men of the dominant race—to underplay the white woman's portraiture career.

Photography constituted a "contact zone" between the always already domestic white woman and the soon-to-be-domesticated, nonwhite Other. It was what Pratt calls a "space of colonial encounters, the space in which peoples geographically and historically separated come into contact with each other and establish ongoing relations, usually involving conditions of coercion, radical inequality, and intractable conflict."[37] Photography recorded the "spatial and temporal co-presence of subjects previously separated by geographic and historical disjunctures, and whose trajectories now intersect."[38] The disjunctive character of this "spatial and temporal co-presence" is evident in Käsebier's attitudes, despite her claim of transcendent connection through her photographs of motherhood. If photography could have provided an opportunity for a certain growth or transculturation, as Vizenor argues, it was also an effective platform for furthering interlocking dominations. The excitation and subsequent defeat of cross-racial empathy is the ultimate failure of these women's work. They might have risen to the occasion as women in political alliance with the "Other," and who knows what visions they might then have shared, but they decided as photographers instead to interpret the occasion according to the wishes of the strongmen of empire.

This is not going to be a cricket club, some day, and
I'm going to have pictures of how it looks now.
—Alice Austen, as quoted in Ann Novotny,
 *Alice's World: The Life and Photography of an
 American Original*

The Domestic Unconscious

. .

There is good evidence that many late-nineteenth-century white
middle-class American women photographers felt photography was an enlarge-
ment, not a constriction, of their lives. Judging from the enthusiastic letters that
women photographers wrote to Frances Benjamin Johnston when she was col-
lecting pictures for an exhibition of American women's photographs in Paris
in 1900, they believed they had many advantages in photography. Zaida Ben-
Yusuf said she was able to become a successful professional portrait photogra-
pher "after a very slight experience" even though she did not have "the advan-
tages of any previous artistic training."[1] The Allen sisters, Frances Stebbins and
Mary Electra, of Deerfield, Massachusetts, who reported that their chief work
was illustration for books and magazines, admitted to having "no training either
technical or artistic—and . . . no theories." Often, they reported, they were forced
to put photography "into the intervals of other duties," caring for "Mother,
Aunt Lucy, and brother Caleb," but these duties did not cripple their photo-
graphic careers.[2] Other women shared similar obstacles and also found photog-
raphy adaptable. Johnston wrote of Mary Bartlett that she was "a busy woman
with a large family but a most energetic worker," was "winner of many prizes
[for] specialty studies in pleine air of children and young girls," and also wrote
for photo magazines.[3] In fact, Sarah Jane Eddy begged Johnston not to give out
her name, explaining, "[T]o be known means more care & more demands upon
me & I have enough already."[4]

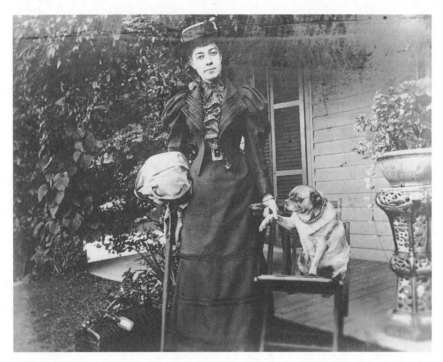

6.1. *Alice Austen with her dog, Punch, "starting for Chicago" and the World's Columbian Exposition, 1893*

Throughout the 1890s, the periodical press carried many articles that praised photography as a vocation for women. Women, argued one writer, had a "keenly developed instinct for the decorative and picturesque"; their "delight in the mere manipulation with their delicate hands of fragile objects, their love of finish in details, their well-known patience" were all characteristics that helped them to succeed.[5] Photography brought opportunities both to work at home and to travel. Being a portrait photographer meant developing broader social contacts and earning welcome income. The new photojournalism gave those who pursued it a vital role in the nation's public life. In sum, photography offered middle-class white women a level of social mobility that had not been open to them before.

But the ways in which these women were *not* able to use their opportunities also expose patterns of authority that are a useful object of inquiry. The bad faith behind the sentimental premise of violence as a sign of tenderness, bad faith that eventually backfired in the face of even a privileged white woman, surfaces with particular clarity in the life and career of Alice Austen. This chapter traces the equivocal results of such vulnerability for the women themselves, as revealed in Alice Austen's amateur photographic career. We have so far been exploring the

6.2. *Clear Comfort and landscaped grounds, from seawall*

harsh effects of domestic images upon the variety of peoples who found them-
selves in the path of American territorial ambitions, attempting to read those
images for signs of resistance to those ambitions and for clues to the ways in
which sentimentalism co-opted even that resistance. This chapter interrogates
the harm of the domestic context for a women photographer who was a member
of the colonizing race and class itself. As a protective membrane that surrounded
the sentimental arena, American white middle-class domesticity kept the imagi-
nary space of the home intact, so that a woman like Alice Austen might come
into contact more safely with potentially disintegrating foreign entities. But at
the same time, domestic ideology created a nearly impermeable barrier through
which information sometimes essential for survival could not pass.

Alice Austen was an amateur photographer who photographed extensively
on Staten Island and in New York City at the turn of the century.[6] She was fully
steeped in domestic life. "Clear Comfort," a Downingesque, Gothic Revival cot-
tage in a Staten Island village, was for over eighty years her home and the inspi-
ration of her photographic work.

Austen was also the first American woman to venture out into the street to
photograph the immigrants streaming past the gatekeepers at Castle Garden and
Ellis Island into *their* American home, the Lower East Side, which is to say, Clear

Comfort's exact antithesis. Fortified, apparently, by a powerful idea of her own safety—the sense that she could at any time return to Clear Comfort—Austen was able to take her camera into the street, the discomfort zone where a few men but no American woman photographer before her had dared to go. "Amateurs like Alice Austen," writes historian Peter Bacon Hales, "thrilled by the portability and unobtrusiveness of the new small-camera technology, took their cameras into areas of the city opened up by reform photography. Wherever people congregated—beaches, parks, zoos—the amateur followed; but areas like New York's Hester Street or Chicago's equivalent Maxwell Street ghetto attracted special attention."[7]

In 1896 Austen copyrighted a set of these images, had them printed by the Albertype Company, placed them in portfolios, and offered them for sale. *Street Types of New York* loosely reconstructs Austen's accustomed progress uptown in Manhattan from the Battery, where the Staten Island ferry docks, to the shopping district at Twenty-third Street, and up to the Metropolitan Opera House, Luchow's, Delmonico's, and the Colony Club.[8]

Street Types shows Austen to be particularly interested in looking at New York's working people. In the portfolio are photographs of a policeman, street sweepers, shoeshine boys, a messenger boy, newsboys, a cab driver, an organ grinder, bootblacks, a postman, and an "ash cart" driver (garbage man). They are very formal photographs, compared to much of Austen's other work. Determinedly frontal, Austen's approach to her working-class subjects seems warm and courteous, but at the same time she is careful not to get too close. Unlike the steady and densely meaningful gazes relayed between photographer and subject in her portraits of family and friends, in *Street Types* there is often a melange of opaque looks. Austen is curious about but not comfortable with the "street type," and the feeling seems to be reciprocated. Photographer and subject size one another up. To Hales, the "sympathetic humanism" of the photographs is "matched by her genuine liking for the streets and their dynamic components" and appears especially admirable when her images are compared with the overtly racist stereotypes of her contemporary, Sigmund Krausz, who published *Street Types of Chicago: Character Studies,* in 1891.[9] However, the "sympathetic humanism" of this period, as we have seen, is an unstable force. While Austen sometimes shares a good-natured sense of humor with her subjects, passersby in the background of several of the images also watch the scene that Austen is making, registering cautious bemusement and mirroring the ironic subject position offered to the viewer.

What seems most truly remarkable about these photographs of New York's working people is the empty space Austen creates around almost all of them. Her subjects are repeatedly isolated in a wide circle of deserted street. That Austen would have done this so consistently indicates a deliberate procedure. In Man-

6.3. *Newsboy Harry Degen, 42nd Street*

6.4. *Messenger boy by wheel, 30th Street near Broadway*

6.5. Postman opening box, John L. Gallagher Station H

6.6. Sweeper in rubber boots

6.7. *Street cleaner with cart*

6.8. *Street cleaner in snow*

6.9. *Policeman, Herald Square*

6.10. *Street cleaner with shovel*

6.11. *Street sweeper in helmet, 48th Street and 7th Avenue*

6.12. *Rag pickers*

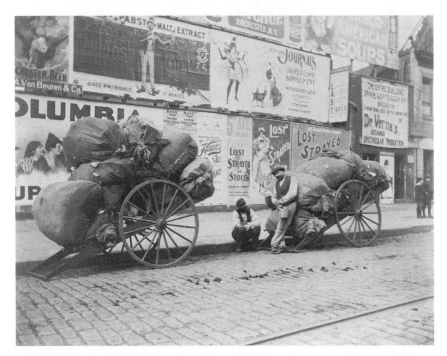

6.13. *Rag pickers with billboard*

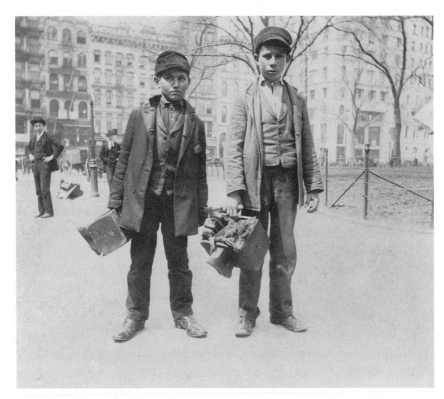

6.14. *Two bootblacks, City Hall Park*

6.15. *Snow removal*

6.16. *Queer emigrant and pretzel vendor*

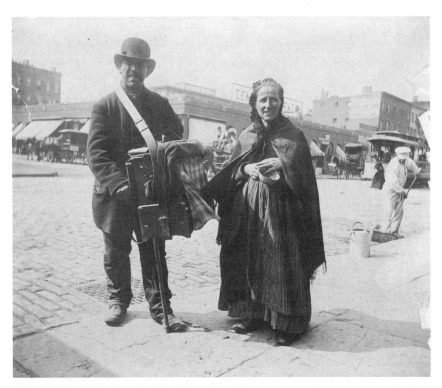

6.17. *Organ grinder and wife, 7th Avenue and 48th Street*

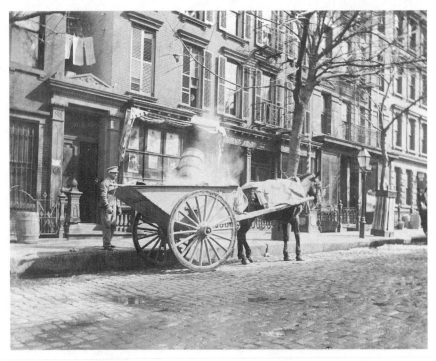

6.18. *Ash cart, 50th Street*

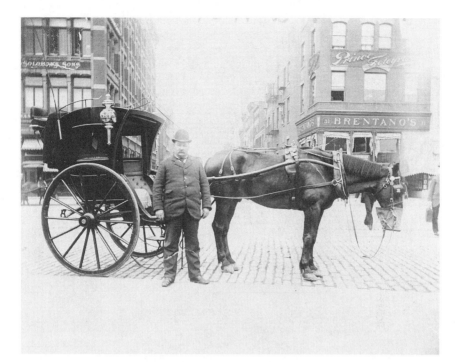

6.19. *Hansom cab, Union Square Brentano's*

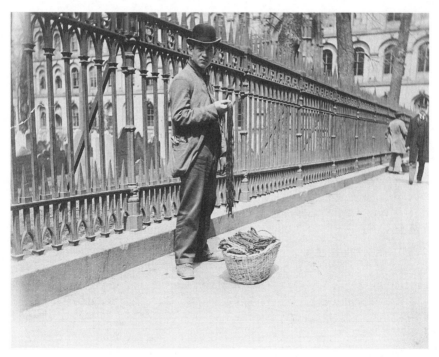

6.20. *Peddler of shoestrings, Trinity Church*

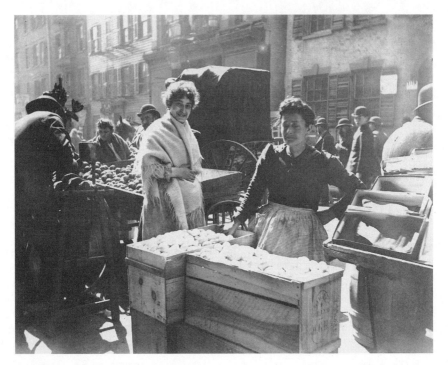

6.21. *Hester Street egg stand*

hattan, empty space like this could not always have been easy to arrange. The production of isolation itself is a hallmark of Austen's street photography. As so many of her subjects labor to keep the streets clean of dirt, snow, and grime, Austen, too, labors to keep the streets clear—of *them*. She was interested in the "queer emigrants" of the working class, as she called them, but only at a distance and only one or two at a time.

Yet, if *Street Types* is a patently nativist text, there is an important exception to Austen's street photography. Austen repeatedly photographed the Jewish marketplace in the Lower East Side, an exotic space where even an intrepid American lady shopper, such as Austen was, might well feel a little intimidated. Streets here were too densely populated to be cleared of crowds. The relaxed and dazzling smile that Austen evoked from the woman in the picture "Hester Street egg stand" is a rare kind of visual exchange in the canon of late-nineteenth-century street photography. It is one of the few public photographs of a first-generation immigrant woman in which the woman's femininity appears along with the difficulty of her economic lot. "Hester Street egg stand" explodes the heavy-handed victimhood overlaid upon immigrant women by early social documentary photographers such as Jacob Riis and Lawrence Veiller, who had their own interests to pursue in New York City reform politics.[10]

Austen had no such agenda. What attracted her, apparently, was the soft white shawl and the warm smile. Austen's portrait of the woman selling eggs is different from Riis's portraits of peddlers because she regarded her subject as a *woman,* rather than as evidence or a statistic. In general, the portraits in Austen's *Street Types* were restrained, set off within a no-contact zone running across the foreground between photographer and nearly all her subjects. But the Hester Street egg stand image has recourse to a commonality that momentarily breaks through this *cordon sanitaire* and allows a relatively unarmored gaze to be exchanged. What accounts for this seeming contradiction?

I think the answer is that gender renders it only a seeming contradiction. For just as Austen's loyalty to race and class arranges her "street types" spatially into a hierarchy of difference, loyalty to "sisterhood" is a bridge that also led in Austen's world to race and class distinctions. Because Austen and her subject were both *women,* Austen could recognize her smile. But because they were *both* women, they also knew that the smile was nothing more.

If one looks closely at the face of the woman at the egg stand, one can just make out that her brilliant smile may be marred by some kind of damage to her upper lip. Is it a birth defect? A current injury? A scar? Of course, we cannot know. But the woman-to-woman smile, sign of sameness, is also the limit of Austen's vision, which offers no way to take the hint of violence beyond her frame. Thus the question arises of what it was exactly that Austen chose to see as she acknowledged the smile of the other woman with the courtesy of her exceptional picture, and vice versa. Austen left virtually no writing except the terse spondaic notations on the envelopes of her glass negatives, of which about 4,000, less than half of her lifetime production, have survived. We cannot compare her words with her images, as we could with those of Gertrude Käsebier; we can only juxtapose her pictures one against the other. There is no evidence in the photographs, however, that Austen took the opportunity to learn more about the meaning of the lives of the people she recorded in New York. The insistence on isolation in most of the other photographs suggests instead that Austen left the Lower East Side and continued uptown with her basic worldview intact.

Meanwhile, other words—or words of the Other—about the contact (or no-contact) zone do exist. Let us consider, for instance, this portrait of a Hester Street peddler, captured by the Russian immigrant woman writer Anzia Yezierska:

> On the corner of the most crowded part of Hester Street I stood myself with my pail of herring.
>
> "Herring! Herring! A bargain in the world! Pick them out yourself. Two cents apiece."
>
> My voice was like dynamite. Louder than all the pushcart peddlers, louder

than all the hollering noises of bargaining and selling, I cried out my herring with all the burning fire of my ten years old.

"Give a look only on the saleslady," laughed a big fat woman with a full basket.

"Also a person," laughed another, "also fighting already for the bite in the mouth."

"How old are you, little skinny bones? Ain't your father working?"

I didn't hear. I couldn't listen to their smartness. I was burning up inside me with my herring to sell. Nothing was before me but the hunger in our house, and no bread for the next meal if I didn't sell the herring. No longer like a fire engine, but like a houseful of hungry mouths my heart cried, "Herring—herring! Two cents apiece!"

First one woman bought. And then another and another. Some women didn't even stop to pick out the herring, but let me wrap it up for them in the newspaper, without even a look if it was squashed or not. And before the day was over my last herring was sold.

I counted my greasy fifty pennies. Twenty-five cents profit. Richer than Rockefeller, I felt.

I was always saying to myself, if I ever had a quarter or a half dollar in my hand, I'd run away from home and never look on our dirty house again. But now I was so happy with my money, I didn't think of running away, I only wanted to show them what I could do and give it away to them.[11]

The speaker is Sara Smolinsky, from Anzia Yezierska's novel *Bread Givers*. The coincidence of Sara's loud voice with Austen's silent picture is suggestive. A Russian immigrant who arrived as a young woman with her family at Castle Garden in 1899 and sold herring at a Hester Street herring stand, Yezierska could very well have been in one of Austen's Lower East Side photographs herself. Yezierska's stories render something of what Austen *could* have learned in her photographic expeditions to the streets, but didn't. Yezierska wrote about how hard it was to work for a living. Like Austen, Yezierska's authorial eye was on the Lower East Side and the immigrants of the 1890s generation, but, unlike Austen, Yezierska rebelled against the domestic narrative that was supposed to govern who and what was seen.

If it was bad luck that put young Sara behind the herring stand, it was serendipity that first placed a camera in young Alice's hands. In 1876, when Austen was ten years old, her uncle Oswald Muller, a sea captain who had been photographing and collecting photographs on his many voyages to China in the 1850s and to Japan after it had been "opened" by Perry, brought a camera home from one of these trips and demonstrated to the family how it worked. Noting the child's avid interest, he gave her permission to experiment with his camera when

he was away. Another uncle, a chemistry instructor at Dartmouth College and also an amateur photographer, taught her the fundamentals of preparing, exposing, and developing the camera's glass plates and how to make her own photographic prints, rinsing them as many as twenty-five times under the hand pump at the well. Still another uncle gave Austen a camera of her own when she entered her teenage years. Her prosperous family could afford to indulge her with the chemicals, paper, time, equipment, and space necessary for this pursuit.

But Austen turned to making photographs with an energy and a steadiness of purpose that totally belie the imputation of dilettantism that in the late twentieth century has come to be associated with the term "amateur photographer." Her uncles, in fact, might have been expecting something much less determined from her. In the strength of her commitment, Austen was truly a photographic visionary. It is easy to forget how early she was. In the single monograph on Austen that has been written to date, author Ann Novotny reminds us that Austen started to photograph "twenty years before Edward Steichen bought his first camera in Milwaukee or Eugene Atget began to record the streets and people of Paris, twenty-five years before Jacques-Henri Lartique (aged seven, so short that he climbed on a stool to focus his camera on its tripod) began his album of family and friends on the beaches and in the gardens of middle-class France." Alice Austen, she concludes, "was an experienced photographer by the time Alfred Stieglitz, her contemporary, exposed his first negative." [12]

When Austen began taking pictures in the late 1870s, the American amateur movement was just beginning to get underway. Amateur photographers were usually wealthy individuals, like Austen, who could afford the time, equipment, and mistakes that learning to photograph entailed. Until the invention of the wet-plate collodion process in 1851, cameras had to be custom made, and photographic technique, consisting of the daguerreotype and the calotype processes, was a cumbersome routine that discouraged nonprofessionals. After 1851, when manufacturers began to supply ready-made equipment, the first photographic societies were formed in London and in Leeds. But even so, the first camera club in the United States to have amateur as well as professional members was not founded until 1861; and this club, located in New York City, gained membership only slowly. It was not until the invention of the Kodak in 1888 that the enormous explosion of picture-making among both men and women expanded their ranks. By then, Alice Austen had already made hundreds of pictures, using the cumbersome fifty pounds of view camera and glass-plate equipment that predated the Kodak and that she stayed with through most of her nearly fifty years of active work.[13]

Austen was also a gender pioneer. If serious amateur photography was not yet a usual pursuit for men, much less so was it a common enterprise for genteel young women when she began to do it. Sanctioned activities for young women

grouped photography among such things as sewing, singing, piano playing, dancing, sketching, skating, and gardening; but this certainly did not mean long solitary periods of immersion in chemicals, with the smells and stains and inconvenience that resulted from a real engagement with the technology. As photohistorian Daile Kaplan points out, "During the period when Austen first became a photographer, it was unusual for women to be associated with the medium, although some who pursued it, such as Julia Margaret Cameron or Lady Clementina Hawarden, became well-known." [14] Kaplan and Novotny offer important reminders of how exceptional Austen's early devotion to photography was, but even this does not convey the depth of Austen's nonconformity. Both Cameron and Hawarden had married, borne children, and secured the protection of family life for themselves long before they took up photography, whereas Austen did no such thing. She entered the eccentric world of serious amateur photography as a very young woman, almost twenty years before either Johnston or Käsebier, and refused to deviate from its demands no matter what difficulties came her way as a photographing woman.

Austen's dissent from gender norms has often been noted, but not, perhaps, her steadfast devotion to the domestic viewpoint generally associated with such norms. In this, Austen differs markedly from other turn-of-the-century American women photographers, who, as we have seen, traded on the attributes of womanhood as a means of escape from their sense of domestic enclosure. Johnston and Käsebier, the women whose careers we have examined so far, used the very fact of being women to their competitive advantage and entered the market conscious of the specific edge that domestic sentiment gave them in competition with men. But Austen never competed with men at all. In fact, although she did exhibit and publish some of her photographs and copyrighted at least 150 of them with the intention of placing them on sale, Austen never had much of a professional or collegial life as a photographer.

Neither, however, was she truly interested in inhabiting the traditional woman's sphere. Instead, Austen had the notion of documenting it, which is a very different thing. The closest analogy to her work is the work of Marion Hooper Adams, called Clover, who took up photography on her honeymoon in 1872–73 after marrying the historian Henry Adams. Clover Adams, like Alice Austen, photographed her intimate circle of family and friends. Adams had a wider range of wealthy and influential relatives and associates, so her photographic world is more elite than Austen's. Yet she too, like Austen, struggled, as Laura Saltz has recently written, to upset Victorian conventions of womanhood by exposing women's self-expression. According to Saltz,

> Clover's photographs do not so much objectify her women as problematize an objecthood already culturally prescribed both by the discourse of science

and by nineteenth-century discourses of female visibility. In picking up a camera, Clover turns the photographic apparatus that has itself participated in such discourses to new ends . . . representing rather than reconstructing the metaphorically dark rooms of women.[15]

Austen also "represents" rather than "reconstructs" the domestic vision's disappearance of women, by removing its smothering wraps. She delighted to set convention aside and to share with other people, as Daile Kaplan writes, "her own acute social insights about the peculiarities of Victorian culture."[16] In a sense it was the very differences between women's lives lived and women's lives observed that drew Austen to photography. Like the twentieth-century street photographer Gary Winogrand, she photographed because she liked to see what something looked like in a photograph.

At the same time, Victorian family life was changing, responding to changes in the racial and class composition of the population, even on Staten Island. Even in her early youth, Alice Austen seems to have sensed that the intimacy that kept her "own" family and friends separate from "others" was rapidly being eroded. Because Austen left so little writing beyond the matter-of-fact jottings on her photographs—noting time, date, and technical information—we are thrown back solely on the pictures themselves for understanding what she believed she was doing. But this she did say, about the Staten Island Cricket and Tennis Club where she spent much of her time: "This is not going to be a cricket club, some day, and I'm going to have pictures of how it looks now."[17] It is the best clue we have to her sense that American life as she knew it was leaching away.

The population of Staten Island grew rapidly in the last quarter of the nineteenth century. "Partly to accommodate the new residents and their visitors, the first consolidated ferry service to and from Manhattan was instituted in 1890, and a few years later Staten Island became (as the Borough of Richmond) part of New York City," Novotny observes. "Oldtimers on the island grumbled that their self-contained and peaceful way of life would be spoiled by these actual and symbolic links to the metropolis. They were right."[18]

Technology brought some of the changes in the quality of life. As Novotny relates,

> By 1900, as electric trolleys replaced horsecars on the streets of the growing towns, light industry began to intrude upon the island's countryside. There were new power plants, and small factories for making paper and fireworks, jewelry boxes and white lead. One of the world's first airplane factories opened on Ocean Terrace to the west of Emerson Hill. Water pollution from sewage and from ships in the harbor began to destroy the oyster beds, which were condemned and abandoned in 1916.[19]

But material progress also meant social change:

> The island's wealthier residents and summer visitors began moving away to quieter and newer residential areas and resorts. The upheavals of World War I and its aftermath ended Edwardian living, and the advent of Prohibition dealt a blow to the island's prosperity for it closed down the breweries, just one year before Alice Austen was legally entitled to vote for the first time. The cotillions, the coachmen with their handsome horses, and the servants in the large houses, slowly disappeared one by one along with the nineteenth-century lifestyle and the residents who had peopled the world of Alice's youth.[20]

Aware of the significance of these changes, Austen worked steadily from the time of her first photographs in the mid-1870s to capture on film the special quality of her disappearing way of life on Staten Island.

Austen's photographic project shifts our perspective on white middle-class American women's domestic vision at the turn of the century. Johnston and Käsebier pictured American domesticity as a given, a firm set of mores and practices that were in comfortable accord with imperialist ambitions. But because Alice Austen was less sure than her photographing contemporaries that the basic terms of middle-class private life in the United States *were* secure, her record of domestic life was made for a very different reason than theirs. Johnston's and Käsebier's portraits of white middle-class groups are static yardsticks against which it was thought possible to measure the achievements of the lives of other people. Austen alone produced an analysis of white middle-class domestic life as a life that itself dissembled. Austen did not measure turn-of-the-century white middle-class homelife as a standard against that of other people, but as against itself. In effect, Austen's photographs redefine American domesticity as a precarious foundation. For Austen, Victorian social mores were a social, not a natural, construction, ones that by the end of the nineteenth century were continually being disrupted by the eruption of internal and external differences.

Staten Island, of course, was not unique. All over the country, capitalist exploitation of plantation agriculture, raw materials, industrialization, and the resultant shifting demands for labor were overturning traditional community life. Nineteenth-century photographs often registered this disruption as an invasion of strangers, as Austen herself had done in *Street Types*. But in Austen's work there is also a uniquely self-conscious reflection of the disorder that capitalism was causing back home in the self-image of the capitalist class itself. In her images no one is exactly who they should be. Austen knew that, as a universal standard, white middle-class life was a kind of lie.

What can be perceived in Austen's work, I believe, is the anxiety of creating and maintaining a continuous, stable social self when because of colonial expan-

sion there was, as Fredric Jameson might put it, "a significant structural segment of the economic system as a whole located elsewhere"—that is to say, a domestic unconscious.[21] The immanent presence of the wings of the imperial stage exacted a toll of de-realization on the center, not only from those whose job it was to conquer and pacify new territories but also from those left at home to mind the metropolis. Austen's photographs register this dislocation as a disturbance in the field of gender. One of the many things they suggest is that while the white middle-class male/female alliance forged during slavery remained intact for late-nineteenth-century white women, the new wave of colonialism also made the full rationale behind such an alliance occult to them. Gender's realm of racial effectivity was now anchored in an expanding sphere of action that was located elsewhere—in colonies that themselves used gender as a pacifying principle, in places that were not the "here and now," but the "there and then."

The obscurity of this mechanism is what gives Austen's work, in Daile Kaplan's words, its "inherent self-reflexiveness." Her photographs have a contemporary quality even though, as Kaplan notes, they "predate turn of the century modernist influences."[22] However, there is no contradiction in seeing Austen as a modernist if we understand, with Jameson, that "the modern" signified the effort to account for the fact that

> daily life and existential experience in the metropolis can now no longer be grasped immanently; it no longer has its meaning, its deeper reason for being, within itself. As artistic content it will now henceforth always have something missing about it, but in the sense of a privation that can never be restored or made whole simply by adding back in the missing component: its lack is rather comparable to another dimension, an outside like the other face of a mirror, which it constitutively lacks, and which can never be made up or made good.[23]

In her confrontations with the "queer" immigrants who flooded New York in the 1890s and 1910s in flight from violent dispossession and in search of jobs and in her explorations of the strangeness within the middle-class Victorian family itself, Austen can be seen trying to juxtapose the two. She was seeking "the other face of the mirror, which it constitutively lacks."

This was, as Jameson puts it, a "new and historically original problem in what is itself a new kind of content"; it constitutes "the situation and the problem and the dilemma, the formal contradiction," of modernism in general.[24] The hypothesis of an imperial domestic unconscious within the metropolitan center helps to explain why Austen, entirely devoted to picturing daily life at Clear Comfort as a kind of utopia, also depicted, in a very concrete sense, a life that referred elsewhere. Her utopian vision referenced in particular the "Orient" of her Aunt Minn and Uncle Oswald, whose many prints and photographs

6.22. *The north lawn at Clear Comfort, decorated with vases and urns brought back from the Orient by Austen's Aunt Minn and Uncle Oswald*

of China and Japan hung on all the walls of Clear Comfort and whose "teak-wood furniture, prints, and porcelain vases of all sizes adorn[ed] the parlor and even (interspersed with Japanese stone lanterns and metal urns) the northern slope of the lawn."[25] The collection of exotic domestic objects at Clear Comfort also suggests the promise of an increasing grasp of the wide range of domestic possibilities that actually existed in the United States. The domestic unconscious accounts for the flash of genius that illuminates the Hester Street egg stand photograph and the flash of wit that undermines the images of proprieties at home. Austen came tantalizingly close to discovering the energies set loose and the people set in motion by the imperial powers.

But, ultimately, Austen failed to grasp these historical relations. She did not read the import of the stranger's dazzling smile, perhaps because she saw it as too much like one of her own. Austen's career reveals how firmly the sentimental eye still shut against its own capacities for insight. Content to keep her distance, Austen did not inquire what world events would have brought that woman to the egg stand in the first place. Unlike others of her contemporaries, such as Jane Addams and John Dewey in Chicago or the members of the Anti-Imperialist League in New York City, and unlike many of her own neighbors on Staten

6.23. *Alice Austen (left) and Gertrude Tate, a portrait from Mr. Pickard's Penny Photo studio on Staten Island*

Island, such as Santa Anna, the ex-president of Mexico; the Hungarian patriot Kossuth, the Italian Garibaldi, and "many revolutionaries from Germany and Poland, and the Russian writer Maxim Gorky," Austen refused to revolt against the overdetermined "innocence" of American life.[26] Faced with the choice of conviction or consumption, Austen remained a lady shopper to the end. As a result, although Austen was extremely energetic in photographing "her world," she returned to the ostensible security of Clear Comfort without any sense of personal implication in it. One might aptly have renamed the place "Close Call."

Austen's homelife was not simple to delineate. Although Clear Comfort conformed to the dictates of nineteenth-century bourgeois respectability, it had only a facade of propriety. There had been an undercurrent of complexities from the very beginning. First, Austen's father had abandoned her mother even before his baby girl was born in 1866. At this, mother and infant moved back into the maternal grandparents' home on rural Staten Island, set on a nicely manicured acre of land sloping down to the water along the busy shipping channel called "the Narrows" at the entrance to New York harbor. Austen never saw her father and never used his family name. But she lived at Clear Comfort, her home for almost eighty years, from 1866 until 1945 solely because of his desertion of her. In a sense, she owed the very ground of her vision to the absence of her father.

Second, Austen never married. Although she enjoyed an active and lively social life during her girlhood and youth, went to the proper schools, and summered in the right places, Austen found her lifelong companion in a woman rather than a man of her social set. Gertrude Tate was a kindergarten teacher and a dancing teacher from Brooklyn, about ten years younger than Austen herself. They met at a resort hotel in the Catskills in 1899, and their closeness lasted for

over fifty-five years. Tate's family disapproved of this "wrong devotion" that discouraged male suitors, and Gertrude did not actually move in to Clear Comfort with Alice until 1917, when Gertrude was in her middle forties and Alice was fifty-one years old. But her family's opposition changed nothing. Much later in life Austen told an interviewer that she was "too good to get married," explaining that she was "too good at sports, too good at photography and all mechanical skills, to appeal for long to the men about [me]."[27]

And finally, if Austen was unconventional in her life course and unconventional in the seriousness of her practice of photography per se, she was also somewhat of a loner in the field. She did not participate much in the camera clubs and exhibitions that had begun to serve as a vital source of stimulation for photographers in New York in the 1890s. She joined instead the more provincial Newark and Jersey City Camera Clubs. She did publish photographs in such publications as *Camera Mosaics* and *Photo American Review,* and in addition to *Street Types,* she took pictures to illustrate a book on the sport of bicycling and sold photographs from the Pan American Exposition. But the aesthetic and political debates in photography of the time left her cold. Although she did exhibit some of her prints at the New York Camera Club and at the Pan-American Exposition in Buffalo, she became neither a pictorialist, nor a photo-secessionist, nor a professional photojournalist. Austen read *Popular Mechanics,* not *Camera Work,* to find out how to improve her pictures. She pursued a private rather than a public career as a documentarian.

Austen did have an important colleague in Gertrude Tate, her personal cheerleader. Tate often agreed to be "squeezed into [the] surrey with trunks full of photographic equipment," to wait patiently for Alice to make views on their many outings and trips to Europe, and to endure the many nights when Alice, working in the darkroom "next to the bedroom that Miss Tate occupied (as guest and resident) [bumped around] developing her negatives, until two or three o'clock in the morning."[28] But Tate was not a photographer. Austen's long career in photography was thus largely a solitary communion. Her vision of the changing horizon of the domestic world was an interrogation from within of the limits of white American middle-class conventions.

From the mid-1880s to the mid-1890s, Austen made a series of portraits of Victorian family life that especially upset many of the stereotypes. These portraits, which Daile Kaplan calls "acute social insights about the peculiarities of Victorian culture," are extraordinary parodies of convention.[29] Did the Victorians like to photograph themselves in stiff but congenial family groups, sitting around together on chairs brought from the house and set out on the lawn? Did they treasure sentimental pictures of "true friends?" Did they celebrate male domination and female submission in photographs of young lovers enacting the

6.24. *Minn, Oswald, and Austen in the garden at Clear Comfort*

patriarchal script: he sitting, she standing to serve him better? Austen mocked all these genres.

In one uncaptioned mid-1880s photograph, Austen's Aunt Minn, her Uncle Oswald, and Austen herself pose together in a corner of the garden. Minn, tightly laced into an elaborately trimmed dress, is holding a parasol. Oswald looks formal and dapper in morning coat, wing collar, and bowler hat. Austen, in silk dress, hat, and corset, is accompanied by her pug dog, Punch. The inevitable garden chair is present but it is Alice Austen, the child, rather than either of the adults, who occupies it. Straight-faced, she mocks the seat of power of a Victorian family photograph.

Austen stares off into the middle distance, away from the camera, and fiddles with the fronds of a fern. In her hands she also holds the pneumatic cable release for her camera. Far from being merely a visual object, she controls the gaze. Meanwhile, Oswald has stuck his walking stick so firmly into the ground that his arm wobbles, and although Minn balances her parasol ever so gracefully over her shoulder, offsetting her nicely formed hairdo, she is somehow less than convincing. As it turns out, Aunt Minn's hairdo is a wig. Minn's head was entirely bald, a result, Ann Novotny reveals, of many years of physical stress accompanying Oswald on his voyages all over the world. As in so many Austen photographs, the family group looks slightly supercilious, and in fact in another image made

6.25. *The Darned Club*

at the same sitting they are all convulsed in giggles. Alice Austen is directing and photographing a charade. It was just too funny for these people to portray themselves as a typical Victorian family. They all know too much about what they are not.

In another photograph, taken on Thursday, October 29, 1891, at 3 p.m., according to Austen's careful notes, "The Darned Club" of female love and friendship had itself recorded. Alice and three of her friends stand "on the Austen lawn overlooking the narrows," as the caption reads. They interlace their arms, place their hands around one another's waists, and touch their boot tips toe to toe. Skirt to skirt, bustle to bustle, they are in close enough contact with one another to seem, visually, like one of those amateur theatrical tricks where a group of people get together under a large cloth and pretend to be a four-legged animal. The friendship is serious enough. The girls have carefully lined themselves up in order of height to signify the conscious, orderly quality of their unity. But Austen, at left, operating the camera once again by remote control, is the only one who can keep a straight face. Perhaps this is the reason the rest must turn their faces a bit away from the camera. Their relationship is real, but its sentimental record is a good joke.

In another photograph of this same group, "The Darned Club in a chair,"

6.26. *The Darned Club in a chair*

three of the friends pile close together upon a single chair, while Austen stands behind and embraces the entire ensemble. Again they are refusing completely to distinguish their individual bodies from their friendship group, and instead seat the fact of their unity, as it were, upon the chair. A paradigm of homosocial bonding, this cluster presents a formidable challenge to any suitor who would cast them into separate female roles and fates. Probably this explains why the young men of their acquaintance had nicknamed them "the Darned Club" in the first place.

More penetrating still are Austen's spoofs of masculinity and femininity. In one of these pictures, made on Thursday, August 6, 1891, Alice and her friend Trude Eccleston, an Episcopal minister's daughter, masquerade in Trude's rectory bedroom as women of ill repute. Dressed in their underclothes and pretending to smoke cigarettes with their hair streaming down and masks over their faces, Austen and her friend transform Trude's bedroom into a brothel and themselves into mirror images of sin. The theatricality of this double portrait is emphasized by the curtains around Trude's bed and window seat that provide an improvised stage for the young women's performance. But unlike a real theater, strangers are not invited here. This is a private space that emphasizes the intimacy of the performance. The photograph gives reason to question public

6.27. *"Trude and I, masked, short skirts"*

representations of Victorian girls as demure young virgins. True Womanhood is not what it is said to be.

In another image, entitled "Trude, Mr. Gregg, and Fred Mercer, August 9, 1891," a romantic triangle is grouped around a rocking chair at the corner of what looks to be the veranda of Austen's house. The image disrupts the smooth surface of Victorian courtship rituals either by exposing or inventing—it is not clear which—nonconforming passions. Trude sits on the arm of the chair, her face averted from the camera, and stares into the eyes of Mr. Gregg, who returns the gaze with a steady, clear, and soulful look. Fred Mercer, on the other hand, shoots daggers from his eyes at Trude. Is she flirting with his friend? Has he lost the love that he once had? Or is it all a practical joke, a masquerade whose only truth is in the mimicry? In this photograph it is impossible to know what is true and what is false. One's idea of the proper order of things, like one's ideals of love itself, may easily be without a basis in the real.

Austen also cast her friends in a virtual performance piece on the subject of courtship—set, ironically, in a graveyard. No record remains of the original order or captions for this set of photographs; they are now like a deck of cards that may be shuffled at will. But one plausible narrative is as follows: in the first frame, a young courting couple, she in a black dress and he in a boater and white flannels, are standing together under her parasol looking at the Noyes family

tombstone. In the next, the young woman is seated at the base of the tombstone, and the young man is on the grass at her feet, imploring her. She is placed so as to obscure the first two letters of the name carved on the tombstone, so that the word "YES" appears above her suitor's head like a cartoon balloon that shows his thoughts: "Say yes!" Sadly for the young man, in the next frame his sweetheart has turned away, moving so as to cover the "YES" and expose the "NO" of her answer. In the fourth frame, the young man stands, rejected and distraught, while the weeping young woman in black, her parasol collapsed, moves off to the left, putting the word "NO" between them. However, at the right-hand corner, another young woman has already appeared. She is wearing a white dress, and her parasol is in full, open flower. In the fifth frame, she comforts the rejected suitor, who recovers brightly under the shelter of that parasol while the Noyes tombstone, fully legible again, stands waiting to the left. In the final frame, at last, a proper couple is united, and the tombstone proclaims "YES" for all the world to see. I have invented these captions and a title for the series—"What a lot of Noyes!"—since Austen did not leave any. But the brilliance and pointed humor of the little photographic skit about the death and rebirth of love are perfectly legible a century later.

In yet another image, the fictionalization of gender norms is explored again, but in a startlingly physical way. "Julia Martin, Julia Bredt and self dressed up as men. 4.40 p.m., Thurs., Oct. 15th, 1891" explores the biological basis of manhood itself. Dressed in male clothing,—and looking, indeed, very much like the young

6.29. *Noyes series, no. 1: Courting couple*

6.30. *Noyes series, no. 2: "Please say yes"*

6.31. *Noyes series, no. 3: "No"*

6.32. *Noyes series, no. 4: Despair*

6.33. *Noyes series, no. 5: "Let me comfort you"*

6.34. *Noyes series, 6: "Yes, I will marry you"*

6.35. *Julia Martin, Julia Bredt, and Austen dressed up as men*

men of their acquaintance—Austen and two girlfriends present themselves to her camera as pranksters who are investigating the masquerade of masculinity. Austen, standing at the left with darkened eyebrows and a mustache, holds a cigarette casually between her fingers and grins. It is one of the few wide open smiles in any of her self portraits. This is a joke she is obviously enjoying.

On the right, in Derby hat and boutonniere, one of her friends glowers sternly at the camera in a good imitation of masculine authority. In the middle, seated in the chair (again) and smiling broadly, her other friend has planted a closed umbrella upside down between her legs so that its curved, carved handle looks like a huge erection escaping from her trousers. If it is surprising today to see such a frank and aggressive reference to male sexuality among these well bred young Victorian women, their freedom to make such a reference is in fact exactly the point of their image. It is not simply the social masquerade of mas-culinity and femininity that they are exploring, but sexuality itself as it has been divided by gender, a partitioning of power and knowledge that they are, at least at this moment, rejecting.

Largely due to these "irreverent tableaux," Austin has come to be admired as having a sensibility far ahead of her time. However, as we have already seen in

Frances Benjamin Johnston's self-mocking self-portraits or in Gertrude Käsebier's "Married—Yoked and Muzzled," and "Where there is so much smoke, there is always a little fire," Austen was not unique among middle-class white women photographers at the turn of the century in producing high-spirited critiques of masculinity and femininity. Jonathan Weinberg has traced an entire line of American photographic deconstructions of gender from F. Holland Day to the pornographic photographic scrapbooks of Carl Van Vechten. Austen's antifoundational images of gender performativity fit comfortably within this subversive tradition.[30] Where they are truly original, instead, I would suggest, is in the connection Austen makes between the conventions of private life, to be explored in private, and the public landscape that surrounds and presumably protects this privacy. Austen's unusual sense of space, first apparent in *Street Types,* permeates her gender series and puts her inquiry into private gender performance squarely on the world map.

The physical setting of Austen's domestic life at Clear Comfort made a sense of the world stage, broadly speaking, inescapable. Clear Comfort was a country retreat, but it was not entirely a pastoral one. In fact, the Austen property on Staten Island was situated just at the entrance to New York harbor, and the shipping channel into New York cut directly across the view from the front lawn. In an early image made by someone other than Austen it is easy to see how closely the ships went by just beyond the swimming beach. Because of this situation the world outside impressed itself upon Austen's domestic space in a particularly forceful way. A photograph from later in her life, "Alice Austen watches her world from the foot of her garden," indicates quite clearly the intimate relationship between Clear Comfort and the shipping channel.

The shipping channel fascinated Austen. It was for fifty years one of her favorite photographic subjects. When interviewed by Novotny, Austen's friends and relations remembered that Austen often stood at the end of the garden path and watched as troops, trade, and travelers sailed past. So too had Captain Muller, the uncle who gave her her first camera, and also his wife, her Aunt Minn, who "would peer through the telescope on the porch at ships streaming through the Narrows, remembering an amazing number of them from her own visits aboard in foreign ports, and naming their captains to her niece."[31] One photograph shows Oswald Muller himself photographing the Narrows.

The Mullers taught Austen to identify all the kinds of ships that went past. She recorded as many as she could with her camera, carefully writing the date and the name of the ship on her negative envelopes. When the *Lusitania* went by, she got its picture, only to write "last voyage" on the envelope when news came that it had been sunk. And she followed certain ships into Manhattan, such as Admiral George Dewey's flagship, the *Olympia,* when it returned from Manila

6.36. *Austen and friends in a boat, just below the end of the garden at Clear Comfort*

6.37. *Austen at the foot of the garden, looking out over the Narrows*

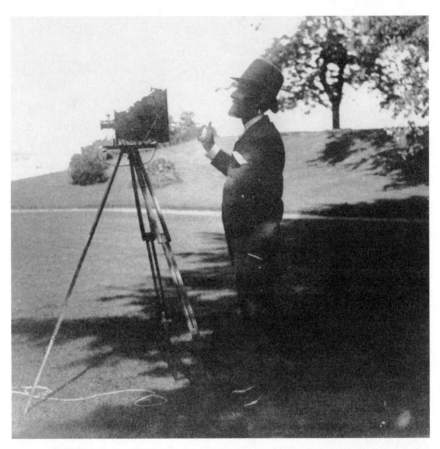

6.38. *Oswald Muller at Clear Comfort, photographing ships sailing through the Narrows*

to sail up the Hudson River with a flotilla, a seventeen-gun salute, and more than a million people watching from Riverside Drive.

But it was Austen's vision that turned the physical proximity of the great world denoted by the ships into a formal principle, by including it as a point of reference in her domestic work. In Austen's images the outside space of the shipping channel figures prominently as part of the "inner space" of private life. It appears either explicitly as the visible background, as in the "Darned Club" or implicitly as the scene that is seen from the yard where a photograph is staged, as in "Trude, Mr. Gregg, and Fred Mercer" or "Julia Martin, Julia Bredt, and self dressed up as men." As a photographic space, this social geography was Austen's invention. Sometimes Austen bifurcated the frame, treating the vast differences in scale that resulted as an interesting visual event. Sometimes she flattened planes and brought remote aspects of the scene into closer visual contact than they might have been in reality. In all such images, there is a startling

6.39. *Sailing ships passing through the Narrows*

juxtaposition of the intimate and the foreign. Through Austen's lens, the private world in which the imperial self was lived joins the looming presence of the American empire, which claims a piece of the field of domestic vision.

But ultimately Austen's most significant contribution to nineteenth-century white middle-class domestic imagery is her invention of a way not to blend but to picture the co-presence of distinct realities. What Austen discovered was the visual intoxication of the contact zone, the precipitous but irreducible contiguity that anthropologist Mary Louise Pratt describes as the "spatial and temporal co-presence of subjects previously separated by geographical and historical disjunctures, whose trajectories now intersect."[32] Home life and public life converge along an invisible border in Austen's space, while they also remain entirely separate and distinct.

I want to suggest that when Austen left Clear Comfort and headed for Manhattan with her camera, it was this discovery of the principle of adjacency, or parallel existence, that inspired her. It accounts for both the intimacy and the failure of intimacy of her image of the Hester Street egg stand. In confronting the newcomers, many long-time New Yorkers were afraid of contagion or of some kind of internal collapse. As fine and courageous an observer as Henry James, for instance, was overcome by the prospect of absorbing into his self-concept such radical difference as the immigrants signified. Despite the richness

6.40. *Sailing ships and steamship in the Narrows*

of sensation that the immigrants brought to New York City, James described the "passage between" the new and the old inhabitants as "sterile." James was embarrassed by his feeling. In *The American Scene,* in 1907, James wrote that this sterility was a lapse that was "recorded, with due dryness, in our staring silence." The "lapse," he believed, was his own. When his eyes met the eyes of an immigrant, it was he, the native English speaker, the former New York resident, who found himself diminished. James sensed a failure of "some impalpable exchange. . . . It was as if contact were out of the question." He was shocked by the aphasia that he contracted in the contact zone: "He doesn't know, he can't say, before the facts, and he doesn't even want to know, or to say, the facts loom, before the understanding, in too large a mass for a mere mouthful; it is as if the syllables were too numerous to make a legible word."[33]

 A curious grammatical ambiguity characterizes the final sentence of the passage above. Does "he" not "even want to know or to say" *because* "the facts themselves loom, before the understanding, in too large a mass," or does "he" not "even want to know or to say" *that* "the facts themselves loom, before the understanding, in too large a mass"? That is to say, is James silenced because there is too much to comprehend, or because he has already comprehended more than he wishes to bear? What was the word that could not be said? Henry James's

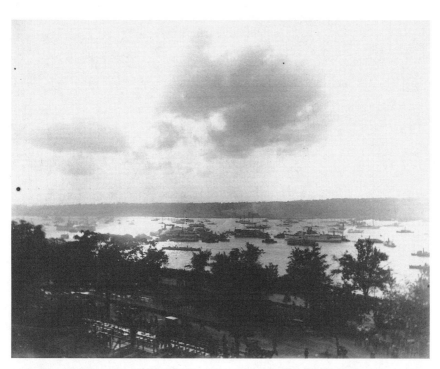

6.41. *Admiral George Dewey's flagship* Olympia, *accompanied by a naval parade and a seventeen-gun salute, steaming down the Hudson River to celebrate the return of the "Hero of Manila," before one million spectators, September 29, 1899*

great literary adaptation of the shot reverse shot sequence came up short before acknowledging the content in the mind of an Other that might include watching one's babies starve, one's grandmother raped, one's house and fields fired, one's simple humanity spat upon and cast out. Not finding a way to "say" this unspeakable awareness, James wrote his novels as if such violence were not part of contemporary life.

But for Austen, the contact zone was not a failure of words because she, unlike James, did not imagine that there was any urgent demand for further exchange. Her years of contemplating the spatial relations of the shipping channel apparently persuaded Austen that two very different worlds didn't need actually to touch. The "passage between" the native English speaker and the immigrant was not threatening to Austen because it was exactly the kind of gulf that she had become accustomed to see as the defining border of domestic life.

Neither was Austen afraid, like so many others, of contamination. Again, she owed this confidence to the vision of the Narrows. As it happens, in 1896, the year she copyrighted *Street Types of New York,* the U.S. Public Health Service commissioned Austen to make a photographic record of the disinfecting equipment

6.42. *Steam disinfecting chamber for clothing and bedding, Hoffman Island*

6.43. *Immigrants' laundry on cart, Hoffman Island*

6.44. Sterilization chamber, Hoffman Island

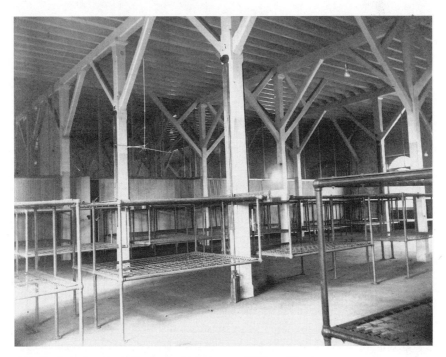

6.45. Bunks in dormitories for detained immigrants, Hoffman Island

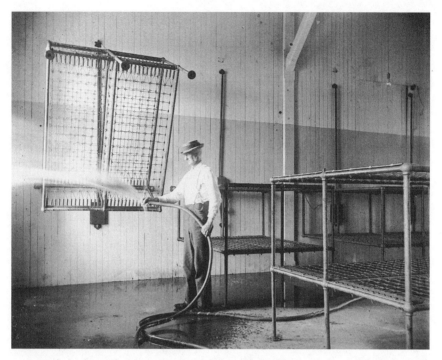

6.46. *Bunks for detained immigrants, raised daily so that the floor can be hosed down, Hoffman Island*

and quarantine procedures at the U.S. government quarantine station housed on Hoffman and Swinburn Islands and on the shore of Staten Island, just to the south side of the Austen house. All ships entering New York harbor had to first pass inspection there. The photographs that Austen made were displayed at the U.S. Public Health Service exhibition at the Pan American Exposition in Buffalo in 1901.

In the hospital on one of the islands were "sailors and immigrants with small-pox, yellow fever, cholera, and typhoid; on the other [was] a complex of build-ings [that] hous[ed] possibly infected crew and passengers in isolation until the danger of a suspected disease had passed."[34] But Austen did not photograph the people. Instead, she focused on the large chambers that could sterilize every-thing aboard the contaminated ships by steam disinfection, including clothes and bedding. In the detention dormitories for steerage passengers, she photo-graphed the bare iron bunks, which were raised daily so that the floors could be hosed down. Her images of quarantine replicate the spatial relations of the ship-ping channel. There is no actual crossover from one space into another; instead, multiple realities exist in parallel.

When Austen did photograph people aboard the *Cyrene,* a British cargo ship

6.47. *Suspecting yellow fever among the crew of the steamer* Cyrene, *Public Health Service officials aboard the* James W. Wadsworth, *a government paddlewheeler and disinfecting boat, draw alongside the steamer.*

from Sunderland, as it was boarded, relieved of its crew, and then sprayed with disinfectant by the crew of the government paddle-wheeler, the *James W. Wadsworth,* she broke the static frontality of her customary format. In this image the *Cyrene* looms out at the viewer perpendicular to the frame, a highly unusual configuration in an Austen photograph. Photographing "Dr. Doty" of the U.S. Public Health Service and his young son on the upper deck of the *Wadsworth* and photographing a chemist named "Fred" in his laboratory on Hoffman Island trying to analyze strains of bacteria brought human actors onto the island. In addition, Austen also made at least one photograph at the quarantine docks of "smiling immigrants, released from isolation, resum[ing] the last stage of their interrupted journey to America," as well as one of "dejected immigrants wait[ing] on Hoffman Island" after they and their ship had been quarantined for possible smallpox.[35]

However, people appear rarely in her set of Public Health Service photographs. Austen's eye was drawn mostly to the physical plant and to the technical apparatus of the quarantine station staff. In fact, she was so interested by the operation that she returned to the subject again and again for over ten years,

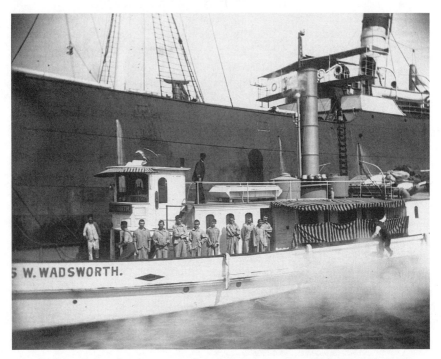

6.48. *Crew members taken off the* Cyrene *line up on the deck of the* Wadsworth *while their clothing is being disinfected.*

long after the Buffalo Exposition was over. Perhaps looking at the technology of sanitation helped to reassure Austen about contamination by the foreign just as effectively as the shipping channel protected her private world from semantic collapse.

Her public world was another matter. As those millions of "foreigners" knew, by the 1870s the changing interface between imperialism, capitalist development, and labor had produced profound alterations in the international territorialization of space, such that its traditional markers no longer adequately described its contemporary economic and political forms. Indeed, that was why so many immigrants had come to New York in the first place. "By the 1870s," writes labor historian David Montgomery, "industrial society had generated abstract but interlocking geographic regions that were to remain essentially in place until after World War I." Drawing upon Immanuel Wallerstein's categories of "core" and "periphery," Montgomery describes a new American space that was much beyond the scope of any previous domestic vision. It consisted of a tripartite division of dynamically interlaced economic regions. First there was

> an industrial core, throbbing with manufacturing activity at continually rising levels, [that] was roughly bounded by Chicago and St. Louis in the west,

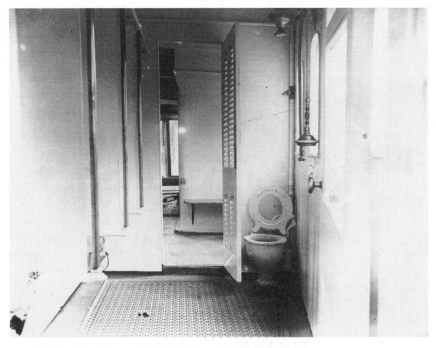

6.49. *Toilet and mandatory shower facilities on the* Wadsworth

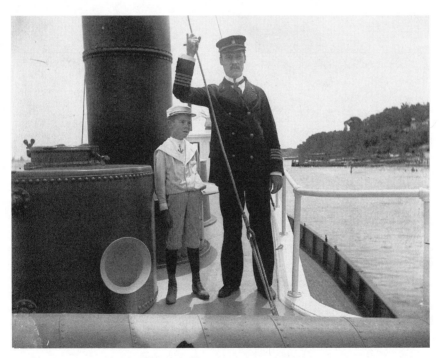

6.50. *Dr. Doty of the U.S. Public Health Service and his son Alvah on deck of the* Wadsworth

6.51. *"Fred at work," laboratory in quarantine station, Hoffman Island*

6.52. *Dejected immigrants wait on Hoffman Island for the period of observation to end.*

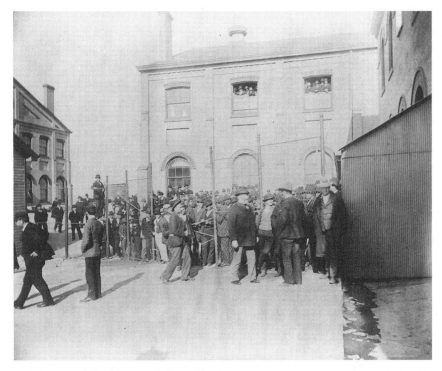

6.53. *Detainees behind fence on Hoffman Island*

by Toronto, Glasgow, and Berlin in the north, by Warsaw, Lodz, and later Budapest (as rather isolated outposts) in the east, and by Milan, Barcelona, Richmond, and Louisville in the south.[36]

This heavily industrialized center profoundly destabilized and reorganized the regions that surrounded it. Traditional agricultural economies were altered; village-centered life was impoverished; and people, goods, and capital migrated toward the center.

Surrounding that core, and indeed enveloping its urban outposts, lay a vast agricultural domain in which capitalist development shattered long-established patterns of economic activity, without cultivating more than scattered pockets of extractive and processing industry. Modernization thus appeared on the periphery more as an alien, destructive force than as an integrated pattern of growth. The region encompassed Quebec and Canada's Maritime Provinces, much of Scandinavia, European Russia (or, more precisely, the domain that Poland had embraced before the eighteenth-century partitions), the Kingdom of Hungary, Croatia-Slovenia, Greece, Italy, Sicily, Andalusian Spain, the defeated Confederate States and Great Plains of America, central and northern Mexico, the hinterland of Canton, and later the southern islands

6.54. *Closer view of detainees behind fence on Hoffman Island*

of Japan. Although this territory shipped agricultural produce, minerals, and forest products to the industrial core, it also exported people.[37]

At the same time, an eccentric vector drew labor, capital, and colonial ambition toward foci far outside of these nested, previously developed regions:

> Beyond the periphery lay an even larger third world that became increasingly tightly integrated into the economy of the core as the nineteenth century drew to a close, although it sent forth few emigrants. On the contrary, capital investment as well as workers migrated from western Europe and North America into that portion of the world to develop mines, plantations, railroads, and ports. A vast export there was based increasingly on the wage labor of local residents, who were put to work in their own countries, and of migrant laborers from other parts of the third world, especially India and China, during this period of history. Accompanying that investment and migration were warships and soldiers, staking out spheres of influence and colonies and embroiling the great powers of the core itself in an ascending spiral of armament and diplomatic controversies.[38]

6.55. *Detainees returning to dormitory on Hoffman Island*

Austen, who watched the panorama of warships and cargo ships, immigrant ships and ocean liners move across her visual field at Clear Comfort for almost eighty years, had a front-row seat at this spectacle. Her tremendous output of shipping pictures give the impression that she certainly sensed the drama of what was going on. Austen, however, did not want these spheres to be imaginatively "interdigitated," as David Montgomery describes them. Rather, she labored mightily to keep them separate. Like Scylla and Charybdis, the forces of history were converging upon Old Staten Island. Domestic sentiment was Austen's frail but only power to stave off their collision. The work of her life in photography went to ensure that the vast, imperial tapestry would remain backdrop for the increasingly strange internal space that modernization had generated at home.

To isolate oneself from history was difficult, even for a privileged woman of "Alice's World." Rumor has it that "more than once" Alice Austen sneaked down to the edge of the front lawn of her family's home on Staten Island under cover of darkness and dressed only in her night clothes. She would pull up the surveying stakes that government workers had the day before put in place as a preliminary step toward cutting a public road across her property, between Clear Comfort and the beach.

The anecdote, as told by Anne Novotny, is certainly amusing, for it turns on

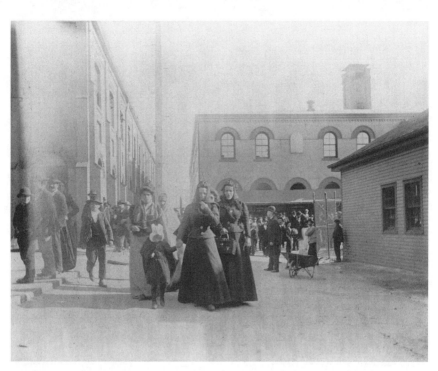

6.56. *Women and children detained on Hoffman Island*

its head the stereotype of the modest and retiring Victorian maiden lady to reveal the iron will and sense of absolute entitlement that lay concealed underneath. Edgewater Street already ran south along the shore but was stopped by the Austens' fence. Official documents called for it to be joined to Andrease Street, on the other side of their property, and thus to make a continuous shore road. Novotny reports that Austen, "convinced that the Austens' deed to the property included riparian rights, and damned if she was going to see their private carriage road turned into a public thoroughfare," watched carefully as the surveyors from the roads department did their work:

> In the dark of the night she tiptoed out of the house and removed their stakes and flags, throwing them into the water and carefully tramping down the turf to remove any sign of where they had been. Next morning, the road crew arrived, exchanged a few words, sighed, and began their work again. That night, Alice came out of the house again and removed all traces of it. Edgewater Street still ends at the fence line, and the Austen garden is today a public park extending to the water.[39]

But this story is also far more than simply an amusing tale. First, it references most if not all of the major passions of Alice Austen's life. In it we see how

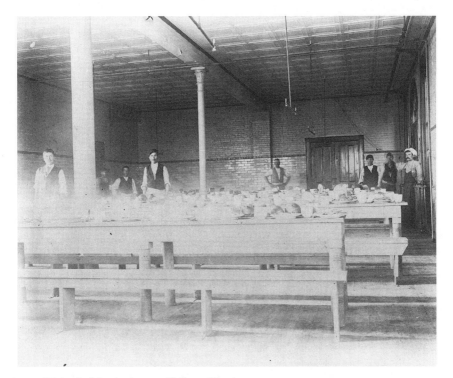

6.57. *Dining hall for detainees on Hoffman Island*

rooted she is in the standpoint of middle-class Victorian values that made one's home one's castle. Then there is her instinctive defense of that prospect when she felt it threatened, her courage to test her own point of view against that of outside institutions, and her utter disregard of the actual "stakes" of the other side, whose daily labor was a "sign" that she erased as if by "rights." Wanting a view of the world, but intent on securing the inviolability of her own individual vantage point, Austen resented and resisted the presence of outsiders.

Novotny ends the story with the triumph of will: Alice Austen kept the family's property intact. But there is also a stunning irony, for, as Novotny notes, "the Austen garden is today a public park." The threatening and hated "public thoroughfare" now extends not merely as a parallel band of road between her beloved Clear Comfort and the water but all through the garden and the house as well.

If Alice Austen's life story can be told as farce, this in itself is perhaps not so exceptional. The image of a "mad Alice" tiptoeing down the lawn in her nightgown is merely a stock figure for any number of American female Victorians—Emily Dickinson, Sophia Hawthorne, Charlotte Perkins Gilman, and Alice James also come to mind—who sought a realm of personal freedom within

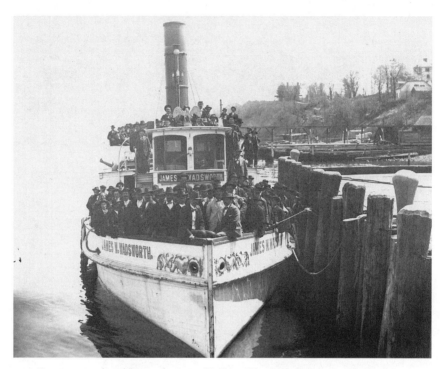

6.58. *Immigrants released from isolation on Hoffman Island, on their way to Manhattan*

the space that seemed guaranteed to them by their display of eccentricities. Austen, however, seems to have had a presentiment from very early in her life that something was amiss. In many of her images she seems to have been trying to escape or avert a disaster she sensed was coming. Austen trusted photography as a means of stopping time. But using the camera to record and explore domestic vision did not enable her to discover what was wrong.

By the second decade of the twentieth century, to rely on the Cult of True Womanhood, or even an eccentric version of it, as a possible space of freedom was not so much a claustrophobic as a perilous plan, not only for those we have seen who were on the receiving end of its tender violence—such as Zitkala-Sa, Adele Quinney, and Mary Lone Bear—but also for those who employed it as a means of self-expression, like Alice Austen. "Women's work" was now dangerous to women to the degree that it *mis*matched the ideology of sentiment to the "hard facts" of a changing world order, which no longer radiated out from mid-century middle-class domestic institutions. Instead, the motive force of history now came from something infinitely more dispersed and remote. As the twentieth century progressed, the domestic sentiments that inspired Austen's photography made Austen herself desperately unfit to see the riven social and economic world such sentiments had aided in bringing about. In Jameson's words, the

domestic unconscious "repressed and buried [the] reality of [the] fundamental history" of class struggle; it was impossible to discover from Austen's domestic images that "history is what hurts."[40]

A stock broker offered bad advice—to invest "on margin in railroads and such enterprises as the New Mexico & Arizona Land Company"—and Austen took it.[41] Trusting his expertise, at the age of sixty-three she lost her means of support in the stock market crash of 1929. Unlike Johnston and Käsebier, Austen had never earned her own living. For some twenty years afterwards she struggled to recuperate her losses, but eventually she was quite literally impoverished. Homeless, crippled by arthritis, and confined to a wheelchair, in 1949 Austen was committed by the charity of the state to the hospital ward of the county poorhouse, the Staten Island Farm Colony. Thousands of the glass negatives that made up her lifetime work were sold to the junkman.

Isolated, forgotten, and virtually abandoned except for the continuing friendship of her longtime companion Gertrude Tate, who was herself by then a frail elderly woman, Austen would have lived out the rest of her life in a room full of enfeebled women confined to their beds, staring up at the ceiling and speaking to no one, had she not been found by an unusually dedicated photographic historian named Oliver Jensen, who was looking for old photographs for a book called *The Revolt of American Women* when he came across some of her pictures, in 1951.

Their remarkable encounter bears relating here. Having discovered a box of Austen's negatives in the basement of the Staten Island Historical Society, Jensen traced Austen to the Staten Island Farm Colony. When he went to visit, he found her living on an open ward of elderly, disoriented women:

> Inquiry took me to a ward on the second floor. There, in the last of a long row of beds, Miss Austen, once so stylish and lively but now eighty-five and withdrawn, lay silently. The room was noisy with the disjointed chatter of the old and generally feebleminded inmates. Over each iron bed hung an electric wire from the ceiling with a naked light bulb at its end. Flies buzzed around the wires and two table radios competed for attention.[42]

Although Austen was awake, she refused at first to respond to Jensen's presence. He sat next to her bed and attempted to draw her into conversation. Nothing worked until he remembered the 11 × 14-inch enlargements of her photographs that he had previously printed. As a last resort, he placed these "rather rudely in front of her nose" and got a dramatic reaction:

> She stared at them, sat up, fished some glasses off her table, and studied the pictures intently.
> Why! she said, this was Trude Eccleston, and someone's bedroom; here

was her house, and the tennis courts at the Cricket Club. How hard it had been to get them all to hold still! She acted, as the very old sometimes will, as though I knew all the people and what she was talking about, and she showed almost no curiosity about who I might be.[43]

Instead, Austen wanted to know why the prints were so large, and how he had gotten hold of her photographs. When they were interrupted by an attendant who asked Jensen to leave and "began heaving the old lady into her wheelchair," Jensen promised to return. This he did, often, and from that moment Austen's life and work were rediscovered. Jensen even raised enough funds to liberate Austen from the nursing home in the final few months of her life and to hold an exhibition of her prints. Remembering the impact of his first encounter with the old photographer, he wrote:

> Walking out of that bare, unhappy room as fast as I could, looking away from the beckoning figures of several of the ancient crones, trying not to hear the meaningless monologues they conducted, smelling the disinfectant and longing for fresh air, I was full of the normal embarrassment of youth and health in the presence of age and sickness. The Farm Colony was kind enough in its dreary way, I reflected, perhaps not too bad if one had never known much better. But what a fate it must have been for one so gently reared, as they used to say, as Alice Austen![44]

It is not alone Austen's dramatic awakening from the near dead by looking at prints of her own photographs that makes this story so remarkable. Again, it is not her illness and her poverty that make it exceptional, or the fact that she and her work were forgotten, for other important American photographers, including Mathew Brady and Lewis Hine, suffered similar fates at the end of their lives.

What makes the story so uncanny is that along with these more ordinary tragedies, it witnesses the transformation of Alice Austen into the very image of the disheveled, impoverished, traumatized immigrants that she herself had photographed on the Lower East Side a half century before. Like that other Alice, she had found at last the "other side of the mirror." The imponderable threat in the wings of Austen's domestic photographs was now legible in her life: the "history that hurts" had now hurt her. Those who fled from famine and force in Southern and Eastern Europe to the Lower East Side had found this out a generation earlier. Now it was Alice Austen's turn to discover what Sara Smolinsky, or the lady at the egg stand, already knew.

Where once she had photographed anonymous immigrants being "disinfected" by the Public Health Service before being allowed to enter the United States, Alice Austen now lived in the stench of disinfectant herself. Where once

6.59. *Alice Austen, 85 years old and crippled by arthritis, in the poor house, July 1951*

she had photographed the iron bedsteads in the miserable dormitories for steerage passengers being held by the U.S. Immigration Service at the Hoffman Island Quarantine Station, Alice Austen now slept on one herself. And where once she had photographed the painful struggle of the immigrants to make a few pennies selling newspapers, eggs, or shoelaces, Alice Austen now suffered the consequences of her own humiliating inability to earn the little money needed to support herself as a "lady."

The tenderness of sentiment had blinded her to the violence of its basic equation, *people = tender*.[45] Domestic vision did not teach Austen what she really needed to know about "Alice's World" at all.

7

ENRAGED PYGMIES ATTACK VISITOR
H. S. GIBBONS OF DURANGO, COLO., PHOTOGRAPHED
THEM, BUT GAVE NO TIPS
HE WAS PURSUED AND BEATEN
MONEY WOULD HAVE BEEN AN EFFECTIVE WEAPON, BUT
HE WOULDN'T USE IT
—*St. Louis Post-Dispatch,* July 19, 1904

The Missing Link

· ·

When the World's Fair opened in St. Louis, Missouri, in 1904, thirty-four-year-old photojournalist Jessie Tarbox Beals was there—along with many other white, middle-class, American women photographers. The spectacle of the nineteenth century's great fairs and expositions held strong attractions for them, and they often went to great lengths to photograph them. For the World's Columbian Exposition of 1893, for instance, Jessie (then Tarbox), a single, twenty-three-year-old, Canadian-born schoolteacher, had taken the train to Chicago from her home in Greenfield, Massachusetts. She stayed for twenty-five days in the women's dormitory, shooting photographs with her new little Kodak (she could not get a permit for a larger view camera with tripod) and developing her own film in the public darkroom facilities that the Exposition's photography department provided. After Chicago, no longer would her own life look the same to her.

She returned to small-town existence in western Massachusetts and to schoolteaching, writes her biographer Alexander Alland, "consumed with the desire to visit the foreign places whose makeshift villages she had seen and photographed at the exposition."[1] When she then discovered that she could make more money in one summer of selling free-lance pictures than she could in a year of teaching school, she was spoiled for "protected" feminine domestic gentility for ever. Within seven years, Jessie Tarbox had married Alfred Beals, an Amherst College

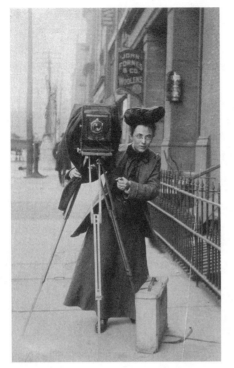

graduate who was working as a machinist in Greenfield, quit schoolteaching, and persuaded Alfred to give up his job, become her darkroom assistant, and set off to see what possibilities there were in earning their living as itinerant photographers. They started in Vermont, traveled for a year through Florida, and regrouped to upstate New York. Alfred, it turned out, had married a "lady" photographer. At the time, neither he nor she quite knew what that was going to mean.

Not only Jessie Tarbox Beals, but Frances Benjamin Johnston, Gertrude Käsebier, and Alice Austen all went to Chicago in 1893. At that time Käsebier was just beginning to photograph, and her images have not survived, although there exists an ironic drawing she made of her husband asleep next to the window on the train en route to Chicago. She labeled it "enjoying the view through the Allegahnies [*sic*] on our way to the world's fair."[2] The drawing gives a hint of the unsettling and arousing effect the Exposition was to have on her sense of herself and the ambitions she was nurturing as an "older student" in painting at the Pratt Institute in Manhattan.

For her part, Johnston was already working as a professional to document the exposition for the government under the direction of Thomas Smillie, and

she made and printed hundreds of photographs, which were widely distributed. Even Alice Austen made a portfolio of twenty-five images of the famous "White City" buildings, which she copyrighted, intending to offer them for sale.

Käsebier does not seem to have gone to the Pan-American Exposition in Buffalo in 1901. She had returned from Chicago to throw herself into photography, and by 1901 she was famous and successful as a photographer. She spent the summer of 1901, when she might have gone to Buffalo, in Europe instead, making contact with the Linked Ring Society in London, with the English photographer Frederick H. Evans, and with Edward Steichen in Paris, with whom she went to see the Secessionist painters exhibition at an International Art Exhibition in Munich.

But Alice Austen was in Buffalo, exhibiting the first of her "sanitation" series of photographs at the Exposition. She took nighttime pictures of the Exposition grounds illuminated by electric light. Frances Benjamin Johnston was also in Buffalo. In fact, there Johnston made some of her most famous and widely publicized images, the last ones ever made of President William McKinley. Johnston had happened to photograph McKinley on September 6, 1901, riding in an open carriage just minutes before he was shot and fatally wounded at the Temple of Music by anarchist Leon Czolgosz's bullets. Another of her photographs of McKinley, taken the day before while he gave a speech on "industrial growth as the guarantor of progress," and "charted the course to future utopia through the establishment of reciprocal commercial relations with Pan-American countries," became widely known as the "Buffalo Pose."[3] The memorial statue in the McKinley monument in Canton, Ohio, was based on this image. In his speech, McKinley had "praised expositions such as Buffalo as 'timekeepers of progress'" and particularly extolled their role in domestic education. Sounding like a Harriet Beecher Stowe for a new era, he lauded the importance of such expositions on several fronts: "[T]hey record the world's advancement. They stimulate the energy, enterprise, and intellect of the people and quicken human genius. They go into the home. They broaden and brighten the daily life of the people."[4]

Johnston's McKinley is solid, paternal, and seemingly imperturbable. There is no suggestion that the American stance on "'reciprocal' commercial relations with Pan-American countries" could have had anything to do with making him a target for assassination, although, as Robert Rydell writes, the police made such a connection: "The shooting triggered the arrests of anarchists and socialists across the country and, since Czolgosz was the son of recent Polish immigrants, escalated nationwide demands for immigration restrictions on European populations perceived as undesirable. . . . McKinley's death exposed the ethnic and class rifts in American society."[5] Johnston may have been oblivious to the

economic tensions, but Czolgosz said after his arrest that he "didn't believe that one man should have so much service, and another man should have none."[6]

To the photographing woman, the fairs and expositions offered congenial stimulation and a way to gain recognition and make some money selling photographs. Simultaneously, they offered a way to construct a larger identity as a "lady photographer." If, as many scholars have proposed, the fairs performed the public function of remaking a national self-definition for a United States reunited a generation after the Civil War and newly emerging as an industrial world power, they also served the private purpose of self-making for white women photographers of the era. The fairs encouraged them to emerge from domestic confinement and to test just how far the designation "lady with a camera" would let them go.

In the process they discovered that nation making, empire building, commodity production, capital accumulation, and the averted gaze of the "innocent eye" could be mutually beneficial. More people than just the women themselves noticed this excellent fit. "When George Eastman discovered that Johnston had used a Number 4 Bulls Eye Special Kodak for the McKinley pictures," write Daniel and Smock, "he considered launching an advertising campaign to stress that she had used standard Kodak equipment."[7] The Kodak was a camera that Eastman marketed particularly to women. The fact that a woman photographer like Johnston had used the Kodak to take these historically significant photographs apparently appeared to Eastman to be a good advertisement. As George Eastman's idea implies, business was realizing at the turn of the century that gender and nation could be profitably interdigitated.

St. Louis was very much a southern city at the start of the nineteenth century. From the time of the Missouri Compromise in 1829, through the 1857 *Dred Scott v. Sanford* decision, which ruled that a slave who lived in a free state or territory was still a slave, debates over slavery and abolition gave a veneer of political debate to St. Louis; meanwhile, slave auctions took place on the steps of the very courthouse where these decisions were handed down. The citizens of St. Louis defiantly elected a Secessionist governor before the Civil War, although the state of Missouri stayed in the Union. Because of strong economic ties to the north, St. Louis eventually became a center of Union support and a staging ground for Union troops, but many there never altered their allegiance to the South.

And now, at the turn of the century, the St. Louis World's Fair of 1904 invited the city and the world to contemplate the triumph of yet another new formulation of United States power. America's recent victory in the war with Spain highlighted the global ambitions of the new American state. More than 1,270 acres of Forest Park had been given over to display the nationalist fervor of a

new imperial order. The fair transformed both the resistant sectionalism of the Old South and the resilient commercialism of the New beyond all possibilities of imagining earlier in the century.

Not that the voices of the Old South were stilled, by any means. Widespread Democratic anti-imperialist agitation built heavily upon the racist presumptions of men like Thomas Nelson Page, author of *Red Rock* (1898), and Thomas Dixon, author of *The Leopard's Spots* (1902), *The Clansman* (1905), and *The Traitor* (1907). Both these men argued against annexation of the Philippines on the grounds that imperial acquisition was unconstitutional and anti-republican and that Filipino self government was the only way to avoid burdening the United States with what Mrs. Jefferson Davis called "fresh millions of foreign negroes, even more ignorant and more degraded . . . than those at home."[8]

However, the thrust of the times was against them. Pro-annexation arguments were neither more egalitarian nor necessarily less racist. They simply alleged that in the Philippines "Caucasians were ushering in a new era in human history," an era in which "human culture is becoming unified, not only through diffusion but through the extinction of the lower grades."[9] The cotton plantations of the Old South were a model for prospective fruit, sugar, and hemp plantations in Hawaii and the Philippines. Nineteen hundred four was one of the peak years of immigration to the United States by whites from western and eastern Europe, most of them poorly educated peasants looking for ways to better themselves and escape from lives of unremitting manual labor. Many blacks were also arriving from the West Indies, not all of whom were fully indoctrinated into the culture of American race relations. Nativist sentiment had not yet pushed Congress toward immigration restriction and overall quotas—that would take another twenty years—but its organization was growing. Those who advocated such legislation were worried about the stability of the American wage and prosperity under the pressure of so many aliens. Those against it argued for the value of the immigrants' labor, especially since slavery was over.

Above all else, then, the St. Louis World's Fair was advancing an argument for the vigor of the Caucasian culture of the United States and its capacity to incorporate the labor of such immigrants, since it had been able so successfully to discipline and assimilate its former slaves and aboriginal Others into a seemingly credible domestic "peace." In exemplifying how the United States had already dealt with similar tasks, the St. Louis World's Fair was addressing the greatest anxieties of its day, to indicate where and how white Americans could and would prevail. Industrial leaders believed that "the burden of humanity is already in large measure the White Man's burden—for, viewing the human world as it is, white and strong are synonymous terms."[10] They looked forward to shouldering America's load.

These particular views on race and national destiny were, in fact, the senti-

ments of Mr. W. J. McGee, one of the chief officers of the St. Louis Fair. McGee, the head of the Anthropology Department of the fair, reasoned that it was precisely the new global industrial opportunities that rationalized the horrific cost of the Civil War and the preservation of the Union. In the south, Reconstruction was over; its demise left a growing ambition to explore these new opportunities. McGee portrayed the field for action as nearly limitless:

> It is the duty of the strong man to subjugate lower nature, to extirpate the bad and cultivate the good among living things, to delve in earth below and cleave the air above in search of fresh resources, to transform the seas into paths for ships and pastures for food-fishes, to yoke fire and lightening in chariots of subtly-wrought adamant, to halter thin vapors and harness turbulent waters into servile subjection, and in all ways to enslave the world for the support of humanity and the increase of human intelligence.[11]

McGee and the rest of the team designed the St. Louis World's Fair to make the perspective of scientific racism and the imperative of United States imperialism seem equally valid and inevitable. "To enslave the world for the support of humanity and the increase of human intelligence" meant simply that the experience of labor and resource management gained by investors in Southern slavery would now be exploitable worldwide. The St. Louis World's Fair was also the Louisiana Purchase Centenary Celebration. It commemorated the treaty which in 1803 had more than doubled the geographical size of the United States and simultaneously transformed the old Creole town of St. Louis into a booming American city, "the gateway to the West." It also celebrated a potent analogy constructed between pacification of "domestic" tribes of Native Americans and "foreign" tribes of Filipinos. As one of the official publications of the Exposition explained, "The time is coming when the purchase and retention of the Philippine Islands will seem as wise to our descendants as does the Louisiana Purchase seem to us who live today."[12]

In the brief nine months that it was open, St. Louis World's Fair of 1904 formulated for almost 19 million people who participated in its construction or visited its grounds a vision not only of the fruits of the past hundred years of expansion and conquest but also of the promising connection between that past and future acquisitions. The intertwined notions of imperialism and progress that the fair projected captured the spirit of the twentieth century as "The American Century," at its very moment of inception.

But if, in 1899, at the beginning of the Philippine conquest, Frances Benjamin Johnston's photographs had to make the case that American domestic virtue *would be* the justification for annexation, in 1904, after "peace" had been declared, it was the job of St. Louis to show what success the strategy was *already* having. Useful photographs would picture successfully sustained domestic ar-

rangements, not the permanent disruption of daily life that the terror of the American invasion and occupation had brought. If scenes of Philippine domesticity could be credibly engineered in living tableaux in St. Louis, surely they could be reconstructed in the Islands themselves after the cities had been laid waste and hundreds of villages had been burned.

Once again, ladyhood was linked to opportunity. Beals and her husband Alfred traveled to St. Louis from Albany, New York, where Jessie had been working as the "first official woman" staff photographer for the *Buffalo Courier,* with Alfred as her darkroom assistant. Beals regularly photographed suicides, murder trials, and fires for the paper when she could. When times were slow, she showed up where work crews met, or lingered at factory doors, or rode door-to-door on her bicycle, balancing twenty- to thirty-odd pounds of camera equipment and soliciting the chance to take portraits. Business was good. Her photographer's diary from the time is peppered with phrases such as "got a fine list of orders" and "Work has been booming—16 to 30 pictures taken daily. Poor Beals is kept busy developing and printing." [13] When they left Albany on April 4, 1904, her departure was mourned in the Buffalo newspapers as the loss not simply of a newspaper photographer but of a *woman* newspaper photographer: "Buffalo lost one of its best professional women today when Mrs. Jessie Tarbox Beals, staff camera artist, departed on an early morning train for St. Louis." [14] At the farewell party they hosted for her, Alland reports, "the staffs of the two dailies Jessie worked for presented her with a parting gift—a gold enameled pin studded with pearls." [15] It was a gift particularly appropriate for the "woman" part of the equation, and it must have encouraged Beals about the viability of her plans to go to St. Louis as a "professional woman."

But although doing "all the work that a man used to do," as she herself boasted, may have brought Beals notoriety and respect in upstate New York, Beals was not unique as a woman photographer at St. Louis. [16] The centrality of gender to the fair's underlying message of the white man's duty to reconstruct patriarchy and export it as social control among the world's newly colonized peoples had spoken to the fair's officials as clearly as it had to America's foremost women photographers. "Lady" photographers had a larger official role at St. Louis in portraying the domestic life of United States "possessions" than at any other fair. For once, in fact, they were important enough to their men that it did not seem so much as if they were possessions themselves.

Among others, Emme and Mamie Gerhard, two sisters who lived in St. Louis and maintained a permanent studio there, had made arrangements with the Fair to make and sell photographs of "the lower culture grades" of the people on exhibition. The work of the Gerhard sisters demonstrated their particularly fine and focused appreciation of one of the Fair's central missions: to construct and highlight subtle and not so subtle racial differences between white Americans

and other peoples. For instance, one of the photographs they made and sold is a sweet-seeming image of two small Chinese children, stood up for display on a table in some exhibition hall and looking only marginally fearful in diminutive traditional silk suits. But the title "Little Chinks" and the designation "copyrighted, Gerhard Sisters, St. Louis, 1904" is handwritten across the image.

Another of their images is a pantomime of an Igorot dance staged by two older men who are naked except for hats, jewelry, and loincloths, and a young girl in a dress of traditional cloth who holds up her tattooed arms for the viewer's gaze. Both the male and the female "primitive" bodily display in this image presumably spoke for itself, since it was untitled, although again the photograph was proudly stamped with the Gerhard sisters' special "1904 St. Louis, Mo." copyright seal.

Taken together as a concise example of the legitimation of many strains of racist thought that were achieving amalgamation at St. Louis, both photographs illustrate a point of view about racial progression that was central to the ideological conception of the fair. Roughly put, they are intended to demonstrate that just as "Little Chinks" grow up to be big ones, in the normal course of affairs "savage" Igorot dances must also give way to a more "evolved," Western culture. Because domestic sentiment ceded to white women the job of educational supervision of the "home," it seemed reasonable that white women photogra-

7.3. *"Igorot Dance." Gerhard Sisters, photographers*

phers, like the Gerhard sisters, would be good at capturing, and naturalizing, images of these developmental "facts."

An anonymous photographic construction of a Bontoc Igorot man ostensibly evolving into "a civilized member of the Philippine Constabulary," also taken at the fair, expresses very well the kind of insight into "development" that the Gerhard sisters were seeking in their Igorot dance photograph. The portrait is actually a triptych of images such as the ones that eugenicist Francis Galton was then using to demonstrate innate "types," such as the "Jewish Type," the "criminal type," or the "ideal family type." Galton, who wanted eugenics to "co-operate with the workings of nature by securing that humanity shall be represented by the fittest races," argued confidently, "What nature does blindly, slowly, and ruthlessly, man may do providentially, quickly, and kindly"[17]—as, presumably, "man" was then in the process of doing to the Igorots in the Philippines.

Two other photographs by the Gerhard Sisters also dwell on the mystery of ethnological transformation. They are portraits of a Negrito man, again stamped with the Gerhard sisters seal and entitled "The Missing Link #1" and "The Missing Link #2" in the same handwriting as "Little Chinks." At the fair, the man whom the Gerhard Sisters named "The Missing Link" was well known as a figure of awful fascination on account of that designation, though it is not clear if they were the first to name him that or if they merely recorded "common knowl-

7.4. *Bontoc Igorot man evolving into member of the constabulary police force. Unknown photographer*

edge" about his "identity." He was not, however, the only "missing link" at the St. Louis Fair in 1904. Ota Benga, a pygmy from the Belgian Congo, shared that dubious honor with the Negrito man, and was displayed as such to the public in photographs and live exhibitions.[18] The seriality of the Gerhard Sisters' captions "The Missing Link #1" and "The Missing Link #2" is ambiguous. It suggests either that there were other photographs of this man or that another man was also a "missing link." The duality points to the overdetermination of the demand to locate such a figure at the fair. The Gerhards' photography put itself fully in the service of this anthropological chimera. Indeed, the logic of the entire chain of racial signification of the fair depended upon *finding* this link.

Frances Benjamin Johnston, too, was active as a photographer at the St. Louis World's Fair. A dignitary herself by then, and an official imagemaker of the fair, Johnston concentrated more on the splendid trade exhibitions and on ceremonial openings, such as the dedication of the "Siam" pavilion, at which elite visitors made speeches and held elaborate parties, than she did on what was happening at the hotter and humbler grounds of the Anthropology Department. However, Johnston also was attracted by some of the official performances put on in the ethnic villages. She took a number of photographs of these staged "ceremonies," for instance, a "pygmy beheading," or a display of "Filipino archers," both of which she carefully visualized from front, sides, and back in a form of objectification that does not occur in her trade-show opening ceremonies. Johnston seems less interested in registering these displays as instances of tribal authenticity, the ruling trope of the public's access to the cultural displays, than as command performances, reflecting a more elite understanding of the politics of the Anthropology Department, which she gained, presumably, from associating with the managers of the fair.

As if the Gerhard Sisters and Frances Benjamin Johnston were not competi-

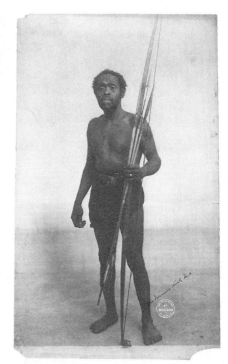

7.5. *"Missing Link #1." Gerhard Sisters,*
photographers

7.6. *"Missing Link #2." Gerhard Sisters,*
photographers

tion enough, Alfred Beals had to share a darkroom with the portrait photographer Mrs. Mattie Edward Hewitt, also of St. Louis and also already credentialed. Hewitt eventually became the partner of Frances Benjamin Johnston in a highly successful Manhattan firm that specialized for many years in garden and architectural photography. And then, not only was Johnston herself photographing at the Fair, but she was also an official judge for the photography awards to be given out at the end of the Fair.

It was good to have "feminine colleagues," as Johnston termed it, but what the presence of these women meant in practice for Jessie Tarbox Beals was that when she arrived at St. Louis, at first all the doors were closed to her: "She had hoped her reputation in Buffalo would warrant an official press card. But officials at the exposition said that the Buffalo newspapers were regional and of no value to the national promotion of the fair. She applied at the St. Louis newspapers; they were fully staffed. She kept overhearing remarks that working on the crowded fairgrounds was too much for a woman to tackle."[19] This was the problem of tokenism: if a few "exceptional" women were to be given relative

7.7. *Pygmy beheading, view 1, St. Louis World's Fair. Frances Benjamin Johnston, photographer*

7.8. *Pygmy beheading, view 2, St. Louis World's Fair. Frances Benjamin Johnston, photographer*

7.9. *Pygmy beheading, view 3, St. Louis World's Fair. Frances Benjamin Johnston, photographer*

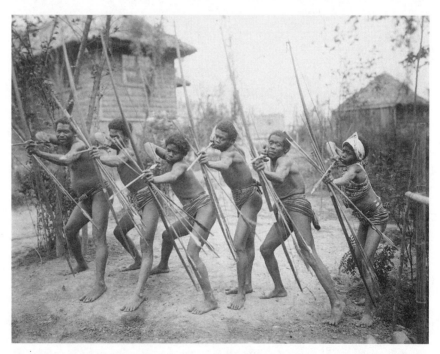

7.10. *Filipino archers, view 1, St. Louis World's Fair. Frances Benjamin Johnston, photographer*

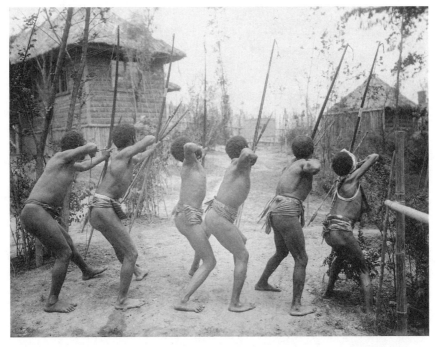

7.11. *Filipino archers, view 2, St. Louis World's Fair. Frances Benjamin Johnston, photographer*

freedom to construct the gaze at St. Louis, on account of their valuable domestic point of view, it had to be made clear that they were exceptions by restricting access to such employment for all others.

Beals solved this problem in a characteristic way. She transformed the fair officials' anxiety that a woman was of "no value to the national promotion of the fair" into evidence that the "nation" could be promoted by a woman. First, she wrangled a "Pre-Exhibition Permit," which allowed her into the fair but limited her to making photographs "prior to the opening of the fair" and prevented her from selling any of the images or using them "in any other way except as ordinary illustrations . . . every negative made under the permit and not accepted as an illustration is to be destroyed."[20] The fair's officials were so eager to marshal all the images of the fair into the grand educational (and commercial) scheme that Beals worked on pain of expulsion from the fairgrounds if she was found to violate these conditions.

If they were used to controlling the access of women photographers, the officials apparently didn't figure on Beals's next step: "Undaunted by the rules, Jessie roamed the fairgrounds as she saw fit, photographing what interested her. Most of the other photographers there concentrated on the sumptuous exhibits of the industrial nations; Jessie was drawn instead to the scenes of the daily lives of exotic, little-known peoples in their native habitats. She took pictures of the

7.12. *Beals's press identification photo, St. Louis World's Fair*

Igorots, the Bogobos, the Zulus, the Hottentots, the Eskimos, the Filipinos and other defenseless recipients of missionary barrels," writes Alland.[21] Her multicultural pictures of domesticity read much like a precursor to Steichen's famous *Family of Man* exhibit.

And then came some good luck. Regular hard work photographing the daily lives of "exotic, little-known peoples" happened to put Beals at the scene when some "Patagonian Giants" of South America arrived at the "village" next door to the "Ainus of Japan." At first, she was the only photographer there. By the time the other photographers arrived, Beals had already made her interpretation of the event. As Alland reports, "An old Patagonian woman issued an edict that no black boxes were to be pointed at her people and she chased the camera men over a barbed wire fence. But Jessie had already made her images, and they were exclusives."[22]

What Beals had done was to show "Patagonian Giants" next to "pygmies," in a comparison by size that imaged the anthropometric premise of the fair—the belief that the essential information about where a group of people fell on the evolutionary ladder could be gleaned from their physical characteristics. Her pictures sold all over the country—providing the "national exposure" the Fair's officials craved—not only because they were positioned as "exclusive images" but because they were images of an "exclusive" position that white Americans were constructing for themselves — as the physical golden mean and the evolutionary model.

Beals was rewarded for this work of making material the abstract racial prem-

7.13. *"Pygmy and Patagonian Giant."*
Jesse Tarbox Beals, photographer

ise of the anthropological "display." The next day's headlines trumpeted the news: "Woman Gets Permit to Take Pictures at the Fair." The story read, "The first permit to be issued to a woman authorizing the taking of photographs in the World's Fair Grounds has been given to Mrs. T. Beals. Mrs. Beals secured notice through her work in obtaining photographs of the double suicide of Mr. and Mrs. Pennell of Buffalo, who rode their automobile over a cliff into a quarry."[23] The pygmy/Patagonian comparison showed the fair officials that Beals's eye was just as good as those of the Gerhard sisters. With it, Beals had become the "First Pictorial Journalist of Her Sex," even though she was not, as we have seen, the first woman licensed to take photographs in the "World's Fair Grounds."[24]

What really made Beals "first"—that is, even ahead of Johnston and the Gerhard Sisters—was that she had understood better than they that in St. Louis, juxtaposition was the clearest signifier of American size and strength. The St. Louis World's Fair was the largest international exposition ever yet presented. Its total exhibition space exceeded that of the Chicago Exposition of 1893 by more than one third. The fair cost $15 million to produce, the same amount of money originally paid for the entire Louisiana Territory. The fair was so big that medical advisers warned "neurasthenic" patients to avoid the fair entirely, for fear of mental collapse, and "brain-fagged businessmen" and "men of affairs" were encouraged to spend "at least several weeks or months in order to avoid the almost certain breakdown that would result from a hurried visit."[25] It took a week merely to view the agricultural display. However, the real core of the Louisiana Purchase Exposition was the Department of Anthropology, headed by W. J. McGee, and the "exposition within an exposition," the U.S. govern-

ment's Philippine Reservation. Other world's fairs, notably the one in Chicago, had featured anthropological divisions, but St. Louis's was by far the largest and the most central.

On the Anthropology Department's grounds and at the Philippine Reservation were displayed "specimens" of the peoples that American civilization had conquered and was now in the process of "educating," "disciplining," and "converting." The Philippine Reservation consisted of almost twelve hundred Filipinos living in villages on a 47-acre site that was deliberately called a "reservation" to make plain the parallel between the subjugation of Native Americans and the domestication of the Philippines. The grounds were carefully laid out to represent "a sequential synopsis of the developments that have marked man's progress." In an essay entitled "The Trend of Human Progress," McGee explained that process as follows:

> a trend of vital development from low toward the high, from dullness toward brightness, from idleness groveling toward intellectual uprightness. . . . It is a matter of common observation that the white man can do more and better than the yellow, the yellow man more and better than the red or black. . . . Classed in terms of blood, the peoples of the world may be grouped in several races; classed in terms of what they do rather than what they merely are, they are conveniently grouped in the four culture grades of savagery, barbarism, civilization, and enlightenment.[26]

McGee believed that at the turn of the century "perfected man is over-spreading the world." "Perfected man," in McGee's terms, meant "the two higher culture-grades—especially the Caucasian race, and (during recent decades) the budded enlightenment of Britain and full-blown enlightenment of America."[27]

To illustrate these "common observations," the Anthropology Department portrayed a "logical arrangement" of ethnological displays of "villages" of "non-white types" and "culture grades." Besides the twelve hundred Filipinos, these "types" included pygmies from the Congo, Japanese Ainu, Patagonian "giants," Kwakiutl Indians from Vancouver Island, and several groupings of Native Americans. Also on exhibit were the Apache leader Geronimo (under armed guard as a military prisoner), Chief Joseph of the Nez Percé, and Quanah Parker of the Comanche. The Indian School Building and the Philippine Reservation were carefully placed to make the instrumental relation between the two as plain as possible. Calling the Indian School building "designed not merely as a consummation, but as a prophecy," McGee explained the rationale behind its inclusion at the Fair: "now that other primitive peoples are passing under the beneficent influence and protection of the Stars and Stripes, it is needful to take stock of past progress as a guide to the future."[28] On the other side of Arrowhead Lake

from the Indian School building was the Philippine Reservation, and McGee explained the juxtaposition of the two as follows: "even as against the Red Man on the continent, just beyond the Pacific, stands the brown man of the nearer Orient; and it is the aim of the Model Indian School to extend influence across both intervening waters to the benefit of both races."[29] The Anthropology Department aimed to invest the ideology of white American supremacy with a persuasive material form. Side-by-side comparisons of one "primitive lifestyle" after another—a kind of monotonously repeated "before" to a tantalizing climax of "after"—allowed fairgoers to reach the inevitable conclusion: just as the United States had organized this greatest of all fairs, which brought so many of the "peoples of the world" peacefully together in one space, so too would it organize the world on a higher plan once it had secured its territories.

Beals played the woman's angle for all it was worth, which was considerable. She made many sets of "sympathetic" pictures of domestic life in the anthropology exhibits. Seen as "ethnological studies," they were eagerly bought by Harvard and Yale Universities and by natural history museums all over the country. Perhaps her most famous set of pictures was *Mother and Babe at the Exhibition;* but Beals made other sets of photographs as well, such as *The Children of the Fair, Musical Instruments, Native Habitations, Strange Wedding Ceremonies, Head Dress, Dances of All Nations, Cooking Methods,* and *The Mutilation Practices.* In fact, Beals's work at St. Louis was taken as so good a model for ethnographic photography that in 1906 she was invited to exhibit some of it at a "women photographers" exhibition (the first ever in New England) at the Camera Club of Hartford, Connecticut, where confused critics singled out her work as "one of the best exhibits," crediting her with having "furnished several scenes in Japan (taken at the St. Louis World's Fair)."[30] Frances Benjamin Johnston herself awarded Jessie Tarbox Beals one of the fair's gold medals in photography.

As if all this were not recognition enough, Beals's photographs of the Philippine reservation were met with such consummate delight by the organizers of that exhibit that they brought them to the notice of Secretary of War William Howard Taft, previously governor-general of the Philippines. Much impressed, Taft offered Beals "a passport and a free round-trip to the islands . . . to bring back, as a contribution to science, pictorial records of the daily life of the little-known wild tribes."[31] Beals was elated, but unfortunately Alfred didn't want to go, quite possibly because he was aware that the fighting still continued in the Philippines.

Beals also exploited her angle of vision in a literal way, by choosing dramatic vantage points from which to photograph and allowing herself to be photographed and written about "as a woman" while in such stances. For instance, she climbed a twenty-foot ladder to photograph a parade. And just before the

7.14. *Beals at work*

beginning of the International Balloon Race she climbed into one of the baskets with her camera. One newspaper years later memorialized the event this way: "Just as one of the balloons was being set free, the huge crowd was thunderstruck to see a woman, a camera slung over her shoulder, grip the top of a basket and pull herself aboard. The balloon was off, and with it the intrepid woman photographer."[32] Dr. David Francis, president of the Exposition, published the resulting panoramas of the fairgrounds, which Beals made from 900 feet aloft, in the official *Louisiana Purchase Exposition Bulletin*. Her bird's-eye view photographs were, he wrote, "a view which I wish to remember."[33] This is perhaps not surprising, since, like the eye of the American eagle, they dominated what they surveyed.

But what exactly *was* the point of view of the "intrepid woman photographer"? The people in Beals's photographs were neither given derogatory names nor photographed as fetishes for the contemplation of nude bodily display. Her images are therefore less overtly racist than the productions of the Gerhard Sisters. Indeed, Beals made a photograph that explicitly mocked the sanctimonious (and highly publicized) efforts of the Board of Lady Managers to make the Igorots wear full sets of clothes rather than the loincloths that were their accustomed dress because it seemed to them that the male nudity was drawing prurient looks, especially from "lady" visitors. In her hilarious but sharply pointed image, the Filipinos cooperate with Beals in performing a satiric pantomime of "'As the Lady Managers wanted to have them'—Prime Christians," which is how she captioned the photograph. Fully and awkwardly covered in heavy robes, coats, and wearing hats, but still barefoot, five Philippine Reser-

7.15. *Beals in a hot-air balloon*

7.16. *"As the Lady Managers wanted to have them—Prime Christians."*
Jesse Tarbox Beals, photographer

vation inhabitants walk in a line, evidently performing one of their ceremonial dances the "Prime Christian" way.

Nor do Beals's images reproduce the most sensational stereotypes of turn-of-the-century primitivism's imaginary, such as the "pygmy beheading" and the "Filipino archers" that Johnston photographed. On the contrary, Beals felt that she had made "many new friends" among the "foreign" people she photographed and "would treasure their many parting gifts, particularly the pina fiber dress presented by the Filipino villagers and the exquisite bolt of Chinese silk given to her by Prince Pu Lun of China."[34] Given the American occupation of the Philippines, such "friendships" must have had a considerable component of fantasy.

Nonetheless, Beals seems to have been personally affected by the racial vision of the fair. The photographs she made are completely complicit in keeping off-stage any vision of the violence of the pacification of a people. While she was still at the fair, Beals made a collage of her photographs from the anthropological villages. The pictures are uniformly gracious and dignified domestic scenes, with their grass-rooted huts, their pastoral waterways, their smiling children, and their graceful young mothers. Like the Cook collection of photographs of free blacks in Richmond, they argue for the unharmed humanity of those they

7.17. *Beals photomontage of native peoples photographed in the anthropological villages at the Fair*

picture but without challenging the violent framework in which that humanity was concurrently differentiated, primitivized, and separated from the "higher" domestic forms of the "white race."

Thus, Beals's pictures extended sympathy, but they also fully eradicated any traces of the military surveillance that had accompanied the Filipinos to St. Louis. That is to say, first, they normalized the presence among the fair's Filipino

delegation of several hundred members of the Philippine constabulary, a para-military force of Philippine collaborators set in place by the American occupation; one of them, photographed with an "innocent eye" by Beals, was included in the upper right-hand corner of her collage. Second, they remained oblivious to the fact that the Philippine villages were surrounded by high board fences and their inhabitants monitored by curfews, in a direct quotation of the so-called "relocation camps" in which thousands of their countrymen were being interned back in the Philippines at that very moment. And third, they avoided any view of the outer perimeter of the Philippine "reservation" itself, which was designed as a model of the old Spanish defenses of the city of Manila. When walking through it to the ethnic villages, every visitor — and every Filipino inhabitant — re-created the heroic story of Dewey's conquest and penetration of the city to gain access to the nation of "primitives" that supposedly lay beyond.[35] Even though during the whole time the fair was open in St. Louis, Filipino insurgents were continuing to battle the United States occupation, and the United States was continuing to execute Filipino patriots as "outlaws," there is no sign of this activity in Beals's images. Her collage of domestic life in the Anthropological Department so completely illustrates the present success and bright future of the American rule of peace that it is no wonder that Taft himself, the author of the concept of "benevolent assimilation," longed to send her to the Philippines.

Finally, given that the experience of black soldiers in the Philippines was that of watching, as Sgt. Major John W. Gallaway in the 24th U.S. Infantry in 1899 wrote home from the Philippines, "the whites . . . [begin] to establish their diabolical race hatred in all its home rancor in Manila, even endeavoring to propagate the phobia among the Spaniards and Filipino so as to be sure of the foundation of their supremacy when the civil rule that must necessarily follow the present military regime, is established," the very fact of the fair's being in St. Louis in the first place was a palimpsest of Jim Crow, a manipulative context that Beals nowhere addressed.[36] So smoothly did the fair's geographical juxtapositions align the future of the Philippines with the new racial order of the American South that visitors did not need to conceptualize it intellectually; they inscribed the connection daily with their feet.

Beals photographed the virtual geography of the fair by moving freely between the obviously "fake" Manila and the obviously "real" St. Louis, but it is difficult to distinguish the two in her photographs. This was, of course, the desired effect. The fact that Harvard and Yale Universities bought Beals's exposition images as ethnographic studies is one result of this confusion. The fact that Beals's photographs of the Ainu were praised by Hartford reviewers as "several scenes in Japan (taken at the St. Louis World's Fair)" is another. But the most significant reality effect of the simulacrum was that in construing the Philippine present as coterminous with the Southern past, the fair was portraying that past

as the progressive and inevitable future of the American empire. Conversely, it was erasing actual Philippine history in order to rescript it as naturally consonant with the context of the American South.

In an essay entitled "The Sign as a Site of Class Struggle," Jo Spence identifies the ideological work of photographs as the production of an "imaginary coherence," one in which "images from . . . photography . . . are immediate yet appear to be retrospective," and in which "their presence confirms the absence of what appears to have been previously present."[37] This elegant formulation exactly describes what Beals's photographs accomplished. Their normalization of St. Louis as the Philippine future confirms the influence of the Southern past as constitutive of the Philippine's immediate reality. Never mind that it was a coherence that was patently corrupt; the conjuncture was made potent by Jim Crow—and rendered invisible by Jessie Beals.

However, the experience of working at the fair, with its emphasis on racial "diversity" and racial "progress," not only translated into photographs that configured the way that viewers were to see the coming American Century; it also prophesied a new Beals. After her work in St. Louis, Beals evolved into an even more ambitious photographer and an even less conventional woman. Beals was aware of its importance to herself. Some years after returning from St. Louis, Beals made another photographic collage, this time a narrative of her own life. The two panels document changes in a small-town girl's experience as she discovers photography. The world in the pictures steadily expands. In them, Beals and her camera conquer obstacles, travel, go to parties, and meet interesting and famous people. There are more photographs of Beals at the fair than at any other period of her life. In the photographs of St. Louis we see Beals in the balloon, Beals on the twenty-foot ladder, Beals working at the fair with her camera assistant named "Pumpkin," and Beals's hard-won press pass and photo ID card. Functioning as the fulcrum of Beals's autobiography, the fair separates her own experience into a "before," and "after." The collage demonstrates that as a sentimental indoctrination, the fair had apparently fulfilled an inner, as well as an ideological, mission.

Indeed, life "before" was one thing, but life "after" was something else again. For a long time after St. Louis, nothing measured up for Jessie to the intensity of the nine months she had spent photographing the fair. Perhaps it was that Alfred Beals had dragged his feet about the trip to the Philippines and prevented her accepting the assignment from Taft. Perhaps it was that Jessie Beals was nearing forty and after many years of marriage she and Alfred still had no children. Her only infant, a girl born in 1901, had died only a few hours after birth. Perhaps it was simply that Beals had grown weary of the concept of "woman photographer" that juxtaposed her solely to Alfred or to other photographing women, when she had seemed in St. Louis to have the whole world as her counterpart.

7.18. *Beals life narrative, panel 1*

7.19. *Beals life narrative, panel 2*

Soon after the St. Louis World's Fair ended, Jessie and Alfred moved to New York City to start their own photography studio, and Alfred, who had earlier in Beals's diary been "poor Beals . . . kept busy developing and printing," now became "a loafer" and "a ne'er do well."[38]

Soon thereafter, as Alland states, Beals formed a passionate liaison with a "scion of a distinguished family, a middle-aged recluse who lived in his ancestral home overlooking the Hudson River."[39] This man, Poultney Bigelow, was the former Professor of Colonial Expansion at Boston University, a Yale graduate, and a famous journalist, whom Beals had earlier met professionally. Founder of *Outing* magazine, he was a war correspondent during the Spanish American and Boer Wars, wrote for *Harper's,* had lived in Europe, Africa, and Asia, and had written several books, including *Paddles and Politics* (1892) and *White Man's Africa* (1897). Bigelow represented the glamour of privilege, experience, and erudition for which Beals so yearned, although his name recently "had come into the news when he was forced to resign a professorship . . . because of his blatantly anti-Negro views, which he frequently aired in letters to the press."[40]

However, the issue was not simply his racism or his virulent anti-Semitism, common enough at the time among members of his race and class, but his vocal opposition to the egregious corruption accompanying the Americanization of the Panama Canal project. In his autobiography, Bigelow wrote:

> When my life had spanned half a century (in 1905) I returned from a journey in the Malay Archipelago broken in health. The Boston University objected to my views on the negro and on Christian Missionaries in the Far East—so I resigned. The Senate of the United States made me the subject of malevolent inquisition because I had published some unsavoury truths touching official mendacity and evil practices on the Isthmus of Panama.
>
> Thus I was in worldly eyes a ruined man—denounced by the governmental Press—boycotted by the Taft-Roosevelt party, anathema in university faculties and looking at the future through lustreless eyes.[41]

Yet Bigelow considered that the nation rather than himself was disgraced by his vilification, and he grew to like his country life, where daily swims, outdoor work, and talk with his neighbor, the naturalist John Burroughs, soon restored his health and vigor.

Beals was fascinated by Bigelow, and as their friendship deepened, love poetry flowed from Beals's pen. Their "passion" was her "greatest joy." She wrote of it using exactly the geographical polarities of the exotic ethnic world the St. Louis Fair had constructed: "We may each of us go our farthest ways / To the reach of the farthest Poles. / We may each of us go to the tropic climes / Where love is born of flame, / We may each of us go to the East or West, / And call a loved one's name. . . . / But we'll not forget these August days / With their riot of dear

delights— / when our love bloomed as Passion Flowers / Through the pulsing days and nights."[42]

On June 8, 1911, Beals bore a child, her daughter Nanette, a triumph for Beals after nearly fifteen years of childless marriage. Alland believed—although Nanette denied it—that Poultney Bigelow was the father. Bigelow was distressed about a diminishing birthrate among white Americans and at the time, wrote Alland, was "raving about the Anglo-Saxon race being surrendered to other breeds: African, Hebrew or Hibernian. 'When it happens,' he said, 'we shall all join the Ku Klux Klan.'"[43]

Although Bigelow married another woman soon after Beals became pregnant, their relationship continued. Both he and his new wife celebrated the tree that Beals planted in the baby's honor on his estate, a custom of the "Teutonic tribes who believed that a child's fate and life were bound up with that of the "Birth Tree.'"[44] For many years, Beals and Nanette traveled up the Hudson to visit the Bigelows and the tree.

But it is not necessary to conclude that Bigelow was Nanette's father to understand why Beals was drawn to him. That thoughts of eugenic babies might already have been taking form even while Beals was working at the fair is suggested by another poem she wrote:

"The Woman"

I'm a woman of brain and sinew,
I'm a woman of spirit and soul,
I've set me a task to finish,
My life is in the goal.
I'm seeking a mate to match me
With never a feeling of shame—
For it's woe to me and my country
If I miss my life's great aim.
My breast is bared for adornment
Of the jewels a woman should wear—
My heart is aflame for the children
I feel I've a right to bear.
My mind is quickened with longing
To teach as I know I could,
To rear in the spirit of gladness
The bodies and souls of my brood.
I have scoured my soul of meanness,
I have wrought with tenderest care,
Til my wonderful body is ready

For the burden I long to bear.
The man must be of the stalwarts,
Not bred on a pygmy plan;
He must fit himself for the honor
Of being my mate and my man.
The men I have met do not measure
The height that I seek in my mate.
I'm facing the thought of the future,
I dream of my high estate.[45]

Evidently, Beals's photographs of *Strange Wedding Ceremonies* or *Cooking Methods* or *Mother and Babe at the Exhibition* had set her out upon another meditation on her own Womanhood—not as a "lady photographer," but as a vessel for the progress of the Anglo-Saxon race. Beals's sentiments seem to echo those of Theodore Roosevelt, who declared in a speech in 1908, "[T]he woman who, whether from cowardice or selfishness, from having a false and vacuous ideal shirks her duty as wife and mother, earns the right of our contempt, just as does the man who, from any motive, fears to do his duty in battle when the country calls him."[46] Beals was no coward. Nor did she wish to be a fool. Contemplating the "pygmy plan" at St. Louis developed her passion for "the stalwarts." Having learned a great deal at the fair about the connection between the national interest, white male energies, and the domestic signifier "white woman," she launched *herself* into circulation as the literal bearer of civilization and achieved her "life's great aim" as men like Roosevelt and Bigelow understood it.

Alfred accepted Nanette with tenderness and apparently tried to be a good parent to her, but by the time Nanette was six, he had to admit that the marriage was destroyed. The racial positionings promoted by the fair, combined with the eugenic ideology of Anglo-Saxon progress and the rendering of "womanhood" as a national imperative, had juxtaposed him to a "larger man," in much the same way that Beals had photographed "the pygmy" and "the Patagonian," and Alfred found himself left behind by evolution.

But if Beals averted her gaze from the manhood of the "pygmies," she looked away also from the historical significance—and manhood—of those "little brown men" like Emilio Aguinaldo (whom Roosevelt called "the typical representative of savagery, the typical foe of civilization of the American people"), men who were setting forth an undeniable challenge to the dominance of the Anglo-Saxon. This, of course, was exactly the link that it was her job to miss.

I might say, she is the pluckiest woman I ever saw. She was
not afraid for herself but shed bitter tears for Mr. Henry
and for the school, which is in all probability broken up.
—George Washington Carver to Booker T. Washington,
Tuskegee, Alabama, November 28, 1902

Epilogue

· ·

One final tale. Upon completion of her work at the Hampton
Institute, Frances Benjamin Johnston continued to document the progress of
black education in the South. She was an acknowledged authority in this genre
of photography, but there was potential competition. For instance, the Hamp-
ton Institute had its own camera club enthusiasts, the Kiquotan Kamera Klub,
founded in 1893, whose membership was comprised of Hampton faculty and
staff.[1] But Hampton principal Hollis Burke Frissell did not ask the Kiquotans,
and the membership did not seek, to add the photographs they made to the
"American Negro Life" exhibition at the Paris Exposition in 1900. The Kiquo-
tans busied themselves instead in making nostalgic images like "The Deserted
Plantation" and "Dinah Kneading Dough" to illustrate Paul Laurence Dun-
bar's dialect verse in *Poems of Cabin and Field* (1899) and *Candle-Lightin' Time*
(1901).[2] For public, highly political representation of Hampton, Frissell judged
that Johnston's skills and credentials were preferable.

Not surprisingly, then, in 1902 when Booker T. Washington wanted to pub-
licize Tuskegee, the institute that he had established in 1881 on the model of
Hampton to spread the Armstrong doctrine of moral and industrial education,
he hired Johnston to photograph it, and Johnston welcomed this chance to ex-
tend her reputation. After making hundreds of photographs at Tuskegee, Johns-
ton determined to press on into rural Alabama to photograph some of the other
schools that Washington and his followers had inspired.

The Ramer Colored Industrial School, located in the small town of Ramer, Alabama, was one of those establishments. Recently founded by Nelson E. Henry, a Tuskegee graduate and its current principal, the Ramer school was one of a number of "Little Tuskegees," which were attempting to spread the Hampton-Tuskegee idea of "education for life" throughout the New South. Near the end of November, accompanied by George Washington Carver, who as an amateur painter must have had an artist's interest in the "lady photographer" and who at that time was head of the agricultural division at Tuskegee, Johnston took the train from Tuskegee to Ramer, about a half day's journey. Nelson Henry and three other leading colored men of the town met Johnston at the station. The men loaded her luggage and camera equipment into Henry's buggy, Carver went to a house in town where he was to stay, and the black principal and the white lady set off for a destination unknown to her some miles into the countryside.

All went smoothly until Johnston, "finding it was to a colored family and 4 miles away" that they were headed, asked Henry "to bring her back to the white people."[3] When they got back to town, it was eleven o'clock at night. Johnston's biographers Pete Daniel and Raymond Smock note that by that time "'respectable' people had gone to bed" and "there was no one in the streets but Postmaster George Turnipseed's son and his companion, a 'desperado' named Armes."[4]

Turnipseed and Armes, defending the "New White" etiquette of the disfranchisement decade, were apparently offended that the mixed-race party had driven off together into the countryside and then returned, seeking a room for the woman with Turnipseed's sister. Not long before, Armes, defender of racial etiquette, "[had driven] out the white teacher with a revolver" and now was evidently ready to do it again.[5] He pulled out a gun and fired three shots at Nelson Henry, who was able to get away. Johnston escaped physical injury. She went to the house where Carver was staying, and Carver helped her to flee to the railroad station, where she took the train the next morning.

In a letter to Washington at Tuskegee, Carver reported the events that followed in Ramer: "The next day everything was in a state of turbulency and a mob had been formed to locate Mr. Henry and deal with him. They did not pay much attention to me as I kept out of the way as much as possible, but it was one of the worst situations I have ever been in. As things are now, the school is broken up and there seems to be no way of settling the difficulty. They say what they want is to get hold of Mr. Henry and beat him nearly to death."[6]

Nelson Henry, physically unhurt, was terrified and remained so for a long time. "Despite attempts by some of Booker T. Washington's staff and friends to calm the Ramer whites and persuade Henry to return," Daniel and Smock report, Henry closed the Ramer school, and did not open another for some years.[7]

In his letter to Washington explaining his resignation, Henry wrote, "You have doubtless heard of the incident at my school . . . on account of Miss Johnston's coming to take pictures for us. It is indeed a sad event to me after having labored so very hard for six years. But under conditions at Ramer, Something [*sic*] would have cropped out at some time and Miss Johnston's trip only brought it out, though none of us expected it. No one can be more sorry than I, for all of my energy and strength has been put on that work."[8] Carver also was badly shaken. He wrote to Washington that it was "the most frightful experience of my life there and for one day and night it was a very serious question indeed as to whether I would return to Tuskegee alive or not as the people were thoroughly bent on bloodshed."[9]

Johnston, too, at least initially, was livid. She had "traveled through Europe and America and never experienced trouble."[10] Clearly, Johnston expected to be treated with the deference due a white lady. Urbane, well informed, and well connected, she was not about to tolerate such behavior from rural thugs. She went immediately to Montgomery, the state capital, which was not much farther down the same train tracks, to complain in person to the governor of Alabama. She also threatened to bring a lawsuit against Turnipseed and Armes. She demanded that Ramer's postmaster, Turnipseed's father, be fired from his government job. She even declared that she would "bring the power of her friend President Roosevelt down on tiny Ramer."[11] But Johnston finally did not follow through on her legal threats, nor did she get Roosevelt involved. Instead, she altered her photographing schedule, chose different schools to photograph, went back on the train, and continued on with her assignment.

It is likely that Washington, who had hired her, convinced her to desist. "If Miss Johnston is still at Tuskegee," he wrote to Emmett Jay Scott, his personal secretary, immediately upon hearing of the incident, "I wish you would ask her not to do anything definite about that Ramer matter until I have had an opportunity to see her. If she has not done so, I hope she will not fail to go to Snow Hill as she will meet with no difficulties there. . . . Perhaps Mr. Bedford might go with her." And indeed, Robert Charles Bedford was able to report to Washington on December 3 that he was "very glad Miss Johnston agreed to leave the matter of the suit til after conferring with you."[12]

Bedford had been dispatched from Tuskegee to accompany Johnston to Montgomery to see the governor, and he seems to have been very able at diffusing her anger. "Miss Johnston went to Montgomery with me yesterday," he wrote. "She feels very deeply and of course we all sympathize with her. We saw Capt. Faulkner. He was very emphatic in his condemnation of the act and advised putting the case into the Solicitor's hands at once. But on further talk considering the interests of the school as well to lay the matter before the Gov."[13]

The governor himself showed even less eagerness to act. Instead, he blamed

the victims: "The Governor condemned the act but said we must face the facts and consider the locality and the people we were dealing with. He thought Miss Johnston ought not to have gone there at night without knowing where she was to stop and that Mr. Henry made a mistake in not asking the white people to entertain her and especially in bringing her back to the white people after they supposed she had been with a colored family." The ultimate official story seems to have been that it was all a simple misunderstanding: "If it had not been so late and other stores had been open and other people around," Bedford opined, "I doubt whether the trouble would have occurred." And he even re-peated the rationalization that "not one had any thing but praise of Henry[,] even the boy who shot at him[,] and he seemed more anxious than any of the rest for Mr. Henry's return."[14]

Bedford reported rather credulously that "[The Governor] gave us a letter to the Solicitor and assured me that Mr. Henry should go on with his school." And he finally concluded that Tuskegee needed a policy of even more stringent self-policing:

> Miss Johnston was fully warned against going to Ramer at night. She had travelled so much she could not conceive the possibility of any one molesting her or mistaking her motives. This lesson shows us that we have not yet got to the point, everywhere, where we can act without great prudence and fore-thought and in view of the actual conditions in a given community. I think hereafter those who go out in any way as representatives of the school must be guided by its judgment or go out on their own responsibility.[15]

In sum, the trouble was Johnston's own fault.

The great accommodationist's response to this particular attempted lynch-ing and to the destruction of the Ramer School conformed to his general policy toward white racial violence. At least publicly he tried to get on with busi-ness. Washington was not ignorant of the iron fist in whose velvet glove his Tuskegee project rested. In January of 1899, during the time Johnston had been photographing at Hampton, Washington undertook a fundraising trip up north. Speaking to the Women's New England Club in Boston, he described the plight of black citizens in the South:

> [T]he Southern people in private conversation do not attempt to hide the fact that they regularly and systematically resort to means to nullify the colored vote, that they are resolved in every case where the colored vote is large enough to have a controlling influence in an election to see that the colored vote is not counted. . . . The vote is quietly and persistently thrown from the ballot box or is not counted. This practice has been so effectually used for so long a time, that it is safe to say that not more than one fifth of the colored

voters ever attempt to vote in the state and national elections, so discouraged have they become. In the districts where the colored people outnumber the whites there the colored people have the least chance for expressing themselves.[16]

But he went on to claim that "force in the form of shot guns, Ku Klux Klans, is now rarely resorted to."[17] As James Anderson points out,

Washington saw whites in power, or the best white folk as he called them, as expounding a gross materialism which propelled them to sacrifice anybody that stood in the way of economic progress. Likewise he believed that they protected and rewarded persons that assisted them in their profit-making efforts. Consequently, Washington believed that it was only in the economic sphere that whites in power welcomed assistance from blacks and rewarded them according to the value of their service. Any attempt to negotiate political and social justice would only lead to antagonistic relationships and would result in the destruction of blacks."[18]

Washington concluded his address to the Women's New England Club with the assurance that if the black farmer could gain superior practical education and learn to raise "50 bushels of corn to the acre, while his white neighbor raises only thirty, the white man will come to the black man to learn . . . [and] will sit down on the same seat and talk about it."[19] "Strangely," notes Anderson, "Washington spoke as if there was no racism in economic matters."[20]

One gets the impression that it might have been very much more difficult for Washington to persuade Johnston not to make trouble than to persuade the Women's New England Club that there was no real trouble. After he made sure that she was safe, George Washington Carver wrote to Booker T. Washington at Tuskegee about Johnston's reaction to the incident: "I might say, she is the pluckiest woman I ever saw. She was not afraid for herself but shed bitter tears for Mr. Henry and for the school which is in all probability broken up."[21] Johnston knew, of course, that it was far easier to substitute one school for another in photographs than in real life, and she was angry over what had happened to the Ramer school and to her companions. But the way that Johnston dealt with this violence was ultimately to accede to Washington's conciliatory policy. She went on to photograph in rural Alabama at the Snow Hill and Mt. Meigs schools instead of Ramer. These photographs show, once again, the placid, beautiful scenes that had so delighted the world when she made them at Hampton. Their pastoral quality gives no hint of the dangers Johnston had just witnessed.

Washington used the Snow Hill and Mt. Meigs photographs in a 1903 article in *The World's Work,* entitled "The Successful Training of the Negro."[22] In this article he transformed the "before" and "after" formula that had worked so well

for Johnston's illuminations of the educational process at Hampton into an even more thoroughly naturalized metaphor of social reproduction. The relationship between Tuskegee proper and the "Little Tuskegees" that he strove to foster throughout the South was, Washington said, like that between "parent" and "child." This familial metaphor equated the struggle against racial violence with the ordinary progress of a young person's coming of age. Washington believed, as Daniel and Smock point out, that Tuskegee was to grow "by the sweat of its own students," who, "having learned the lessons of industrial education, went out into the world to teach or to ply their trade." As Daniel and Smock also point out, this metaphor also makes the Hampton-Tuskegee vision seem undeniable: "Even in those desperate days of lynching, peonage, and Jim Crow," Tuskegee's natural progress in education would inevitably "pave the way to respectability."[23]

Washington did include a kind of parable in "The Successful Training of the Negro," one that obliquely addressed both Johnston's recent experience of racial violence and his own prescription for the "successful training" of professionally active women in general. His article ended with the example of the Voorhees Industrial School in Denmark, South Carolina. The Voorhees Industrial School was founded by a woman Tuskegee graduate. She was, Washington noted, "greatly opposed at first by both the white and colored people, but she persevered until now all are her friends. She has three hundred acres of land, all paid for. A large central building has been erected at a cost of $3,000 . . . and a girls' dormitory to cost $4,000 . . . is in the process of erection." In Washington's estimation, these results were clear. Both "the white and colored people" who had "greatly opposed" her "at first" were now "her friends," and her capital campaign was progressing smoothly. The female founder of Voorhees had succeeded in executing the Tuskegee plan, and others might properly aspire to her achievements.[24]

But Johnston had just received another kind of education. Johnston, like one of Washington's students, had gone "out in the world, to ply her trade" as a lady photographer and had expected that hard work and "a talent for detail" would win success. Mostly, the formula worked for her. But in 1902 in Ramer, Alabama, she learned a different lesson. It was brought home not by the sweat of her brow but by the cold sweat of fear. Turnipseed and Armes instructed her in the metaphysics of her "place." This was something that had not concerned her in her photographic travels, had not constrained her in her work in 1899 at Hampton, had not convinced her when she was advised not to go to Ramer at night, and infuriated her now. Ultimately, however, she accepted its terms.

No doubt Carver's estimate of her bravery was sound; Johnston could well have been the "pluckiest woman" Carver had ever seen. It was probably very difficult for Booker T. Washington to persuade the "greatest woman photog-

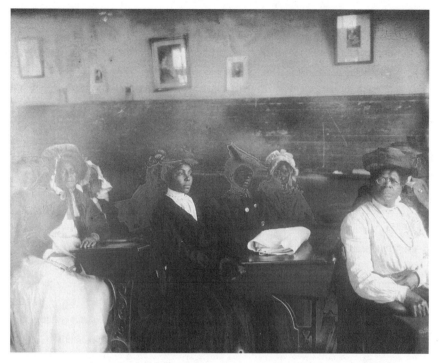

E.1. *Women in a classroom, Snow Hill Institute. Frances Benjamin Johnston, photographer*

rapher in the world" that "the successful training of the Negro" required the successful disciplining of the white woman to assume the correct perspective on such incidents such as this. Nonetheless, there *were* women of greater pluck. For one, there was her fellow journalist Ida B. Wells, who, having been threatened with death and having had her newspaper office destroyed because of her antilynching journalism, published a scathing condemnation of white racism in *A Red Record: Tabulated Statistics and Alleged Causes of Lynchings in the United States, 1892–1893–1894* and spent the next decades organizing a radical campaign to fight racial terrorism.[25] Nor did "pluck" come only with fame. There were many others whose courage was more anonymous outside their own communities. The black women who organized to fight Jim Crow in North Carolina during the lynching epidemic in the 1890s, such as Sarah Dudley Petty, showed "the extraordinary potential of ordinary African Americans in the first three decades of freedom."[26]

There is one telling sign that this time, perhaps, it was not so easy for Johnston to restrain her more unruly insights. In a classroom photograph taken at the Snow Hill school that Johnston did *not* publish, a group of black women wear hats very much like the one that Johnston had earlier mocked in her own self-portrait. But these women are entirely serious. They manage to communi-

cate that they wear this symbol of middle-class respectability with a determined purpose that is a match for Johnston's own professional focus. As Judith Fryer Davidov points out, in newly bringing this image to our attention, "the group of women displays a range of attitudes that are far from passive."[27] One woman, in fact, openly annoyed, even returns the meddling white lady photographer's gaze with hostility.

In allowing that woman's anger to be recorded and reproduced, Johnston made an image unlike any of her others. It suggests a certain willingness to examine the difficulties that her earlier photographs disguised. Nevertheless, Johnston did not choose to publish this image, just as she finally chose not to bring legal action against Turnipseed and Armes, even though she was a highly educated, well-connected white woman whose first impulse was to bring them to justice. Johnston accepted, instead, the veiled threat from Tuskegee that she had been "fully warned" and turned aside.

We do not know the whole story of the Ramer incident, and doubtless its complexities were many. But if we are to grasp the history and ongoing production of conditions that enable racial terror and oppression in the United States, we cannot afford to ignore its implications. Johnston's patrons clearly encouraged her genteel fiction that a "lady" could best further the goals of the male leadership across the lines of race and class by remaining compliant and deferring to her elite male advisers, black and white. We must consider that, rather than "gender trouble," it may well have been this kind of loyalty to gender difference that persuaded successful white American women photographers at the turning point of the world's bloodiest century to look away.

In 1864, writing in his popular manual *The Camera and the Pencil,* Marcus Aurelius Root observed of photography the usual laudatory things:

> By heliography, our loved ones, dead or distant; our friends and acquaintances, however far removed, are retained within daily and hourly vision. To what extent domestic and social affections and sentiments are conserved and perpetrated by these "shadows" of the loved and valued originals, every one may judge. The cheapness of these pictures brings them within reach, substantially, of all.
>
> In this competitious and selfish world of ours, whatever tends to vivify and strengthen the social feelings should be hailed as a benediction. With these literal transcriptions of features and forms, once dear to us, ever at hand, we are scarcely more likely to forget or grow cold to their originals, than we should in their presence. How can we exaggerate the value of an art which produces effects like these?[28]

This was the sentimental axiom.

But Oliver Wendell Holmes was much closer to the mark, although perhaps inadvertently, when, in celebrating the discovery of photography, he called photographs "the social currency, the sentimental 'green-backs' of civilization."[29] In a social order that was structured by fundamental racial and sexual inequalities and increasingly maintained by the cynical or self-deluded management of affect, the exchange of photographs that helped to cement the regime of sentiment—and with it the triadic system of kinship, conquest, and incorporation that it sponsored—could become the very triage point of human status. Like the currency of money or the currency of freedom, it is the conditions for the circulation of one's image, and not the image itself, that will either cast up individuals and whole peoples on the shore of social protection or feed them to the void.

Photography has always been a constitutive force, not merely reflecting but actively determining the social spaces in which lives are lived. The narratives we make about domestic photographs, relating image to image and to other cultural forms, have helped to shape our current violent predicaments of race, class, and gender. Were she writing it now, Gisele Freund's pioneering work *Photography and Society* would need to be recast: photography *is* society; they are not distinct. As a social institution, American domestic photography commemorates a popular struggle to envision—and the struggle to be visible in—a modus vivendi for American lives. The right to see and be seen, in one's own way and under one's own terms, has been the point of contention.

But, impressive as is its capacity to envision lives, American domestic photography has also had the capacity to destroy them. Photography has always been an enforcer, with the power to make certain things invisible just as surely as it has made other things appear. It behooves us now to learn just how this differentiating function of photography has proceeded, so as to loosen its grip on the continuing production of democratic signs and cultures. We must seek out what Hortense Spillers has called "the cognitive appropriation of the Real." The photographic positivist's "mirror with a memory" in the nineteenth century, must become the historian's "memory with a mirror" in the twenty-first.

"The reading of a photograph is always historical" wrote Roland Barthes. "It depends on the reader's 'knowledge,' just as if this were a matter of a real language intelligible only if one has learned its sign."[30] "To articulate the past historically," wrote Walter Benjamin, "does not mean to recognize it 'the way it really was.' It means to seize hold of a memory as it flashes up at a moment of danger. Every image of the past that is not recognized by the present as one of its concerns threatens to disappear irretrievably."[31] But what do Barthes and Benjamin mean by history?

For Barthes, an historical reading calls upon a fund of knowledge about the past. In looking at a photograph, Barthes is interested in reading signs of the way

things must have been. He is a linguist, a translator. He translates the meaning of the image by decoding emanations from the past. But for Benjamin, all knowledge is in the present, about the present. The only reason that Benjamin wants to remember the way things were is to help in a present emergency. Benjamin's term "to articulate" is a pun. To "articulate the past historically" is to speak about history, but it is also to mesh the past and the present into the future, as the wheels of one gear articulate with the next. Eduardo Cadava has glossed this idea in *Words of Light:*

> To say that history withdraws from sight or understanding is not to say that history is what is past, but rather that it passes away; not that it has disappeared, but rather that it "threatens to disappear"; it is always on the verge of disappearing, without disappearing. The possibility of history is bound to the survival of the traces of what is past and to our ability to read these traces as traces. That these traces are marked historically does not mean that they belong to a specific time—as Benjamin explains in his early essay on the *trauerspiel* and tragedy, "the time of history is infinite in every direction and unfulfilled in every instant. This means that no single empirical event is conceivable that would have a necessary connection to the temporal situation in which it occurs." Rather, as he says of images in general, they only come to legibility at a specific time.[32]

To articulate the past historically is to use images of the past in a specific way to aid in the legibility of something better.

If we have learned in recent years from Barthes and others, including feminists, how to look closely at photographs, we must learn from Benjamin why. Surely, the most important reason to read historical photographs is not to review the record of the past as it is simply illustrated in photographs, as an inert collage of "the way things were," as a window to a past that accepts the fiction of being over. Nor is it to investigate the past that photography has brought to bear on and in itself, as in the history of the medium.

Instead, the photographic past that ought now to be among our most urgent concerns presents the fact that sentimental domestic images have helped to shape our current genocidal predicaments of nation, race, class, and gender. "We would argue," write Patricia Holland, Jo Spence, and Simon Watney, that "photography has played an important role in identifying people who are not like 'us,' who become the bearers of all those qualities which 'we' find unfamiliar and unacceptable—from the violent and disorderly to the exotic and the quaint." This is the tradition, they continue,

> of the representation of "inferior" groups which has evolved within the history of colonialism and imperialism, and which feeds and sustains contem-

porary racism. A politics of anti-racism takes on these issues within the social structure and within the realm of representation.[33]

Since the second half of the nineteenth century, tender violence in the eyes of "good women" has produced some of photography's least innocent views. It is way past time to look back.

Notes

INTRODUCTION

1. Moutoussamy-Ashe, *Viewfinders,* 7.

2. Ibid. Moutoussamy-Ashe believes that "some slaves may have learned the photographic process in exchange for labor from a 'liberal' slave owner . . . [since] some masters realized that it was advantageous to make the slaves more efficient by giving them necessary manual training." But on the whole, she concludes, even though "competition drove prices down . . . few blacks used the [daguerreotype] process. The blacks who could afford to purchase a daguerreotype outfit were among the free blacks, and most free blacks were busy trying to defend and free the rest of the enslaved race." Ibid., 8. The 1850 census reported a single free black male daguerreotypist in Connecticut, but, notes Moutoussamy-Ashe, since "in the South the slaves were kept ignorant and unlettered by slave owners, who prohibited their receiving any formal education, it was natural that most business ventures by Negroes were established in the North." Ibid., 7.

3. In Scott's view, "Every subordinate group creates, out of its ordeal, a 'hidden transcript' that represents a critique of power spoken behind the back of the dominant. The powerful, for their part, also develop a hidden transcript representing the practices and claims of their role that cannot be avowed." James C. Scott, *Domination and the Arts of Resistance,* xii.

4. See Painter, *Sojourner Truth,* 188–93, 195; and Jacobs, *Incidents in the Life of a Slave Girl,* frontispiece. See also Frederick Douglass's opinion that "Negroes can never have impartial portraits at the hands of white artists": "[It is] next to impossible for white men to take likenesses of black men, without most grossly exaggerating their distinctive features. And the reason is obvious. Artists, like all other white persons, have adopted a theory dissecting the distinctive features of Negro physiognomy." Douglass, "A Tribute to the Negro," *The North Star,* April 17, 1849, as reprinted in Willis, *Picturing Us,* 17.

5. Davis, *Women, Culture, Politics,* 221.

6. Ibid. Historian Valencia Hollins Coar also writes of curating an exhibition on black photographers: "One of the most painful aspects . . . has been the recognition of the fact that most of the information and images that we sought are lost forever. Much of the work of even the most accomplished nineteenth and early twentieth century black photographers cannot be located." Coar, *Century of Black Photographers,* 9.

7. Mattison, *Louisa Piquet, the Octoroon.* See also Deborah Willis, "A Search for Self: The Photograph and Black Family Life," in Hirsch, *Familial Gaze,* 107–23, which offers a reading very similar to my own. For invaluable commentary on the Piquet narrative and an analysis of the response of Louisa to the "male gaze," see Foreman, "Who's Your Mama?"

8. This correspondence appears as quoted in Moutoussamy-Ashe, *Viewfinders,* 6–7. It appears also in Deborah Willis, "A Search for Self," in Hirsch, *Familial Gaze,* 115–16; and in Mattison, *Louisa Piquet, the Octoroon,* 31, 35 (Mattison's description of the daguerreotype is found on 35).

9. Gabrielle Foreman, personal communication with the author, February 1999.

10. Sobieszek and Appell, *Spirit of Fact*, x; and Albert Southworth, "An Address to the National Photographic Association of the United States," *The Philadelphia Photographer* 8, no. 94 (October 1871): 315–23, as quoted in ibid., xxiii.

11. Martin Jay, "Scopic Regimes of Modernity," in Foster, *Vision and Visuality*, 19. See also Jay, *Downcast Eyes.*

12. Holland, Spence, and Watney, "Introduction," in *Photography/Politics: Two*, 2. See also Watney, "On the Institutions of Photography," in the same volume, 187–97; and Sylvia Harvey, "Ideology: The 'Base and Superstructure' Debate," in Dennett and Spence, *Photography/Politics: One*, 3–12.

13. John Berger, "Understanding a Photograph," in Trachtenberg, *Classic Essays*, 294.

14. Sontag, *On Photography*, 178.

15. John Berger, "Uses of Photography," in *About Looking*, 58.

16. Berger, *Ways of Seeing*, 33.

17. The definition of ideology I use here is Althusser's: "What is represented in ideology is therefore not the system of the real relations which govern the existence of individuals, but the imaginary relation of those individuals to the real relations in which they live." Louis Althusser, "Ideology and the Ideological State Apparatuses," in *Lenin and Philosophy and Other Essays* (London: New Left Books, 1971), 155. The definition of "counter-memory" is Foucault's: "The historical sense gives rise to three uses that oppose and correspond to the three Platonic modalities of history. The first is parodic, directed against reality, and opposes the theme of history as reminiscence or recognition; the second is dissociative, directed against identity, and opposes history given as continuity, or representative of a tradition; the third is sacrificial, directed against truth, and opposes history as knowledge. They imply a use of history that severs its connection to memory, its metaphysical and anthropological model, and constructs a counter-memory, a transformation of history into a totally different form of time." Michel Foucault, "Nietzsche, Genealogy, History," in *Language, Counter-Memory, Practice*, 160.

18. Jay, *Downcast Eyes*, 592.

19. John Berger, "Uses of Photography," in Berger, *About Looking*, 58.

20. Ibid., 57.

21. Sekula, *Photography Against the Grain*, ix. This volume of essays on photography and ideology has been indispensable to me, as have the following: Dennett and Spence, *Photography/Politics: One*; Holland, Spence, and Watney, *Photography/Politics: Two*; Tagg, *Burden of Representation*; and Trachtenberg, *Reading American Photographs*.

22. Jacobson, *Whiteness of a Different Color*, 222.

23. Davidov, *Women's Camera Work.*

24. Martina Attille, "Still," in Skipwith, *Rhapsodies in Black*, 158.

25. Bederman, *Manliness and Civilization*; Boisseau, "They Called Me BeBe Bwana"; Frankenberg, *White Women, Race Matters*; Marilyn Frye, "On Being White: Toward a Feminist Understanding of Race and Race Supremacy," in *Politics of Reality*; Gunning, *Race, Rape and Lynching*; J. D. Hall, "'The Mind that Burns in Each Body'"; A. Kaplan, "Romancing the Empire"; Lazarre, *Beyond the Whiteness of Whiteness*; Morrison, *Playing in the Dark*; Newman, *White Women's Rights*; Minnie Bruce Pratt, "Identity: Skin, Blood, Heart," in Bulkin, Pratt, and Smith, *Yours in Struggle*; Sanchez-Eppler, *Touching Liberty*; Ware, *Beyond the Pale*; and Wiegman, *American Anatomies.*

26. Elizabeth Abel, "Domestic Borders, Cultural Boundaries: Black Feminists Review the Family," in Hirsch, *Familial Gaze;* Berlant, *Queen of America;* Butler, "Endangered/Endangering"; Carby, *Race Men;* Davidov, *Women's Camera Work;* DuCille, *Skin Trade;* Faris, *Navajo and Photography;* Guimond, *American Photography and the American Dream;* Haraway, "Teddy Bear Patriarchy"; Holloway, *Portraiture and the Harlem Renaissance;* hooks, *Black Looks;* Lippard, *Partial Recall;* Andrea Liss, "Black Bodies in Evidence: Maternal Visibility in Renée Cox's Family Portraits," in Hirsch, *Familial Gaze;* Lutz and Collins, *Reading National Geographic;* Deborah McDowell, "Viewing the Remains: A Polemic on Death, Spectacle, and the [Black] Family," in Hirsch, *Familial Gaze;* Rabinowitz, *They Must Be Represented;* Rafael, "Nationalism, Imagery, and the Filipino Intelligentsia"; Stange, " 'Illusion Complete Within Itself' "; S. M. Smith, *American Archives;* Wexler, "Techniques of the Imaginary Nation"; and Willis, *Picturing Us.*

27. Balibar and Wallerstein, *Race, Nation, Class;* Blauner, *Racial Oppression in America;* Dominguez, *White by Definition;* Fields, "Ideology and Race in American History"; Fredrickson, *Black Image in the White Mind* and *White Supremacy;* Gilroy, *Black Atlantic;* Horseman, *Race and Manifest Destiny;* Ignatiev, *How the Irish Became White;* Jacobson, *Whiteness of a Different Color;* Kevles, *In the Name of Eugenics;* Lott, *Love and Theft;* Omi and Winant, *Racial Formation in the United States;* Roach, *Cities of the Dead;* Roediger, *Wages of Whiteness;* Rogin, *Blackface, White Noise;* Sollors, *Beyond Ethnicity; Consent and Descent in American Culture;* Stocking, *Race, Culture and Evolution;* Takaki, *Iron Cages* and *Strangers from a Different Shore;* and Wald, *Constituting Americans.*

28. Butler, *Gender Trouble.*

29. Christopher Vaughan, "Ogling Igorots; The Politics and Commerce of Exhibiting Cultural Otherness, 1898–1913," in Thomson, *Freakery,* 219–33.

30. Berger and Mohr, *Another Way of Telling,* 287.

CHAPTER ONE

1. The episode of Johnston's photographing of Admiral Dewey aboard the flagship *Olympia* is discussed in Daniel and Smock, *A Talent for Detail,* 57–67. *A Talent for Detail* is the only monograph yet published on Johnston, but further information is available in several other sources, including Davidov, *Women's Camera Work;* Gover, *Positive Image;* S. M. Smith, *American Archives;* Guimond, *American Photography and the American Dream;* Quitslund, "Her Feminine Colleagues"; and Watts, "Frances Benjamin Johnston."

2. The entire poem in reproduced in Stickney, *Life of Admiral Dewey,* 416.

3. Daniel and Smock, *A Talent for Detail,* 58.

4. S.v. "George Dewey," *Encyclopedia Americana,* vol. 6.

5. Ibid.

6. Stickney, *Life of Admiral Dewey,* 162.

7. Ibid., 164.

8. Weinstein and Wilson, *Freedom and Crisis,* 583. Information on Frances A. Johnston, Frances Benjamin Johnston's mother, comes from the "Scope and Content Note," p. 4, *The Papers of Frances Benjamin Johnston,* Manuscript Division, Library of Congress.

9. The phrase "a talent for detail" comes from an article Frances Benjamin Johnston herself wrote for the *Ladies' Home Journal* in 1897, in which she said, "The woman who makes photography profitable must have, as to personal qualities, good common sense, unlimited patience to carry her through endless failures, equally unlimited tact, good taste, a quick eye, a talent for detail, and a genius for hard work." The phrase was highlighted by Daniel and Smock as the title of their biography of Johnston.

10. Daniel and Smock, *A Talent for Detail*, 27.

11. On the halftone printing process, see Neil Harris, "Iconography and Intellectual History: The Halftone Effect," 304–17. See also Jussim, *Visual Communication and the Graphic Arts;* Ivins, *Prints and Visual Communications;* Earle, "Halftone Effects"; D. Phillips, "Art for Industry's Sake" and "Birth of Mass Photography."

12. Hales, *Silver Cities*, 271. See also Green-Lewis, *Framing the Victorians*, 187–206.

13. Hales, *Silver Cities*, 274.

14. Rosenblum, *History of Women Photographers*, 70.

15. Jacobson, *Special Sorrows*, esp. 177–216.

16. "Soldiers' Letters: Being Materials for the History of a War of Criminal Aggression" (Chicago: Anti-Imperialist League, 1859), in Zwick, *Anti-Imperialism in the United States*.

17. McClintock, *Imperial Leather*, 14.

18. Ibid., 15.

19. Graff, *American Imperialism and the Philippine Insurrection*, 115.

20. A. Miller, *Empire of the Eye*, 3.

21. Trachtenberg, *Reading American Photographs*, 46, 48.

22. Ibid., 62.

23. "Soldiers' Letters," in Zwick, *Anti-Imperialism in the United States*.

24. Graff, *American Imperialism and the Philippine Insurrection*, 71–72.

25. Ibid., 74–75.

26. Trachtenberg, *Reading American Photographs*, 290.

27. See Bederman, *Manliness and Civilization*, 12.

28. Henry Graff, "Introduction," in *American Imperialism and the Philippine Insurrection*, vii.

29. The term is Anne McClintock's, in *Imperial Leather*, 32.

30. See the close reading and political analysis of these three representations of the Battle of San Juan Hill in A. Kaplan, "Black and Blue on San Juan Hill."

31. Carl Schurtz, "The Policy of Imperialism," Liberty Tract No. 4, in Zwick, *Anti-Imperialism in the United States*, n.p.

32. Johnston, "What a Woman Can Do with a Camera."

33. Quoted in Quitslund, "Her Feminine Colleagues," 97.

34. Rosenblum, *History of Women Photographers*, 7.

35. Quitslund, "Her Feminine Colleagues," 101.

36. Gover, *Positive Image*, xvii.

37. See Lerner, "Placing Women in History."

38. Riley, *Am I That Name?*, 1–2.

39. Ibid., 7.

40. Johnston, "What a Woman Can Do with a Camera," 6.

41. Frances Benjamin Johnston, "Lecture #8," Bureau of Vocational Information

Records, S-21, Microfilm M-18, Reel 1, Schlesinger Library, Radcliffe Institute, Harvard University, Cambridge, Mass.

42. Ibid.

43. Daniel and Smock, *A Talent for Detail*, 34.

44. Schurtz, *Policy of Imperialism*, n.p.

45. Graff, *American Imperialism and the Philippine Insurrection*, 23.

46. Ibid., 7–8.

47. Ibid., 33.

48. Poore, *Pictorial Composition*, 50.

49. Ibid.

50. Rafael, "Nationalism, Imagery, and the Filipino Intelligentsia," 606.

51. Schurtz, *Policy of Imperialism*, n.p.

52. Graff, *American Imperialism and the Philippine Insurrection*, 23, 25.

53. Stickney, *Life of Admiral Dewey*, 34.

54. See Stoler, *Race and the Education of Desire;* and Ware, *Beyond the Pale.*

55. Pete Daniel and Raymond Smock identify the male photographer in Johnston's image as "one of Johnston's competitors, possibly J. C. Hemment." Daniel and Smock, *A Talent for Detail*, 67. However, I am persuaded by the circumstantial evidence that it is Hemment, even though I have found no other photograph of him with which to compare it. In 1898, Hemment published *Cannon and Camera: Sea and Land Battles of the Spanish-American War in Cuba, Camp Life, and the Return of the Soldiers,* a dashing, photographically illustrated account of his adventures as a "War Artist at the Front." In this book, Hemment included an appendix of advice to aspiring war photojournalists, in which he wrote, "I trust in these few suggestions that something may be found to help my brothers and sisters—for has not this glorious art been taken up by women with all the enthusiasm and pride which they infuse into all their undertakings?" (271). Johnston was, I believe, very likely to respond to this attitude of genuine professional camaraderie with the admiration that would prompt a picture as well as the belief that it was safe to entrust her negatives to Hemment, even though Bain had earlier warned her that "two or three persons have said . . . lately that he was tricky, so it will be as well to be on your guard." Daniel and Smock, *A Talent for Detail*, 58.

56. George Grantham Bain to Frances Benjamin Johnston, August 22, 1898, Frances Benjamin Johnston Collection, Library of Congress, Washington, D.C.

57. Daniel and Smock, *A Talent for Detail*, 58.

58. Ibid., 58–59.

59. Ibid.

60. Joan Scott, "Gender: A Useful Category of Historical Analysis," in *Gender and the Politics of History*, 42.

61. Ibid., 48, 49.

CHAPTER TWO

1. Samuel Chapman Armstrong, quoted in Engs, "Red, Black and White," 232.

2. Samuel Chapman Armstrong, "Lessons from the Hawaiian Islands," quoted in Robinson, "History of Hampton Institute," 44.

3. June Howard makes an analogous point concerning naturalism as a literary form: "My contention will not be that naturalism has an ideology or reflects an ideology, but that the form itself *is* an immanent ideology. It is a way of imagining the world and the relation of the self to the world, a way of making sense—and making narrative—out of the comforts and discomforts of the historical moment." *Form and History in American Literary Nationalism,* ix.

4. Siegel, "Why Equal Protection No Longer Protects," 1115.

5. Barthes, *Camera Lucida,* 26.

6. Ibid., 26–27.

7. Foucault, *Power/Knowledge,* 83.

8. Ibid., 82.

9. Ibid.

10. Ibid.

11. My philosophical position here is informed by Donna Haraway's discussion of partial perspectives in "Situated Knowledges: The Science Question in Feminism and the Privilege of Partial Perspective"; by Sandra Harding's analysis of standpoint theory in *The Science Question in Feminism;* by Michel Foucault's discussion of "subjugated knowledge" in *Power/Knowledge;* by Mieke Bal's discussion of complicity in "Postcards from the Edge," in *Double Exposures; The Subject of Cultural Analysis,* 195–224; and by Patricia Hill Collins's formulation of the "outsider-within," in *Black Feminist Thought: Knowledge, Consciousness, and the Politics of Empowerment.*

12. Wolf, "Confessions of a Closet Ekphrastic," 185.

13. Updike, *Just Looking.*

14. See Guilbaut, *How New York Stole the Idea of Modern Art;* and C. Phillips, "Judgment Seat of Photography," 14–47. See also Steichen, *Family of Man;* Allan Sekula, "The Traffic in Photographs," in *Photography Against the Grain;* and Roland Barthes's classic deconstruction of the exhibition, "The Great Family of Man."

15. Marianne Hirsch cautions against adopting the facile assumption that the ideological effect of the *Family of Man* was either puerile or reactionary in the postwar period. See her thoughtful essay "Reframing the Family Romance," in Hirsch, *Family Frames,* 41–77.

16. Alan Trachtenberg has been the chief and most persuasive advocate for reading the historical evidence of photographs. In his most recent book, *Reading American Photographs: Images as History, Mathew Brady to Walker Evans,* Trachtenberg argues a social constructionist position for photographs as documents of American cultural history: "Just as the meaning of the past is the prerogative of the present to invent and choose, the meaning of an image does not come intact and whole. Indeed, what empowers an image to represent history is not just what it shows but the struggle for meaning we undergo before it, a struggle analogous to the historian's effort to shape an intelligible and usable past" (xvii). The politically nuanced attention that Trachtenberg is advocating as "readings" should not be confused with formalism.

17. An excellent discussion of the pitfalls of a merely additive conceptualization of oppression may be found in Spelman, "Theories of Race and Gender: The Erasure of Black Women." See also Spelman, *Inessential Woman.*

18. See Tompkins, *Sensational Designs.* See also Reynolds, *Beneath the American Renaissance.*

19. Dorothy Sterling dates the image "circa 1865." Sterling, *We Are Your Sisters,* 359. Jacqueline Jones dates it 1865 but locates it, incorrectly, in Charleston, South Carolina. Jones, *Labor of Love, Labor of Sorrow,* 122. Joan Severa dates it more precisely, as "July, 1868." Severa, *Dressed for the Photographer,* 281. Norman Yetman does not date the image but places it within a portfolio of images of "Former Slaves" photographed "during the period from about 1861 to 1935 in Virginia, South Carolina, North Carolina, and Washington, D.C." Yetman, *Voices from Slavery,* portfolio of images following p. 338.

20. Severa, *Dressed for the Photographer,* 281.

21. The Cook photographs I am analyzing in this chapter may all be found in the George Cook Collection of the Valentine Museum in Richmond, Virginia. Although the "Nursemaid and Her Charge" has been reprinted, there are still hundreds of unpublished images by George and Heustis Cook extant in the archives.

22. Painter, *Sojourner Truth,* 185–99.

23. Jacobs, *Incidents in the Life of a Slave Girl,* cover and frontispiece.

24. Kristeva, "Motherhood According to Bellini," 243.

25. Ibid., 241, 237.

26. See discussion in Wardley, "Relic, Fetish, Femmage," 216–17.

27. Yetman, *Voices from Slavery,* portfolio of images following p. 338.

28. Ibid.

29. Dickson, *Covered Wagon Days,* 191–92.

30. The locus classicus on this role of photography in the process of mythologization (and still one of the best discussions of this process) is Barthes, "Myth Today."

31. Holland, Spence, and Watney, *Photography/Politics: Two,* 2.

32. Pollock, "What's Wrong with 'Images of Women'?" 26.

33. Richard Brodhead's discussion of the function of domestic fiction in the consolidation of the early-nineteenth-century bourgeois family offers an illuminating and substantially parallel example of the "cultural work" (Jane Tompkins's term) accomplished by sentimental cultural products. See Brodhead, "Sparing the Rod."

34. Fisher, *Hard Facts.*

35. G. Brown, *Domestic Individualism,* 64, 71.

36. Deborah Willis, Valencia Hollins Coar, and Jeanne Moutoussamy-Ashe have published the major works to date on the history of black photographers in the nineteenth century, and a great deal more research is currently underway. See Willis-Thomas, *Black Photographers, 1840–1940: A BioBibliography;* Coar, *A Century of Black Photographers, 1840–1960;* and Moutoussamy-Ashe, *Viewfinders: Black Women Photographers.*

37. "Outsider-within" is the term Patricia Hill Collins uses to designate the social position of the black woman domestic worker in white families. I have here extended it to apply to the social position of the black man connected with the Cook family as well. See discussion in Collins, *Black Feminist Thought,* 10–13. I would also suggest a similar deployment of the excellent term "hidden witness," taken from the name of the exhibition of Jackie Napolean Wilson's collection of photographs of African Americans in the mid-nineteenth century, held at the J. Paul Getty Museum, February 18–June 18, 1995. See Naef and Wilson, *Hidden Witness: African Americans in Early Photography.*

38. Willis, *Picturing Us,* 25.

39. Indira Karemcheti first pointed out to me the almost worldwide extent of this

photographic practice, whose toxic historical and political meanings ought, in many cases, to be reconstructed and attended to. For a good number of Latin American examples, see Levine, *Images of History.*

40. Willis, *Picturing Us,* 25. See also Abel, "Domestic Borders, Cultural Boundaries"; and Liss, "Bodies in Evidence."

41. "An old-time Charleston 'Mommer' and her charge" appears as an example of clothing in the 1890s in Severa, *Dressed for the Photographer,* 536.

42. Stoler, *Race and the Education of Desire,* 145. A particularly concise expression of the racialized misogyny of this formulation came from the Portuguese Franciscans in Goa, who during the colonial period agitated against admission of creoles to their religious order, giving the following reason: "even if born of pure white parents [they] have been suckled by Indian ayahs in their infancy and thus had their blood contaminated for life." Charles R. Boxer, *The Portuguese Seaborne Empire, 1415–1825,* 253, quoted in B. Anderson, *Imagined Communities,* 60.

43. J. D. Anderson, *Education of Blacks in the South,* 55.

44. Booker T. Washington, "Address before the Faculty and Members of the Theological Department of Vanderbilt University and Ministers of Nashville," March 29, 1907, quoted in ibid.

45. Gilmore, *Gender and Jim Crow,* 153, 138.

46. Severa, *Dressed for the Photographer,* 281.

47. Ibid., 218.

48. Ibid., 509.

49. For a provocative account of the complex social significations of the banjo player figure, see Lott, *Love and Theft.*

50. Valentine, *Ole Marster,* 60–63.

51. Mary Newton Stanard, "Foreword," in Valentine, *Ole Marster,* 9.

52. Ibid.

53. Ibid., 10–11.

54. Clinton, *Plantation Mistress,* 201.

55. Ibid., 201–2.

56. Edward A. Pollard, *The Lost Cause,* quoted in Fredrickson, *Black Image in the White Mind,* 187.

57. Gunning, *Race, Rape, and Lynching,* 21.

58. I am using the term "puncture" here in accordance with Roland Barthes's account of the "punctum" in *Camera Lucida.* I differ from Barthes, however, in that the puncture he seeks is a purely private sensation, whereas my notion of the punctum includes as well the registration of ideological rupture, like puncturing a balloon that has kept one from seeing where one really is. For a helpful way to extend the Barthean dichotomy of "studium" and "punctum" in this direction, see S. Hall, "The Rediscovery of 'Ideology.'"

59. Harriet Beecher Stowe, *Household Papers and Stories* (Boston: Houghton Mifflin, 1896), quoted in Wardley, "Relic, Fetish, Femmage," 216.

60. G. Brown, *Domestic Individualism,* 60.

61. Clinton, *Plantation Mistress,* 202.

62. Gabrielle Foreman first pointed out to me the possible link between a nursemaid, nursing, and the invisible presence of a child of her own.

63. Carby, *Reconstructing Womanhood*, 31.

64. Valentine, "Mammy's Charge," in *Ole Marster*, 56–57.

65. This citation is based on the October 1992 version of a paper entitled "'All the Things You Could Be Right Now if Sigmund Freud's Wife Was Your Mother': Psycho-analysis and Race," presented by Hortense Spillers at the conference "Psychoanalysis in African American Contexts: Feminist Reconfigurations," held at the University of California, Santa Cruz. In the significantly revised version of Spillers's paper published in 1997 in Abel, Christian, and Moglen, *Female Subjects in Black and White*, some of these words have disappeared.

66. Alan Trachtenberg published several of these photographs in *Reading American Photographs*, 55, along with an extensive discussion. They are also published in Banta and Hinsley, *From Site to Sight*, 56; Goldberg, *Power of Photography*, 64–65; and Moutoussamy-Ashe, *Viewfinders*, 5. In response to the "Hidden Witness" exhibition at the J. Paul Getty Museum in 1995, Carrie Mae Weems made an installation titled "From Here I Saw What Happened and I Cried," which powerfully reframes them. See Larsen, "Between Worlds." I thank Cheryl Finley for bringing this to my attention.

67. See Mullen, "Gender and the Subjugated Body," 223.

68. Ibid., 227.

69. This reading of resistance accords with Barbara Christian's assertion that the mammy figure in slave narratives, "unlike the white southern image of mammy," is "cunning, prone to poisoning her master, and not at all content with her lot." Christian, *Black Feminist Criticism*, 5. See also T. Harris, *From Mammies to Militants,* and Patricia Hill Collins, "Mammies, Patriarchs, and Other Controlling Images," in *Black Feminist Thought*, 4–90. But I want to add a cautionary note to the idea that resistance to the master discourse may be legible in the body language and discursive signs of the photograph. As both Carla Kaplan and Franny Nudelman have recently argued, the assignation by a would-be "emancipatory reader" of a language of resistance to indi-viduals who are placed in situations of domination and oppression is a complex wish, and such an assignation, when it is merely projection, may be a subtle form of "other-ing." See C. Kaplan, "Narrative Contracts and Emancipatory Readers," and Nudelman, "Harriet Jacobs and the Sentimental Politics of Female Suffering." Yet, to refuse to read such a language is also to objectify.

70. Yetman, *Voices from Slavery,* introduction to "A Photo Essay of Former Slaves," following p. 338.

71. Mulvey, "Visual Pleasure and Narrative Cinema," 33.

72. Gaines, "White Privilege and Looking Relations," 198.

73. Mulvey, "Visual Pleasure and Narrative Cinema," 33.

74. Spillers, "Papa's Baby, Momma's Maybe."

75. Chesnut, *Mary Chesnut's Civil War*, 29–30.

76. Thomas, *Secret Eye*, 128–29.

77. Nell Irvin Painter, "Introduction," to Thomas, *Secret Eye*, 59.

78. Thomas, *Secret Eye*, 128.

79. Ibid., 57.

80. Nell Irvin Painter, "Introduction," to Thomas, *Secret Eye*, 59.

81. Caroline Gilman, *Recollections of a Southern Matron*, 256.

82. Carby, *Reconstructing Womanhood*, 31.

1. Douglas, *Feminization of American Culture,* 6–7, 11, 10, 13, 12, 13, 5, 12, 11, 256, 13.

2. Ibid., 7, 13; Tompkins, *Sensational Designs,* 123.

3. Tompkins, *Sensational Designs,* 12, 126.

4. Ibid., 122, xiv, xvi, xvii, xviii, xiii, xvi.

5. Douglas, *Feminization of American Culture,* 11.

6. Tompkins, *Sensational Designs,* xiv, 187.

7. Ibid., 217 n. 3.

8. Ibid., 200; Douglas, *Feminization of American Culture,* 12.

9. Tompkins, *Sensational Designs,* xiv, 200; Douglas, *Feminization of American Culture,* 9.

10. Douglas, *Feminization of American Culture,* 9.

11. Tompkins, *Sensational Designs,* xi, 123, and passim.

12. Douglas, *Feminization of American Culture,* 61.

13. Ibid., 3, 4, 5.

14. Tompkins, *Sensational Designs,* 122.

15. Spacks, *Gossip,* 5.

16. Baym, *Woman's Fiction,* 25.

17. Douglas, *Feminization of American Culture,* 12, 11.

18. Baym, *Woman's Fiction,* 27.

19. Sterling, *We Are Your Sisters,* xiii.

20. Frederick Douglass, *Narrative of the Life of Frederick Douglass, An American Slave* (1845; Cambridge: Harvard University Press, 1980), 66.

21. Brodhead, "Sparing the Rod," 70, 90–91, 76–77.

22. Fisher, *Hard Facts,* 92, 99, 98, 100, 98.

23. Quoted in Banta and Hinsley, *From Site to Site,* 18.

24. Stange, *Symbols of Ideal Life,* 13, 16, 4.

25. Engs, *Freedom's First Generation,* 147. William Roscoe Davis is also reported to have said, "If Negroes don't get any better education than Armstrong is giving them . . . they may as well have stayed in slavery!" Quoted in Engs, 147.

26. Engs, "Red, Black, and White," 243.

27. Kirstein, *Hampton Album,* 7; Engs, "Red, Black, and White," 244, 259.

28. Engs, *Freedom's First Generation,* 149–50.

29. Ibid., 151, 144, 151.

30. Ibid., 144, 149.

31. Samuel Chapman Armstrong, *Catalogue of the Hampton Normal and Agricultural Institute, Hampton, Virginia, 1870–71* (Hampton, Va., 1870), 19–20, quoted in Engs, *Freedom's First Generation,* 143.

32. Warner, *From the Beast to the Blonde,* xx.

33. Dexter Fisher, "Foreword" to Zitkala-Sa, *American Indian Stories,* x.

34. Quoted in Banta and Hinsley, *From Site to Site,* 105.

35. Douglas, *Feminization of American Culture,* 10.

36. Lydia Maria Child, *The Mother's Book* (Boston, 1831), 86; quoted in Douglas, *Feminization of American Culture,* 62.

37. *Catalogue of the Indian Industrial School* (Jamestown, N.Y., 1920), 4; quoted in Malmsheimer, "Imitation White Man," 69.

38. Malmsheimer, "Imitation White Man," 69–70.

39. Dexter Fisher, "Foreword" to Zitkala-Sa, *American Indian Stories,* v. Fisher's excellent work in rediscovering, republishing, and contextualizing the life and writing of Zitkala-Sa has been crucial to my own formulation.

40. "Our Indian School," in *(Carlisle, Pa.) Valley Sentinel*, September 19, 1879; quoted in Malmsheimer, "Imitation White Man," 56–57.

41. Malmsheimer, "Imitation White Man," 64.

42. Zitkala-Sa, *American Indian Stories,* 41, 42, 7, 9.

43. Ibid., 39, 27, 34–35, 13.

44. Ibid., 43, 44.

45. Ibid., 44–45.

46. Ibid., 47–48, 49–50, 50–51.

47. Ibid., 52, 67–68.

48. Ibid., 42.

49. Dexter Fisher, "Foreword" to Zitkala-Sa, *American Indian Stories,* vii.

50. Ibid., vii.

51. Zitkala-Sa, *American Indian Stories,* 96–99.

52. Tompkins, *Sensational Designs,* 122; Douglas, *Feminization of American Culture,* 3.

53. Armstrong, *Desire and Domestic Fiction,* 27.

54. Steedman, *Landscape for a Good Woman,* 1–2.

55. Armstrong, *Desire and Domestic Fiction,* 255.

56. Kelley, *Private Woman, Public Stage.*

CHAPTER FOUR

1. The lynching statistics are taken from Ware, *Beyond the Pale,* 171. For further discussion of their meaning, see also Wells, *A Red Record.*

2. Zwick, *Anti-Imperialism in the United States,* n.p.

3. Ibid.

4. Gatewood, *"Smoked Yankees" and the Struggle for Empire,* 15.

5. Ibid., 237.

6. Quoted in ibid., 13.

7. Ibid., 237.

8. J. D. Anderson, "Education for Servitude," 274.

9. Tileston T. Bryce, *Economic Crumbs, or Plain Talks for the People about Labor, Capital, Money, Tariff, etc.* (Hampton, Va.: Normal School Press, 1879), as quoted in J. D. Anderson, *Education of Blacks in the South,* 50.

10. Hollis Burke Frissell, untitled article, *Southern Workman* 14 (June 1885): 85, as quoted in J. D. Anderson, *Education of Blacks in the South,* 57–58.

11. Engs, "Red, Black, and White," 243.

12. Washington, *Up From Slavery,* 37, 39.

13. Kirstein, *Hampton Album,* 7.

14. Daniel and Smock, *A Talent for Detail*, 87–127. Allan Sekula's essay "School Is a Factory," in *Photography Against the Grain*, 226–34, offers a particularly illuminating discussion of the educational politics of school photographs, including Johnston's.

15. Daniel and Smock, *A Talent for Detail*, 86–93.

16. Evans made his famous photographs of three Southern sharecropper families in a period of six weeks in 1936 while on leave from his post at the Farm Security Administration.

17. Kirstein, *Hampton Album*, 5.

18. Daniel and Smock, *A Talent for Detail*, 96.

19. Ibid.

20. This phrase is the title of Robert Sobieszek and Odette Appell's study of the nineteenth-century daguerreotypes of Southworth and Hawes, *The Spirit of Fact: The Daguerreotypes of Southworth and Hawes, 1843–1862*.

21. Anonymous, quoted in Daniel and Smock, *A Talent for Detail*, 96.

22. Trachtenberg, "Albums of War," 2–3.

23. Kirstein, *Hampton Album*, 55.

24. Editorial, *The Southern Workman and Hampton School Record*, January 1900, quoted in Daniel and Smock, *A Talent for Detail*, 96. Also see the brilliant discussion of the Du Bois exhibition in S. M. Smith, *American Archives*.

25. Kirstein, *Hampton Album*, 5.

26. Ibid. For an informative discussion of the possible motivations of the Museum of Modern Art selection, see Davidov, *Women's Camera Work*, 157–83.

27. Kirstein, *Hampton Album*, 11.

28. See Daniel and Smock, *A Talent for Detail*, 87–93.

29. Goffman, *Asylums*, 5.

30. Washington, *Up From Slavery*, 45.

31. Ibid., 46.

32. Engs, *Freedom's First Generation*, 143.

33. Kirstein, *Hampton Album*, 11.

34. Washington, *Up From Slavery*, 47–48.

35. Ibid., 51.

36. See Hurston, *Their Eyes Were Watching God* and *Mules and Men*.

37. Sergeant Major John Galloway, quoted in Gatewood, *"Smoked Yankees" and the Struggle for Empire*, 252.

38. Hampton Alumni Association, as quoted in J. D. Anderson, *Education of Blacks in the South*, 62.

39. West, *1900*, 162, 163.

40. Ibid., 173.

41. Washington, *Up From Slavery*, 67.

42. For a discussion of the "seamless" affect of patriarchal discourse, see Furman, "The Politics of Language: Beyond the Gender Principle?"

43. Frances Benjamin Johnston, as quoted in Daniel and Smock, *A Talent for Detail*, 34.

44. See Hill, *The World Their Household*; and Blair, *The Clubwoman as Feminist*.

45. Hansen, "Frances Benjamin Johnston," 382.

46. Anonymous review, "Whittier's Moral Power," reprinted in Kribbs, *Critical Essays on John Greenleaf Whittier*, n.p.

47. Ibid.

48. Whittier, "The Slave-Ships," reprinted in *Anti-Slavery Poems*, 21.

49. Whittier, "The Christian Slave," reprinted in *Anti-Slavery Poems*, 87.

50. Whittier, "Massachusetts to Virginia," reprinted in *Anti-Slavery Poems*, 80–81.

51. Whittier, "The Sentence of John L. Brown," reprinted in *Anti-Slavery Poems*, 93–94.

52. Robert Penn Warren, "Whittier," in Kribbs, *Critical Essays on John Greenleaf Whittier*, 122, 128.

53. Whittier, "In School Days," reprinted in *Poems of Nature*, 162–64.

54. Carby, "Articulating Race and Gender," 22.

55. Daniel and Smock, *A Talent for Detail*, 145.

56. Kirstein, *Hampton Album*, 11.

57. Ibid.

58. Ibid.

59. Engs, "Red, Black, and White," 242.

60. For a discussion of the kinds of power that may accrue to women "in flaunting femininity," see Doane, "Film and the Masquerade," 49.

61. Judith Fryer Davidov has persuasively and importantly enlarged my earlier reading of "Class in American History" by identifying the figure of the Native American in that photograph as John Wizi. If true, it offers an additional reason for Quinney's discomfort, since she and her male classmate had evidently been paired by the photographer in a charade of coupling that implicates her also in this scene. See Wexler, "Black and White and Color"; and Davidov, *Women's Camera Work*, 170–73.

CHAPTER FIVE

1. Pratt, *Imperial Eyes*.

2. Ibid., 7.

3. See Carby, "Articulating Race and Gender."

4. Pratt, *Imperial Eyes*, 105.

5. Jules Janin, quoted in Rudisill, *Mirror Image*, 41.

6. Albert Southworth, quoted in Rudisill, *Mirror Image*, 176. See also Sobieszek and Appell, *Spirit of Fact*.

7. Samuel F. B. Morse, quoted in Sobieszek and Appell, *Spirit of Fact*, ix.

8. Pratt, *Imperial Eyes*, 105.

9. B. Michaels, *Gertrude Käsebier*, 70. Additional sources include Beasley, "Another View Regarding 'Chance' Photographs"; Bunnell, "Gertrude Käsebier"; Caffin, "Photography as a Fine Art"; Cram, "Mrs. Käsebier's Work"; Hartmann, "Gertrude Käsebier"; Hervey, "Gertrude Käsebier—Photographer"; Homer, *Pictorial Heritage;* Johnston, "Foremost Women Photographers of America"; Keiley, "Gertrude Käsebier"; Keller, *After the Manner of Women;* O'Mara, "Gertrude Käsebier"; Palmquist, *Camera Fiends and Kodak Girls;* Quitslund, "Her Feminine Colleagues"; Slater, "Profitable In-

dustries for Women"; Tighe, "Gertrude Käsebier Lost and Found"; and Tucker, *The Woman's Eye*.

10. Allan Sekula, "The Body and the Archive," in Bolton, *Contest of Meaning*, 345, 347 (italics in original).

11. B. Michaels, *Gertrude Käsebier*, 70.

12. Owens, "Posing," 206.

13. B. Michaels, *Gertrude Käsebier*, 82.

14. Kristeva, "Motherhood According to Bellini," 246.

15. Rubin, "Traffic in Women."

16. Giles Edgerton, "Photography as an Emotional Art," in Palmquist, *Camera Fiends and Kodak Girls*, 179–80.

17. Joseph Keiley, quoted in B. Michaels, *Gertrude Käsebier*, 92.

18. Marshall, "The Indian Portraits," 31–32.

19. B. Michaels, *Gertrude Käsebier*, 29.

20. Gertrude Käsebier's mother is quoted in Joseph T. Keiley, "Gertrude Käsebier," in Palmquist, *Camera Fiends and Kodak Girls*, 163–64.

21. B. Michaels, *Gertrude Käsebier*, 30.

22. I derive support for this conclusion from my own reading of "Some Indian Portraits," published in *Everybody's Magazine* 4, no. 17 (January 1901), as well as from Marshall, "The Indian Portraits." Marshall notes that unpublished manuscript notes by Käsebier and by her granddaughter Mina Turner also support this judgment. Marshall, "The Indian Portraits," 37 n. 39.

23. "Some Indian Portraits," *Everybody's Magazine*, 3.

24. Ibid., 4–5.

25. Ibid., 7–12.

26. Besides Laura Mulvey's influential formulation of the relationship between "the male gaze" and visual pleasure, see E. Ann Kaplan, "Is the gaze male?" in *Women and Film;* and John Berger, *Ways of Seeing*. For important considerations of female spectatorship, see Mary Ann Doane, "Film and the Masquerade: Theorizing the Female Spectator" and "Masquerade Reconsidered: Further Thoughts on the Female Spectator." Also see Linda Williams, "When the Woman Looks." For feminist visual theory on the gaze returned, see Lucy Lippard, *Partial Recall;* and bell hooks, *Black Looks*.

27. Owens, "Posing," 210, 215 (italics in original).

28. B. Michaels, *Gertrude Käsebier*, 32.

29. Ibid., 33.

30. Roland Barthes, as quoted in Gerald Vizenor, "Socioacupuncture: Mythic Reversals and the Striptease in Four Scenes," in Martin, *American Indian and the Problem of History*, 180–81.

31. Vizenor, "Socioacupuncture," 181.

32. "Some Indian Portraits," 12.

33. Ibid.

34. Ibid., 24.

35. Ibid.

36. W. B. Michaels, *Our America*.

37. Pratt, *Imperial Eyes*, 6.

38. Ibid., 7.

1. Zaida Ben-Yusuf, quoted in Quitslund, *Women Artists,* 115.
2. Frances Stebbins Allen and Mary Electra Allen, quoted in ibid., 112.
3. Frances Benjamin Johnston, quoted in ibid., 114.
4. Sarah Jane Eddy, quoted in ibid., 118.
5. Margaret Bisland, "Women and Their Cameras," quoted in ibid., 100.
6. The chief source of biographical information about Alice Austen is Ann Novotny's *Alice's World: The Life and Photography of an American Original: Alice Austen, 1866–1952,* the only monograph on Austen's life and work. Additional sources include Gover, *Positive Image;* Grubler, *Alice Austen;* Hales, *Silver Cities;* D. Kaplan, *Fine Day;* and Moeller, *Nineteenth-Century Women Photographers.*
7. Hales, *Silver Cities,* 261–62.
8. Austen, *Street Types of New York.* I am much influenced in my reading of Austen's *Street Types* by the work of art historian Timothy J. Clark on the social spaces of Impressionist street painting, esp. *The Painting of Modern Life: Paris in the Art of Manet and His Followers.*
9. Hales, *Silver Cities,* 239.
10. See the important discussion of the Riis and Veiller photographs in Stange, *Symbols of Ideal Life,* 1–46.
11. Yezierska, *Bread Givers,* 21–23.
12. Novotny, *Alice's World,* 162.
13. Capa, *International Center of Photography Encyclopedia,* 26–27.
14. D. Kaplan, *Fine Day,* n.p.
15. Saltz, "Disappearing Women," 163–64.
16. D. Kaplan, *Fine Day,* n.p.
17. Alice Austen, quoted in Novotny, *Alice's World,* 73.
18. Ibid., 74.
19. Ibid.
20. Ibid.
21. Jameson, "Modernism and Imperialism," 50.
22. D. Kaplan, *Fine Day,* n.p.
23. Jameson, "Modernism and Imperialism," 51.
24. Ibid.
25. Novotny, *Alice's World,* 23.
26. Ibid., 68.
27. Alice Austen to Oliver Jensen, 1951, as paraphrased in Novotny, *Alice's World,* 60.
28. Ibid., 46, 60, 114, 163.
29. D. Kaplan, *Fine Day,* n.p.
30. See Weinberg, "'Boy Crazy.'"
31. Novotny, *Alice's World,* 26.
32. Pratt, *Imperial Eyes,* 7.
33. James, *The American Scene,* 118–19, 121. For a provocative discussion of the "ethnic semiosis" of this incident, see Boelhower, *Through a Glass Darkly,* 21.
34. Novotny, *Alice's World,* 75.
35. Novotny, *Alice's World,* 89.

36. Montgomery, *Fall of the House of Labor,* 70.

37. Ibid., 70–71.

38. Ibid., 71.

39. Novotny, *Alice's World,* 61.

40. Jameson, *Political Unconscious,* 102.

41. Novotny, *Alice's World,* 182.

42. Oliver Jensen, in Novotny, *Alice's World,* 11.

43. Ibid.

44. Ibid.

45. I am grateful to Lynn Wardley for pointing out to me this spectacular double entendre.

CHAPTER SEVEN

1. Alland, *Beals,* 22. Other published sources of information on Beals include Cutler, *Song of the Molimo;* and Museum of the City of New York, *"Beals' Bohemians."*

2. B. Michaels, *Gertrude Käsebier,* 14–15.

3. Rydell, *All the World's a Fair,* 152 (quotes); and Daniel and Smock, *A Talent for Detail,* 69 ("Buffalo Pose").

4. Rydell, *All the World's a Fair,* 152.

5. Ibid.

6. Cashman, *America in the Gilded Age,* 380.

7. Daniel and Smock, *A Talent for Detail,* 69.

8. Mrs. Jefferson Davis is quoted in W. B. Michaels, "Anti-Imperial Americanism," in Kaplan and Pease, *Cultures of U.S. Imperialism,* 387 n. 1.

9. Rydell, *All the World's a Fair,* 161.

10. W. J. McGee, "Trend of Human Progress," quoted in Rydell, *All the World's a Fair,* 161.

11. W. J. McGee, "National Growth and National Character," quoted in Robert Rydell, *All the World's a Fair,* 161.

12. W. J. McGee, quoted in Robert Rydell, *All the World's a Fair,* 167.

13. Alland, *Beals,* 26.

14. Ibid., 40.

15. Ibid., 40–41.

16. Ibid., 32.

17. Quoted in D. Green, "Veins of Resemblance," 14.

18. Bradford and Blume, *Ota Benga.*

19. Alland, *Beals,* 43.

20. Ibid.

21. Ibid.

22. Ibid.

23. Ibid., 43, 45.

24. Ibid., 45.

25. Rydell, *All the World's a Fair,* 157.

26. Ibid., 160.

27. Ibid., 161.

28. Ibid., 167.

29. Ibid.

30. Camera Club of Hartford, Conn., April 1906, quoted in Alland, *Beals,* 62.

31. Ibid., 52.

32. *Philadelphia Public Ledger,* January 26, 1921, quoted in Alland, *Beals,* 48.

33. Ibid.

34. Ibid.

35. Grindstaff, "Exhibiting the Philippines," 22–24.

36. Gatewood, *"Smoked Yankees" and the Struggle for Empire,* 255.

37. Spence, "The Sign as a Site of Class Struggle" 176.

38. Alland, *Beals,* 65.

39. Ibid., 69–71.

40. Ibid., 76.

41. Bigelow, *Seventy Summers,* 1:vii.

42. Ibid., 71.

43. Ibid. It is important to note that letters from Nanette to Alland held by the Museum of the City of New York contest his claim that her mother had an affair with Bigelow and vigorously assert that Alfred Beals is her biological father.

44. Jessie Tarbox Beals, quoted in Alland, *Beals,* 71.

45. Jessie Tarbox Beals, "The Woman," in *Songs of a Wanderer,* 61.

46. Theodore Roosevelt, quoted in Ehrenreich and English, *For Her Own Good,* 190. On turn-of-the-century eugenic thought, see Kevles, *In the Name of Eugenics.*

EPILOGUE

1. Nancy B. McGhee, "Portraits in Black: Illustrated Poems of Paul Laurence Dunbar," in Schall, *Stony the Road,* 74.

2. See ibid., 78–102.

3. Robert Charles Bedford to Booker T. Washington, December 3, 1902, in Harlan and Smock, *Washington Papers,* 602. The fullest extant historical record of the Ramer school shooting is in a series of letters written between November 28 and December 8, 1902, to Booker T. Washington by George Washington Carver, Robert Charles Bedford, Emmett Jay Scott, and Nelson Edward Henry, and to Emmett Jay Scott from Booker T. Washington. I have drawn chiefly on these letters for my understanding of the event, but I have used as well the account offered by Peter Daniel and Raymond Smock, in *A Talent for Detail,* which differs on a few small points.

4. This incident is reported with care and attention by Pete Daniel and Raymond Smock in *A Talent for Detail,* 115–17 (quote on 116), and by James Guimond in *American Photography and the American Dream,* 48. However, I have been unable to find an account that considers its pertinence to the general conditions of race and gender that governed white women's possibilities for success in photography at the turn of the century. Avoidance of the trenchant significance of this episode because, as Guimond

points out, "it was not difficult for Washington to ignore the events at Ramer, since they did not end tragically" (48) is a clear sign of the continuing power of the averted gaze in written histories of women photographers and American visual culture.

5. Robert Charles Bedford to Booker T. Washington, December 3, 1902, in Harlan and Smock, *Washington Papers,* 603.

6. George Washington Carver to Booker T. Washington, November 28, 1902, in ibid., 595–96.

7. Daniel and Smock, *A Talent for Detail,* 117.

8. Nelson Edward Henry to Booker T. Washington, December 4, 1902, in Harlan and Smock, *Washington Papers,* 605–6.

9. George Washington Carver to Booker T. Washington, November 28, 1902, in ibid., 595.

10. Daniel and Smock, *A Talent for Detail,* 116.

11. Ibid., 117.

12. Booker T. Washington to Emmett Jay Scott, December 4, 1902, in Harlan and Smock, *Washington Papers,* 604.

13. Robert Charles Bedford to Booker T. Washington, December 3, 1902, in ibid., 602.

14. Ibid., 602, 603; and Robert Charles Bedford to Booker T. Washington, December 8, 1902, in ibid., 608.

15. Robert Charles Bedford to Booker T. Washington, December 3, 1902, in ibid., 602, 603.

16. Booker T. Washington, "Address before The Women's New England Club," January 29, 1899, Boston, quoted in J. D. Anderson, "Education for Servitude," 169.

17. Ibid.

18. Ibid., 168.

19. Ibid., 169.

20. Ibid., 175.

21. George Washington Carver to Booker T. Washington, November 28, 1902, in Harlan and Smock, *Washington Papers,* 596.

22. Washington, "The Successful Training of the Negro."

23. Daniel and Smock, *A Talent for Detail,* 117.

24. Washington, "Successful Training of the Negro," 20.

25. Wells, *Crusade for Justice.*

26. Gilmore, *Gender and Jim Crow,* 4.

27. Davidov, *Women's Camera Work,* 176.

28. Root, *The Camera and the Pencil,* 26–27.

29. Holmes, "Doings of the Sunbeam," 8. For a fascinating discussion of the social history of cartes de visite in the post–Civil War era, see Volpe, *Cheap Pictures.*

30. Barthes, *Image, Music, Text,* 28.

31. Benjamin, "Theses on the Philosophy of History," 255.

32. Cadava, *Words of Light,* 64.

33. Holland, Spence, and Watney, *Photography/Politics: Two,* 7.

Bibliography

MANUSCRIPT AND PHOTOGRAPH ARCHIVES

Cambridge, Mass.
 Harvard University
 Arthur and Elizabeth Schlesinger Library on the History of Women
 in America, Radcliffe Institute
 Jessie Tarbox Beals Collection
 Bureau of Vocational Information Collection
 Loeb Design Library
 Jessie Tarbox Beals Collection
New Haven, Conn.
 Yale University
 Collection of American Literature, Beinecke Rare Book and Manuscript
 Library
 Käsebier-Stieglitz correspondence
New York, N.Y.
 Metropolitan Museum of Art
 Gertrude Käsebier photographs
 Museum of the City of New York
 Jessie Tarbox Beals Collection
 Museum of Modern Art
 Frances Benjamin Johnston photographs
 New York Historical Society
 Jessie Tarbox Beals Collection
Richmond, Va.
 The Valentine Museum
 The Cook Collection
Staten Island, N.Y.
 Staten Island Historical Society
 E. Alice Austen papers
Washington, D.C.
 Library of Congress
 Manuscript Division
 Papers of Frances Benjamin Johnston
 Papers of Booker T. Washington
 Prints and Photographs Division
 Alice Austen photographs
 Jessie Tarbox Beals photographs
 Gerhard Sisters photographs
 Frances Benjamin Johnston photographs

Abel, Elizabeth. "Domestic Borders, Cultural Boundaries: Black Feminists Re-view the Family." In *The Familial Gaze,* edited by Marianne Hirsch. Hanover, N.H.: University Press of New England, 1999.

Abel, Elizabeth, Barbara Christian, and Helene Moglen, eds. *Female Subjects in Black and White: Race, Psychoanalysis, Feminism.* Berkeley: University of California Press, 1997.

Alland, Alexander, Sr. *Jessie Tarbox Beals: First Woman News Photographer.* New York: Camera/Graphic Press, 1978.

Althusser, Louis. *Lenin and Philosophy and Other Essays.* London: New Left, 1974.

Anderson, Benedict. *Imagined Communities: Reflections on the Origins and Spread of Nationalism.* New York: Verso, 1983.

Anderson, James D. "Education for Servitude: The Social Purposes of Schooling in the Black South, 1870–1930." Ph.D. diss., University of Illinois, Urbana-Champaign, 1973. Ann Arbor, Mich.: University Microfilm.

———. *The Education of Blacks in the South, 1860–1988.* Chapel Hill: University of North Carolina Press, 1988.

Anonymous. *Everyday Life at Hampton Institute.* Hampton, Va.: Hampton Institute, 1907.

Armstrong, Nancy. *Desire and Domestic Fiction: A Political History of the Novel.* New York: Oxford University Press, 1987.

Aumont, Jacques. *The Image.* Translated by Claire Pajackowska. London: British Film Institute, 1997.

Austen, Alice. *Street Types of New York.* New York: The Albertype Company, 1896; reprint, Staten Island, N.Y.: Friends of Alice Austen House, 1994.

Ayers, Edward L. *The Promise of the New South: Life After Reconstruction.* New York: Oxford University Press, 1992.

Badger, R. Reid. *The Great American Fair: The World's Columbian Exposition and American Culture.* Chicago: Nelson Hall, 1919.

Bal, Mieke. *Double Exposure: The Subject of Cultural Analysis.* New York: Routledge, 1996.

Balibar, Etienne, and Immanuel Wallerstein. *Race, Nation, Class: Ambiguous Identities.* London: Verso, 1992.

Banta, Martha. *Imaging American Women: Idea and Ideals in Cultural History.* New York: Columbia University Press, 1987.

Banta, Melissa, and Curtis M. Hinsley, eds. *From Site to Site: Anthropology, Photography, and the Power of Imagery.* Cambridge: Harvard University Press, 1986.

Barthes, Roland. *Camera Lucida: Reflections on Photography.* Translated by Richard Howard. New York: Hill and Wang, 1981.

———. *Image, Music, Text.* Translated by Stephen Heath. New York: Hill and Wang, 1977.

———. "The Great Family of Man," In *Mythologies,* 100–102. Translated by Annette Lavers. New York: Hill and Wang.

———. "Myth Today." In *Mythologies,* 109–59. Translated by Annette Lavers. New York: Hill and Wang, 1957.

Baym, Nina. *Women's Fiction: A Guide to Novels by and about Women in America, 1820–1870*. Ithaca, N.Y.: Cornell University Press, 1978.

Beals, Jessie Tarbox. *Songs of a Wanderer*. New York: August Gauthier, 1928.

Beasley, H. A. "Another View Regarding 'Chance' Photographs." *The Photographic Times* 32, no. 5 (May 1900): 193–94.

Bederman, Gail. *Manliness and Civilization: A Cultural History of Gender and Race in the United States, 1880–1917*. Chicago: University of Chicago Press, 1995.

Benjamin, Walter. "The Author as Producer." In *Reflections: Essays, Aphorisms, Autobiographical Writings*, edited by Peter Demetz. New York: Harcourt Brace Jovanovich, 1979.

———. "A Short History of Photography." In *Classic Essays on Photography*, edited by Alan Trachtenberg. New Haven, Conn.: Leete's Island Books, 1980.

———. "Theses on the Philosophy of History." In *Illuminations*, edited by H. Arendt. New York: Schocken, 1973.

———. "The Work of Art in the Age of Mechanical Reproduction." In *Illuminations*, edited by Hannah Arendt. New York: Schocken, 1973.

Berger, John. *About Looking*. New York: Pantheon, 1980.

———. *Ways of Seeing*. New York: Penguin, 1972.

Berger, John, and Jean Mohr. *Another Way of Telling*. New York: Pantheon, 1982.

Berlant, Lauren. *The Queen of America Goes to Washington City*. Durham, N.C.: Duke University Press, 1997.

Bigelow, Poultney. *Seventy Summers*. 2 vols. London: Edward Arnold & Co., 1925.

Blair, Karen J. *The Clubwoman as Feminist: True Womanhood Redefined, 1868–1914*. New York: Holmes and Meier, 1980.

Blauner, Robert. *Racial Oppression in America*. New York: Harper and Row, 1972.

Boelhower, William. *Through a Glass Darkly: Ethnic Semiosis in American Literature*. New York: Oxford University Press, 1987.

Boisseau, T. J. "They Called Me BeBe Bwana: A Critical Cultural Study of an Imperial Feminist." *Signs* 21, no. 1 (1995): 116–46.

Bolton, Richard, ed. *The Contest of Meaning: Critical Histories of Photography*. Cambridge: MIT Press, 1989.

Bonnin, Gertrude. *American Indian Stories*. Lincoln: University of Nebraska Press, 1979.

Bradford, Phillips Verner, and Harvey Blume. *Ota Benga: The Pygmy in the Zoo*. New York: Dell, 1992.

Breibart, Eric. *A World on Display: Photography from the St. Louis World's Fair, 1904*. Albuquerque: University of New Mexico Press, 1997.

Brodhead, Richard. "Sparing the Rod: Discipline and Fiction in Antebellum America." *Representations* 21 (Winter 1988): 67–96.

Brown, Gillian. *Domestic Individualism: Imaging Self in Nineteenth-Century America*. Berkeley: University of California Press, 1990.

Brown, Julie. *Contesting Images: Photography and the World's Columbian Exposition*. Tucson: University of Arizona Press, 1994.

Bryson, Scott, Barbara Kruger, Lynne Tillman, and Jane Weinstock, eds. *Beyond Recognition: Representation, Power, and Culture*. Berkeley: University of California Press, 1992.

Bulkin, Elly, Minnie Bruce Pratt, and Barbara Smith, eds. *Yours in Struggle: Three Feminist Perspectives on Anti-Semitism and Racism.* Ithaca, N.Y.: Firebrand, 1988.

Bulosan, Carlos. *America Is in the Heart: A Personal History.* Seattle: University of Washington Press, 1943.

Bunnell, Peter C. "Gertrude Käsebier." *Arts in Virginia* 16, no. 1 (Fall 1975): 2–15, 40.

———. "Gertrude Stanton Käsebier." In *Notable American Women, 1607–1950: A Biographical Dictionary,* edited by Edward James, Janet James, and Paul Boyer, 2:308–9. Cambridge: Harvard University Press, 1971.

———. *The Universal Exposition of 1900.* New York: Arno, 1979.

Bush, Alfred L., and Lee Clark Mitchell. *The Photograph and the American Indian.* Princeton: Princeton University Press, 1994

Butler, Judith. "Endangered/Endangering: Schematic Racism and White Paranoia." In *Reading Rodney King/Reading Urban Uprising,* edited by R. Gooding-Williams. New York: Routledge, 1993.

———. *Gender Trouble: Feminism and the Subversion of Identity.* New York: Routledge, 1990.

Butler, Judith, and Joan Scott. *Feminists Theorize the Political.* New York: Routledge, 1992.

Cadava, Eduardo. *Words of Light: Theses on the Photography of History.* Princeton: Princeton University Press, 1997.

Caffin, Charles H. "Photography as a Fine Art: Mrs. Gertrude Käsebier and the Artistic-Commercial Portrait." *Everybody's Magazine* 4 (May 1901): 480–95.

Capa, Cornell, ed. *International Center of Photography Encyclopedia of Photography.* New York: Crown, 1984.

Carby, Hazel. "Articulating Race and Gender in a Theory of Social Formations." Unpublished paper, presented to the Women's Studies Faculty Seminar, Wesleyan University, February 1986.

———. *Race Men.* Cambridge: Harvard University Press, 1998.

———. *Reconstructing Womanhood: The Emergence of the Afro-American Woman Novelist.* New York: Oxford University Press, 1987.

Carlebach, Michael L. *American Photojournalism Comes of Age.* Washington, D.C.: Smithsonian Institution Press, 1997.

Cashman, Sean Dennis. *America in the Gilded Age: From the Death of Lincoln to the Rise of Theodore Roosevelt.* New York: New York University Press, 1993.

Chesnut, Mary Boykin Miller. *Mary Chesnut's Civil War.* Edited by C. Vann Woodward. New Haven, Conn.: Yale University Press, 1981.

Christian, Barbara. *Black Feminist Criticism: Perspectives on Black Women Writers.* New York: Pergamon, 1985.

Clark, Timothy J. *The Absolute Bourgeois: Artists and Politics in France, 1848–1851.* London: Thames and Hudson, 1973.

———. *Image of the People: Gustave Courbet and the Second French Republic, 1848–1851.* Greenwich, Conn.: New York Graphic Society, 1973.

———. *The Painting of Modern Life: Paris in the Art of Manet and His Followers.* New York: Knopf, 1985.

Clinton, Catherine. *The Plantation Mistress: Women's World in the Old South.* New York: Pantheon, 1982.

Coar, Valencia Hollins. *A Century of Black Photographers, 1840–1960*. Providence: Rhode Island School of Design, 1983.

Cohn, Jan. *Creating America: George Horance Lorimer and the Saturday Evening Post*. Pittsburgh: University of Pittsburgh Press, 1989.

Collier, John, Jr., and Malcolm Collier. *Visual Anthropology: Photography as a Research Method*. Albuquerque: University of New Mexico Press, 1986.

Collins, Patricia Hill. *Black Feminist Thought: Knowledge, Consciousness, and the Politics of Empowerment*. Boston: Unwin Hayman, 1990.

Cott, Nancy. *The Grounding of Modern Feminism*. New Haven: Yale University Press, 1987.

———. "What's in a Name?: The Limits of 'Social Feminism'; or Expanding the Vocabulary of Women's History." *Journal of American History* 76 (December 1989): 808–29.

Cowie, Elizabeth. "Woman as Sign." In *The Woman in Question*, edited by Parveen Adams and Elizabeth Cowie. Cambridge: MIT Press, 1990.

Cram, R. A. "Mrs. Käsebier's Work." *Photo Era* 4, no. 5 (May 1900): 131–36.

Crary, Jonathan. *Techniques of the Observer: On Vision and Modernity in the Nineteenth Century*. Cambridge: MIT Press, 1992.

Crichton, Judy. *America 1900: The Turning Point*. New York: Henry Holt, 1998.

Cutler, Jane. *The Song of the Molimo*. New York: Farrar Straus Giroux, 1998.

Daniel, Pete, and Raymond Smock. *A Talent for Detail: The Photographs of Miss Frances Benjamin Johnston*. New York: Harmony, 1974.

Davidov, Judith Fryer. *Women's Camera Work: Self/Body/Other in American Visual Culture*. Durham, N.C.: Duke University Press, 1998.

Davis, Angela. *Women, Culture, Politics*. New York: Vintage, 1990.

Dennett, Terry, and Jo Spence, eds. *Photography/Politics: One*. London: Photography Workshop, 1979.

Dickson, Arthur Jerome. *Covered Wagon Days: A Journey Across the Plains in the Sixties, and Pioneer Days in the Northwest; from the Private Journals of Albert Jerome Dickson*. Cleveland: Arthur H. Clark Co., 1929.

Dimock, Wai-chee. *Empire for Liberty: Melville and the Poetics of Individualism*. Princeton: Princeton University Press, 1989.

Doane, Mary Ann. "Film and the Masquerade: Theorizing the Female Spectator." *Screen* 23, no. 3–4 (September/October 1982): 74–88.

———. "Masquerade Reconsidered: Further Thoughts on the Female Spectator." *Discourse* 11, no. 1 (Fall-Winter 1988): 42–54.

Dolan, Jill. *The Feminist Spectator as Critic*. Ann Arbor, Mich.: UMI Research Press, 1988.

Dominguez, Virginia. *White by Definition: Social Classification in Creole Louisiana*. New Brunswick, N.J.: Rutgers University Press, 1986.

Douglas, Ann. *The Feminization of American Culture*. New York: Alfred A. Knopf, 1977.

Du Bois, W. E. B. *Black Reconstruction: An Essay toward a History of the Part Which Black Folk Played in the Attempt to Reconstruct Democracy in America, 1860–1880*. New York: Harcourt, Brace, 1935.

———. *The Souls of Black Folk*. New York: New American Library, 1969.

DuCille, Ann. *The Coupling Convention: Sex, Text, and Tradition in Black Women's Fiction*. New York: Oxford University Press, 1993.

———. *Skin Trade*. Cambridge: Harvard University Press, 1996.

Duster, Alfreda, ed. *Crusade for Justice: The Autobiography of Ida B. Wells*. Chicago: University of Chicago Press, 1970.

Dyer, Richard. *White*. London: Routledge, 1997.

Eagleton, Terry, Frederic Jameson, and Edward Said, eds. *Nationalism, Colonialism, and Literature*. Minneapolis: University of Minnesota Press, 1990.

Earle, Edward. "Halftone Effects: A Cultural Study of Photographs in Reproduction." *California Museum of Photography Bulletin* 8, no. 1 (1989): 1–24.

Edwards, Elizabeth, ed. *Anthropology and Photography, 1860–1920*. New Haven: Yale University Press, 1992.

Ehrenreich, Barbara, and Dierdre English. *For Her Own Good: 150 Years of the Experts' Advice to Women*. Garden City, N.Y.: Doubleday, 1978.

Ellison, Ralph. *Invisible Man*. New York: Random House, 1952.

Emery, Michael, and Edwin Emery. *The Press and America: An Interpretive History of the Mass Media*. 8th ed. Boston: Allyn and Bacon, 1996.

The Encyclopedia Americana. Edited by Frederick Converse Beach. New York: The Americana Company, 1903.

Engs, Robert Francis. *Freedom's First Generation: Black Hampton, Virginia, 1861–1890*. Philadelphia: University of Pennsylvania Press, 1979.

———. "Red, Black, and White: A Study in Intellectual Inequality." In *Region, Race, and Reconstruction: Essays in Honor of C. Vann Woodward*, edited by J. M. Kousser and J. M. McPherson. New York: Oxford University Press, 1982.

Faris, James C. *Navajo and Photography: A Critical History of the Representation of an American People*. Albuquerque: University of New Mexico Press, 1996.

Fetterly, Judith. *The Resisting Reader: A Feminist Approach to American Fiction*. Bloomington: Indiana University Press, 1978.

Fields, Barbara Jeanne. "Ideology and Race in American History." In *Region, Race, and Reconstruction: Essays in Honor of C. Vann Woodward*, edited by J. M. Kousser and J. M. McPherson. New York: Oxford University Press, 1992.

Fisher, Philip. *Hard Facts: Setting and Form in the American Novel*. New York: Oxford University Press, 1987.

Foner, Eric, ed. *The New American History*. Philadelphia: Temple University Press, 1990.

Foreman, P. Gabrielle. " 'Reading Aright': White Slavery, Black Referents, and the Strategy of Histotextuality in Iola Leroy." *Yale Journal of Criticism* 1997 (Fall): 327–54.

———. "Who's Your Mama? Louisa Piquet and White 'Mulatta Genealogies.' " Paper read at conference on Nineteenth-Century American Women Writers in the Twenty-First Century, at the Harriet Beecher Stowe House and Trinity College, Hartford, Conn., June 1996.

Foster, Hal, ed. *Vision and Visuality: Discussions in Contemporary Culture, #2*. Seattle: Bay Press, 1988.

Foucault, Michel. *The History of Sexuality*. Vol. 1. New York: Pantheon, 1978.

———. *Language, Counter-Memory, Practice: Selected Essays and Interviews.* Edited by
 D. F. Bouchard. Ithaca, N.Y.: Cornell University Press, 1977.

———. *Power/Knowledge: Selected Interviews and Other Writings, 1972–1977.* Edited by
 C. Gordon. New York: Pantheon, 1980.

Fox-Genovese, Elizabeth. *Within the Plantation Household: Black and White Women of
 the Old South.* Chapel Hill: University of North Carolina Press, 1988.

Frankenberg, Ruth. *White Women, Race Matters: The Social Construction of Whiteness.*
 Minneapolis: University of Minnesota Press, 1993.

Fredrickson, George. *The Black Image in the White Mind: The Debate on Afro-
 American Character and Destiny, 1817–1914.* Hanover, N.H.: University Press of
 New England, 1987.

———. *White Supremacy: A Comparative Study in American and South African
 History.* New York: Oxford University Press, 1981.

Freund, Giselle. *Photography and Society.* Boston: David R. Godine, 1980.

Frye, Marilyn. *The Politics of Reality: Essays in Feminist Theory.* Trumansberg, N.Y.:
 The Crossing Press, 1983.

Furman, Nelly. "The Politics of Language: Beyond the Gender Principle?" In
 Making a Difference, edited by Gayle Green and Coppelia Kahn, 59–79. London:
 Methuen, 1985.

Gaines, Jane. "White Privilege and Looking Relations: Race and Gender in Feminist
 Film Theory." In *Issues in Feminist Film Theory,* edited by Patricia Erens.
 Bloomington: Indiana University Press, 1990.

Gatewood, Willard B., Jr., ed. *"Smoked Yankees" and the Struggle for Empire: Letters
 from Negro Soldiers, 1898–1902.* Urbana: University of Illinois Press, 1971.

Giddings, Paula. *When and Where I Enter: The Impact of Black Women on Race and
 Sex in America.* New York: William Morrow, 1984.

Gilman, Caroline. *Recollections of a Southern Matron.* New York: Harper & Brothers,
 1837.

Gilmore, Glenda Elizabeth. *Gender and Jim Crow: Women and the Politics of White
 Supremacy in North Carolina, 1896–1920.* Chapel Hill: University of North Carolina
 Press, 1996.

Gilroy, Paul. *The Black Atlantic: Modernity and Double Consciousness.* Cambridge:
 Harvard University Press, 1993.

Goffman, Erving. *Asylums.* New York: Doubleday, 1961.

Goldberg, Vicki. *The Power of Photography: How Photographs Changed Our Lives.* New
 York: Abbeville, 1991.

Goldsby, Jackie. "The Meaning of Lynching and the Death of Emmett Till." *Yale
 Journal of Criticism* 9 (Fall 1996): 245–82.

Goodenough, Ronald K., and Arthur O. White, eds. *Education and the Rise of the New
 South.* Boston: G. K. Hall, 1981.

Gooding-Williams, Robert, ed. *Reading Rodney King/Reading Urban Uprising.* New
 York: Routledge, 1993.

Gover, Jane C. *The Positive Image: Women Photographers in Turn of the Century
 America.* Albany: State University of New York Press, 1988.

Graff, Henry F., ed. *American Imperialism and the Philippine Insurrection: Testimony*

Taken from Hearings on Affairs in the Philippine Islands before the Senate Committee on the Philippines, 1902. Boston: Little, Brown, 1969.

Green, David. "'Veins of Resemblance': Photography and Eugenics." In *Photography/Politics: Two,* edited by Patricia Holland, Jo Spence, and Simon Watney. London: Comedia, 1986.

Green, Gayle, and Coppelia Kahn, eds. *Making a Difference: Feminist Literary Criticism.* London: Methuen, 1985.

Green-Lewis, Jennifer. *Framing the Victorians: Photography and the Culture of Realism.* Ithaca, N.Y.: Cornell University Press, 1996.

Grindstaff, Beverly K. "Exhibiting the Philippines: Institutional Racism at the 1904 Louisiana Purchase Exhibition." Unpublished paper presented at the conference "Mapping Race: Bodies of Knowledge, Boundaries of Difference," Yale University, May 9–10, 1997. In collection of author.

Grubler, Mitchell. *Alice Austen: The Larky Life—An Exhibition Celebrating the 125th Anniversary of the Photographer's Birth* (exhibition catalog). Staten Island, N.Y.: Alice Austen House Museum, 1991.

Guilbaut, Serge. *How New York Stole the Idea of Modern Art: Abstract Expressionism, Freedom, and the Cold War.* Chicago: University of Chicago Press, 1983.

Guimond, James. *American Photography and the American Dream.* Chapel Hill: University of North Carolina Press, 1991.

Gunning, Sandra. *Race, Rape, and Lynching: The Red Record of American Literature.* New York: Oxford University Press, 1996.

Hale, Grace Elizabeth. *Making Whiteness: The Culture of Segregation in the South, 1980–1940.* New York: Vintage, 1999.

Hales, Peter Bacon. *Silver Cities: The Photography of American Urbanization, 1839–1915.* Philadelphia: Temple University Press, 1984.

Hall, Jacquelyn Dowd. "'The Mind that Burns in Each Body': Women, Rape, and Racial Violence." In *Powers of Desire: The Politics of Sexuality,* edited by A. Snitow, C. Stansell, and S. Thompson. New York: Monthly Review Press, 1983.

Hall, Stuart. "Encoding/Decoding." In *Culture, Media, Language: Working Papers in Cultural Studies, 1972–79.* London: Hutchinson, 1980.

———. "The Rediscovery of 'Ideology': Return of the Repressed in Media Studies." In *Culture, Society and the Media,* edited by T. B. Michael Gurevitch, Tony Bennett, James Curran, and Janet Woollacott, 56–90. London: Routledge, 1982.

Hansen, Olaf. "Frances Benjamin Johnston." In *Notable American Women: The Modern Period,* edited by Barbara Sicherman and Carol Hurd Green, 381–83. Cambridge: Harvard University Press, 1980.

Haraway, Donna. "Situated Knowledges: The Science Question in Feminism and the Privilege of Partial Perspective." *Feminist Studies* 14, no. 3 (Fall 1988): 575–99.

———. "Teddy Bear Patriarchy: Taxidermy in the Garden of Eden, New York City, 1908–36." *Social Text* 4, no. 2 (Winter 1984–85): 20–64.

Harding, Sandra. *The Science Question in Feminism.* Ithaca, N.Y.: Cornell University Press, 1991.

Harlan, Louis R. *Booker T. Washington: The Wizard of Tuskegee, 1901–1915.* New York: Oxford University Press, 1983.

Harlan, Louis R., and Raymond W. Smock, eds. *The Booker T. Washington Papers,* Vol. 6: *1901–2.* Urbana: University of Illinois Press, 1977.

Harris, Neil. "Iconography and Intellectual History: The Halftone Revolution." In *Cultural Excursions, Marketing Appetites, and Cultural Tastes in Modern America,* edited by N. Harris. Chicago: University of Chicago Press, 1990.

Harris, Neil, ed. *The Land of Contrasts: 1890–1901.* New York: George Braziller, 1979.

Harris, Trudier. *From Mammies to Militants: Domestics in Black American Literature.* Philadelphia: Temple University Press, 1982.

Hartman, Saidiya V. *Scenes of Subjection: Terror, Slavery, and Self-Making in Nineteenth-Century America.* New York: Oxford University Press, 1997.

Hartmann, Sadakichi. "Gertrude Käsebier." *Photographic Times* 32 (May 1900): 195–99.

Hemment, John C. *Cannon and Camera: Sea and Land Battles of the Spanish American War in Cuba, Camp Life, and the Return of the Soldiers.* New York: D. Appleton, 1898.

Hervey, Walter L. "Gertrude Käsebier—Photographer." *Photo-Era Magazine* 2 (March 1929): 121–32.

Hewitt, Nancy, and Suzanne Lebsock, eds. *Visible Women: New Essays on American Activism.* Urbana: University of Illinois Press, 1993.

Hill, Patricia. *The World Their Household.* Ann Arbor: University of Michigan Press, 1985.

Hirsch, Marianne. *The Familial Gaze.* Hanover, N.H.: University Press of New England, 1999.

———. *Family Frames: Photography, Narrative and Post-memory.* Cambridge: Harvard University Press, 1997.

Hodes, Martha. *White Women, Black Men: Illicit Sex in the Nineteenth-Century South.* New Haven, Conn.: Yale University Press, 1997.

Holland, Patricia, Jo Spence, and Simon Watney, eds. *Photography/Politics: Two.* London: Comedia, 1986.

Holloway, Camara. *Portraiture and the Harlem Renaissance: The Photographs of James L. Allen.* New Haven, Conn.: Yale University Art Gallery, 1999.

Holmes, Oliver Wendell. "Doings of the Sunbeam." *Atlantic Monthly* 12, no. 14 (July 1863): 1–15.

———. "The Stereoscope and the Stereograph." *Atlantic Monthly* 3, no. 20 (June 1859): 738–48.

———. "Sun-Painting and Sun-Sculpture." *Atlantic Monthly* 8, no. 45 (July 1861): 13–29.

Homans, Margaret. *Bearing the Word.* Chicago: University of Chicago Press, 1986.

Homer, William Innis, ed. *A Pictorial Heritage: The Photographs of Gertrude Käsebier.* Wilmington: Delaware Art Museum, 1979.

hooks, bell. *Black Looks: Race and Representation.* Boston: South End, 1992.

Horseman, Reginald. *Race and Manifest Destiny: The Origins of American Anglo-Saxonism.* Cambridge: Harvard University Press, 1981.

Howard, June. *Form and History in American Literary Naturalism.* Chapel Hill: University of North Carolina, 1985.

———, ed. *New Essays on "The Country of the Pointed Firs."* Cambridge: Cambridge University Press, 1994.

Hurston, Zora Neale. *Their Eyes Were Watching God.* 1937; reprint, Urbana: University of Illinois Press, 1978.

———. *Mules and Men.* 1935; reprint, Bloomington: Indiana University Press, 1978.

Ignatiev, Noel. *How the Irish Became White.* New York: Routledge, 1995.

Ivins, William, Jr. *Prints and Visual Communications.* Cambridge: MIT Press, 1969.

Jacobs, Harriet. *Incidents in the Life of a Slave Girl, Written by Herself.* Edited by Jean Fagan Yellin. Cambridge: Harvard University Press, 1987.

Jacobson, Matthew Frye. *Special Sorrows: The Diasporic Imagination of Irish, Polish, and Jewish Immigrants in the United States.* Cambridge: Harvard University Press, 1995.

———. *Whiteness of a Different Color: European Immigrants and the Alchemy of Race.* Cambridge: Harvard University Press, 1998.

James, Henry. *The American Scene.* 1907; reprint, Bloomington: Indiana University Press, 1968.

Jameson, Fredric. "Modernism and Imperialism." In *Nationalism, Colonialism, and Literature,* edited by Terry Eagleton, Fredric Jameson, and Edward Said. Minneapolis: University of Minnesota Press, 1990.

———. *The Political Unconscious: Narrative as a Socially Symbolic Act.* Ithaca, N.Y.: Cornell University Press, 1981.

Jay, Martin. *Downcast Eyes: The Denigration of Vision in Twentieth-Century French Thought.* Berkeley: University of California Press, 1993.

Johnston, Frances Benjamin. "The Foremost Women Photographers of America: First—The Work of Mrs. Gertrude Käsebier." *Ladies' Home Journal* 18, no. 6 (May 1901): 1.

———. "What a Woman Can Do with a Camera." *Ladies' Home Journal* 14, no. 10 (September 1897): 6–7.

Jones, Jacqueline. *Labor of Love, Labor of Sorrow: Black Women, Work, and the Family from Slavery to the Present.* New York: Basic, 1985.

Jussim, Estelle. *Visual Communication and the Graphic Arts: Photographic Technologies in the Nineteenth Century.* New York: Bowker, 1974.

Kaplan, Amy. "Black and Blue on San Juan Hill." In *Cultures of U.S. Imperialism,* edited by A. Kaplan and D. Pease. Durham, N.C.: Duke University Press, 1993.

———. "Romancing the Empire: The Embodiment of American Masculinity in the Popular Historical Novel of the 1890s." *American Literary History* 2 (December 1990): 659–90.

Kaplan, Amy, and Donald Pease, eds. *Cultures of United States Imperialism.* Durham, N.C.: Duke University Press, 1983.

Kaplan, Carla. *The Erotics of Talk.* New York: Oxford University Press, 1996.

———. "Narrative Contracts and Emancipatory Readers." *Yale Journal of Criticism* 6 (Spring 1993): 93–119.

Kaplan, Daile. *Fine Day: An Exhibition Featuring Photographs by Alice Austen, Frank Eugene, Gertrude Käsebier, and Others.* Staten Island, N.Y.: Friends of Alice Austen, 1988.

Kaplan, E. Ann. *Looking for the Other: Feminism, Film, and the Imperial Gaze.* New York: Routledge, 1997.

———. *Women and Film: Both Sides of the Camera.* New York: Methuen, 1983.

[Käsebier, Gertrude.] "Some Indian Portraits." *Everybody's Magazine* 4, no. 17 (January 1901): 3–25.

———. "Studies in Photography." *The Photographic Times* 30 (June 1898): 269–72.

Keiley, Joseph T. "Gertrude Käsebier." *Camera Work* 20 (October 1907): 27–31.

Keller, Judith. *After the Manner of Women: Photographs by Käsebier, Cunningham, and Ulmann* (pamphlet). Los Angeles: The J. Paul Getty Museum, September–December 1988.

Kelley, Mary. *Private Woman, Public Stage: Literary Domesticity in Nineteenth-Century America.* New York: Oxford University Press, 1984.

Kerber, Linda, Alice Kessler-Harris, and Kathryn Kish Sklar, eds. *U.S. History as Women's History: New Feminist Essays.* Chapel Hill: The University of North Carolina Press, 1995.

Kessler-Harris, Alice. *Out to Work: A History of Wage-Earning Women in the United States.* New York: Oxford University Press, 1982.

Kevles, Daniel. *In the Name of Eugenics: Genetics and the Uses of Human Heredity.* Berkeley: University of California Press, 1985.

Kirstein, Lincoln, ed. *The Hampton Album.* New York: Museum of Modern Art, 1966.

Kousser, J. Morgan, and James M. McPherson, eds. *Region, Race, and Reconstruction: Essays in Honor of C. Vann Woodward.* New York: Oxford University Press, 1982.

Kribbs, Jane K., ed. *Critical Essays on John Greenleaf Whittier.* Boston: G. K. Hall, 1980.

Kristeva, Julia. "Motherhood According to Bellini." In *Desire in Language,* edited by Leon S. Roudiez. New York: Columbia University Press, 1980.

Kuhn, Annette. *The Power of the Image: Essays on Representation and Sexuality.* London: Routledge & Kegan Paul, 1985.

———. *Women's Pictures: Feminism and Cinema.* London: Routledge & Kegan Paul, 1982.

Larsen, Ernest. "Between Worlds." *Art in America* (May 1999): 122–29.

Lazarre, Jane. *Beyond the Whiteness of Whiteness: Memoir of a White Mother of Black Sons.* Durham, N.C.: Duke University Press, 1996.

Lerner, Gerda. "Placing Women in History: Definitions and Challenges." In *The Majority Finds Its Past: Placing Women in History.* New York: Oxford University Press, 1979.

Lesy, Michael. *Dreamland: America at the Dawn of the Twentieth Century.* New York: New Press, 1997.

Levine, Robert M. *Images of History: Nineteenth and Early Twentieth Century Latin American Photographs as Documents.* Durham, N.C.: Duke University Press, 1989.

Lippard, Lucy. *Partial Recall.* New York: New Press, 1992.

Liss, Andrea. "Black Bodies in Evidence: Maternal Visibility in Renée Cox's Family Portraits." In *The Familial Gaze,* edited by Marianne Hirsch. Hanover, N.H.: University Press of New England, 1999.

Lott, Eric. *Love and Theft: Blackface Ministrelsy and the American Working Class.* New York: Oxford University Press, 1993.

Lutz, Catherine A., and Jane L. Collins. *Reading National Geographic.* Chicago: University of Chicago Press, 1993.

McClintock, Anne. *Imperial Leather: Race, Gender, and Sexuality in the Colonial Context.* New York: Routledge, 1985.

Malmsheimer, Lonna. "Imitation White Man: Images of Transformation at the Carlisle Indian School." *Studies in Visual Communication* 2 (Fall 1985): 54–75.

Marshall, Deborah Jane. "The Indian Portraits." In *A Pictorial Heritage: The Photographs of Gertrude Käsebier,* edited by W. I. Homer. Wilmington: Delaware Art Museum, 1979.

Martin, Calvin, ed. *The American Indian and the Problem of History.* New York: Oxford University Press, 1987.

Mattison, Reverend H. *Louisa Piquet, the Octoroon: or, Inside Views of Southern Domestic Life* (1861). Reprinted in *Collected Black Women's Narratives,* edited by A. Barthelemy. New York: Oxford University Press, 1988.

Meyer, Susan. *Imperialism at Home: Race and Victorian Women's Fiction.* Ithaca: Cornell University Press, 1996.

Michaels, Barbara. *Gertrude Käsebier: The Photographer and Her Photographs.* New York: Harry H. Abrams, 1992.

Michaels, Walter Benn. "Anti-Imperial Americanism." In *Cultures of U.S. Imperialism,* edited by Amy Kaplan and Donald Pease. Durham, N.C.: Duke University Press, 1993.

————. *Our America: Nativism, Modernism, and Pluralism.* Durham, N.C.: Duke University Press, 1995.

Mies, Maria. *Patriarchy and Accumulation on a World Scale: Women in the International Division of Labor.* London: Zed, 1986.

Miller, Angela. *The Empire of the Eye: Landscape, Representation, and American Cultural Politics, 1825–1875.* Ithaca, N.Y.: Cornell University Press, 1993.

Miller, Stuart Creighton. *"Benevolent Assimilation": The American Conquest of the Philippines.* New Haven, Conn.: Yale University Press, 1982.

Minh-ha, Trinh T. *Woman, Native, Other: Writing Postcoloniality and Feminism.* Bloomington: Indiana University Press, 1989.

Mitchell, Juliet, and Ann Oakley, eds. *What Is Feminism?* Oxford: Basil Blackwell, 1986.

Moeller, Madelyn. *Nineteenth-Century Women Photographers: A New Dimension in Leisure* (exhibition catalog). Norwalk, Conn.: Lockwood-Mathews Mansion Museum, 1987.

Montgomery, David. *The Fall of the House of Labor.* Cambridge: Cambridge University Press, 1989.

Moon, Michael, and Cathy Davidson, eds. *Subjects and Citizens: Nation, Race, and Gender from Oroonoko to Anita Hill.* Durham, N.C.: Duke University Press, 1995.

Morrison, Toni. *Playing in the Dark: Whiteness and the American Literary Imagination.* Cambridge: Harvard University Press, 1992.

Morton, Patricia. *Disfigured Images: The Historical Assault on Afro-American Women.* New York: Greenwood, 1991.

Moutoussamy-Ashe, Jeanne. *Viewfinders: Black Women Photographers*. New York: Dodd, Mead, 1986.

Mullen, Harryette. "Gender and the Subjugated Body: Readings of Race, Subjectivity, and Difference in the Construction of Slave Narratives." Ph.D. diss., University of California, Santa Cruz, 1990.

Mulvey, Laura. "Visual Pleasure and Narrative Cinema." In *Issues in Feminist Film Criticism,* edited by Patricia Erens. Bloomington: Indiana University Press, 1990.

Museum of the City of New York. *"Beals' Bohemians": Greenwich Village Through the Lens of Jessie Tarbox Beals* (pamphlet). New York: Museum of the City of New York, n.d.

Naef, Weston, and Jackie Napolean Wilson. *Hidden Witness: African Americans in Early Photography*. Los Angeles: J. Paul Getty Museum, 1995.

Newhall, Beaumont. *The Daguerreotype in America*. 3d rev. ed. New York: Dover, 1976.

———. *The History of Photography*. New York: Museum of Modern Art, 1982.

Newman, Louise Michele. *White Women's Rights: The Racial Origins of Feminism in the United States*. New York: Oxford University Press, 1999.

Noble, Marianne. "The Ecstasies of Sentimental Wounding in *Uncle Tom's Cabin.*" *Yale Journal of Criticism* 10 (Fall 1997): 295–320.

Novotny, Ann. *Alice's World: The Life and Photography of an American Original: Alice Austen, 1866–1952* . Old Greenwich, Conn.: Chatham, 1976.

Nudelman, Franny. "Harriet Jacobs and the Sentimental Politics of Female Suffering." *ELH: A Journal of English Literary History* 59, no. 4 (Winter 1992): 939–64.

O'Mara, Jane Cleland. "Gertrude Käsebier: The First Professional Woman Photographer, 1882–1934." *Feminist Art Journal* 3 (Winter 1974-75): 18–21, 23.

Omi, Michael, and Howard Winant. *Racial Formation in the United States: From the 1960s to the 1980s*. 2d ed. New York: Routledge, 1994.

O'Neil, William. *Everyone Was Brave: A History of Feminism in America*. Chicago: Quadrangle, 1989.

Owens, Craig. "Posing." In *Beyond Recognition: Representation, Power, and Culture,* edited by Scott Bryson, Barbara Kruger, Lynne Tillman, and Jane Weinstock. Berkeley: University of California Press, 1992. Originally published in *Art in America* (January 1984): 97–105.

Painter, Nell Irvin. *Sojourner Truth: A Life, A Symbol*. New York: W. W. Norton, 1996.

———. *Standing at Armageddon: The United States, 1877–1919*. New York: W. W. Norton, 1987.

Palmquist, Peter E., ed. *Camera Fiends and Kodak Girls: Fifty Selections by and about Women in Photography, 1840–1930*. New York: Midmarch Arts, 1975.

Patterson, Orlando. *Slavery and Social Death: A Comparative Study*. Cambridge: Harvard University Press, 1982.

Phillips, Christopher. "The Judgement Seat of Photography." In *The Context of Meaning,* edited by R. Bolton. Cambridge: MIT Press, 1989.

Phillips, David. "Art for Industry's Sake: Halftone Technology, Mass Photography, and the Social Transformation of American Print Culture, 1880–1920." Ph.D.

diss., Yale University, 1996. Available at
http://pantheon.cis.yale.edu/~davidp/halftone/hyper.html.
———. "The Birth of Mass Photography, Halftone Technology, Illustrated
Magazines, and the Social Transformation of American Print Culture, 1890–1950."
Textual Studies in Canada 10/11 (Winter 1998): 5–16.
Pollock, Griselda. *Vision and Difference: Femininity, Feminism, and the Histories of
Art.* London: Routledge, 1998.
———. "What's Wrong with 'Images of Women?'" *Screen Education* 24 (1977):
25–33.
Poore, Henry. *Pictorial Composition and the Critical Judgement of Pictures.* New York:
Baker and Taylor, 1903.
Pratt, Mary Louise. *Imperial Eyes: Travel Writing and Transculturation.* London:
Routledge, 1992.
Prown, Jules David. "Mind in Matter: An Introduction to Material Culture Theory
and Methods." *Winterthur Portfolio* 17, no. 1 (Spring 1982): 1–19.
Quitslund, Toby. "Her Feminine Colleagues: Photographs and Letters Collected by
Frances Benjamin Johnston in 1900." In *Women Artists in Washington Collections,*
edited by Josephine Withers. College Park: University of Maryland Art Gallery,
1979.
Rabinowitz, Paula. *They Must Be Represented: The Politics of Documentary.* London:
Verso, 1994.
Rafael, Vicente L. "Colonial Domesticity: White Women and United States Rule in
the Philippines." *American Literature* 67 (December 1995): 639–66.
———. "Nationalism, Imagery, and the Filipino Intelligentsia in the Nineteenth
Century." *Critical Inquiry* 16, no. 3 (Spring 1990): 591–611.
Reiter, Rayna, ed. *Toward an Anthropology of Women.* New York: Monthly Review
Press, 1975.
Reynolds, David. *Beneath the American Renaissance: The Subversive Imagination in the
Age of Emerson and Melville.* New York: Alfred A. Knopf, 1988.
Riley, Denise. *Am I That Name? Feminism and the Category of "Women" in History.*
Minneapolis: University of Minnesota Press, 1988.
Roach, Joseph. *Cities of the Dead: Circum-Atlantic Performance.* New York: Columbia
University Press, 1996.
Robinson, William Hannibal. "The History of Hampton Institute, 1868–1949."
Ph.D. diss., New York University, 1954.
Rodowick, D. N. *The Difficulty of Difference: Psychoanalysis, Sexual Difference and Film
Theory.* New York: Routledge, 1991.
Roediger, David. *The Wages of Whiteness: Race and the Making of the American
Working Class.* London: Verso, 1994.
Rogin, Michael. *Blackface, White Noise: Jewish Immigrants in the Hollywood Melting
Pot.* Berkeley: University of California Press, 1996.
Romero, Lora. "Vanishing Americans: Gender, Empire, and New Historicism." In
Subjects and Citizens: Nation, Race, and Gender from Oroonoko to Anita Hill, edited
by M. Moon and C. Davidson. Durham, N.C.: Duke University Press, 1995.
Rony, Fatimah Tobing. *The Third Eye: Race, Cinema, and Ethnographic Spectacle.*
Durham, N.C.: Duke University Press, 1996.

Root, Marcus Aurelius. *The Camera and the Pencil*. Pawlet, Vt.: Helio, 1971.

Rose, Jacqueline. *Sexuality in the Field of Vision*. London: Verso, 1986.

Rosenblum, Naomi. *A History of Women Photographers*. New York: Abbeville, 1994.

Rubin, Gayle. "The Traffic in Women: Notes on the 'Political Economy of Sex.'" In *Toward an Anthropology of Women*, edited by Rayna Reiter. New York: Monthly Review Press, 1975.

Rudisill, Richard. *Mirror Image: The Influence of the Daguerreotype on American Society*. Albuquerque: University of New Mexico Press, 1971.

Rydell, Robert W. *All the World's a Fair: Visions of American Empire at American International Expositions, 1876–1916*. Chicago: University of Chicago Press, 1987.

Saltz, Laura. "Clover Adams's Dark Room: Photography and Writing, Exposure and Erasure." *Prospects: An Annual of American Cultural Studies* 24 (1999): 449–50.

———. "Disappearing Women: Gender and Vision in Nineteenth Century American Fiction and Photographs." Ph.D. diss., Yale University, 1997.

Samuels, Shirley, ed. *The Culture of Sentiment: Race, Gender, and Sentimentality in Nineteenth-Century America*. New York: Oxford University Press, 1992.

Sanchez-Eppler, Karen. "Bodily Bonds: The Intersecting Rhetorics of Feminism and Abolition." *Representations* 24 (Fall 1988): 28–59.

———. *Touching Liberty: Abolition, Feminism and the Politics of the Body*. Berkeley: University of California Press, 1993.

Schall, Keith L., ed. *Stony the Road: Chapters in the History of Hampton Institute*. Charlottesville: University Press of Virginia, 1977.

Schlereth, Thomas J., ed. *Material Culture Studies in America*. Nashville: American Association for State and Local History, 1982.

Schurtz, Carl. *The Policy of Imperialism*. Chicago: American Anti-Imperialist League, 1899. Reprinted as "The Policy of Imperialism," Liberty Tract No. 4, in *Anti-Imperialism in the United States, 1898–1935*, edited by Jim Zwick. Available at http://www/boondocksnet.com/ai198-35.html (March 12, 2000).

Scott, Ann Firor. *The Southern Lady: From Pedestal to Politics, 1830–1930*. Chicago: University of Chicago Press, 1970.

Scott, Joan. *Gender and the Politics of History*. New York: Columbia University Press, 1988.

Scott, James C. *Domination and the Arts of Resistance: Hidden Transcripts*. New Haven, Conn.: Yale University Press, 1990.

———. *Weapons of the Weak: Everyday Forms of Peasant Resistance*. New Haven, Conn.: Yale University Press, 1985.

Sekula, Allan. *Photography Against the Grain: Essays and Photo Works, 1975–1983*. Halifax: Press of the Nova Scotia College of Art and Design, 1984.

Severa, Joan L. *Dressed for the Photographer: Ordinary Americans and Fashion, 1840–1900*. Kent, Ohio: Kent State University Press, 1995.

Siegel, Reva. "Why Equal Protection No Longer Protects: The Evolving Forms of Status-Enforcing State Action." *Stanford Law Review* 49, no. 5 (May 1997): 1111–48.

Silber, Nina. *The Romance of Reunion: Northerners and the South, 1865–1900*. Chapel Hill: University of North Carolina Press, 1993.

Skipwith, Joanna, ed. *Rhapsodies in Black: Art of the Harlem Renaissance.* Berkeley: University of California Press, 1997.

Slater, Sarah E. "Profitable Industries for Women: Photography." *New Idea Women's Magazine* 10 (February 1904): 28–31.

Smith, Raymond. "Eva Newell, the Recent Discovery of a Nineteenth-Century Photographer." *American Art Review* 2, no. 6 (September–October 1975): 57–77.

Smith, Shawn Michele. *American Archives: Gender, Race and Class in Visual Culture.* Princeton, N.J.: Princeton University Press, 1999.

Smith-Rosenberg, Carol. *Disorderly Conduct: Visions of Gender in Victorian America.* New York: Alfred A. Knopf, 1985.

Snitow, Ann, Christine Stansell, and Sharon Thompson, eds. *Powers of Desire: The Politics of Sexuality.* New York: Monthly Review Press, 1983.

Sobieszek, Robert A., and Odette M. Appell. *The Spirit of Fact: The Daguerreotypes of Southworth & Hawes, 1843–1862.* Boston: David R. Godine and the International Museum of Photography at the George Eastman House, 1976.

Sollors, Werner. *Beyond Ethnicity: Consent and Descent in American Culture.* New York: Oxford University Press, 1986.

Sontag, Susan. *On Photography.* New York: Farrar, Straus and Giroux, 1993.

Spacks, Patricia Meyer. *Gossip.* Chicago: University of Chicago Press, 1985.

Spelman, Elizabeth V. *Inessential Women: Problems of Exclusion in Feminist Thought.* Boston: Beacon, 1988.

———. "Theories of Race and Gender: The Erasure of Black Women." *Quest* 5, no. 4 (1982): 36–62.

Spence, Jo. "The Sign as a Site of Class Struggle." In *Photography/Politics: Two,* edited by P. Holland, J. Spence, and S. Watney. London: Comedia, 1986.

Spence, Jo, and Terry Dennett, eds. *Photography/Politics: One.* London: Photography Workshop, 1979.

Spillers, Hortense. "'All the Things You Could Be By Now, If Sigmund Freud's Wife Was Your Mother': Psychoanalysis and Race." In *Female Subjects in Black and White: Race, Psychoanalysis, Feminism,* edited by E. Abel, B. Christian, and H. Moglen. Berkeley: University of California Press, 1997.

———. "Papa's Baby, Mama's Maybe: An American Grammar Book." *Diacritics* 17, no. 2 (Summer 1987): 65–81.

Spivak, Gayatri. *In Other Worlds: Essays in Cultural Politics.* New York: Methuen, 1987.

Spurr, David. *The Rhetoric of Empire: Colonial Discourse in Journalism, Travel Writing, and Imperial Administrations.* Durham, N.C.: Duke University Press, 1993.

Stange, Maren. "'Illusion Complete Within Itself': Roy Decarava's Photography." *Yale Journal of Criticism* 9, no. 1 (Spring 1996): 63–92.

———. *Symbols of Ideal Life: Social Documentary Photography in America, 1890–1950.* Cambridge: Cambridge University Press, 1989.

Steedman, Carolyn Kay. *Landscape for a Good Woman.* New Brunswick, N.J.: Rutgers University Press, 1987.

Steichen, Edward. *The Family of Man.* New York: Museum of Modern Art, 1955.

Sterling, Dorothy, ed. *We Are Your Sisters: Black Women in the Nineteenth Century.* New York: W. W. Norton, 1984.

Stickney, Joseph L. *The Life of Admiral George Dewey and the Conquest of the Philippines: The Story of a Hero and How We Acquired an Empire.* Philadelphia: P. W. Ziegler, 1899.

Stocking, George. *Race, Culture and Evolution: Essays in the History of Anthropology.* Chicago: University of Chicago Press, 1968.

Stoler, Ann Laura. *Race and the Education of Desire: Foucault's History of Sexuality and the Colonial Order of Things.* Durham, N.C.: Duke University Press, 1995.

Suleri, Sarah. "The Feminine Picturesque." In *The Rhetoric of English India.* Chicago: University of Chicago Press, 1992.

Susman, Warren. *Culture as History: The Transformation of American Society in the Twentieth Century.* New York: Pantheon, 1973.

Taft, Robert. *Photography and the American Scene: A Social History, 1839–1880.* 1938; reprint, New York: Dover, 1964.

Tagg, John. *The Burden of Representation: Essays on Photographies and Histories.* Minneapolis: University of Minnesota Press, 1988.

Takaki, Ronald. *Iron Cages: Race and Culture in Nineteenth-Century America.* Seattle: University of Washington Press, 1979.

———. *Strangers from a Different Shore.* New York: Penguin, 1989.

Tate, Claudia. *Domestic Allegories of Political Desire: The Black Heroine's Text at the Turn of the Century.* New York: Oxford University Press, 1992.

Thomas, Ella Gertrude Clanton. *The Secret Eye: The Journal of Ella Gertrude Clanton Thomas, 1848–1889.* Edited by Virginia Ingraham Burr, introduction by Nell Irvin Painter. Chapel Hill: University of North Carolina Press, 1990.

Thomson, Rosemarie Garland, ed. *Freakery: Cultural Spectacles of the Extraordinary Body.* New York: New York University Press, 1996.

Tighe, Mary Ann. "Gertrude Käsebier Lost and Found." *Art in America* 65 (March 1977): 94–98.

Tingey, Joseph Willard. "Indians and Blacks Together: An Experiment in Biracial Education at Hampton Institute (1878–1923)." Ph.D. diss., Columbia University, 1978.

Tompkins, Jane. *Sensational Designs: The Cultural Work of American Fiction, 1790–1860.* New York: Oxford University Press, 1985.

Toulet, Emmanuelle. "Cinema at the Universal Exposition, Paris, 1900." *Persistence of Vision* 9 (1991): 10–36.

Trachtenberg, Alan. "Albums of War: On Reading Civil War Photographs." *Representations* 9 (Winter 1983): 1–32.

———. *The Incorporation of American Culture: Culture and Society in the Gilded Age.* New York: Hill and Wang, 1982.

———. *Reading American Photographs: Images as History, Mathew Brady to Walker Evans.* New York: Hill and Wang, 1989.

———, ed. *Classic Essays on Photography.* Stony Creek, Conn.: Leetes Island Books, 1980.

Tucker, Anne. *The Woman's Eye.* New York: Alfred A. Knopf, 1973.

Updike, John. *Just Looking: Essays on Art.* New York: Alfred A. Knopf, 1989.

Valentine, Benjamin Batchelder. *Ole Marster and Other Verses.* Richmond: Whittet and Shepperson, 1921.

Viehmann, Martha. "Writing Across the Cultural Divide: Images of Indians in the Lives and Works of Native and European Americans, 1890–1935." Ph.D. diss., Yale University, 1994.

Vizenor, Gerald. "Socioacupuncture: Mythic Reversals and the Striptease in Four Scenes." In *The American Indian and the Problem of History,* edited by C. Martin. New York: Oxford University Press, 1987.

Volpe, Andrea. "Cheap Pictures: Cartes de Visite Portrait Photographs and Visual Culture in the United States, 1860–1877." Ph.D. diss., History, Rutgers University, 1999.

Wald, Priscilla. *Constituting Americans: Cultural Anxiety and Narrative Form.* Durham, N.C.: Duke University Press, 1995.

Wardley, Lynn. "Relic, Fetish, Femmage: The Aesthetics of Sentiment in the Work of Stowe." In *The Culture of Sentiment: Race, Gender, and Sentimentality in the Nineteenth Century,* edited by Shirley Samuels. New York: Oxford University Press, 1992.

Ware, Vron. *Beyond the Pale: White Women, Racism, and History.* London: Verso, 1992.

Warner, Marina. *From the Beast to the Blonde: On Fairy Tales and Their Tellers.* New York: Farrar, Straus, and Giroux, 1994.

Washington, Booker T. "The Successful Training of the Negro." Reprinted from *The World's Work* 6 (August 1903) by Doubleday Page & Company, New York, 1903, n.p.

———. *Up From Slavery.* 1901; reprint, New York: Airmont, 1967.

Watts, Jennifer. "Frances Benjamin Johnston: The Huntington Library Portrait Collection." *History of Photography* 19, no. 3 (Autumn 1995): 252–62.

Weimann, Jeanne Madeline. *The Fair Women: The Story of the Woman's Building, World Columbian Exhibition, Chicago, 1893.* Chicago: Academy Chicago, 1981.

Weinberg, Jonathan. "'Boy Crazy': Carl Van Vechten's Queer Collection." *Yale Journal of Criticism* 7, no. 2 (Fall 1994): 25–49.

Weinstein, Alan, and R. Jackson Wilson. *Freedom and Crisis: An American History.* Vol. 2. New York: Random House, 1974.

Welling, William. *Photography in America: The Formative Years, 1839–1900.* New York: Thomas Y. Crowell, 1978.

Wells, Ida B. *Crusade for Justice: The Autobiography of Ida B. Wells.* Edited by Alfreda Duster. Chicago: University of Chicago Press, 1970.

———. *A Red Record: Tabulated Statistics and Alleged Causes of Lynchings in the United States, 1892-1893-1894.* In *Selected Works of Ida B. Wells-Barnett,* compiled by Trudier Harris. New York: Oxford University Press, 1991.

Wells-Barnett, Ida B. *On Lynching: Southern Horrors, A Red Record, Mob Rule in New Orleans.* New York: Arno, 1969.

Welter, Barbara. "The Cult of True Womanhood: 1820–1869." *American Quarterly* 18 (Summer 1966): 151–74.

———. *Dimity Convictions: The American Woman in the Nineteenth Century.* Athens: Ohio State University Press, 1976.

West, Rebecca. *1900.* New York: Viking, 1982.

Wexler, Laura. "Black and White and Color: American Photography at the Turn of the Century." *Prospects: An Annual of American Cultural Studies* 13 (1988): 341–90.

———. "Photographies and Histories. Coming into Being: John Tagg's *The Burden of Representation: Essays on Photographies and Histories.*" *Exposure* 27, no. 2 (1989): 38–53.

———. "Techniques of the Imaginary Nation: Engendering Family Photography." In *Race and the Production of Modern American Nationalism,* edited by R. J. Scott-Childress. New York: Garland, 1999.

Whittier, John Greenleaf. *Anti-Slavery Poems: Songs of Labor and Reform.* Boston: Houghton Mifflin, 1892.

———. *Poems of Nature; Poems Subjective and Reminiscent; Religious Poems.* Boston: Houghton Mifflin, 1892.

Wiebe, Robert H. *The Search for Order, 1876–1920.* New York: Hill and Wang, 1967.

Wiegman, Robyn. *American Anatomies: Theorizing Race and Gender.* Durham, N.C.: Duke University Press, 1995.

Williams, Linda. "When the Woman Looks." In *Re-Visions: Essays in Feminist Film Criticism,* edited by Mary Anne Doane, Patricia Mellencamp, and Linda Williams. Frederick, Md.: University Publications of America, 1984.

Willis, Deborah, ed. *Picturing Us: African Americans Identity in Photographs.* New York: New Press, 1994.

Willis-Thomas, Deborah. *Black Photographers, 1840–1940: A BioBibliography.* New York: Garland, 1985.

Withers, Josephine, ed. *Women Artists in Washington Collections.* College Park: University of Maryland Art Gallery, 1979.

Wolf, Bryan. "Confessions of a Closet Ekphrastic." *Yale Journal of Criticism* 3 (Spring 1990): 181–203.

Wolff, Janet. *The Social Production of Art.* New York: New York University Press, 1984.

Wong, Hertha. *Sending My Heart Back Across the Years: Tradition and Innovation in Native American Autobiography.* New York: Oxford University Press, 1992.

Woodward, C. Vann. *Origins of the New South, 1877–1913.* Baton Rouge: Louisiana State University Press, 1951.

———. *The Strange Career of Jim Crow.* New York: Oxford University Press, 1974.

Wyatt, Victoria. "Images of Native Americans." *Exposure* 28 (Winter 1992): 21–31.

Yellin, Jean Fagan. *Women and Sisters: The Anti-Slavery Feminists in American Culture.* New Haven, Conn.: Yale University Press, 1989.

Yetman, Norman. *Voices From Slavery.* New York: Holt, Reinhart, and Winston, 1970.

Yezierska, Anzia. *Bread Givers: A Novel.* New York: George Braziller, 1955.

Zagarell, Sandra. "Crosscurrents: Registers of Nordicism, Community, and Culture in Jewett's *Country of the Pointed Firs.*" *Yale Journal of Criticism* 10 (Fall 1997): 355–70.

Ziff, Larzer. *The American 1890s: Life and Times of a Lost Generation.* Lincoln: University of Nebraska Press, 1966.

Zitkala-Sa. *American Indian Stories.* 1921; reprint, Lincoln, Nebr.: University of Nebraska Press, 1985.

Zwick, Jim, ed. *Anti-Imperialism in the United States, 1898–1935.* Available at http://www/boondocksnet.com/ai198-35.html (March 12, 2000).

Credits

Frontispiece: See Figure 1.13

CHAPTER I

1.1 Unknown photographer, *Portrait of Frances Benjamin Johnston,* Library of Congress, LC-USZ62-47062
1.2 *My Dear Admiral Dewey,* Library of Congress, LC-USZ62-63530
1.3 Unknown photographer, *The Gift of a Nation,* previously published in Joseph L. Stickney, *The Life of Admiral George Dewey and the Conquest of the Philippines: The Story of a Hero and How We Acquired an Empire* (Philadelphia: P. W. Zeigler, 1899)
1.4 Unknown photographer, *The Dewey Medal,* previously published in Joseph L. Stickney, *The Life of Admiral George Dewey and the Conquest of the Philippines: The Story of a Hero and How We Acquired an Empire* (Philadelphia: P. W. Zeigler, 1899)
1.5 Frances Benjamin Johnston, *Untitled,* Library of Congress, LC-J698-61262
1.6 Frances Benjamin Johnston, *Untitled,* Library of Congress, LC-J698-61259
1.7 Frances Benjamin Johnston, *Untitled,* Library of Congress, LC-J698-61267
1.8 Frances Benjamin Johnston, *Untitled,* Library of Congress, LC-J698-61334
1.9 Frances Benjamin Johnston, *Untitled,* Library of Congress, LC-J698-61342
1.10 Frances Benjamin Johnston, *Untitled,* Library of Congress, LC-J698-61327
1.11 Frances Benjamin Johnston, *Untitled,* Library of Congress, LC-J698-61314
1.12 Unknown photographer, *Untitled,* Library of Congress, LC-J698-61317
1.13 Frances Benjamin Johnston, *Untitled,* Library of Congress, LC-J698-61312
1.14 Joseph Stickney, *On Board the Olympia,* previously published in Joseph L. Stickney, *The Life of Admiral George Dewey and the Conquest of the Philippines: The Story of a Hero and How We Acquired an Empire* (Philadelphia: P. W. Zeigler, 1899)
1.15 Frances Benjamin Johnston, *Untitled,* Library of Congress, LC-J698-61299
1.16 Unknown photographer, *Untitled,* Library of Congress, LC-J713-4931
1.17 Frances Benjamin Johnston, *Untitled,* Library of Congress, LC-USZ62-47558
1.18 Frances Benjamin Johnston, *Untitled,* Library of Congress, LC-J698-61278
1.19 "The first step towards lightening The White Man's Burden is through teaching the virtues of cleanliness," previously published in *McClure's Magazine* 13 (May–October 1899)
1.20 Unknown photographer, *Aguinaldo, the Insurgent Leader of the Filipinos,* previously published in Joseph L. Stickney, *The Life of Admiral George Dewey and the Conquest of the Philippines: The Story of a Hero and How We Acquired an Empire* (Philadelphia: P. W. Zeigler, 1899)

1.21 Frances Benjamin Johnston, *Untitled,* Library of Congress, LC-J698-61331
1.22 Unknown photographer, *Untitled,* Library of Congress, LC-USZ62-47057

CHAPTER 2

2.1 George Cook, *Nursemaid and Her Charge,* The Valentine Museum, Richmond, Va.
2.2 Giovanni Bellini, *Madonna and Child,* ca. 1485, oil on canvas, transferred from panel, 29 9/16 × 21 13/16″ (72.5 × 55.4 cm), The Nelson-Atkins Museum of Art, Kansas City, Mo. (Gift of the Samuel H. Kress Foundation)
2.3 George Cook, *Untitled,* The Valentine Museum, Richmond, Va.
2.4 Giovanni Bellini, *Madonna and Child,* ca. 1480. Glasgow Museums: The Burrell Collection
2.5 Unknown photographer, *Frances Adams and her Daughter as a Small Child,* ca. 1852, The State Historical Society of Wisconsin, WHi (x3) 35904, Lot 4195
2.6 George Cook, *Untitled,* The Valentine Museum, Richmond, Va.
2.7 Unknown photographer, *Portrait of a Nurse and Young Child,* ca. 1850, daguerreotype, hand-colored, 2 7/16 × 1 7/8″ (8.3 × 7.1 cm), The J. Paul Getty Museum, Los Angeles, 84.XT.172.4
2.8 Unknown photographer, *Charleston "Mommer,"* Library of Congress, LC-USZ62-26366
2.9 Unknown photographer, *Aunt Lizzie,* The Valentine Museum, Richmond, Va., 51.1.1
2.10 Heustis Cook, *Alice Blair and Nurse,* The Valentine Museum, Richmond, Va., X60.7.1
2.11 George Cook, *Untitled,* The Valentine Museum, Richmond, Va.
2.12 George Cook, *Untitled,* The Valentine Museum, Richmond, Va.
2.13 George Cook, *Untitled,* The Valentine Museum, Richmond, Va.
2.14 George Cook, *Untitled,* The Valentine Museum, Richmond, Va.
2.15 George Cook, *Untitled,* The Valentine Museum, Richmond, Va.
2.16 George Cook, *Untitled,* The Valentine Museum, Richmond, Va.
2.17 George Cook, *Untitled,* The Valentine Museum, Richmond, Va.
2.18 George Cook, *Untitled,* The Valentine Museum, Richmond, Va.

CHAPTER 3

3.1 Unknown photographer, *On Arrival at Hampton, Va.: Carrie Anderson—12 yrs., Annie Dawson—10 yrs., and Sarah Walker—13 yrs.,* ca. 1880s. Courtesy President and Fellows of Harvard College, Peabody Museum, Harvard University, N30439A
3.2 Unknown photographer, *Fourteen Months After, Hampton, Va,* ca. 1880s. Courtesy President and Fellows of Harvard College, Peabody Museum, Harvard University, N30440A

4.21 Frances Benjamin Johnston, *Self-Portrait,* Library of Congress, LC-J698-81151

4.22 Frances Benjamin Johnston, *Class in American History,* Library of Congress, LC-USZ62-38149Q

4.23 Frances Benjamin Johnston, *Adele Quinney. Stockbridge Tribe,* Library of Congress, LC-USZ62-86982

4.24 Frances Benjamin Johnston, *John Wizi. Sioux,* Library of Congress, LC-USZ62-18647

CHAPTER 5

5.1 Hermine Turner, *Portrait of Gertrude Käsebier,* platinum print, 7 7/8 × 6″, Davis Museum and Cultural Center, Wellesley College, Wellesley, Mass., 1973.44

5.2 Gertrude Käsebier, *The Hand That Rocks the Cradle (Mrs. Beatrice Baxter Ruyl and Infant),* 1913, platinum print, 7 1/4 × 9 5/8″ (18.4 × 24.4 cm), The Museum of Modern Art, New York, gift of Mrs. Hermine M. Turner; copy print © 1999 The Museum of Modern Art, New York

5.3 Gertrude Käsebier, *Mrs. R. Nursing Baby,* Photographic History Collection, National Museum of American History, Smithsonian Institution, 73.15.21

5.4 Gertrude Käsebier, *Emmeline Stieglitz and Katherine (Kitty) Stieglitz,* 1899–1900, platinum print, 16.9 × 15.0 cm, The Art Museum, Princeton University, Clarence H. White Collection, assembled and organized by Professor Clarence H. White Jr., and given in memory of Lewis F. White, Dr. Maynard P. White Sr., and Professor Clarence H. White Jr., the sons of Clarence H. White Sr. and Jane Felix White; photograph by Clem Fiori, CHW x108-1

5.5 Gertrude Käsebier, *Mother and Child (Mrs. Ward and Baby),* Library of Congress, LC-USZ62-54342

5.6 Gertrude Käsebier, *Adoration,* ca. 1897, platinum print, courtesy George Eastman House, GEH 26705

5.7 Gertrude Käsebier, *The Picture Book (Beatrice Baxter Ruyl and Charles O'Malley),* Library of Congress, LC-USZ62-52459

5.8 Gertrude Käsebier, *Lolly Pops (Mrs. Hermine M. Turner and Children),* 1910, platinum print, 11 1/4 × 8 3/8″ (28.6 × 21.3 cm), The Museum of Modern Art, New York, Gift of Mrs. Hermine M. Turner; copy print © 1999 The Museum of Modern Art, New York

5.9 Gertrude Käsebier, *The Manger,* or *Ideal Motherhood,* 1899, platinum print on Japanese vellum, 12 3/4 × 9 1/2″ (32.4 × 24.1 cm), The Museum of Modern Art, New York, gift of Mrs. Hermine M. Turner; copy print © 1999 The Museum of Modern Art, New York

5.10 Gertrude Käsebier, *Real Motherhood,* previously published in *The Craftsman: An Illustrated Monthly Magazine in the Interest of Better Art, Better Work, and a Better and More Reasonable Way of Living* 12 (April–September 1907): 81

5.11 Gertrude Käsebier, *Blessed Art Thou Amongst Women,* 1899, platinum print on Japanese tissue, 9 3/8 × 5 1/2″ (23.8 × 13.9 cm), The Museum of Modern Art, New York, gift of Mrs. Hermine M. Turner, copy print © 1999 The Museum of Modern Art, New York

5.12 Gertrude Käsebier, *The Heritage of Motherhood,* 1904, gum bichromate on platinum, 9 1/4 × 12 7/16″ (23.5 × 31.6 cm), The Museum of Modern Art, New York, gift of Mrs. Hermine M. Turner; copy print © 1999 The Museum of Modern Art, New York

5.13 Gertrude Käsebier, *Marriage—Yoked and Muzzled,* Library of Congress, LC-USZ62-78357

5.14 Gertrude Käsebier, *"Where there is so much smoke, there is always a little fire,"* platinum print, 6 × 8″, Davis Museum and Cultural Center, Wellesley College, Wellesley, Mass., 1973.33

5.15 Gertrude Käsebier, *Joe Black Fox,* Photographic History Collection, National Museum of American History, Smithsonian Institution, 81-9561

5.16 Gertrude Käsebier, *American Indian Portrait (Joe Black Fox),* ca. 1898–1901, platinum print, 8 × 6″ (17.5 × 15.2 cm), The Museum of Modern Art, New York, gift of Miss Mina Turner; copy print © 1999 The Museum of Modern Art, New York

5.17 Gertrude Käsebier, *Samuel Lone Bear,* Library of Congress, LC-K2-T01-67

5.18 Gertrude Käsebier, *Willie Spotted Horse,* Photographic History Collection, National Museum of American History, Smithsonian Institution, 83-903

5.19 Gertrude Käsebier, *Iron Tail,* Photographic History Collection, National Museum of American History, Smithsonian Institution, 85-7212

5.20 Gertrude Käsebier, *Profile of Iron Tail,* Photographic History Collection, National Museum of American History, Smithsonian Institution, 83-902

5.21 Gertrude Käsebier, *Mary Lone Bear,* Photographic History Collection, National Museum of American History, Smithsonian Institution, 83-9562

5.22 Gertrude Käsebier, *Profile of Mary Lone Bear,* Photographic History Collection, National Museum of American History, Smithsonian Institution, 83-916

5.23 Gertrude Käsebier, *American Indian Portrait (Indians Drawing in Käsebier's Studio),* ca. 1900, platinum print, 6 7/8 × 6″ (17.5 × 15.2 cm), The Museum of Modern Art, New York, gift of Mrs. Mina Turner; copy print © 1999 The Museum of Modern Art, New York

5.24 Samuel Lone Bear, *Catch Girls,* Photographic History Collection, National Museum of American History, Smithsonian Institution, 89-13431

CHAPTER 6

6.1 Unknown photographer, *Self—starting for Chicago, Punch also, Staten Island, Saturday July 1, 1893,* Staten Island Historical Society, A1204

6.2 Alice Austen, *Extended view of Austen House, "Clear Comfort,"* Staten Island Historical Society, E116

6.3 Alice Austen, *Street Types,* Library of Congress, LC-USZ62-76951

6.4 Alice Austen, *Street Types,* Library of Congress, LC-USZ62-76952

6.5 Alice Austen, *Street Types,* Library of Congress, LC-USZ62-76957

6.6 Alice Austen, *Street Types,* Library of Congress, LC-USZ62-76954

6.7 Alice Austen, *Street Types,* Library of Congress, LC-USZ62-76950

6.8 Alice Austen, *Street Types,* Library of Congress, LC-USZ62-76956

6.9 Alice Austen, *Street Types*, Library of Congress, LC-USZ62-76958

6.10 Alice Austen, *Street Types*, Library of Congress, LC-USZ62-60523

6.11 Alice Austen, *Street Types*, Library of Congress, LC-USZ62-60524

6.12 Alice Austen, *Street Types*, Library of Congress, LC-USZ62-21000

6.13 Alice Austen, *Street Types*, Library of Congress, LC-USZ62-76959

6.14 Alice Austen, *Street Types*, Library of Congress, LC-USZ62-49556

6.15 Alice Austen, *Street Types*, Library of Congress, LC-USZ62-76949

6.16 Alice Austen, *Street Types*, Library of Congress, LC-USZ62-76960

6.17 Alice Austen, *Street Types*, Library of Congress, LC-USZ62-11036

6.18 Alice Austen, *Street Types*, Library of Congress, LC-USZ62-60522

6.19 Alice Austen, *Street Types*, Library of Congress, LC-USZ62-76953

6.20 Alice Austen, *Street Types*, Library of Congress, LC-USZ62-76955

6.21 Alice Austen, *Egg Stand Group, Hester Street, New York City, April 16, 1895*, Alice Austen Collection, Staten Island Historical Society, A74c

6.22 Alice Austen, *Austen House*, Staten Island Historical Society, E146d

6.23 Pickard, *Pickard's Penny Photo, Alice Austen and Gertrude Tate*, Staten Island Historical Society

6.24 Alice Austen, *Aunt Minn, Alice and Uncle Oswald with Punch*, Staten Island Historical Society, A1315c

6.25 Alice Austen, *The Darned Club, Thursday, October 29, 1891*, Staten Island Historical Society, A1198

6.26 Alice Austen, *The Darned Club in a Chair, Thursday, October 29, 1891*, Staten Island Historical Society, A1197

6.27 Alice Austen, *Trude and I Masked, Short Skirts, Thursday, August 6, 1891*, Staten Island Historical Society, A1191d

6.28 Alice Austen, *Trude, Mr. Gregg and Fred Mercer, August 9, 1891*, Staten Island Historical Society, D103d

6.29 Alice Austen, *Trude and Mr. Hopper Approaching Tombstone, Watkins, N.Y., Wednesday, August 3, 1892*, Staten Island Historical Society, A1270

6.30 Alice Austen, *At Tombstone — Trude and Mr. Hopper "YES", Watkins, N.Y., August 3, 1892*, Staten Island Historical Society, A470d

6.31 Alice Austen, *At Tombstone — Trude and Mr. Hopper "NO," Watkins, N.Y., August 3, 1892*, Staten Island Historical Society, A473d

6.32 Alice Austen, *At Tombstone — Trude and Mr. Hopper and Self "NO," Watkins, N.Y., August 3, 1892*, Staten Island Historical Society, A474d

6.33 Alice Austen, *At Tombstone — Myself and Mr. Hopper — Approaching, Watkins, N.Y., August 3, 1892*, Staten Island Historical Society, A471d

6.34 Alice Austen, *Approaching Tombstone — Myself and Mr. Hopper "YES," Watkins, N.Y., August 3, 1892*, Staten Island Historical Society, A472d

6.35 Alice Austen, *Julia Martin, Julia Bredt and Self, Dressed Up, Sitting Down*, Staten Island Historical Society, D122d

6.36 Alice Austen, *September 17, 1885*, Staten Island Historical Society, C22d

6.37 Alice Austen, *Ship from Austen Lawn*, Staten Island Historical Society, A1115

6.38 Alice Austen, *Oswald Muller on Lawn at Clear Comfort*, Staten Island Historical Society

6.39 Alice Austen, *Sailing Ships in Front of Austen House,* Bark "Palgrave" at Anchor, Staten Island Historical Society, D357d

6.40 Alice Austen, *September 27, 1890, Tree, Bay and Ships, Staten Island N.Y.,* Staten Island Historical Society, D356d

6.41 Alice Austen, *Dewey Parade, 1899,* Staten Island Historical Society, A124d

6.42 Alice Austen, *Gas Generator—Formaldehyde Gas, Wednesday March 31, 1897, Quarantine boat "James Wadsworth,"* Public Health Service series, Staten Island Historical Society, A994

6.43 Alice Austen, *Receiving End, Door Open in One Car, Clothes in Car, Swinburne Island, Wednesday March 31, 1897,* Public Health Service series, Staten Island Historical Society, A938d

6.44 Alice Austen, *Hoffman Island,* Public Health Service series, Staten Island Historical Society, A917d

6.45 Alice Austen, *Interior View Showing Beds, Quarantine,* Public Health Service series, Staten Island Historical Society, A956d

6.46 Alice Austen, *Man Hosing Out Beds, Quarantine, Hoffman or Swinburne Island, ca. 1900,* Public Health Service series, Staten Island Historical Society, A935d

6.47 Alice Austen, *"James W. Wadsworth" alongside incoming Steamer, Quarantine,* Quarantine series, Staten Island Historical Society, E182d

6.48 Alice Austen, *Quarantine boat "James W. Wadsworth" at Steamer's Side, Quarantine, S.I.,* Quarantine series, Staten Island Historical Society, A937d

6.49 Alice Austen, *Disinfecting Boat—bathroom, Quarantine, Thursday ____ 23rd, 1895,* Quarantine series, Staten Island Historical Society, A1002d

6.50 Alice Austen, *Ship's Officer and Child on Quarantine Side, Wheeler "James W. Wadsworth," ca. 1901,* Quarantine series, Staten Island Historical Society, A916d

6.51 Alice Austen, *Laboratory Upstairs—"Fred at Work," Quarantine Station, Monday, April 29, 1901, 11:10 AM,* Quarantine series, Staten Island Historical Society, A903d

6.52 Alice Austen, *Untitled,* Detention series, Library of Congress, LC-USZ62-65172

6.53 Alice Austen, *Untitled,* Detention series, Library of Congress, LC-USZ62-40457

6.54 Alice Austen, *Untitled,* Detention series, Library of Congress, LC-USZ62-124479

6.55 Alice Austen, *Untitled,* Detention series, Library of Congress, LC-USZ62-124475

6.56 Alice Austen, *Untitled,* Detention series, Library of Congress, LC-USZ62-40456

6.57 Alice Austen, *Untitled,* Detention series, Library of Congress, LC-USZ62-40455

6.58 Alice Austen, *Boat "James W. Wadsworth" tied up at pier, shore and House on hill, Quarantine,* Detention series, Staten Island Historical Society, E235

6.59 Alfred Eisenstaedt, *Alice Austen in Wheelchair, Life Magazine,* © Time Inc., Set #34753

EPILOGUE

Index

Page numbers in italics refer to photographs.

and Käsebier's photographs, 193–94, *194*, *195*; and Austen, 222–23, 225–27, 235–40; and women in men's clothing, 237, 239, *239*

Genealogy, 56–57

George Eastman House Collection, 36

Georgia Sea Island, 7

Gerhard, Emme, 7, 268–71, *269*, *270*, *272*, 280

Gerhard, Mamie, 7, 268–70, *269*, *270*, *272*, 280

Geronimo, 278

Getty Museum, 311 (n. 66)

Gibbons, H. S., 262

Gilman, Caroline, 83, 92

Gilman, Charlotte Perkins, 36, 257

Gilmore, Glenda, 72

Gilroy, Paul, 8

Goffman, Erving, 141–42

Goldman, Emma, 37

Gorky, Maxim, 231

Gover, Jane, 37

Grant, Ulysses S., 131

Green, Floride, 35

Gregg, Mr., 236, *237*

Guilbaut, Serge, 58

Guimond, James, 8, 319–20 (n. 4)

Gunning, Sandra, 7–8, 82–83

Hales, Peter, 20, 212

Halftone printing process, 20

Hall, Jacquelyn Dowd, 7–8

Hampton Album, 11, 134–39, 171–76

Hampton Institute: Du Bois on, 10, 130; African Americans at, 10–11, 52, 106–8, 113–14, 312 (n. 25); Johnston's photographs of, 10–11, 127, 129, 131–41, *132–45*, *147*, 147–61, *154*, 162, 163–64, *167*, 167–76, *172*; Native Americans at, 107–14, *109*, *110*, 129, 169, 171–76, *172*; photographs of Native American female students at, *109*, 109–13, *110*; and African Americans in military, 127–29; "industrial" versus "academic" focus of, 129–30, 148, 149; B. T. Washington on, 130–31, 142–47, 150–51;

fundraising for, 131; backers of, 131, 155; quietness and fixity of photographs of, 139, 140–41, 144, 152; learning from "underlife" in, 142; debating societies at, 145–46; and Alumni Association protests, 149; teacher training at, 149; stance of Johnston toward, 151–53; literature lesson on Whittier at, 153–61, *154*; Kiquotan Kamera Klub at, 291

Hampton Quartet, 131

Hampton Student Singers, 131

"Hand That Rocks the Cradle," *183*

"Hansom cab, Union Square Brentano's," *221*

Haraway, Donna, 8, 308 (n. 11)

Harding, Sandra, 308 (n. 11)

Harper's, 115

Harper's Bazaar, 121–22

Harrison, Benjamin, 21

Harrison, Gabriel, 23

Harvard University, 88, 279, 284

Hawaii, 52–53, 127, 266

Hawarden, Lady Clementina, 226

Hawes, Josiah, 4, 61

Hawthorne, Nathaniel, 65, 100

Hawthorne, Sophia, 65, 257

Head Dress (Beals), 279

Hemment, J. C., 15, 47–48, *48*, 49, 307 (n. 55)

Henry, Nelson E., 292–95

"Heritage of Motherhood," 12, 191, *192*, 193

"Hester Street egg stand," 222, 222–23, 243

Hewitt, Mattie Edward, 272

Hiawatha (Longfellow), 122

"Hidden transcripts," 2, 3, 303 (n. 3)

"Hidden Witness" exhibition, 83, 309 (n. 37), 311 (n. 66)

Hine, Lewis, 35, 260

Hirsch, Marianne, 308 (n. 15)

History, 129–30, 299–300

History of Woman Suffrage (Anthony), 164

Hoffman Island, 12, 245, *246–48*, 248, 249, *252–58*, 261

Holland, Patricia, 4–5, 66, 300–301

Parker, Quanah, 278
Patagonian Giants, 276–77, *277*, 278, 290
Patterson, Orlando, 65
Patterson, Thomas MacDonald, 29, 43
Paul, Susan, 101
Peabody, Endicott, 183
Pears' Soap, advertisement for, 44, *45*
"Peddler of shoestrings, Trinity Church," *221*
Pennell, Mr. and Mrs.: Beals photographs of death of, 277
Periodicals. *See* Magazines
"Periphery" and "core," 250, 253–54
Petty, Sarah Dudley, 297
"Phallic" mothers, 183
Philippines: African American soldiers in, 11, 127–28, 148, 284; and Aguinaldo, 16, 17–18, 28, 42–46, *46*, 290; Dewey's conquest of, 16–18, 31, 32, 42–44, 284; Spanish navy in, 18; and anti-imperialist sentiments, 20–21, 266; and torture of Filipinos by U.S. military, 28–31; Schurtz on, 34; Dewey's testimony on, 43–44; and Filipinos on display at St. Louis World's Fair, 106, *274–75*, 276–80, 282, *282*, *283*, 283–84; "tribes" in, 178; U.S. occupation and annexation of, 266, 267, 268, 284; Igorots from, 269–70, *270*, *271*, 276, 280, 282, *282*; Beals's proposed trip to, 279, 284, 285; constabulary in, 284
Phillips, Ammi, 61
Phillips, Christopher, 58
Photo American Review, 232
Photography: democratic vision and antidemocratic potential of, 1–6, 59; invention of, 3, 66; and capitalism, 5; and "innocent eye," 6–7, 8, 13, 181, 265, 284; essay form of, 20; sales of to magazines, 20, 48; social documentary, 35; amateur, 35, 210–12, 224–26; meaning of, 50–51, 66; and *studium* of photograph, 55; and *punctum* of photograph, 55, 153, 310 (n. 58); field, 63; as ideological, 66; nineteenth-century

functions of, 66–67, 83–84; documentary display of, 106; objectivity of, 179; portrait, 181–83, 207–11; as "contact zone," 208; careers in, 210; equipment for, 212, 225; small-camera, 212, 225, 265; societies for, 225; and Kodak camera, 225, 265; ethnographic, 279, 284; Root on, 298; Holmes on, 299; reading of historical, 299–301. *See also* Women photographers; *specific photographers*
"Picture Book," *187*
"Pinkie," 73–74, *75*
Piquet, Louisa, 3–4, 303 (n. 7)
Plumbe, J. S., 61
Poe, Edgar Allan, 100
Poems of Cabin and Field (Dunbar), 291
"Policeman, Herald Square," *216*
Pollack, Peter, 36
Pollard, Edward A., 82
Pollock, Griselda, 66
Poore, H. R., 44
Pornography, 59, 240
Portraits, 181–83, 207–11. *See also* Family portraits; *specific photographers*
Portugal, 310 (n. 42)
"Postman opening box, John L. Gallagher," *214*
Prall, Virginia, 35
Pratt, E. Spenser, 18, 43, 44
Pratt, Mary Louise, 177, 178–80, 208, 243
Pratt, Minnie Bruce, 8
Pratt, Richard Henry, 114, 115
Presidents, photographs of administrations of, 21, 38, 153
"Pretzel vendor," *219*
Primitivism. *See* St. Louis Exposition/World's Fair
Public Health Service photographs, 12, 245, *246–58*, 248–50, 260, 264
Punctum of photograph, 55, 153, 310 (n. 58); and "puncture" in Barthean sense, 83, 310 (n. 58)
Puritan culture, 94, 95, 96
Pygmies, 271, *273–74*, 276–77, *277*, 278, 282, 289, 290